The Intersectional Internet

Steve Jones

General Editor

Vol. 105

The Digital Formations series is part of the Peter Lang Media and Communication list.
Every volume is peer reviewed and meets
the highest quality standards for content and production.

PETER LANG
New York • Bern • Frankfurt• Berlin
Brussels • Vienna • Oxford• Warsaw

The Intersectional Internet

Race, Sex, Class, and Culture Online

Edited by
Safiya Umoja Noble and Brendesha M. Tynes

PETER LANG
New York • Bern • Frankfurt • Berlin
Brussels • Vienna • Oxford • Warsaw

Library of Congress Cataloging-in-Publication Data

The intersectional Internet: race, sex, class and culture online /
edited by Safiya Umoja Noble, Brendesha M. Tynes.
pages cm. — (Digital formations; vol. 105)
Includes bibliographical references and index.
1. Internet—Social aspects. 2. Digital divide. 3. Race. 4. Sexism. 5. Social classes.
I. Noble, Safiya Umoja, editor. II. Tynes, Brendesha M., editor.
HM851.I5855 302.23'1—dc23 2015029829
ISBN 978-1-4331-3001-4 (hardcover)
ISBN 978-1-4331-3000-7 (paperback)
ISBN 978-1-4539-1717-6 (e-book)
ISSN 1526-3169

Bibliographic information published by Die Deutsche Nationalbibliothek.
Die Deutsche Nationalbibliothek lists this publication in the "Deutsche
Nationalbibliografie"; detailed bibliographic data are available
on the Internet at http://dnb.d-nb.de/.

The paper in this book meets the guidelines for permanence and durability
of the Committee on Production Guidelines for Book Longevity
of the Council of Library Resources.

Contents

Introduction

SAFIYA UMOJA NOBLE AND BRENDESHA M. TYNES

This book opens up new lines of inquiry using various intersectional frameworks. Whether we use Black feminism as a lens that allows us to ask questions and conduct new investigations, or other lenses such as political economy, cultural studies, and critical theory, what we need are theoretical and methodological approaches that allow us to intervene on the organization of social relations that are embedded in our digital technologies and that can foster a clearer understanding of how power relations are organized through technologies. In this book, we have engaged a number of leading scholars from the fields of information studies/library and information science, communications, digital media studies, education, sociology, and psychology, who are all researching how intersectional power relations function within the digital. The goal of this book is to provide a text that can inspire thinking about new methods, new theories, and, ultimately, new interventions in the study of the many global Internet(s).

This book was originally the brainchild of André Brock, Assistant Professor of Communication at the University of Michigan, who first conceptualized and proposed the framework and scope of the volume to Steve Jones, the Digital Formations Series editor for Peter Lang and editor of *New Media & Society*. We became partners with André and ultimately brought the book forward, but this book would not exist without his intellectual contributions and friendship. In the first call for papers for this book, Brock encouraged intersectionality as a lens for interrogating the Internet this way:

We view race as an "instrument of social, geographic and economic control" (Guinier, 2004). We acknowledge the importance of individual agency, but also the "institutional and environmental forces that both shape and reflect that agency" (Guinier, 2004). As such, intersectionality in this collection may highlight how individuals experience intersecting oppressions in a given socio/historical/political context, but also how they may transcend and even thrive in the face of economic and social inequality and oppression (Collins, 2000).

After meeting at a National Council of Black Studies conference in Indianapolis in 2013, we discussed broadening the intersectional approach to thinking about the Internet from the social sciences, including library and information science, education, sociology, and psychology. With the wide-ranging number of scholars from various fields conducting research in these areas, we felt the book would be more innovative and interdisciplinary, with representation from multiple methods and approaches. Along the way, Safiya Noble took primary responsibility for shepherding the collection through, with support and editorial contributions from Brendesha Tynes. What has come forth in this volume is a way of thinking critically about the Internet as a system that *reflects*, and a site that *structures*, power and values.

INTERSECTIONALITY

There is now quite a robust literature on intersectionality, although not a lot in the broadest scope of Internet studies. Taking a long view of the origins of intersectionality, scholars point to the speeches of Maria Stewart (1831) and Sojourner Truth (1851), among others, who conceptualized power and oppression across multiple axes. Intersectionality has been articulated through varied terminology including "double jeopardy" (Beale, 1970), "simultaneity" (Combahee River Collective, 1986), "interlocking oppressions" (Hull et al., 1982), "race-gender-class" (Collins, 1991, 2000), and "intersectionality" (Crenshaw, 1989, 1991). Scholars such as Angela Y. Davis have long argued for the elimination of oppression of all kinds and a more complex analysis of power relations that cannot be understood studying individual variables such as race, class, gender, or sexuality (Davis, 1983). We now see intersectional frameworks in a wide range of theoretical traditions and fields, including queer theory, third wave feminism, and cultural studies. Crenshaw's (1989) coining of the term *intersectionality* offered a single word to describe a long and complex discussion about Black women's multiple forms of simultaneous oppression, best described in the following metaphor:

> Consider an analogy to traffic in an intersection, coming and going in all four directions. Discrimination, like traffic through an intersection, may flow in one direction, and it may flow in another. If an accident happens in an intersection, it can be caused by cars traveling from any number of directions and, sometimes, from all of them. Similarly, if a Black woman is harmed because she is in an intersection, her injury could result from sex

discrimination or race discrimination.... But it is not always easy to reconstruct an accident: Sometimes the skid marks and the injuries simply indicate that they occurred simultaneously, frustrating efforts to determine which driver caused the harm. (Crenshaw, 1989)

The field now enjoys broad popularity, with entire centers devoted to the scholarship of intersectionality. The Institute for Intersectionality, Research, and Policy was created at Simon Fraser University in 2005, and the Center for Intersectionality and Social Policy Studies was created at Columbia University with Kimberlé Crenshaw at the helm in 2011. We also see the Consortium on Race, Gender, and Ethnicity at the University of Maryland, which houses the Intersectional Research Database, a collection of resources on intersectional scholarship. Collins (2015) also outlines a host of special issues including those in *Journal of Sex Roles*, *Race, Ethnicity, and Education*, *Journal of Broadcasting and Electronic Media*, *Social Politics*, *Gender and Society*, and *Signs*, along with a number of readers such as *Race, Class and Gender, An Anthology* (Andersen & Collins, 2012) and *Intersectionality: A Foundations and Frontiers Reader* (Grzanka, 2014) that point to the institutionalization of intersectionality.

In fact, the field of intersectionality has become so vast that Patricia Hill Collins (2015) suggests there are "definitional dilemmas," where there is a risk of defining the field so narrowly or so broadly that it loses its meaning. She argues that its general contours include "the critical insight that race, class, gender, sexuality, ethnicity, nation, ability, and age operate not as unitary, mutually exclusive entities, but as reciprocally constructing phenomena that in turn shape complex social inequalities" (p. 32). She further argues that intersectionality is a "field of study that is situated within the power relations that it studies," that it is an analytic approach as well as critical praxis that can inform social justice projects. Collins articulates intersectionality as both an overarching knowledge project and a constellation of knowledge projects, the latter of which involves a host of disagreements about its history, current organization, and future directions.

A CALL FOR INTERSECTIONAL CRITICAL RACE TECHNOLOGY STUDIES

Cultivating a theoretical frame such as Black feminist technology studies (Noble, 2012) and reframing it as intersectional critical race technology studies (ICRTS) is but one means of doing a closer reading of the politics of the Internet, from representation to infrastructure. It allows us to interrogate naturalized notions of the impartiality of hardware and software and what the Web means in differential ways that are imbued with power. It allows us to examine how information, records, and evidence can have greater consequences for those who are marginalized. Unequal

and typically oppressive power relations map to offline social relations in ways that are often, if not mostly, predicated on racialized and gendered practices. ICRTS could be theorized as an epistemological approach to researching gendered and racialized identities in digital and information studies. It offers a lens, based on the past articulations of intersectional theory, for exploring power in digital technologies and the global Internet(s). More research on the politics, culture, and values embedded in, and on, the Internet and its many platforms, devices, interfaces, and representations can help continue to frame broader contexts of digital information and technology engagements on the Internet. Specifically in the context of an intersectional analysis, concerns are largely underexamined in the multiple fields that embrace the study of the Internet. In Noble's (2013) research on the study of search engine results, her call for Black feminist technology studies was a way to articulate concerns about how Black women and girls are racially engaged through algorithmic imperatives that foreground profits over problematic narratives. In the future, she will continue to expand the theoretical and methodological imperatives of an intersectional critical race technology field of study that is situated at the interdisciplinary crossroads of information studies, African American studies, and gender studies.

Future research using critical, intersectional frameworks can surface counter-narratives in fields engaging questions about information and technology and marginalized or oppressed groups, which is the aim of this book. By looking at both the broader political and economic context and the many digital technology acculturation processes as they are differentiated intersectionally, a clearer picture emerges of how under-acknowledging culturally situated and gendered information technologies are affecting the possibilities of participation with (or purposeful abstinence from) the Internet. In essence, this book is attempting to engage with a series of concerns about how race, gender, and sexuality often preclude intersectional interrogations of the structure, activities, representations, and materiality of the Internet. These concerns are buttressed by state policies and economic forces, namely the interests of capital to expand its profits, in both local and global contexts.

This book could also be an incremental, modest response to Daniels's (2013) call for theorization in the field of Internet studies that engages with social constructions of Whiteness and the material power and accumulation of wealth, resources, and privileges based on historical and contemporary discrimination against the "other." We believe this is a research imperative, particularly as power is obscured by narratives of "post-raciality," and ideological investments in color-blindness are adding to greater hostilities in society (Brown, 2003; Neville, Awad, Floress, & Bluemel, 2013; Tynes & Markoe, 2010). Tettegah (2015) found, for example, that an "empathy bias" exists among those who embrace color-blind ideologies, and this results in increased stereotyping and negative attitudes

toward people of color. Noble discussed this lack of racial empathy in her examination of discourses about the death of Trayvon Martin, for example, and how profitable racist media narratives are, particularly as they circulate online (Noble, 2014). As an enduring narrative in technology fields, color-blindness makes it more difficult to intervene on how power operates on the Internet surface. Through this book we are introducing evidence that beckons a deeper look into the development of Intersectional Critical Race Technology Studies, which is a burgeoning articulation of intersectional theory in the digital and informational landscapes.

Certainly, there has been some important scholarly research on race and the Internet that predates this book by more than a decade. Daniels (2013) wrote an important and broad literature review covering the study of race and racism in the field of Internet studies, for those who want to quickly catch up on all of the former contributions. However, in her review, she offered a powerful critique of what was missing from the field: namely, a need to shift Whiteness away from serving as the primary, unnamed, lens for theorizing within the field. What she is naming are the ways that the field only nominally engages race, gender, and power simultaneously, set against a default backdrop of White normativity and investments (Lipsitz, 1998). Kendall (2002) and Brock (2011) have both studied the ways that Whiteness and maleness work as the default identities that define the culture of the Internet. These ways of thinking about the structure and practice of the Web are consistent with the way Harris (1995) theorizes Whiteness as a fundamental property right in the United States. Whiteness as a social construct (Daniels, 2009; Harris, 1995; Leonard, 2009; Noble, 2013, 2104; Roediger, 1991) has been the central organizing framework for the study of the Internet, which Daniels rightly critiques as underexamined in understanding the complexities of the activities, culture, and structure of the Web that substantively marginalize, without interrogation.

We, too, have been writing about how race and gender are implicated in intersectional ways on the Web. Noble researched the ways that the commercial search engine, Google, profits from hypersexualized misrepresentations of Black women and girls and cautions against the outsourcing of public information needs to private corporations (Noble, 2013). Tynes has published extensively about the racial landscape adolescents navigate online; the construction of racial identity, gender, and sexuality; and associations between racial discrimination online, mental health, and behavior (Subrahmanyam, Greenfield, & Tynes, 2004; Tynes, 2005, 2007; Tynes et al., 2014; Tynes, Giang, Williams, & Thompson, 2008; Tynes, Reynolds, & Greenfield, 2004). Tynes's work has consistently shown that online experiences have implications for adolescent mental health and behavior offline. Together, our findings are consistent with the way Brock (2011) characterizes how technology design and practice are instantiated with racial ideologies:

> I contend that the Western Internet, as a social structure, represents and maintains White, masculine, bourgeois, heterosexual and Christian culture through its content. These ideologies are translucently mediated by the browser's design and concomitant information practices. English-speaking Internet users, content providers, policy makers, and designers bring their racial frames to their Internet experiences, interpreting racial dynamics through this electronic medium while simultaneously redistributing cultural resources along racial lines. These practices neatly recreate social dynamics online that mirror offline patterns of racial interaction by marginalizing women and people of color. (p. 1088)

The work of many important scholars, including Anna Everett, Oscar Gandy Jr., Jessie Daniels, André Brock, Rayvon Fouché, Christian Fuchs, and David Harvey, to name a few, has laid the groundwork for those in this edited collection to add to discussions about how power and policy are manifest in intersectional ways on the Web. Each of us is engaging how discourses of technology are explicitly linked to racial and gender identity, all of which normalize Whiteness and maleness in the domain of digital technology. Intersectionality and critical race theory help us think about these social, political, and economic racialized patterns of inequality.

THE INTERSECTIONAL INTERNET

This book engages a number of established and emerging scholars who are integrating intersectionality in their research. It represents a scholarly dialogue among critical media and information studies scholars as a means of foregrounding new questions, methods, and theories we can apply to digital media, platforms, and infrastructures. These inquires include how everything from representation to hardware, software, computer code, and infrastructures might be implicated in global economic, political, and social systems of control. We must keep a close eye on these practices, and this book gives voice to our mounting concerns that we expand the research that explicitly traces and intervenes on the types of uneven power relations that exist in technological spaces.

Part I: Cultural Values in the Machine

This section addresses the relative dearth of research on intersectionality and technology, which includes approaching techno-cultural beliefs from a structural perspective, examining institutional discourses about technology's effects on perceptions of intellect, sociability, progress, or culture as they are mediated by technology. In Part I, we emphasize intersectionality within real-world cultural interactions with technology, as opposed to speculating about technology's future with some yet-to-be-established sociopolitical reality. To frame this section, we contend that information and communication technologies (ICTs) create

social worlds that retain ideologies born of physical, temporal, and social beliefs, although early cyberculture researchers worked hard to convince us that digital worlds would be free from those constraints. That ideological retention can be seen in technological beliefs that privilege governments over citizens, corporations over people, and the expansion of White privilege in cyberspace. Examples of chapters in this section include technology debates on identity formation in the media, online activism, and discourses about technology's tensions between mainstream and minority cultures.

Brendesha Tynes, Joshua Schuschke, and Safiya Umoja Noble open the book by examining the dimensions and applications of what they call digital intersectionality theory. Using hashtag ethnography, they conduct a thematic analysis of text, images, and video from Twitter and Instagram focused on the Black Lives Matter movement. Keyword searches for #BlackLivesMatter, #HandsUpDontShoot, #icantbreathe, and #BaltimoreUprising were used. The authors find that previous theoretical approaches to race and social movements online inadequately describe the nature and critical praxis of participants in the movement. They note that cultural assets participants bring to online spaces inform their definitions of intersecting oppressions at the core of the movement as well as their agency.

Jessie Daniels, in "The Trouble With White Feminism: Whiteness, Digital Feminism, and the Intersectional Internet," brings a clear analysis about how the lack of intersectionality in three highly visible online feminist movements perpetually buttresses feminist action with notions of White racial supremacy, to the detriment of any cohesive, anti-racist possibilities. Daniels examines three cases of White women's activism online, including Facebook Chief Operating Officer Sheryl Sandberg's "Lean In" and "Ban Bossy" campaigns stemming from her popular *New York Times* and Amazon.com bestselling book, *Lean In*. Daniels also explores Eve Ensler's "One Billion Rising" campaign and how it appropriated and exploited Indigenous feminists of color while remaining incapable of introspection. She includes a third case study that offers a detailed critique of a report on online feminism authored by Vanessa Valenti and Courtney Martin for the #FemFuture project. Her chapter elucidates the difficulties of challenging White feminism on the Internet by using critical Whiteness frameworks that underscore the importance of anti-racist, intersectional theory and application to social justice work online.

Myra Washington has contributed important work on the representation and commodification of PSY and *Gangnam Style*'s popularity on YouTube in 2012–2013, as an example of the virility, visibility, and virality of Asian/American masculinity. Her work explores the "*conditional visibility* of Asian/Americans," and how Asian bodies and images are consumed and rendered both visible and invisible in the dominant U.S. culture of Whiteness. Washington's discussion of the seemingly positive embrace of Korean popular culture, as evidenced through *Gangnam*

Style's co-optation in social and traditional media, is nuanced. She reframes these embraces through a critical and close reading of key media articulations of the social, political, economic, and technological forces that have become part of the latest wave of yellow peril discourses, which she frames as Yellow Peril 2.0.

Catherine Knight Steele's work is an important reflection of why this book matters; her statement that "much of the early research on the Internet, particularly the blogosphere, centralized the experiences of western White men" underscores why we need more Black feminist theory in critical technology studies. Her contribution details the ways in which marginalized groups are using blogs online to engage in re-conceptualizations of participation in the democratic processes in the United States. She argues that new understandings of the Internet as a "public sphere" require epistemologies that allow for diverse ways of understanding the production of knowledge- and meaning-making. Steele's study looks at online gossip of Black women and its potential as a "discourse of resistance." Using a typology she crafted from Patricia Collins's "matrix of domination," Steele looks at celebrity gossip blogs edited by Black bloggers and analyzes how Black bloggers "resist or tolerate oppression at three levels: the personal, the communal and the institutional." Her work suggests that "Black women use these blogs to 'talk back' (hooks, 1988) to the systems and structures from which they are excluded or within which they are exploited."

Aymar Jean Christian writes about how "networked" (digital, peer-to-peer) television creates new opportunities and challenges for queer performers historically excluded from traditional media such as network television. He traces how marginalized voices rely on "difference" to present themselves to mass audiences that come at a variety of costs in platforms such as YouTube. Christian conducted interviews with producers of viral content and analyzes the making and spreading of viral video content. He analyzes the work of YouTube celebrities who are thrust into mass public view without explicit consent. In this timely essay, he helps us understand how intersectionality functions across multiple identities performed in online publics that foreground the complexities of being Black, queer, and woman on the Internet.

Jenny Ungbha Korn studies racially underrepresented populations and their activities and articulations of identity in Facebook Groups. In her study, she analyzed Facebook Group members across a variety of social and political interests to see how they align with multiple intersectional identities and signal belonging. Korn explores racial stereotyping and how Facebook Group users articulate their racialized and gendered experiences online. Her chapter explicitly engages intersectional identity and highlights the cultural constructions of Asian, Black, Latina, and White women's identities in Facebook Groups.

David J. Leonard has come back to writing about video games and brings us up to date on why we should care about the release of *Grand Theft Auto V.*

He contextualizes racialized and gendered tropes of the game in the context of racial violence and police brutality in Ferguson, Missouri, as part of an ongoing assault on Black life in reality and in video games. Using critical Whiteness and interesectionality, Leonard argues against claims that racism is irrelevant in virtual games such as *GTA:V*. This chapter explores "the dialectics that exist between the narrative and representational discourse offered through *Grand Theft Auto V* and within the Ferguson rebellion." Leonard argues that *GTA:V* signifies the hegemonic nature of contemporary racial discourse, and he concludes that both virtually and in everyday life, Black lives still don't matter, as video game narratives "reflect the ideological and representational landscape of society as a whole."

Part II: Cultural Values as the Machine

This section addresses the materiality of the digital and the politics embedded in systems and emphasizes how social and technical conditions work to create and constrain understandings of digital technologies. In this section, our contributors address how cultural values are articulated through technology design, in terms of both hardware and software. We placed this section toward the end of the book, rather than the beginning, to draw readers away from technological determinist perspectives on society and culture. Our foundational document for this section is Arnold Pacey's (1983) *The Culture of Technology*. Pacey argues that technology can be understood as the amalgam of an artifact, the associated practices, and the beliefs of its users. Our vision for this section is that it synthesizes the beliefs and practices articulated in Part I and specifically focuses on the design of software artifacts and platforms that shape electronic experiences. As well, this section examines the politics, infrastructures, and labor that support them.

This section starts with **Sarah T. Roberts**'s work on Commercial Content Moderators (CCM), which stems from her interviews with workers at social media companies who manage and curate our digital content consumption. Her chapter is an important contribution to how we can rethink social media platforms as "essentially empty vessels that need user-generated uploads," which, in turn, are either unrestricted or loosely managed through community codes of engagement. Her work underscores the relationship between CCM workers, who guard against digital damage to the brands of companies; and the politics of taste, acceptability, and the "logics by which content is determined to be appropriate or inappropriate." Through her work, we are able to see how the logics of racism, sexism, and state power operate in an uneven and politicized way, as determined by the frameworks of CCM. Roberts's research on CCM provides a unique insight into how racialized and racist language and imagery operate in social media and how these technology practices are predicated on the palatability of racist content to some imagined audience; the potential for its marketability and vitality; and the

likelihood of it causing offense and brand damage. CCM work is directly implicated in the curation of such content for its profitability.

Molly Niesen, in "Love, Inc.: Toward Structural Intersectional Analysis of Online Dating Sites and Applications," writes the first intersectional and political economic critique of online dating systems, which is much needed in the fields of information and communication studies. This chapter offers new insight on what Niesen has coined "Online Dating Sites and Applications (ODSAs)" and "mobile geosocial applications." Niesen uses an intersectional lens to think through how online dating is commercially structured, in whose interests, and to what consequences. Using historical methods, she traces the "marginalization of identities" and how online dating platforms enhance differences, which can exacerbate racism, sexism, homophobia, and body shaming. This chapter will be heavily cited in its exploration of practical questions about the racial and gendered politics of online dating platforms.

Ergin Bulut discusses the national context of censorship and the relationship between the Turkish state and two major social media companies, Facebook and Twitter. In his work, he calls into question claims about the decline of the nation-state and emerging discourses about the liberating aspects of new media technologies posing challenges to traditional forms of political engagement. Bulut names with specificity the interrelations of the nation-state and social media companies in the aftermath of the Arab Spring and in light the NSA scandal, which exposed the ways in which everyday people around the world are being surveilled by governments and various U.S. national security agencies. His work challenges the notion that social media companies are politically neutral and challenges us to rethink how these platforms support activists, given social media companies' willingness to cooperate with demands of government for records on citizens. In this work, we are able to trace the global/financial nature of multinational technology firms' operations, and how these work in tandem with neoliberal political regimes.

Melissa Villa-Nicholas's original research on the lack of Latinas in science, technology, engineering, and math (STEM), information technology (IT), and tech-related fields provides new insights into the historical precedents of underrepresentation. By tracing the *EEOC vs. AT&T* court case and consent decree, which mandated equal employment and affirmative action, she discusses the ways in which discrimination toward White women and women and men of color were differentially experienced, based on the intersectional experiences of simultaneously being women *and* people of color. Villa-Nicholas's work uses intersectionality to theorize how Latinas entering lower levels of the telecommunications field has had long-term implications for their engagements in technology related fields. Her study argues that Latinas have largely worked as invisible information laborers, which directly affects Latina representation in Internet companies and IT environments today.

Miriam E. Sweeney provides a powerful feminist critique of the history of computer programs and the quest to assign human features, characteristics, and personality traits to virtual agents. In this research, she examines the ways in which embodied representations of interface agents are predicated on stereotypical and oppressive narratives of gender, race, and sexuality. Her work is an important contribution to theorizing the design of intelligent computer agents in the fields of artificial intelligence (AI) and human-computer interaction (HCI). Sweeney carefully traces the history of how conceptions of humanness and intelligence, and even gender roles, have influenced the development of computer programs that mimic humans, specifically in the design of anthropomorphized virtual agents (AVAs). This important chapter details how power structures predicated on social constructions of gender and race are operationalized in computer interfaces, and she interrogates AVAs as sites of intersectional power relations. Her research adds to a growing body of critical technology studies that challenge interfaces as neutral in their design and effects. Sweeney calls for "ethically responsible and socially just design," which we agree can be successfully argued for across a variety of platforms and computing projects.

Robert Mejia forces us to engage with the future of the Internet. His chapter argues for an epidemiological turn for scholars engaging in Internet studies. He argues that media and cultural studies scholars, informed by British cultural studies and Black feminism, can take on "the forces that affect the meaning of a message as it travels through the circuit of communication." Mejia calls our attention to digital technologies and the Internet as a material infrastructure that forces us to intersectionally engage "systems of communication and power." He calls for greater recognition of the ways that "the experience and effects of global desire, pleasure, anxiety, and suffering operate unevenly across race, gender, class, and national lines." This chapter has three case studies that elucidate why we must understand the epidemiological impact of media production, usage, and disposal, which happens across local and global boundaries that reflect uneven global power relationships.

Tiera Chante' Tanksley powerfully closes this collection by blending together intersectionality, Black feminist thought, and critical race theory with critical media scholarship and calls for a Black Feminist Media Literacy to foreground a range of skills that we need for analyzing media codes, including how to speak back to, or criticize, dominant ideologies in social media. The goal of Tanksley, an emerging new media and education scholar, is to produce transformative change that can bolster students' academic resilience. In her chapter, she brings attention to the ways Black women and girls are engaging their oppressive experiences with race, gender, and class through the circulation of alternative values and narratives in Instagram memes. We believe Tanksley is another one to watch as she cultivates theory about Black feminist media literacy, a framework we agree "can help students and teachers make strides toward eliminating marginalization in schools, media, and society."

BINARY CODES OF RACE, SEX, AND CLASS:
INTERSECTIONALITY IN PRAXIS

The cover of this book, illustrated by the extraordinary John Jennings, Associate Professor of Art and Visual Studies at the University at Buffalo, SUNY, presents *The Intersectional Internet: Race, Class, Sex, and Culture Online* against the backdrop of intersecting binary code. We believe the chapters are set in a racial framework and social code that is embedded with the historical (and contemporary) Black-White racial binary in the United States. We would be remiss to not acknowledge that this binary racial framework is part of what structures racialization in the United States (and even globally). We saw evidence of the realities of two different Americas in the news headlines while we were writing the introduction to this book in the spring of 2015. We have been deeply affected by the #BlackLivesMatter movement organized in response to escalating and out-of-control social inequality, racial profiling, mass incarceration, police brutality, and murder of African American women, men, and children.[1] In the midst of the intense media coverage of victims killed at the hands of militarized police forces, Kimberlé Crenshaw foregrounds the importance of intersectionality by addressing the disparate resources, coverage, and care for Black women and girls. Her report, published by the African American Policy Institute, titled "Black Girls Matter: Pushed out, Overpoliced and Underprotected,"[2] specifies the ways that gender and race simultaneously erase the importance of Black women and girls, especially in the context of national uprisings and demonstrations for justice and accountability of police officers who murder not just Black men and boys, but women and girls too. We need intersectional social justice. This book was almost complete as the national news coverage of activists and community members called for an intensification of surveillance and the use of body cameras and digital technologies to address these crises. We could not respond fully to these gestures in this book, but there was room for response outside of the context of this project that illuminates why we must take up social justice frameworks for interrogating the uses of technology.

In an effort to clarify the importance of the role of information studies researchers and educators to bringing intersectional, critical lenses to the role of digital technologies, information, records, and evidence, the majority of the faculty in the Department of Information Studies at UCLA, at the behest of Safiya Noble, crafted a "Statement From Information Studies Academics and Professionals on Documentary Evidence and Social Justice"[3] and posted it online for other information and technology researchers and practitioners to sign on and support:

December 2014

We, the undersigned, are academic scholars and professional practitioners in the field of Information Studies and Library and Information Science. We support the role of information institutions such as libraries, archives, museums and academic institutions in fostering social justice and specifically affirm the importance of evidence and documentation in making sense of, and resolving, racial and social disparities, and injustice.

We are dedicated to inquiry and the advancement of knowledge. We develop future generations of scholars, teachers, information professionals, and institutional leaders. Our work is guided by the principles of individual responsibility and social justice, an ethic of caring, and commitment to the communities and public we serve. Moreover, we are committed to diversity, equity, and inclusion of all members of society, and recognize our responsibility in contributing knowledge, research, and expertise to help foster social, economic, cultural, and racial equity and justice. Thus, for example, we stand in solidarity with members of multiple communities in their recent calls on all Americans to recognize that "Black Lives Matter."

We affirm our long-standing commitment to the pursuit of social justice through the study of the production, management, authentication and use of documentary evidence, and the transformative role of education, as ways to promote better understanding of complex social issues, identify injustices and inequities, and formulate solutions to these problems. We believe that cultural and information institutions such as libraries and archives play a central role in advancing social justice and equity by offering spaces and resources for community-based dialog and reflection, providing access to information in all its forms, and designing and building systems of information classification, retrieval and access that expose and resist, rather than perpetuate, pervasive and unjust economic, class, racial, and gender disparities.

Furthermore, we recognize the vital importance of all forms of documentation, and especially records, in mediating contemporary conflicts and disputes rooted in longstanding historical patterns of injustice, such as the recent spate of killings of African-American men, women, and children at the rate of one person every 28 hours in the United States by law enforcement or security officers, as reported in the media. In these and other crises, publicly-created documentary evidence (such as photographs, cellphone-generated video, and oral testimony) has emerged as an indispensable resource for helping victims' advocates, community members, and legal authorities alike to determine the facts of these cases, including claims of state violence against citizens. These records are necessary to assist victims' families and advocates to pursue claims of wrongful prosecution or injury.

We believe that greater transparency of government agencies and actions through documentation and the public release of documents is essential. We call for national debate and professional engagement on why racism and state-sanctioned violence persists and is systemically embedded in our culture. We also see a disturbing connection between the local events and global instances of human rights abuses, including those chronicled in

the most recent investigatory report on CIA torture processes. At the same time, we are doubtful that the growing, technologized "culture of surveillance," in which both citizens and the state engage in a constantly-escalating spiral of hypervigilance, data capture, and retaliatory exposure of sensitive information, in any sense constitutes a sustainable solution to social injustice or state violence, nor does it address the root causes and consequences of an increasingly violent and painfully divided society.

The core ethics and values of the information disciplines and professions require that we steward, validate, protect, and also liberate the cultural and documentary record; that we insure that documentation is transparent and accountable; and that we provide equitable and ready access to information for all. Our teaching, research and practice must manifest these values. We call on our academic and professional colleagues across the nation and around the world to join our efforts to build archives, collections, and repositories of documents in all media forms, and systems of access to and use of these resources, in the service of helping people experiencing injustice to talk back to the record, and to power.

We encourage all educators to stand with us, and encourage signatures to this Statement in affirmation of our professional and personal commitments to social justice.

The statement signaled a critical engagement with the role of evidence, much of which is increasingly digital and on the Internet. One item of key importance in the UCLA faculty conversations while crafting the statement (a few faculty declined to sign their names for a variety of reasons), included the language, "At the same time, we are doubtful that the growing, technologized 'culture of surveillance,' in which both citizens and the state engage in a constantly-escalating spiral of hypervigilance, data capture, and retaliatory exposure of sensitive information, in any sense constitutes a sustainable solution to social injustice or state violence, nor does it address the root causes and consequences of an increasingly violent and painfully divided society." If there were any key omissions from this book, it is a specific focus on these issues. Noble will be addressing them specifically in her future work, as she believes that a critical engagement with intersectionality, surveillance, and activism must become more central to our understandings of the long-term implications of the affordances and consequences of the Internet. The intensifications of racial, class, gendered, and transgendered inequality are ever apparent, and the Internet continues to be a contested space over its ability to ameliorate or exacerbate these tensions.

As we take up the frameworks for the book, we note that at the time of this editing, the class binary is profound, and wealth inequality is escalating. Black and White wealth gaps have become so acute, a recent report by Brandeis University found, that the racial wealth gap quadrupled between 1984 and 2007, making Whites five times richer than Blacks in the United States (McGreal, 2010). An intersectional analysis of wealth points toward hierarchies of income inequality that persistently depress wages and wealth for women. We recognize that sex

and gender throughout this book are fluid and include a variety of transgendered identities (Sedgwick, 1990). As dramatic shifts are occurring in an era of neo-liberal U.S. economic policy that has accelerated globalization, moved real jobs offshore, and decimated labor interests (Harvey, 2005), we see how these crises are under-theorized in intersectional ways by political economists studying the implications of the Internet and "informationalized capitalism" (Schiller, 2007). The traditional political economists offer us important histories and details about economic processes that others will take up intersectionally in this book, in local and global contexts. The sex and gender binary, upon which so much meaningful public policy is based, means we must resist dominant cisgendered narratives and demand space for transgender and queer theory to disrupt the normative land-scape in intersectional ways. The chapters of this book illuminate the complexities of these concerns and the value in seeing things in these ways.

FINAL THOUGHTS: THE EMERGING BORN-CRITICAL-DIGITAL RACE TECHNOLOGY SCHOLARS

A senior person in the field of Internet Studies once said that she was envious of the new scholars who are among the first to earn doctorates explicitly engag-ing with the Internet as subjects of dissertations. Unlike many important early contributors to the nearly 20-year-old field of Internet studies, not including the long legacy of information studies and the field of communications, we are meeting the first "born-critical-digital" generation of scholars engaged in interdis-ciplinary approaches to technology, media, and information studies. These schol-ars are explicitly linking critical race theory and intersectional women of color feminisms to their work. Those holding degrees or enrolled in doctoral programs conducting what could loosely be called a first generation of "critical race tech-nology studies scholars" include André Brock, Miriam Sweeney, Safiya Umoja Noble, Michelle Caswell, Sarah T. Roberts, Catherine Knight Steele, Felicia Harris, Delicia Tiera Green, Melissa Villa-Nicholas, Kristin Hogan, Wendy Duff, Stacy Wood, Ricardo Punzalan, Robin Fogle Kurz, Anthony Dunbar, Kishonna Gray, Sandra Hughes Hassell, Myrna Morales, LaTesha Velez, Karla Lucht, Ivette Bayo Urban, Jenny Korn, Sarah Florini, Meredith Clark, Dayna Chat-man, Jillian Baez, Tanner Higgin, Ben Burroughs, Myra Washington, Sarah Park, Aguynamed Michael Sarabia, Aymar Jean Christian, Khadijah Costley White, Kristen Warner, Al Martin, Racquel Gates, Raechel Lee Annand, Tara Conley, Matthew Haughey, Molly Niesen, Nicole A. Cooke, Constance Iloh, TreaAndrea Russworm, Tressie McMillan Cottom, Regina N. Bradley, Paula D. Ashe, Faithe Day, Douglas Wade-Brunton, Omar Wasow, LaCharles Ward, Carole Bell, Dan

Greene, Elizabeth Shaffer, Faith Cole, Reginald Royston, DaMaris Hill, Darrell Wanzer-Serrano, Adeline Koh, Deen Freelon, Alex Cho, Florence Chee, Jeffrey Jackson, Lori K. Lopez, and Cass Mabbott, to name just a few.

We believe that these few scholars we know and name here, and those we will come to know soon, are among the voices we need to hear from to help move our many intersecting research concerns forward.

NOTES

1. A list of victims of state-sanctioned and extra-legal violence by police against people of color was published by Gawker.com at http://gawker.com/unarmed-people-of-color-killed-by-police-1999–2014–1666672349.
2. See interview at http://www.forharriet.com/2015/02/kimberle-crenshaw-on-black-girls-matter.html.
3. The statement can be found at www.criticalLIS.com.

REFERENCES

Andersen, M. L., & Collins, P. H. (Eds.). (2012). *Race, class, gender: An anthology*. Belmont, CA: Wadsworth.

Beale, S. (1970). Double jeopardy: To be Black and female. In T. Cade (Ed.), *The black woman: An anthology*, pp. (90–100). New York: Mentor.

Brock, A. (2011). Beyond the pale: The Blackbird Web browser's critical reception. *New Media and Society, 13*(7), 1085–1103.

Brown, M. (2003). *Whitewashing race: The myth of a color-blind society*. Berkeley: University of California Press.

Collins, P. H. (1991). *Black feminist thought: Knowledge, consciousness, and the politics of empowerment*. New York: Routledge.

Collins, P. H. (2000). *Black feminist thought: Knowledge, consciousness, and the politics of empowerment* (2nd ed.). New York: Routledge.

Collins, P. H. (2015). Intersectionality's definitional dilemmas. *The Annual Review of Sociology, 41*(3): 1–3.20.

Combahee River Collective. (1986). The Combahee River Collective statement: Black feminist organizing in the seventies and eighties.

Crenshaw, K. (1989). Demarginalizing the Intersection of race and sex: A Black feminist critique of antidiscrimination doctrine, feminist theory, and antiracist politics. *University of Chicago Legal Forum*, 139–167.

Crenshaw, K. (1991). Mapping the margins: Intersectionality, identity politics, and violence against women of color. *Stanford Law Review, 43*(6), 1241–1299.

Daniels, J. (2009). *Cyber racism: White supremacy online and the new attack on civil rights*. Lanham, MD: Rowman and Littlefield.

Daniels, J. (2013). Race and racism in Internet studies: A review and critique. *New Media & Society*, *15*(5), 695–719.

Davis, A. Y. (1983). *Women, race & class*. New York: Vintage.

Grzanka, P. R. (Ed.). (2014). *Intersectionality: A foundations and frontiers reader*. Boulder, CO: Westview.

Guinier, L. (2004). From racial liberalism to racial literacy: *Brown v. Board of Education* and the interest-divergence dilemma. *Journal of American History*, *91*(1), 92–118.

Harris, C. (1995). Whiteness as property. In K. Crenshaw, et al. (Eds.), *Critical Race Theory: The key writings that informed the movement*. New York: The New Press.

Harvey, D. (2005). *A brief history of neoliberalism*. Oxford, UK: Oxford University Press.

Hull, G. T., Scott, P. B., & Smith, B. (1982). *But some of us are brave*. Old Westbury, NY: Feminist Press.

Kendall, L. (2002). *Hanging out in the virtual pub: Masculinities and relationships online*. Berkeley: University of California Press.

Leonard, D. (2009). Young, Black (or Brown), and don't give a fuck: Virtual gangstas in the era of state violence. *Cultural Studies Critical Methodologies*, *9*(2), 248–272.

Lipsitz, G. (1998). *The possessive investment in Whiteness: How White people profit from identity politics*. Philadelphia, PA: Temple University Press.

McGreal, C. (2010). A $95,000 question: Why are Whites five times richer than Blacks in the US? *Guardian*, UK. Retrieved from http://www.guardian.co.uk/world/2010/may/17/white-people-95000-richer-black

Neville, H. A., Awad, G. H., Floress, J., & Bluemel, J. (2013). Color-blind racial ideology. *American Psychologist*, *68*(6), 455–466. doi:10.1037/a0035694

Noble, S. U. (2012). *Searching for Black girls: Old traditions in new media*. Unpublished doctoral dissertation, University of Illinois at Urbana-Champaign, Champaign, IL.

Noble, S. U. (2013). Google search: Hyper-visibility as a means of rendering Black women and girls invisible. *InVisible Culture*, *19*.

Noble, S. U. (2014). Trayvon, race, media and the politics of spectacle. *The Black Scholar*, *44*(1).

Pacey, A. (1983). *The culture of technology*. Cambridge, MA: MIT Press.

Roediger, D. R. (1991). *The wages of Whiteness: Race and the making of the American working class*. London: Verso.

Schiller, D. (2007). *How to think about information*. Urbana: University of Illinois Press.

Sedgwick, E. K. (1990). *Epistemology of the closet*. Berkeley: University of California Press.

Subrahmanyam, K., Greenfield, P., & Tynes, B. (2004). Constructing sexuality and identity in an online teen chat room. *Journal of Applied Developmental Psychology*, *25*(6), 651–666.

Tettegah, S. (2015). The good, the bad and the ugly: Colorblind racial ideology and lack of empathy. In H. A. Neville, M. E. Gallardo, & D. W. Sue (Eds.), *What does it mean to be color-blind?: Manifestations, dynamics and impact*. Washington, DC: American Psychological Association Press.

Tynes, B. (2005). Children, adolescents and the culture of online hate. In D. Singer, N. Dowd, & R. Wilson (Eds), *Handbook of children, culture and violence* (pp. 267–290). Thousand Oaks, CA: Sage.

Tynes, B. (2007). Role-taking in online "classrooms": What adolescents are learning about race and ethnicity. *Developmental Psychology*, *43*(6), 1312–1320.

Tynes, B. M., Giang, M., Williams, D., & Thompson, G. (2008). Online racial discrimination and psychological adjustment among adolescents. *Journal of Adolescent Health*, *43*(6), 565–569.

Tynes, B. M., Hiss, S., Rose, C., Umaña-Taylor, A., Mitchell, K., & Williams, D. (2014). Internet use, online racial discrimination, and adjustment among a diverse, school-based sample of adolescents. *International Journal of Gaming & Computer Mediated Simulations, 6*(3), 1–16.

Tynes, B. M., & Markoe, S. L. (2010). The role of color-blind racial attitudes in reactions to racial discrimination on social network sites. *Journal of Diversity in Higher Education, 3*(1), 1–13.

Tynes, B., Reynolds, L., & Greenfield, P. M. (2004). Adolescence, race and ethnicity on the Internet: A comparison of discourse in monitored and unmonitored chat rooms. *Journal of Applied Developmental Psychology, 25*(6), 667–684.

Part One:
Cultural Values in the Machine

Digital Intersectionality Theory AND the #BlackLivesMatter Movement

BRENDESHA TYNES, JOSHUA SCHUSCHKE,
AND SAFIYA UMOJA NOBLE

When we say Black Lives Matter, we are talking about the ways in which Black people are deprived of our basic human rights and dignity. It is an acknowledgement Black poverty and genocide is state violence. It is an acknowledgment that 1 million Black people are locked in cages in this country—one half of all people in prisons or jails—is an act of state violence. It is an acknowledgment that Black women continue to bear the burden of a relentless assault on our children and our families and that assault is an act of state violence. Black queer and trans folks bearing a unique burden in a hetero-patriarchal society that disposes of us like garbage and simultaneously fetishizes us and profits off of us is state violence; the fact that 500,000 Black people in the United States are undocumented immigrants and relegated to the shadows is state violence; the fact that Black girls are used as negotiating chips during times of conflict and war is state violence; Black folks living with disabilities and different abilities bear the burden of state-sponsored Darwinian experiments that attempt to squeeze us into boxes of normality defined by White supremacy is state violence. And the fact is that the lives of Black people—not ALL people—exist within these conditions is consequence of state violence.

—ALICIA GARZA, CO-FOUNDER, #BLACKLIVESMATTER[1]

Many historians cite the 1954 landmark case *Brown v. Board of Education of Topeka* and the 1955 death of Emmett Till as the catalysts for starting the Civil Rights Movement in America (Bynum, 2013). Sixty years later, the deaths of Trayvon Martin, Michael Brown, Eric Garner, Freddie Gray, and others have grabbed national headlines as the United States has again been thrust into heightened

protest around racial inequality. Since August 9, 2014, when Michael Brown was killed by Officer Darren Wilson in Ferguson, Missouri, protesters have organized a number of demonstrations, including rallies, "die-ins," and boycotts (Lowery, 2015; Petersen-Smith, 2015). Like many other social movements across the globe, including the Arab Spring, social media has amplified the visibility of these events and the potential for actors to promote social change using digital technologies (Srinivasen, 2013). Using platforms such as Twitter, Instagram, and Vine, with the fight against police brutality at its core, the movement has frequently been dubbed the "Black Lives Matter movement" (often rendered as "the #BlackLivesMatter movement," a reference to the Twitter hashtag).

The origin of "Black Lives Matter" began with the 2013 death of Trayvon Martin. Originally formulated as a hashtag on Twitter, a popular social networking site, #BlackLivesMatter was created by Alicia Garza, Patrisse Cullors, and Opal Tometi. Garza (2014) states in the epigraph to this chapter that Black Lives Matter is concerned with how Black people are denied human rights along with the ways in which poverty and genocide are violence sponsored by the state. The acquittal of Martin's killer, George Zimmerman, as well as the deaths of Oscar Grant and Michael Brown, pushed #BlackLivesMatter into the national spotlight allowing it to sustain its visibility (Bonilla & Rosa, 2015; Guynn, 2015). Social media served as a site of expanding coverage of the death of Martin, though such coverage was often produced in the interest of creating a media spectacle through discourses of Black male criminality, which is highly profitable to the media industries (Noble, 2014). Yet Black women and girls are also disproportionately over-policed and are victims of police violence who deserve the sustained attention of the #Black-LivesMatter movement.[2] The erasure of women's lives, despite the inception of the movement by women, demands theorization of digital intersectionality, such that continued erasures are not fomented by scholars. We have noticed these discontinuities, and we are interested in how they can inform a theory of digital intersectionality.

In the context of a theory of digital intersectionality, what is troublesome about the broadening of the #BlackLivesMatter movement is the almost complete erasure of Black women, even and especially when they are at the forefront of organizing. We find this untenable, given that the history of Black feminism and intersectionality is rooted in the erasure of Black queer women from feminist and women of color organizing and intellectual thought (Harris, 1996) in previous historical social movements. We invoke the names of Barbara Smith, Adrienne Rich, Evelynn Hammond, Audre Lorde, and Laura Alexandra Harris, who not only theorized Black women's gender and sexuality but also foregrounded the need for articulating a politic of inclusion of Black queer women's knowledge production to the liberation of all Black people. Part of the ongoing marginalization and co-optation of queer Black women's contributions to the #BlackLivesMatter

movement has been in the emblematic commercialization and, frankly, stolen legacy of the intellectual and organizing capacity of the founders of the hashtag activism they generated on Twitter. We argue that current social movements and social theory are insufficient in helping to explain the movement from its origins through its spread after the death of Mike Brown and beyond.

We use articulations by Garza as an organizing logic, coupled with a method of hashtag ethnography (Bonilla & Rosa, 2015) to explore the dimensions and applications of what we call digital intersectionality through the use of social media and hashtags in Twitter. In their recently published article on #Ferguson, Bonilla and Rosa (2015) note, "in addition to providing a filing system, hashtags simultaneously function semiotically by marking the intended significance of an utterance." Notably, they argue that hashtags provide a performative frame that signals the context of a stream of conversation. In addition, the importance of hashtags lies in their ability to group potentially disparate perspectives. For example, tweets supportive of Ferguson protestors, as well as those in opposition who showed support for officer Darren Wilson, might both register sentiment under the hashtag #Ferguson. Before providing examples from the movement we briefly describe extant theorizing on race and why intersectionality provides a useful framework for the interactions and practices in the movement.

THEORIES OF RACE ONLINE

Theorizing about race online expands our understanding of racial representations, of how race is performed and modeled, and of the pedagogical function of digital tools and platforms. Many of the theories and models proposed tend to draw from and extend offline sites of inquiry. Some new media scholars are focused on how the social construct of Whiteness serves as a context for understanding how race and identity are specifically engaged online through the use of critical race theory, critical Whiteness theory, and intersectional theory (Brock, 2009, 2012; Daniels, 2009, 2013; Noble, 2012, 2013, 2014). An early effort to theorize race on the Internet, inspired by critical race theory (Matsuda, Lawrence, Delgado, & Crenshaw, 1993) but less widely adopted and tested, is Kang's (2000) cyber-race theory, which now might be characterized as more optimistic and utopian in its hope for transcendent racial experiences online. He argued that the Internet serves as a space where individuals and society might escape or transcend offline patterns of racial discrimination. He noted the primary differences in the ways race functions online, which he theorized as abolition, integration, and transmutation, and he suggested that the technical design of Internet-based platforms in the early years of the design and architectural buildout of the Web could foster the abolition of race by disrupting racial mapping and "promoting racial anonymity."

Integration, according to Kang, offers the possibility of challenging racial mean-ings and increasing social interactions with people different from us, much like the offline goals of educational or residential integration. Transmutation, Kang posited, may ultimately lead to racial passing through racial pseudonymity, which could bring about a host of unintended consequences that keep racial Otherization intact. He articulated this model as a question of design and stated that the Inter-net holds "both redemptive and repressive potential." A design for redemptive capabilities can potentially usher in changes in ways race is constructed. This is consistent with Dery (1996) who notes that technology is an engine of liberation *and* an instrument of repression. Though Kang proposed these ideas early in the history of scholarship of race and the Internet, it is still the case that affordances in the technology can help to shape the ways race is performed online, for better and for worse. What is missing, however, is an analysis that incorporates the power structures that privilege Whiteness and foster simultaneously racialized and gen-dered experiences on the Web, which are marked by difference from the normative White-male, cisgendered landscape.

Since the early days of theorizing race online, the more cogent scholars have applied critical race and critical Whiteness theoretical approaches to online settings. Jessie Daniels' (2009) canonical work on cyber-racism argues that the default culture of the Internet is racist and protects perpetrators of racial hostilities more than it protects targets of race-based hate. Words online may wound just as they do in offline experiences. Further, Daniels' (2013) exhaustive review of the literature in 15 years of study of race online suggests that the social construction of Whiteness is underexamined and needs to move to the fore in any meaningful study of race and racism online. Along these lines, other theories suggest a peda-gogical function for both the technological tools and user interaction within them. Tynes' (2007) manuscript suggested that adolescents learn about race through racialized role-taking, or the adoption and enactment of race-related roles. These roles include witnesses, targets, advocates, discussants, sympathizers, and friends. These roles allow adolescents to learn about the cultural practices and belief sys-tems of others as well as about the racial oppression and how it affects the lives of people of color. Similarly, Everett and Watkins (2008) argue that digital spaces can be racialized pedagogical zones that reinforce dominant ideologies about race and that stereotypes are taught, reproduced, and intensified through such practices as game play.

In addition, new media scholars have drawn upon Omi and Winant's (1994) racial formation theory. Nakamura (2008), for example, argues a digital racial for-mation theory, which is the sociohistorical process by which racial categories are developed, inhabited, transformed, and potentially distorted. She argues that race online is a process by which racial categories get organized, represented, and in some cases reproduced. She draws directly from Omi and Winant on the idea

of racial projects, which are "simultaneously an interpretation, representation, or explanation of racial dynamics, and an effort to reorganize and redistribute resources along particular racial lines" (Omi & Winant, 1994). One example of this type of racial project online, Nakamura notes, is the creation of avatars, which are visual representations that necessarily result in new organizations and distribution. However popular this perspective has become in the field of Internet studies, Daniels (2013) argues that the racial formation theory framework is insufficient and has been an unfortunate theoretical model for the field, as it insufficiently implicates systemic, structural racism, and ultimately locates racism online as a matter of individual, dispersed, erratic behavior.

Though this review of the literature is not exhaustive (for a more extensive review see Daniels, 2013), it is worth noting that theories of race online have failed to capture the intersectional nature of race, gender, class, and other categories and the context within which they are structured by Whiteness as a practice of power. A digital intersectionality theory is needed to fully capture representations, critical praxis, and the changing racial landscape being navigated at what may prove to be the most politically volatile time since the 1960s. As early as 2005, Glaser and Kahn (2005) argued that we were witnessing pre–Civil Rights era race relations online. It has been argued that the #BlackLivesMatter movement is the 21st century's Civil Rights Movement, redefining race and racial structures both online and off.

NETWORKED SOCIAL MOVEMENTS AND INTERSECTIONALITY

The work of Manuel Castells (2011, 2015) on networked social movements draws on what he calls a grounded theory of power. He notes that

> Power is exercised by means of coercion (the monopoly of violence, legitimate or not, by the control of the state) and/or by the construction of meaning in people's minds, through mechanisms of symbolic manipulation. Power relations are embedded in the institutions of society, particularly in the state. However, since societies are contradictory and conflictive, where there is power there is also counterpower, which I understand to be the capacity of social actors to challenge the power embedded in the institutions of society for the purpose of claiming representation for their own values and interests. (Castells, 2015, pp. 4–5)

His position on "counterpower," specifically, has been cogently argued by scholars such as bell hooks, who posits that marginality can not only be a site of deprivation but also one of radical possibility: a site of resistance, creativity, and power (hooks, 1989). In this space, she notes, the oppressed can move in solidarity to erase colonized/colonizer positionalities. These arguments have been made previously in Black feminist scholarship and intersectionality literatures that have not

specifically included the Internet as a site of inquiry. A new generation of Black feminist new media scholars are taking up these concerns and are beginning to articulate a need for digital intersectional theory in their research (Noble, 2012, 2013; Steele, 2014).

Our definition of intersectionality draws on the canonical work of Kimberlé Crenshaw (1989, 1991), Patricia Hill Collins (1990, 2000, 2015) and bell hooks (1984, 1990). Echoing "A Black Feminist Statement" by the Combahee River Collective (1977, 1982), which argued that gender, race, class, and sexuality are "interlocking," these scholars posit that oppressions, including those based on the categories of race, gender, and class (among others), are inextricably connected. Intersectionality may take multiple forms that include (1) an analytical strategy, or the ways in which intersectional frameworks "provide new angles of vision on social institutions, practices, social problems, and other social phenomena associated with social inequality"; and (2) critical praxis, or the ways in which social actors use intersectionality for social justice projects (Collins, 2015). We argue that an intersectional lens permeates all aspects of the movement—that the movement originated and is sustained through the intersectional critical praxis of Black women.

Edwards and McCarthy (2004) note that when activists want to inspire collective action, their success is largely based on resources, which include moral, cultural, social-organizational, human, and material resources. Drawing on resource mobilization theory, Eltantawy and Wiest (2011) argue that the availability of resources such as social media and an individual's efficacy in using these resources contributed to the birth of the January 25 protest, a key event in Egypt's so-called Facebook Revolution, in which protesters gathered in Tahrir Square to protest corruption, police brutality, and unemployment. In addition, interactivity and speed facilitated the advancement of the movement in ways that traditional methods, such as leaflets, could not. Perhaps one of the most important resources was the intersectional vision of administrators of the "We Are All Khaled Said" Facebook page, which was inclusive of women, Christians, Muslims, nationals, and expatriates (Ghonim, 2013). It was women and girls who had played a critical role in creating the "alternative news universe" that ultimately set the stage for revolution (Herrera, 2014); a woman who posted the video that galvanized participants for the January 25 protest; and women who risked their lives in public protest alongside their male counterparts both online and off.

We view intersectionality, in the form of both analytic strategy and critical praxis, as a resource grounded in the offline and online subjectivities of participants. Central to the development of this resource are cultural and community strengths of respective movement participants of every race—ethnicity, religion, sexual orientation, or gender. With respect to African Americans, for example, Robert Hill (1972, 1999), in his key text on the Black family, names strong kinship bonds, religious orientation

(spirituality), and adaptability of family roles among its strengths. He further argues that the adaptability of family roles in Black families is often a response to economic necessity for low-income (and, we would argue, middle-class) families. Moreover, this flexibility in roles includes the sharing of decisions and jobs in the home. These experiences provide Black women with multiple opportunities for leadership in their communities as well as ample space in which to develop an intersectional lens that allows them to think critically and with complexity about issues that affect Black communities as a whole. Though there is considerable variation within African American communities and among women specifically, these experiences may be brought to the digital space and inform the nature of their interactions and involvement in the #BlackLivesMatter movement.

INTERSECTIONALITY AS ANALYTIC STRATEGY IN THE #BLACKLIVESMATTER MOVEMENT

Several news articles and documentary films about the #BlackLivesMatter movement and its origins have been made and posted on Twitter.[3] Erica Totten helped organize an informal teach- and die-in at a Washington, D.C., theater in a mall on December 12, 2014. She and other participants purchased tickets to Chris Rock's movie but actually went to see *Exodus: Gods and Kings*. Ten minutes into the film she rose with a bullhorn and announced, "Good evening, ladies and gentlemen, we are here to disrupt your evening.... This film is racist and depicts Africans as slaves and white Europeans as Africans. Egypt is in Africa. This is white supremacist propaganda, and we are shutting it down" (Hafiz, 2014). When asked why Black women were at the forefront of organizing the movement, Totten noted that they were organized, they were good communicators, they didn't have egos, and they are able to make connections with their "sisters" (other Black women). She further noted, "What happens to them happens to me." Totten's co-organizer similarly saw the shutdowns as a personal fight to demand her rights: a fight for her future. When asked why she followed the organizers, a Howard University student mentioned, "I follow them because they are women. They are organized, think things through strategically, and make powerful statements by making controversial and most [of the] time illegal actions like this possible" (Hafiz, 2014). Here, the student suggests being a woman informs the strategic thinking shown in both online and offline organizing—a characteristic, along with their communication and technical skills, that makes them ideal leaders for the movement. The use of the intersectional lens or analytic strategy broadens the movement's scope, as leaders see their participation and their fight for other Black people as a fight for their own lives.

This more expansive analytic strategy allows participants to see social problems with greater complexity and to post links that educate fellow protesters about key social issues. At the core of the movement, as Garza (2014) has noted, is a fight against police brutality and what Michelle Alexander (2012) calls "the New Jim Crow," or the creation of a permanent caste system through the incarceration and disenfranchisement of African Americans. A link to a story posted on Twitter called "8 Horrible Truths About Police Brutality and Racism in America Laid Bare by Ferguson" underscores the fact that participants view race and class as inextricably linked.[4] It reads: "The black-white disparity in infant mortality has grown since 1950. Whereas 72.9 percent of whites are homeowners, only 43.5 percent of Blacks are. Blacks constitute nearly 1 million of the total 2.3 million people incarcerated. According to Pew, white median household wealth is $91,405; Black median household wealth is $6,446—the gap has tripled over the past 25 years. Since 2007, the Black median income has declined 15.8 percent. In contrast, Hispanics' median income declined 11.8 percent, Asians' 7.7 percent and Whites' 6.3 percent."[5]

The story notes that these statistics fly in the face of President Obama's claims that the economy and race relations are improving. Issues within the larger context of police brutality include mass incarceration, the politics of respectability, and representations of African Americans in the media. These issues shape the discourse of the movement by allowing users to advocate in both online and offline spaces on issues that pertain directly to them. Disparate outcomes at the intersection of education and wealth (Johnson, 2006) and a number of other social gauges for African Americans have become contributing factors in the construction of the movement as a call for equity in various aspects in American society. Interconnected structural inequalities have a trickle-down effect on individuals who participate in this movement, as they see the dismantling of not just one but all structural impediments as the key to their liberation.

INTERSECTIONALITY AS CRITICAL PRAXIS

In our understanding of intersectionality as critical praxis, we outline the ways in which the movement's reflexivity, the ability to counter hegemonic narratives, and self-care are key components of digital intersectionality. By modeling the standard of reflexivity, the movement is able to critique and correct its own narrative and practices. For example, Alicia Garza (2015) wrote a piece for thefeministwire.com that speaks directly to how the erasure of African Americans was performed within the movement. She noted that, as individuals took the movement's demands to the streets, mainstream media and corporations took up the call. Then adaptations of their work began to crop up—with All Lives Matter, Brown Lives Matter, Migrant Lives Matter, etc. She further noted that presumed allies coopted

the #BlackLivesMatter hashtag for a campaign, failed to credit its origins, and even applauded incarceration. She also wrote:

> When you design an event / campaign / etcetera based on the work of queer Black women, don't invite them to participate in shaping it, but ask them to provide materials and ideas for next steps for said event, that is racism in practice. It's also hetero-patriarchal. Straight men, unintentionally or intentionally, have taken the work of queer Black women and erased our contributions. Perhaps if we were the charismatic Black men many are rallying around these days, it would have been a different story, but being Black queer women in this society (and apparently within these movements) tends to equal invisibility and non-relevancy.
>
> We completely expect those who benefit directly and improperly from White supremacy to try and erase our existence. We fight that every day. But when it happens amongst our allies, we are baffled, we are saddened, and we are enraged. And it's time to have the political conversation about why that's not okay. (Garza, 2014)

We foreground the words of Garza because she, Patrisse Cullors, and Opal Tometi have been rendered virtually invisible as the growth of the movement has moved from online activism to international organizing on behalf of protecting Black lives, often placing Black men as the central subject(s) of care. Even more concerning is the way in which the intellectual and organizational work of Black cisgendered and transgendered women who have been at the forefront of articulating multiple, intersectional calls for social justice had not spurred mass social organizing on behalf of Black women who were and are victims of police murders and extra-judicial killings.[6] Kimberly N. Foster, Black feminist blogger and founder of *For Harriet*, an online blog for women of color, published a story on Thursday, April 23, 2015, titled "No One Showed Up to March for Rekia Boyd Last Night" to underscore concerns over the invisibility of coverage and mass concern for Black women and girls who are also killed by law enforcement.

On May 20, 2015, the African American Policy Forum released a report titled "Say Her Name: Resisting Police Brutality Against Black Women." This report was accompanied by mass protest across the country. A national day of action was planned (see Figure 1) to specifically focus on the plight of Black women and girls. The report was coauthored by Kimberlé Crenshaw of UCLA and the Center for Intersectionality and Social Policy Studies—the woman who coined the term *intersectionality*. Interestingly, more than 25 years later she is still at the forefront of modeling how intersectionality might be lived in policy and practice.

Crenshaw, Ritchie, Anspach, Gilmer, and Harris (2015) assert that social justice organizers have used intersectionality as critical praxis in ways that go beyond the theoretical musings in academia and have used their social positions to combat multiple forms of oppression simultaneously through the embodiment of their work. Crenshaw continues her analysis by directly naming young, poor women of color as chief organizers through their critical praxis of intersectionality. These

organizers have used intersectional praxis as a way to not only correct the norms of the movement but also to intervene in popular historical narratives and stereotypes about African Americans, economic inequality, and racist policies. Countering narratives and renegotiating movement standards through intersectional approaches has already manifested on the national stage.

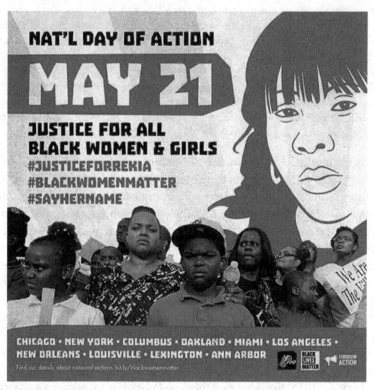

Figure 1.1. Justice for All Black Women and Girls National Day of Protest.
(Source: https://twitter.com/BYP_100/status/600709015358672896)

The intersectional critical praxis and reflexivity of members sparked what appears to be a pivot in the movement. Garza's (2014) critique of the movement's hetero-patriarchal co-optation, along with Crenshaw's report, which offered several recommendations for improving the awareness and condition of Black, queer, cis, and transgendered women, has led to an effort to re-center the movement to include all of those at the margins. Much of the focus of the movement has centered Black cisgender men, but Garza notes that the #BlackLivesMatter movement is a specific effort to rebuild a Black liberation movement along intersectional axes, recognizing that cisgender Black men continue to name and claim themselves as the center subject of the movement:

Black Lives Matter is a unique contribution that goes beyond extrajudicial killings of Black people by police and vigilantes. It goes beyond the narrow nationalism that can be prevalent within some Black communities, which merely call on Black people to love Black, live Black and buy Black, keeping straight cis Black men in the front of the movement while our sisters, queer and trans and disabled folk take up roles in the background or not at all. Black Lives Matter affirms the lives of Black queer and trans folks, disabled folks, Black-undocumented folks, folks with records, women and all Black lives along the gender spectrum. It centers those that have been marginalized within Black liberation movements. It is a tactic to (re)build the Black liberation movement. (Garza, 2014)

Yet because Black women continue to lead the movement, it is reflexive and can engage in self-correctives that consistently negotiate and renegotiate, in ever more complex ways, its mission and the scope of its demands. Planned protests for Black women and girls proved to be successful and, in some cities, had turnouts comparable to those when men are at the center. By offering a reflexive program and a counter to dominant hegemonic narratives, Black women have been able to combat their erasure publicly within the movement.

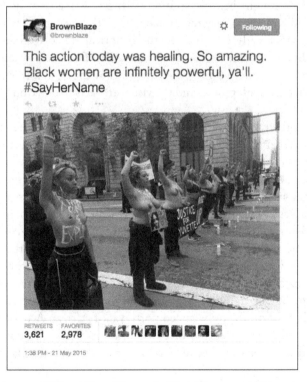

Figure 1.2. #Sayhername National Day of Protest for Black Women and Girls.
(**Source:** https://twitter.com/brownblaze/status/601442031236321280, Photo Credit: Ashley Yates)

At the #SayHerName National Day of Protest, Black women were given specific recognition, in large part because of their previous erasure in the mainstream movement. Perhaps the most powerful image was from San Francisco, where protestors stood topless as a symbol of reclamation and resistance against oppressive forces that subjugate Black women's bodies as sights of exploitation (see Figure 1.2). The protest drew from cultural traditions of their women counterparts in Uganda, Gabon, and South Africa and was an attempt to end the societal fixation on Black women's bodies except in cases of violence (Desmond-Harris, 2015). They also tapped into their African heritage in their hair and head wraps as well as body/face paint. This connection to African cultures, the advocacy on behalf of Black women, and the acknowledgment of the paradox of invisibility and visibility was said to be healing for the person who posted the image. The significance of healing to the movement and its participants is not to be understated, as the concept of self-care is integral in their praxis, which allows groups or individuals to physically and mentally recuperate from the stress of dealing with oppression and discrimination. Images like those from the protests in San Francisco are powerful, not only through their recognition of Black women's struggle but also in their counter-discourse to hegemonic narratives. Posing topless with writing on their bodies that directly pertained to the historical stereotypes and oppression placed upon Black women's bodies is representative of a critical awareness, cultural agency, and a more nuanced understanding of how multiple forms of oppression can be subverted through protest and the visual artifacts that live online potentially in perpetuity.

We have presented images and links that make up a moment-to-moment log of the movement and of efforts to mobilize that are often not seen on cable or other news sites. The representation of images from the movement not seen on television in #BlackLivesMatter also offer a counter-discourse to hegemonic narratives that impede sociopolitical progress for African Americans. Mainstream narratives regarding stereotypes of African American men and women have been historically pervasive, which has led to the movement's concerted efforts to battle these messages by using social media as a corrective (Bonilla & Rosa, 2015). An example of online protest or activism would be the hashtag "#IfTheyGunnedMeDown." Although this hashtag serves as its own discussion, it still operates under the umbrella of the movement as a whole. This specific hashtag sheds light on the unbalanced portrayal of African American victims in mainstream media, which all too often becomes fixated on troubles in the victim's past and uses negative imagery to push the narrative of Black criminality.

Participants in this online form of protest post pictures of themselves that would appear to be contradictory, as one picture would be "refined," such as a picture from a graduation, while the other would be viewed as "problematic," such as an image of the user drinking and/or smoking, for example. This hashtag campaign on social media sought to challenge mainstream media portrayals of African American men as inherently criminal, by posting an image that would likely be shown on a major news outlet versus a "positive" image that would evoke a more sympathetic reaction (Bonilla & Rosa, 2015). It is important to note that this campaign to bring attention to this issue of disparate media representations took place strictly on social media, as the fast-paced nature of social media enables these movements to aggregate and go viral quickly before mainstream media can react (Sharma, 2013). Countering dominant discourses occurs on social media as conversation is intersectional, multidimensional, and less restricted. This enables users to effectively "talk back" and mobilize around topics outside of the view of the mainstream, until they go viral, at which point they gain the desired attention of the media.

As suggested in the BET headline "Nine Ways to Mentally Cope With Racial Injustice" (Terrell, 2014; Figure 1.3) from a link posted on Twitter, self-care is a key aspect of the movement's intersectional critical praxis. Within this list of coping mechanisms, which includes community engagement ("Give Back"), exercise ("Get Your Sweat On"), and spirituality ("Pray or Meditate"), individuals taking time to care for their specific needs in constructive fashions is presented as important for the health of those participating in the movement. The article further encourages people to allow themselves to cry and feel the emotion from the trauma associated with racial injustice, to "Speak Out!" or get involved in their local fights against injustice, and to not engage bigots. They note, "Self-care is really important when coping with issues like this. One way to protect yourself is to not engage with people who are bigoted or refuse to see our plight as a problem. Let people know that you are not interested in talking and keep it moving. Same applies with social media" (Terrell, 2014). Rather than using their energy responding to racists, the article guides readers toward channeling their energies into their communities. Finally, the article instructs participants to "Love Yourself and Others More." Despite a climate of rampant degradation of Black life and persistent messages of Black inferiority, they say, "the most radical thing we can do in times like these is to unconditionally love ourselves and each other. We can never allow for the devaluing of our lives to stop us from seeing our greatness, value and infinite potential" (Terrell, 2014).

Figure 1.3. Nine Ways to Mentally Cope With Racial Injustice.
(Source: http://www.bet.com/news/health/photos/2014/12/nine-ways-to-mentally-cope-with-racial-injustice.
html#!120414-national-no-justice-for-eric-garner-scenes-from-protests-across-the-nation-13)

While the Civil Rights Movement drew much of its spiritual core and self-care
from the Christian church, the #BlackLivesMatter movement members are quick
to assert how the present moment contrasts with previous movements for social
change. Members both embrace and reject aspects of traditional Christian theol-
ogy, holding events in churches and inviting clergy to participate in protests, while
also denouncing the heteronormative and patriarchal doctrine of the traditional
congregations. Reverend Al Sharpton, perhaps the most popular minister alive
who worked with Dr. Martin Luther King Jr., inserted himself onto the Black Lives
Matter platform but has at times been disinvited to movement events, for example.
Pastors who have been embraced tend to endorse a more inclusive historical-critical
biblical perspective. The Reverend Starsky Wilson of the St. John's United Church
of Christ in St. Louis hosted Black Lives Matter Freedom Riders the weekend of

August 30, 2014. In a sermon, he argued that to be the Church is to practice "the politics of Jesus." He further noted that Jesus was a radical and revolutionary who was concerned about social justice and the need for a movement of not just men but one that affirms the power of the "sisters." He also articulated a vision of a movement that viewed all people as made in the image and likeness of God.

A similar position has been argued by Reverend Osagyefo Sekou, who recently spoke at the Black Lives Matter conference on how Black queer women are doing the work of God. This is an important aspect of an expanded and inclusive spirituality that meets the needs of movement participants. Spiritual aspects of the movement extend beyond the church and also include a number of African and other spiritual and cultural traditions. Most importantly, participants see love as integral to the movement's success. Just as in the BET.com article, participants question how love, both of self and others, can be a spiritual practice as they engage in social change efforts. In an interview on the Real News Network, Sekou argued:

> My grandmama sang a song. There's joy that I have. The world didn't give it to me and the world can't take it away. It's this ability to be able to look at the material conditions and call them a lie. And so I think part of it is, what are the ways in which we can love each other through this work? How can we care for each other, right? How can we not reproduce the imperial capacity to shame, to discipline, to punish? So how in our social movements can we love each other in such a way? ("Cornel West, Eddie Conway, & Rev. Sekou," 2015)

Within this counter-hegemonic theological discourse, self-care through more broad conceptions and practices of spirituality is a key component of intersectionality as critical praxis and how it becomes operational within the movement.

DISCUSSION

From its earliest articulations, intersectionality has not only been used in scholarly work and teaching but has also been used as analytic strategy and critical praxis directed at social and political intervention (Cho, Crenshaw, & McCall, 2013; Collins, 2015). For the #BlackLivesMatter movement the intersectional lens informs participants' ability to think critically and complexly about social problems. It also subsequently influences the nature of demands participants make on government officials, local communities, policy changes, and on themselves. As such, movement participants illustrate the ways that practice can inform theory, as well as how theory informs best practices in community organizing both online and offline (Cho, Crenshaw, & McCall, 2013).

According to Shirky (2011), access to conversation is the greatest benefit to users of digital media during political protest. When looking at the #BlackLives-Matter movement, this becomes especially true, as protesters have used various

social media platforms to share information, discuss beliefs, and plan protests (Bonilla & Rosa, 2015). Twitter specifically grants access to conversation through hashtags that enable users to express their cultural competency, identification with Black culture, and deep understanding of social problems through a racialized lens (Brock, 2012; Florini, 2014; Sharma, 2013). However, users bring not only their racial backgrounds with them online, but they also carry their class, gender, sexuality, religious, and other embodied identities and experiences. These intersecting identities can influence their contribution to the larger discussion, which in turn may have an impact on the larger movement. Through these conversations held online, norms and behaviors can be debated and negotiated through critical communication, not only directed at the systemic entities participants are engaging but with each other as well. In this negotiation of terms, individuals' intersectional vantage points on topics allow for a fluid exchange of ideas and beliefs that can both propel and/or stunt the movement's ideological underpinnings.

Scholars, including Clay (2012) and Chun, Lipsitz, and Shin (2013), have noted the role of intersectionality in previous social movements. Studying the Asian Immigrant Women Advocates (AIWA) in the Bay Area (Oakland and San Jose), an organization created to serve the needs of Asian women employed in low-paid manufacturing and service jobs, Chun and colleagues suggest that the organization's intersectional optic is a mechanism for the movement. They also note its numerous functions, including exposing how power works in uneven and differentiated ways and expanding their conceptions of and targets of collective struggle. Chun et al. (2013) further argue that AIWA's constituency's problems "cannot be addressed by single-axis struggles for national liberation, peace, feminism, class justice, or multilinguality, yet every disempowerment they face reveals a different dimension of how inequalities are created and maintained" (p. 937). Using an intersectional lens and building multiracial, multigenerational campaigns with advocates that sometimes spanned across the country, the organization was able to increase awareness of the plight of Asian women and advocate for change on their behalves.

Similarly, Clay's (2012) ethnographic work on activism among youth of color in Oakland, California, outlines how youth experiences with racism, classism, sexism, and ageism inform their organizing strategies. Also integrated into these strategies is the use of hip-hop culture to mobilize youth around issues of social injustice, including homophobia and heterosexism. Clay posits that youth activism is like a hip-hop sample where youth draw on movement tools, images, texts, geographic landscapes, popular constructions of urban youth of color, hip-hop culture, and their own experiences. If youth activism in Oakland is a sample, then #BlackLivesMatter is the remix 2.0. The interactivity, speed at which messages can be transmitted, and virality (coupled with video, text, and images) enhance creative power and potential to affect social change.

Social media therefore becomes a tool for the empowerment of individuals claiming identification with multiple social groups and allows them to positively affirm their unique positioning within society (Lindsey, 2013). The use of hashtags and imagery shows how visual and textual representations of the #BlackLivesMatter movement contribute to the mission of the protests, as participants use themselves as the embodiment of justice. The previously noted hashtag campaign #IfThey-GunnedMeDown is an example of how critical praxis manifests itself online as a part of the larger movement, but it is not the movement in totality. By posting pictures that would seemingly contradict each other, participants show the multiplicity of their identities and the spatial awareness of how these images may evoke particular prejudices within American society (Bonilla & Rosa, 2015). Their keen understanding of the complexities of social problems rooted in racism, sexism, classism, homophobia, transphobia, and sexuality among other categories informs all aspects of the movement and as hooks (1984) notes, participants are able to move their needs to the center from the margin. Twitter as a digital space and the hashtag itself become sites of powers that cannot be understood without intersectional frameworks. Social media is not the movement itself, but it certainly amplifies and clarifies the work of organizers and offers a means for disrupting the silences and erasures.

NOTES

1. View the article at http://thefeministwire.com/2014/10/blacklivesmatter-2/.
2. See interview of Kimberlé Crenshaw at http://www.forharriet.com/2015/02/kimberle-crenshaw-on-black-girls-matter.html.
3. The following is one example that describes efforts by young Black women leaders in the Washington, D.C., area to disrupt White supremacy and racism: http://america.aljazeera.com/watch/shows/america-tonight/articles/2014/12/22/watch-how-women-areleadingtheblacklivesmattermovement.html.
4. See story at http://www.alternet.org/civil-liberties/8-horrible-truths-about-police-brutality-and-racism-america-laid-bare-ferguson.
5. Ibid.
6. See "No One Showed Up to March for Rekia Boyd Last Night" at http://theculture.forharriet.com/2015/04/no-one-showed-up-to-rally-for-rekia.html#ixzz3ZDYWSK00.

REFERENCES

Alexander, M. (2012). *The new Jim Crow: Mass incarceration in the age of colorblindness*. New York: New Press.

Bonilla, Y., & Rosa, J. (2015). #Ferguson: Digital protest, hashtag ethnography, and the racial politics of social media in the United States. *American Ethnologist, 4*(16), 4–17.

Brock, A. (2009). "Who do you think you are?": Race, representation, and cultural rhetorics in online spaces. *Poroi, 6*(10), 15–35.

Brock, A. (2012). From the blackhand side: Twitter as a cultural conversation. *Journal of Broadcasting & Electronic Media, 56*(4), 529–549.

Bynum, T. (2013). *NAACP youth and the fight for Black freedom, 1936–1965.* Knoxville: University of Tennessee Press.

Castells, M. (2011). *The rise of the network society: The information age: Economy, society, and culture* (Vol. 1). Oxford, UK: John Wiley & Sons.

Castells, M. (2015). Networks of outrage and hope: Social movements in the Internet age. Cambridge, UK: Polity Press.

Cho, S., Crenshaw, K. W., & McCall, L. (2013). Toward a field of intersectionality studies: Theory, applications, and praxis. *Signs, 38*(4), 785–810.

Chun, J. J., Lipsitz, G., & Shin, Y. (2013). Intersectionality as a social movement strategy: Asian immigrant women advocates. *Signs, 38*(4), 917–940.

Clay, A. (2012). *The hip-hop generation fights back: Youth, activism and post–Civil Rights politics.* New York: New York University Press Press.

Collins, P. H. (1990). *Black feminist thought: Knowledge, consciousness, and the politics of empowerment.* New York: Routledge.

Collins, P. H. (2000). Gender, black feminism, and black political economy. *The Annals of the American Academy of Political and Social Science, 568*(1), 41–53.

Collins, P. H. (2015). Intersectionality's definitional dilemmas. *Annual Review of Sociology, 41*(1), 3–20.

Combahee River Collective. (1977). The Combahee River Collective statement. *Capitalist patriarchy and the case for socialist feminism,* 362–372.

Combahee River Collective. (1982). A Black feminist statement. In C. Moraga & G. Anzaldúa (Eds.), *This bridge called my back: Writings by radical women of color* (pp. 210–218). Watertown, MA: Persephone.

Cornel West, Eddie Conway, and Rev. Sekou on building a mass movement. (2015, May 18). Retrieved from http://therealnews.com/t2/index.php?option=com_content&task=view&id=31&Itemid=74&jumival=13843#.VVoqtFfG-Eo.twitter

Crenshaw, K. (1989). Demarginalizing the intersection of race and sex: A Black feminist critique of antidiscrimination doctrine, feminist theory and antiracist politics. *University of Chicago Legal Forum,* 139–167.

Crenshaw, K. (1991). Mapping the margins: Intersectionality, identity politics, and violence against women of color. *Stanford Law Review,* 1241–1299.

Crenshaw, K. W., Ritchie, A. J., Anspach, R., Gilmer, R., & Harris, L. (2015). Say her name: Resisting police brutality against black women. African American Policy Forum. Retrieved from http://static1.squarespace.com/static/53f20d90e4b0b80451158d8c/t/55a810d7e4b058f3 42f55873/1437077719984/AAPF_SMN_Brief_full_singles.compressed.pdf

Daniels, J. (2009). *Cyber racism: White supremacy online and the new attack on civil rights.* Lanham, MD: Rowman and Littlefield.

Daniels, J. (2013). Race and racism in Internet studies: A review and critique. *New Media & Society, 15*(5), 695–719.

Dery, M. (1996). *Escape velocity: Cyberculture at the end of the century.* New York: Grove Press.

Desmond-Harris, J. (2015, May). Black women get killed by police, too: The #SayHerName demonstrations explained. Vox. Retrieved from http://www.vox.com/2015/5/23/8644441/say-her-name-report-protests

Edwards, B., & McCarthy, J. D. (2004). Resources and social movement mobilization. In D. A. Snow, S. A. Soule, & H. Kriesi (Eds.), *The Blackwell companion to social movements* (pp. 116–152). Oxford, UK: Blackwell.

Eltantawy, N., & Wiest, J. B. (2011). The Arab Spring: Social media in the Egyptian Revolution: Reconsidering resource mobilization theory. *International Journal of Communication, 5*, 18.

Everett, A., & Watkins, S. C. (2008). The power of play: The portrayal and performance of race in video games. In K. Salen (Ed.), *The ecology of games: Connecting youth, games, and learning* (141–166). Cambridge, MA: The MIT Press.

Florini, S. (2014). Tweets, tweeps, and signifyin': Communication and cultural performance on "black twitter." *Television & News Media, 15*(3), 223–237.

Garza, A. (2014, October). A herstory of the #BlackLivesMatter movement by Alicia Garza. The Feminist Wire. Retrieved from http://thefeministwire.com/2014/10/blacklivesmatter-2/

Ghonim, W. (2013). *Revolution 2.0: The power of the people is greater than the people in power: A memoir.* New York: Houghton Mifflin Harcourt.

Glaser, J., & Kahn, K. B. (2005). Prejudice and discrimination and the Internet. In Y. Amichai-hamburger (Ed.), *The social net: Understanding human behavior in cyberspace* 247–274. Oxford, UK: Oxford University Press.

Guynn, J. (2015, March). Meet the woman who coined #BlackLivesMatter. *USA Today.* Retrieved from http://www.usatoday.com/story/tech/2015/03/04/alicia-garza-black-lives-matter/24341593/

Hafiz, J. (2014, December). How women are leading the #BlackLivesMatter movement. Aljazeera America. Retrieved from http://america.aljazeera.com/watch/shows/america-tonight/articles/2014/12/22/watch-how-women-areleadingtheblacklivesmattermovement.html

Harris, A. L. (2011). *Kids don't want to fail: Oppositional culture and the Black-White achievement gap.* Cambridge, MA: Harvard University Press.

Harris, L. A. (1996). Queer Black feminism: The pleasure principle. *Feminist Review, 54,* 3–30.

Herrera, L. (2014). *Revolution in the age of social media: The Egyptian popular insurrection and the Internet.* London: Verso Books.

Hill, R. (1972). *The strengths of the Black family.* New York: Emerson Hall.

Hill, R. B. (1999). *The strengths of African American families: Twenty-five years later.* Lanham, MD: University Press of America.

hooks, b. (1984). *Feminist theory: From margin to center.* Cambridge, MA: South End Press.

hooks, b. (1989). Choosing the margin as a space of radical openness. In b. hooks, *Yearnings: Race, gender and cultural politics* (pp. 145–153). Cambridge, MA: South End Press.

hooks, b. (1990). *Yearning: Race, gender, and cultural politics.* Boston, MA: South End Press.

Johnson, H. B. (2006). *The American dream and the power of wealth: Choosing schools and inheriting inequality in the land of opportunity.* New York: Routledge.

Kang, J. (2000). Cyber-race. *Harvard Law Review, 113,* 1130–1208.

Lindsey, T. B. (2013). "One time for my girls": African American girlhood, empowerment, and popular visual culture. *Journal of African American Studies, 17*(1), 22–34.

Lowery, W. (2015, January 21). "Black Lives Matter" protesters stage "die-in" in Capitol Hill cafeteria. *The Washington Post.* Retrieved from http://www.washingtonpost.com/blogs/post-politics/wp/2015/01/21/black-lives-matter-protesters-stage-die-in-in-capitol-hill-cafeteria/

Matsuda, M. J., Lawrence, C. R., Delgado, R., & Crenshaw, K. W. (1993). *Words that wound: Critical race theory, assaultive speech, and the first amendment.* Boulder, CO: Westview Press.

Nakamura, L. (2008). *Digitizing race: Visual cultures of the Internet.* Minneapolis: University of Minnesota Press.

Noble, S. U. (2012). *Searching for Black girls: Old traditions in new media.* Unpublished doctoral dissertation, University of Illinois at Urbana-Champaign, Champaign, IL.

Noble, S. U. (2013). Google search: Hyper-visibility as a means of rendering black women and girls invisible. *InVisible Culture, 19,* n.p.

Noble, S. U. (2014). Teaching Trayvon, race, media and the politics of spectacle. *The Black Scholar, 44*(1), 12–29.

Omi, M., & Winant, H. (1994). *Racial formation in the United States: From the 1960s to the 1990s.* New York: Routledge.

Petersen-Smith, K. (2015). Black Lives Matter: A new movement takes shape. *International Social Review, 96.* Retrieved from http://isreview.org/issue/96/black-lives-matter

Sharma, S. (2013). Black Twitter? Racial hashtags, networks and contagion. *New Formations, 78*(2), 46–64.

Shirky, C. (2011). The political power of social media: Technology, the public sphere, and political change. *Foreign Affairs, 90*(1), 28–41.

Srinivasan, R. (2013). Bridges between cultural and digital worlds in revolutionary Egypt. *The Information Society, 29*(1), 49–60.

Steele, C. K. (2014). Digital barbershops: *The politics of African American oral culture in online blogs.* Unpublished doctoral dissertation, University of Illinois at Chicago, Chicago, IL.

Terrell, K. (2014, December). Nine ways to mentally cope with racial injustice. Retrieved from http://www.bet.com/news/health/photos/2014/12/nine-ways-to-mentally-cope-with-racial-injustice.html#!120414-national-no-justice-for-eric-garner-scenes-from-protests-across-the-nation-13

Tynes, B. M. (2007). Role taking in online "classrooms": What adolescents are learning about race and ethnicity. *Developmental Psychology, 43*(6), 1312–1320.

The Trouble With White Feminism: Whiteness, Digital Feminism, AND the Intersectional Internet

JESSIE DANIELS

INTRODUCTION

In the summer of 2013, writer and pop-culture analyst Mikki Kendall grew increasingly frustrated watching her friends being viciously attacked online, particularly by a White male academic who identified as a "male feminist." Kendall's friends, like her, are women of color engaged in digital activism through social media, particularly Twitter, and through writing in longer form on their own blogs and for online news outlets. Kendall's friends were being called names, bullied, and threatened by the self-professed male feminist. During a rather public meltdown, the man admitted that he had intentionally "trashed" women of color, posting on Twitter: "I was awful to you because you were in the way" (Kendall, 2013).

The behavior of this one man was hurtful and disappointing, but it was the inaction of prominent White feminist bloggers[1] who failed to acknowledge the racist, sexist behavior of one of their frequent contributors that prompted Kendall to create #SolidarityIsForWhiteWomen.[2] Kendall's hashtag quickly began trending on Twitter and ignited a wide range of discussions about hashtag campaigns as a form of cyberfeminist activism and, more broadly, about social media, feminism, and call-out culture. One journalist, Michelle Goldberg, excoriated Kendall specifically, and women of color more generally, for starting a "toxic Twitter war" that is destructive for feminism (Goldberg, 2014). Another journalist referred to Kendall's hashtag in

a sideways swipe at the "convulsions of censoriousness" among American liberals online, which he saw as damaging for all of liberalism (Chait, 2015). A third journalist, Jon Ronson, wrote sympathetically about a White woman who lost her PR job because of "one stupid Tweet" ("Going to Africa. Hope I don't get AIDS. Just kidding. I'm white!") that "blew up" her life (Ronson, 2015). Ronson is also the author of a book about being "publicly shamed," and his focus is on the destructiveness of call-out culture and social media on the lives of otherwise well-intentioned people. While not about White feminism online, Ronson's account of the "one stupid Tweet" incident completely elided the racism of the woman's remarks and instead reconfigured her as a victim of those who called her out online, including many of the women of color Kendall was supporting with her hashtag activism. This is precisely what Goldberg argued in her analysis of the "toxicity" online, which she locates within women of color, such as Kendall, and not within dominant White feminism.

What remains unquestioned in these journalistic accounts, and in much of the scholarship to date, is the dominance of White women as architects and defenders of a particular framework of feminism in the digital era. Although a number of scholars have critiqued the first and second waves of feminist movements as rooted in Whiteness (Hull, Scott, & Smith, 1982; Truth, 2009; Ware, 1992), there is little existing literature that does lay out a systematic critique of Whiteness in contemporary digital feminist activism. To address this gap in our understanding of White feminism, I examine three case studies of White feminist activism: (1) Sheryl Sandberg's "Lean In" and "Ban Bossy" campaigns, the former tied to her 2013 book of the same name; (2) "One Billion Rising" campaign; and (3) "The Future of Online Feminism," a report authored by Vanessa Valenti and Courtney Martin for the #FemFuture project. Through these three case studies I will demonstrate some of the trouble with White feminism.

LITERATURE REVIEW

During the early days of the Internet, some scholars theorized that the emergence of virtual environments and an attendant culture of fantasy would mean an escape from the boundaries of race and the experience of racism. A few imagined that people would go online to escape their embodied racial and gender identities (Nakamura, 2002; Turkle, 1995), and some saw the Internet as a "utopia" where, as the 1990s telecom commercial rendered it, there is "no race, no gender." The reality that has emerged is quite different. Race and racism persist online, both in ways that are new and unique to the Internet and alongside vestiges of centuries-old forms that reverberate significantly both offline and on (Brock, 2006, 2009; Daniels, 2009, 2013). The reality of the Internet we have today has important implications for understanding Whiteness and feminism.

The examination of Whiteness in the scholarly literature is well-established (Fine et al., 2004); Frankenberg, 1993; Hughey, 2010; Twine & Gallagher, 2008). Whiteness, like other racial categories, is socially constructed and actively maintained through social boundaries. A key strategy in maintaining these boundaries involves efforts to define who is, and is not, White. Ample historical evidence demonstrates that the boundaries of Whiteness are malleable across time, place, and social context (Allen, 1994; Daniels, 1997; Roediger, 2007; Wray, 2006). Another central mechanism of Whiteness is a seeming invisibility, or "unmarked" quality, that allows those within the category "White" to think of themselves as simply human, individual and without race, while Others are racialized (Dyer, 1988). At the same time, some scholars have noted that Whiteness can also be characterized by a paradoxical "hypervisiblity" (Reddy, 1998). We know that Whiteness shapes housing (Low, 2009), education (Leonardo, 2009), politics (Feagin, 2012; Painter, 2010), law (Lopez, 2006; Painter, 2010), social science research methods (Arnesen, 2001; Zuberi & Bonilla-Silva, 2008) and indeed, frames much of our (mis)understanding of U.S. society (Feagin, 2010; Lipsitz, 2006; Mills, 1997; Painter, 2010). Much of the writing in the field of Whiteness studies has come from the United States and remains rather myopically focused on the North American context (Bonnett, 2008); however, scholars writing in a transnational, postcolonial framework have begun the work of "re-orienting Whiteness" with a more global lens (Anderson, 2006; Boucher, Carey, & Ellinghaus, 2009).

Those writing in the field of media studies point to British scholar Richard Dyer's (1988) essay "White" in the film journal *Screen* as the catalyst for subsequent scholarly considerations of the representational power of Whiteness. Such a reading of the field of Whiteness studies elides the contributions of scholars such as W. E. B. Du Bois, who was writing about Whiteness a century earlier. A number of scholars, from Du Bois onward (e.g., Brock, 2006; Twine & Gallagher, 2008), have been critical observers of Whiteness out of necessity. As bell hooks notes, "Black folks have, from slavery on, shared with one another…knowledge of Whiteness gleaned from close scrutiny of White people" (hooks, 1992, p. 165). Still, Dyer's work, in both the *Screen* article (1988) and the book-length elaboration of those arguments in *White* (1997), has been enormously influential in both Whiteness studies and in visual culture studies. Here, too, Dyer follows the path of Du Bois, who used his photo exhibition at the Paris *Exposition Universelle* (the 1900 World's Fair) to address racial inequality through a particular deployment of visual representation (Smith, 2004).

One of the key insights of Whiteness studies is that it is difficult to speak about White pathology because, as Dyer suggests, it falls apart in your hands, or it fades into what is merely "human" (Dyer, 1988, p. 22). Whiteness is a mercurial topic to analyze precisely because it does not inhere in bodies but rather functions to reinforce a system of domination (Nakayama, 2000). The issue is not only

the representation of Whiteness, but what Whiteness is used to do (Projansky & Ono, 1999). The White racial frame (Feagin, 2010) is a key component of how Whiteness gets operationalized in popular culture. Yet Whiteness is not often the focus of critical attention when it comes to discussions of the Internet and race (a notable exception to this is McPherson, 2003), and to date, there is scant research on Whiteness and women online (Daniels, 2009).

The historical antecedents of White feminism are rooted in colonialism. In *Beyond the Pale*, Ware (1992) examines the ways in which attempts to enlarge the scope of women's opportunities have historically worked simultaneously to support regimes that restricted such opportunities for people of color. She uses this evidence to make the argument that contemporary feminists' failure to recognize the function of race in the fashioning of White femininity has a long history. One of Ware's most enduring contributions is her argument for the political necessity of analyzing Whiteness as an ethnicity. As she observes, "White feminists have managed to avoid dissecting these cultural and racial components of White femininity, although they have become eager to hear what Black women have to say about their racialized and gendered identities" (1992, p. 85). Subsequent research has explained how it is that White feminists "avoid dissecting" White femininity.

Whiteness is crucial in structuring the lived experiences of White women across a variety of contexts. In a qualitative study with White women in California, Frankenberg (1993) found that most White girls had been taught to fear Black men, yet all the women in her small sample said they struggled with trying to situate themselves within or outside of existing structures of racialization. In a study of White women in South London, Byrne (2006) demonstrates how dominant ideas of the "common sense" and "normal" come to be overlaid with racialized notions of Whiteness. In the UK, understanding notions of race among White women is often about understanding silences, because it is regarded as a taboo subject.

However, race is not a taboo subject for all White women, such as those on the far right of the political spectrum. White women on the far right have historically talked about race and continue to do so in the digital era. During the 1920s in the United States, a third of the White native-born women in Indiana belonged to the Women of the Ku Klux Klan (Blee, 2009, p. 125). Blee argues that membership in the WKKK provided White women with an outlet for political participation, social connection, and a sense of belonging and collective importance (p. 128). In the digital era, Stormfront, the global portal for "White pride," includes a "Ladies Only" discussion board. The women there are openly, explicitly dedicated to discussing the cause of White supremacy while also espousing liberal feminist views. The "ladies" of Stormfront are largely in favor of the right to equal pay for equal work, the right to have an abortion (although they are conflicted about terminating pregnancies that would result in the birth of a White child), and even in favor of some gay rights (as long as they're still White supremacists). The women in the "Ladies Only"

discussion identify as both White supremacists and as feminists and see no contradiction between these worldviews. This suggests something troubling about liberal feminism. To the extent that liberal feminism articulates a limited vision of gender equality without challenging racial inequality, White feminism is indistinguishable from White supremacy. Without an explicit challenge to racism, White feminism is easily grafted onto White supremacy and becomes a useful ideology with which to argue for equality for White women within a White supremacist context (Daniels, 2009).

In the current multimedia landscape, Whiteness remains an infrequently examined part of feminist digital activism. While there is a growing literature about race and racism in Internet studies (Daniels, 2013), there has not been peer-reviewed academic scholarship to date that critically examines White feminism online. In the section that follows, I take up three case studies of White feminism.

CASE STUDIES OF WHITE FEMINISM

I selected the following case studies for their prominence in American popular culture during 2012–2014. These three cases were also widely discussed among feminists online on blogs and through Twitter. All three of the case studies have strong components of online engagement and digital activism, both by design of their creators and through the comments of feminists and others who are critical of these projects.

THE "LEAN IN" AND "BAN BOSSY" CAMPAIGNS

Sheryl Sandberg is the Chief Operating Officer of Facebook and has recently emerged as a leading spokesperson for a particular kind of feminism. Sandberg has explained that she was encouraged to write *Lean In: Women, Work and the Will to Lead* (2013) based on her 2010 talk at the Technology, Entertainment, Design (TED) conference, an online video of which has received more than five million views. Sandberg's basic message is that there are so few women leaders in politics, government, and corporations because women are limiting themselves. If women can just get out of their own way and "lean in"—by which she means assert themselves in male-dominated offices and boardrooms—then the entire "power structure of the world" will be changed and this will "expand opportunities for all" (Sandberg, 2013). More than a mere self-help book, *Lean In* is also an online campaign and what Sandberg likes to refer to as "a movement." Sandberg hopes to inspire women to create their own "Lean In Circles," or peer support groups, to facilitate "leaning in."

Sandberg has conceded that she has only recently begun to identify as a feminist. Her book is her first public declaration of her feminism, but what she articulates is a form of liberal feminism long interwoven with Whiteness, class privilege, colonialism, and heteronormativity (Ahmed, 2006; Collins, 2002; Spelman, 1988; Srivastava, 2005). Sandberg's answer to her central question—"why there aren't more women leaders"—is not that there are structural barriers or systematic inequality, but that women need to change. The intended audience for Sandberg's message is specific and limited: she writes for women in corporate work environments who are heterosexual, married (or planning to marry), cisgender, middle to upper-middle class, and predominantly (though not exclusively) White. Drawing on her experience as an executive at Facebook, and before that at Google, Sandberg instructs her audience on "choosing the right husband" (i.e., one who helps with domestic labor and child care). Searches for the words "lesbian," "gay," and "transgender" in the text of *Lean In* yield no results. Similarly, there are virtually no mentions of African American, Asian American, Native American, or Latina women in the book, nor any discussion of how "leaning in" might be different for women who are not White. Such a narrow conceptualization of who is included in the category of "woman" fits neatly with liberal feminism.

The basic tenets of liberal feminism emphasize equal access to opportunity for women and men. The goal of liberal feminism is for women to attain the same levels of representation, compensation, and power in the public sphere as men. For change to happen, liberal feminists primarily rely on women's ability to achieve equality through their own individual actions and choices. In the first wave of feminism, this meant advocating for White women's right to vote; in the second wave, this meant advocating for things like the Equal Rights Amendment to the Constitution, but distancing the movement from the "lavender menace" of lesbians (Frye, 2001). Third wave feminists were more conscientiously intersectional. In her foundational piece, Crenshaw writes: "The failure of feminism to interrogate race means that the resistance strategies of feminism will often replicate and reinforce the subordination of people of color" (Crenshaw, 1991, p. 1252). Sandberg's version of feminism exemplifies this failure and compounds it by not considering the multiplicity of gender expression or experiences. For Sandberg, the root cause of gender inequality rests with the individual choices women make, and to a lesser extent, society's beliefs about women, which women then internalize. For there to be "more women leaders," women need to shake off their temerity, sharpen their elbows, and claim their space at the corporate table. The praxis—the actual work involved that follows from such a perspective—becomes the "motivational work" women must do to and for themselves to fit into the male-dominated corporate structure, not on efforts to change that structure or the economic system upon which it rests.

Given the huge effort of this motivational work, Sandberg says, it is best to start early. Sandberg believes that young girls are being given the wrong messages

in childhood, an idea that is also a familiar tenet of liberal feminism. According to Sandberg, girls with leadership potential are called "bossy," which is a pejorative in American culture, and they internalize this message. To create change, she envisions a world in which all little girls who were called "bossy" come to see themselves instead as "leaders." To facilitate this change, Sandberg has now launched a spin-off campaign, in partnership with the Girl Scouts, called "Ban Bossy." In the illustration for the campaign, a figure of a little girl sits with her head down, playing alone. The large, bold text reads: "Bossy holds girls back" (Girl Scouts of America, 2014). Below that, in a smaller font, the text reads: "Girls are twice as likely as boys to worry that leadership roles will make them seem 'bossy.'" At the bottom, the viewer is directed to visit BanBossy.com. The "twice as likely" claim about the greater concern among girls about seeming "bossy" is a cornerstone for the campaign. This fact is taken from a small subsample ($N = 360$) of a 2008 study conducted by the Girl Scout Research Institute; the subsample included those who said they were "not interested" in leadership positions (Girl Scout Research Institute, 2008).

While it is true that 29 percent of girls and 13 percent of boys in the subsample said "I do not want to seem bossy," this is somewhat misleading in light of the data from the larger sample.[3] When looking at the larger sample ($N = 2,475$ girls, $N = 1,514$ boys) the data reveal that the lack of interest in leadership is disproportionately a problem among White youth. In fact, the data show that the proportion of youth who think of themselves as leaders is highest among African American girls (75 percent), African American boys (74 percent), and Hispanic girls (72 percent). It is lowest among boys who are White (32 percent) or Asian American (33 percent), and then among White girls (34 percent). Given this breakdown of the sample as a whole, the campaign to "ban bossy" seems to be an effort that would benefit young White girls most, as that is the cohort of girls least likely to see themselves as leaders.

Sandberg has enlisted the support of high-profile women of color to promote the "Ban Bossy" campaign. Some of the promotional posters feature a photo of Sheryl Sandberg, flanked by former U.S. Secretary of State Condoleezza Rice and Anna Maria Chávez, the CEO of the Girl Scouts of the USA. But the fact that Sandberg has enlisted some prominent women of color to sign on to her campaign does not change the fact that liberal feminism is consistent with White supremacy. As feminist cultural critic bell hooks (2013) writes in her assessment of *Lean In*,

> The call for gender equality in corporate America is undermined by the practice of exclusivity, and usurped by the heteronormative White supremacist bonding of marriage between White women and men. Founded on the principles of White supremacy and structured to maintain it, the rites of passage in the corporate world mirror this aspect of our nation. Let it be stated again and again that race, and more importantly White supremacy, is a taboo subject in the world according to Sandberg.

In Sandberg's corporate-themed liberal feminism there is no apparatus—either in theory or in practice—for dealing with race or racism. As long as these are, as bell hooks suggests, a "taboo subject" for liberal feminists, then liberal feminism will continue to be aligned with White supremacy. The focus in *Lean In* and "Ban Bossy" is on a feminism for women who are White, cisgender, heterosexual, married or about to be, middle or upper-middle class, and working in corporations. Though this is a narrow and exclusive conceptualization of who is a "woman," this makes no difference for the ideologies and expressions of White feminism.

ONE BILLION RISING (OBR)

Eve Ensler is an American playwright most well known for her play *The Vagina Monologues* (1998) about rape and sexual violence. Ensler is also a feminist activist who has launched a number of campaigns intended to raise awareness about violence against women, among them the V-Day campaign to stop violence against women. Ensler's most recent endeavor, One Billion Rising (OBR), is an expansion of the V-Day franchise and intended to reach a broader global audience. As Ensler explains: "We founded V-Day, a global movement to stop such violence 16 years ago, and we have had many victories. But still we have not ended the violence. On February 14, 2013 millions of people rose up and danced in 207 countries with our campaign One Billion Rising" (Ensler, 2013b). Ensler has received numerous awards, including several honorary doctorate degrees, and admirers of her work point to the millions of dollars raised through V-Day events. A supporter of the One Billion Rising project of worldwide dancing praises it as a "good first step" toward how "highlighting a shared problem can encourage the sharing of solutions" (Filipovic, 2013). There is plenty of criticism of Ensler's work, as well; taken together, these illustrate some of the trouble with White feminism.

There is no account available of why Ensler chose February 14 as the focus for her charitable efforts other than alliteration. The Wikipedia entry for Ensler states that "the 'V' in V-Day stands for Victory, Valentine and Vagina." According to the website for V-Day, "Eve, with a group of women in New York City, established V-Day. Set up as a 501(c)(3) and originally staffed by volunteers, the organization's seed money came from a star-studded, sold out benefit performance at the Hammerstein Ballroom in New York, a show that raised $250,000 in a single evening." At the time of Ensler's inaugural "star-studded, sold out" event, held in 1998, February 14 was already a signifier for the struggle of Indigenous women. Since 1990, Indigenous and First Nations women in Canada have led marches on February 14 to call attention to the violence against native women. These events, known as the "Memorial March for Missing and Murdered Indigenous Women" (shared using the hashtag #MMIW), began as a way to commemorate the murder

of an Indigenous woman on Powell Street in Vancouver, Coast Salish Territories. If Ensler's V-Day had remained a New York City–based event, or even a U.S.-focused event, this confluence of dates might not have been an issue, but V-Day expanded to Canada. In an "Open Letter to Eve Ensler," Lauren Chief Elk (2013), a Native American activist, critiqued the organization's marketing campaign in Canada, writing:

> Your organization took a photo of Ashley Callingbull, and used it to promote V-Day Canada and One Billion Rising, without her consent. You then wrote the word "vanishing" on the photo, and implied that Indigenous women are disappearing, and inherently suggested that we are in some type of dire need of your saving. You then said that Indigenous women were V-Day Canada's "spotlight". V-Day completely ignored the fact that February 14th is an iconic day for Indigenous women in Canada, and marches, vigils, and rallies had already been happening for decades to honor the missing and murdered Indigenous women.

In response, Ensler and a spokesperson for OBR said they did not know that there was a conflict with the date, and then the spokesperson added, "every date in the calendar has importance." The move into Canada by Ensler's OBR on a day already commemorated by Indigenous women, using the photo of Ashley Callingbull without permission, and writing "vanishing" on it are forms of theft, appropriation, and erasure of Indigenous women and their activism. Theft, appropriation, and erasure are painful to those whose work is being stolen and whose very existences are being erased. Yet, through the lens of White feminism, it is difficult, if not impossible, to stay focused on Indigenous women's pain of erasure. As Lauren Chief Elk (2013) goes on to explain in her letter, "When I told you that your White, colonial, feminism is hurting us, you started crying. Eve, you are not the victim here." Theft, appropriation, and erasure are key strategies of settler colonialism, a disturbingly consistent feature of OBR.

A central activity of OBR events is dancing. As Ensler explains, "It turns out that dancing, as the women of Congo taught me, is a most formidable, liberating and transformative energy" (Ensler, 2013b). However, some Congolese women do not share Ensler's enthusiasm for dancing as a response to systematic sexual violence. In a meeting of "radical grassroots feminists" that she attended in London, Gyte (2013) described listening to a Congolese woman express anger toward One Billion Rising, using words like "insulting" and "neo-colonial" to describe the campaign. The woman pointed out that it would be difficult to imagine a White, middle-class, educated, American woman (like Ensler) turning up on the scene of some other kind of atrocity to tell survivors to "rise" above the violence they have seen and experienced by dancing—"imagine someone doing that to holocaust survivors" (Gyte, 2013). Ensler has made several trips to the Democratic Republic of Congo and reported for Western audiences on the use of rape as a weapon of war,

which may be useful for raising awareness about systematic sexual violence, but the move to take a Congolese tradition of dance and use it as a campaign strategy for OBR suggests a form of appropriation. This is not an isolated instance.

Following a diagnosis of cancer, Ensler wrote about her experiences in a memoir, *In the Body of the World* (2013a). The memoir, subtitled *A Memoir of Cancer and Connection*, is not a typical narrative of disease and recovery, but instead conflates stories of the sexual violence in the Democratic Republic of Congo with her own experience of illness. In a section of the memoir called "Congo Stigmata," Ensler writes:

> Cells of endometrial (uterine) cancer had created a tumor between the vagina and the bowel and had "fistulated" the rectum. Essentially, the cancer had done exactly what rape had done to so many thousands of women in the Congo. I ended up having the same surgery as many of them. (p. 41)

Here, Ensler equates her cancer with the systematic sexual violence against women in the Democratic Republic of Congo, not because they are similarly situated politically, geographically, or economically, but because she "ended up having the same surgery as many of them." With the reference to her illness as a "stigmata," Ensler conjures the symbolism of the Christian tradition, positioning herself either as a Christ figure or a saint.

The memoir also recounts some of Ensler's travels to Africa and reflections on her vision of the Earth itself, "pillaged and exploited for political and material gain, polluted with its own virulent cancers," as one reviewer of the book wrote in the *New York Times* (McNatt, 2013). The confluence of Ensler's assessment of the Democratic Republic of Congo as "the worst situation I've seen of women anywhere in the world" (2007) in terms of experiencing sexual violence; her characterization of herself in a (White) savior through the evocation of stigmata; that she chose Africa as a destination for finding "a second wind" and embracing "a second life"; and naming as the impetus for her OBR campaign her own "destiny to birth the new paradigm" (2013a, pp. 213, 211) together suggest some of the deep trouble with White feminism.

The White feminism of the OBR campaign is rooted in what Toni Morrison (1992) refers to as "sycophancy of White identity" in which White writers use Africa as a means to contemplate their own terror and desire (p. 19). When such critiques are levied at Ensler's work, often by women of color, many White feminists come to her defense to argue that she is "doing good work" and thus should be released from any obligation to respond to such criticism, as happened recently (Romano, 2015). When such controversies erupt, they are dismissed as the result of disgruntled, envious, or "angry" women of color who are "using" social media to "attack" well-meaning White feminists (Goldberg, 2014). Such a misreading of the situation derails any sustained critique of the architecture of White feminism,

such as OBR, or its leading figures, like Ensler. But what of the work that has been produced with the millions of dollars raised from V-Day events and OBR?

The kinds of change brought about through Ensler's activism further highlight the trouble with White feminism. In describing what change looks like as a result of OBR, Ensler (2013b) writes:

> In Guatemala, Marsha Lopez, part of the V-Day movement since 2001, says the most important result of OBR was the creation of a law for the criminalisation of perpetrators who impregnate girls under 14 years old. The law also includes penalties for forced marriage of girls under 18.

Through speaking for and through Marsha Lopez of Guatemala, Ensler identifies "criminalization of perpetrators" as the greatest achievement of OBR. Such an approach to systematic sexual violence, which relies primarily on engagement by the State, does not acknowledge—and indeed cannot conceptualize—the ways in which the State is an agent of sexual violence, nor does it acknowledge the ways in which the State enacts violence against some men. The latter is what Bernstein refers to as carceral feminism, with incarceration as the underlying paradigm for justice (Bernstein, 2014, p. 70). The focus on incarceration as a solution to gender inequalities is both insufficient to address the problems of systematic sexual violence (across differences of race, national context, and gender identity) and shifts the focus to another system of oppression that in the United States consumes the bodies of Black and Brown men. To be sure, the carceral paradigm of justice is part of the trouble with the White feminism of Ensler's One Billion Rising.

The Future of Online Feminism

Digital activism is the most important advance in feminism in 50 years, but it is in crisis and unsustainable. This is the central message of a report released in April 2013 by the Barnard Center for Research on Women (BCRW). The report, called *The Future of Online Feminism* (using the hashtag #FemFuture), was written by Courtney Martin and Vanessa Valenti, both involved at different times with the prominent feminist blog Feministing.com. While less widely known than the work of Sandberg or Ensler, the report by Martin and Valenti seems to encapsulate a set of debates about digital activism; as with Sandberg and Ensler, the report illustrates some of the trouble with White feminism.

Martin and Valenti, currently the co-principals of a communications consulting firm, approached BCRW about doing a report on the "online revolution" in feminism. A key observation of the report is that "many have called feminist blogs the 21st century version of consciousness raising" (Martin & Valenti, 2013, p. 3). The 34-page report sets out an overview of what the authors call "online feminism," by which they mean blogs and online petitions in support of feminist issues.

The report was informed by a one-day "convening" of online feminists in June 2012, but it is authored by Martin and Valenti and contains their vision. While they recognize that the emergence of digital technologies has been a boon to feminist causes, Martin and Valenti contend that online feminism is at "a crisis point" because feminist bloggers are not getting paid for their activism, thus making such activism "unsustainable." But, as the BCRW's introduction to the report explains, "Martin and Valenti had a compelling vision to make the landscape of feminist writers and activists online stronger" and they proposed doing this through a variety of tactics (Martin & Valenti, 2013, p. 2).

When it was released, there was an immediate negative reaction to the report, which was voiced largely, but not exclusively, by women of color (Johnson, 2013; Loza, 2014). Many objected to the closed-ended nature of the report, which was released in Portable Document Format (PDF), which does not allow for commenting, an ironic choice for a report about the power of the Internet for engaging wide audiences in feminist causes. #FemFuture, created by the authors to publicize the report, instead quickly became a mechanism for focused criticism.

Some critics took issue with Martin and Valenti's historical account of online feminism. In describing the emergence of feminists' use of the Internet to share stories, raise awareness, and organize collective actions, the authors of the report assert that "[the feminist Internet's] creation was largely accidental…. Women were quietly creating spaces for themselves, all the while not realizing they were helping to build the next frontier of the feminist movement" (Martin & Valenti, 2013, p. 6). Veronica Arreola, who created and maintains the blog Viva La Feminista, responded to the report with wide-ranging critique, particularly this latter finding. Specifically, she points to her extensive feminist online organizing from the mid-1990s to the present and observes, "None of this was an accident" (Arreola, 2013). Arreola's piece goes on to attribute this mistake to the fact that "this call to action read to me as a young feminist document" that "plays into the stereotype that no one over 30 is online." She then questions who might lead in online feminism.

There is a tension in the report, enlarged in the criticisms that followed, between the document's authorship by two White women and the racially diverse 2012 gathering that informed the report. Many of the criticisms of the report saw the invitation-only convening of "a core group of trailblazing feminists working online" as cliquish, if not elitist. Martin and Valenti write that "what transpired was no less than historic," but it is not clear what was historic about the gathering. Although the convening included a racially diverse group of feminists engaged online—a fact mentioned often to defend the report as inclusive—the document ultimately contains the vision of Martin and Valenti. The authors suggest the possibility of intersectionality when they write that theirs is "boundary-crossing work—cross-generational, cross-class, cross-race, cross just about every line that

still divides us both within and outside of the feminist movement" (Martin & Valenti, 2013, p. 4). This is the only mention of race, generation, or class in the text. However, the report does name a number of women of color who were included, without their permission and without invitations to the convening, as exemplars of online feminism. For many observers, the process of developing, writing, and releasing the report was one that centered elite White women's experiences while using the presence of women of color—at the convening and in textual examples—to avoid that insinuation. As Susana Loza (2014) observes, "The production of the #FemFuture report is emblematic of the White liberal feminist approach to its perceived exclusivity: symbolic multiculturalism."

The trouble with the White feminism of the report is rooted in the ideas, if not quite theories, that inform it. Martin and Valenti write that they were inspired to create a "feminist version" of something called "collective impact," a model for social change developed by nonprofit consultants John Kania and Mark Kramer. The central concept that Martin and Valenti take from this model is that the key to large-scale social change is convening power and agenda setting. What make these effective, according to Kania and Kramer (2011), is a "shared vision for change, one that includes a common understanding of the problem and a joint approach to solving it through agreed upon actions." The formidable challenge in trying to create a feminist version of the Kania and Kramer model is finding a "shared vision" among feminists that includes a "common understanding of the problem." It may be that Martin and Valenti believed that they had arrived at this based on the convening of 21 "trailblazing" feminists, but they did not—and, with such a small group, indeed could not, however diverse the group or well-intentioned the organizers. Instead, Martin and Valenti proceeded with the "convening power" and "agenda setting" without the shared vision and this, in many ways, illustrates some of the trouble with White feminism.

The crisis that the report identifies among feminist online activists is primarily an economic one, with affective peril a close second. It is not surprising, then, that the solutions Martin and Valenti offer include a wide range of tactics and strategies to make feminist blogging economically lucrative and more emotionally satisfying. Some of the proposed solutions include sponsoring a "Feminist Business Boot Camp" (a weeklong opportunity to learn about business and financial structures and examine social business case studies), "Corporate Partnerships" (not every corporation's mission and operations would fit within the ethical and political framework that many online feminists demand of our partners), and "Self-Care & Solidarity Retreats" (order to reconnect with renewed purpose and clarity). The proposed solutions in the report are a combination of economic empowerment and emotional uplift, with an ambitious overall goal: "We must create a new culture of work, a vibrant and valued feminist economy that could resolve an issue that's existed for waves before us" (Martin & Valenti, 2013, p. 23).

In many ways, what Martin and Valenti are proposing is a well-trod path in the world of women's blogging conferences, most notably the BlogHer franchise. At these blogging conferences, which began in 2005 to highlight the work of women bloggers, thousands of women, predominantly White, come together looking for emotional support and for ways to "monetize"—make money from—their blogs. Although not explicitly a form of feminist organizing, there is a kind of women's empowerment ethos to these conferences. Reporters from the *New York Times* and the *Wall Street Journal* have covered the BlogHer conferences, but the Whiteness of women's blogging conferences is rarely remarked on by the mainstream media. However, the racial composition of these conferences is set in relief when contrasted with the Blogalicious conference, developed and attended by African American women; there is also stark difference in sponsorship between the two conferences. Research on sponsorship at these conferences from 2007–2009 found that there were consistently more than 40 sponsors at BlogHer, many of them corporations such as GM, which provided cars for attendees, and some of the top tech firms, while there were fewer than 10 sponsors at Blogalicious, and many of these were small or single proprietor businesses (Daniels, 2011). The top women bloggers who are touted as financial success stories at BlogHer are almost always White (e.g., Heather Armstrong, a well-known "mommy blogger," is a millionaire), while women of color bloggers talk about the struggle to attract sponsorship for their blogs. This stark difference speaks to the racialized political economy in which White women earn more than African American, Native American, and Latina women; this includes income earned from doing work online, such as blogging for feminist causes. What Martin and Valenti miss in their proposed "new culture of work, a vibrant and valued feminist economy" is the way that race still matters in the economy. In contrast to some in the "waves that came before," who might have been critical of the idea of feminism joined seamlessly with capitalism, the Martin and Valenti report, like the women's blogging conferences, embraces the idea of a corporate-sponsored feminism. And this fits very neatly with White feminism.

DISCUSSION

There are a number of challenges with discussing White feminism. For women of color, the initial challenge is simply being heard, as they are frequently ignored. Once their voices have registered, they risk being bullied and verbally abused (or worse). Most likely they will be called "angry," or in some cases, accused of starting a "war" (Goldberg, 2014). These misreadings of critique as attack cause some White women to further retreat from engaging about race and may lead to their excluding women of color from feminist organizing to avoid even the

possibility of criticism. For White women like myself, speaking out about White feminism is to risk hurt feelings and the loss of connection with other White women—and the opportunities that come with that. Even as I was writing this piece, I could not keep from my mind the White women I know who might be upset by my writing this. To speak about White feminism, then, is to speak against a social order.

When Mikki Kendall's hashtag #SolidarityIsForWhiteWomen was trending, many White feminists reporting feeling hurt, attacked, wounded, or simply left out of the conversation (Van Deven, 2013). In many ways, the reaction to challenges to White feminism causes "unhappiness," which, as Sara Ahmed (2010) explains, can be a good thing:

> To be willing to go against a social order, which is protected as a moral order, a happiness order is to be willing to cause unhappiness, even if unhappiness is not your cause. To be willing to cause unhappiness might be about how we live an individual life (not to choose "the right path" is readable as giving up the happiness that is presumed to follow that path).... To be willing to cause unhappiness can also be how we immerse ourselves in collective struggle, as we work with and through others who share our points of alienation. Those who are unseated by the tables of happiness can find each other.

As I read it, Ahmed's is a hopeful analysis for those who seek to challenge White feminism. For those who are willing to cause unhappiness by challenging White feminism, we can find each other as we work together and share our alienation from it.

The era of digital activism presents new opportunities for digital feminism; at the same time the intersectional Internet makes challenging hegemonic White feminism easier and more effective. Twitter, in particular, is changing the landscape of feminism. Loza (2014) notes the proliferation of hashtags created by feminists of color with intersectional themes and observes "these hashtags are a direct indictment of the parochial vision of online feminism articulated in the #FemFuture report."

Mikki Kendall agrees: "I do know that Twitter is changing everything. Now, people are forced to hear us and women of color no longer need the platform of White feminism because they have their own microphones" (qtd. in Vasquez, 2013). If the goal is a sustained critique of White feminism, then we have to see Twitter as a key tool in that effort.

To sustain a challenge to White feminism, we have to become more adept at critically examining Whiteness. As it is elsewhere in the sociopolitical landscape, when race is addressed in and by feminist blogs, the subject is nearly always raised by a person of color (de la Peña, 2010, p. 926). Challenging White feminism means, at the very least, bringing up race and recognizing that White people have race. To go further, we must understand the ways that constructing and protecting

Whiteness has been a core feature in the rise of the popular Internet (de la Peña, 2010, p. 936), and we must join this with a dissection of how White feminism has benefitted from this technological development.

CONCLUSION

In conclusion, I discussed three case studies of White feminism that were widely circulated in popular culture in recent years. The focus in Sheryl Sandberg's *Lean In* and the "Ban Bossy" campaign is on women and girls doing the motivational work necessary to assert themselves in the workplace and think of themselves as leaders from an early age. While Sandberg admits she is new to feminism, her ideas are in sync with the tenets of liberal feminism. Sandberg's vision of the world is one in which all the women are White, cisgender, heterosexual, married or about to be, middle or upper-middle class, and working in corporations. In other words, they are like her. Sandberg's experiences as a woman become the stand-in for all women's experiences, and this is some of the trouble with White feminism. Although Sandberg includes some prominent women of color in her promotional materials for "Ban Bossy," her brand of liberal feminism does nothing to challenge White supremacy, but instead is quite consistent with it.

The V-Day and One Billion Rising campaigns created by playwright Eve Ensler have raised millions of dollars and much awareness about sexual violence, yet they have been criticized for theft, erasure, and neocolonial practices with regard to Indigenous and Native women. Her conflation of her own cancer with the experience of survivors of rape in the Democratic Republic of Congo and her use of the phrase "Congo Stigmata" to describe her illness point to the problematic White savior rhetoric and politics within Ensler's work. The policy emphasis of One Billion Rising on the "incarceration of perpetrators" completely elides the way that the State is implicated in systemic violence, including sexual violence. The focus on carceral justice is a key part of the trouble with White feminism.

The BCRW report, *The Future of Online Feminism*, repeats some of the old trouble with White feminism from previous waves and presents some new ones. The report's authors, Martin and Valenti, published a report that was supposedly based on a shared vision of what the future of online feminism might look like, but they based it mostly on their own experiences as White feminists and in consultation with a gathering of 21 racially diverse feminist bloggers. The report met with immediate and heated criticism on the hashtag #FemFuture, much of it for the thoroughly closed way the report was developed, written, and released, which is anathema to those used to the Open Web. Their lack of technological transparency and accountability is a new kind of trouble with White feminism. Martin and Valenti proposed a set of economic and affective strategies to bring about a new,

creative, feminist economy, but they proposed these without taking into account the way race matters in the political economy, a very old kind of trouble with White feminism.

Taken together, Sandberg's *Lean In* and "Ban Bossy," Eve Ensler's V-Day and OBR, and *The Future of Online Feminism* report reveal some of the dominance of White women as architects and defenders of a framework of feminism in the digital era.

Challenging White feminism in favor of an intersectional feminism that centers the experiences of Black, Latina, Asian, Indigenous, queer, disabled, and trans women is to speak against a social order. To challenge White feminism is also to risk causing unhappiness, but this is a risk we must take so that we can find each other in our resistance to it.

NOTES

1. Kendall named Jill Filipovic, Jessica Coen, Jessica Valenti, and Amanda Marcotte, in particular. They have written (or founded) popular feminist sites such as Feministing, Jezebel, and Pandagon.
2. For the uninitiated, a hashtag is merely a word or phrase with a # symbol in front of it. It is a way to have a conversation around a topic on Twitter; if it catches on, the hashtag is said to be "trending," and appears on a sidebar that attracts even more attention to it.
3. For the subsample used for the statistic in the promotional material for the campaign, the data on race are not reported but they are for the full sample.

REFERENCES

Ahmed, S. N. (2006). *Queer phenomenology: Orientations, objects, others.* Durham, NC: Duke University Press.

Ahmed, S. N. (2010). Feminist killjoys (and other willful subjects). *The Scholar and Feminist Online* 8(3). Retrieved from http://sfonline.barnard.edu/polyphonic/print_ahmed.htm

Allen, T. W. (1994). *The invention of the White race.* London: Verso.

Anderson, W. (2006). *The cultivation of Whiteness: Science, health and racial destiny in Australia.* New York: Basic Books.

Arnesen, E. (2001). Whiteness and the historians' imagination. *International Labor and Working-Class History, 60*, 3–32.

Arreola, V. (2013). Back to the #FemFuture. Retrieved from http://www.vivalafeminista.com/2013/04/back-to-femfuture.html

Bernstein, E. (2014). Militarized humanitarianism meets carceral feminism: The politics of sex, rights, and freedom in contemporary antitrafficking campaigns. *Signs, 36*(1), 45–72.

Blee, K. M. (2008). *Women of the Klan: Racism and gender in the 1920s* (2nd ed.). Berkeley: University of California Press.

Bonnett, A. (2008). Review article: Whiteness studies revisited. *Ethnic and Racial Studies, 31*(2), 185–196.

Boucher, L., Carey, J., & Ellinghaus, K. (Eds.). (2009). *Re-orienting Whiteness.* New York: Palgrave Macmillan.

Brock, A. (2006). "A belief in humanity is a belief in colored men": Using culture to span the digital divide. *Journal of Computer-Mediated Communication, 11*(1), 357–374.

Brock, A. (2009). Life on the wire: Deconstructing race on the Internet. *Information, Communication & Society, 12*(3), 344–363.

Byrne, B. (2006). *White lives: The interplay of "race," class and gender in everyday life.* New York: Routledge.

Chait, J. (2015). Not a very P.C. thing to say: How the language police are perverting liberalism. *New York Magazine.* Retrieved from http://nymag.com/daily/intelligencer/2015/01/not-a-very-pc-thing-to-say.html

Chief Elk, L. (2013). An open letter to Eve Ensler. Retrieved from http://chiefelk.tumblr.com/post/49527456060/an-open-letter-to-eve-ensler

Collins, P. H. (2002). *Black feminist thought: Knowledge, consciousness, and the politics of empowerment.* New York: Routledge.

Crenshaw, K. (1991). Mapping the margins: Intersectionality, identity politics, and violence against women of color. *Stanford Law Review, 43*(6), 1241–1299.

Daniels, J. (1997). *White lies.* New York: Routledge.

Daniels, J. (2009). *Cyber racism: White supremacy online and the new attack on civil rights.* Lanham, MD: Rowman and Littlefield.

Daniels, J. (2011). BlogHer and Blogalicious: Gender, race, and the political economy of women's blogging conferences. In R. Gajjala & Y. J. Oh (Eds.), *Cyberfeminism 2.0* (pp. 29–60). New York: Peter Lang.

Daniels, J. (2013). Race and racism in Internet studies: A review and critique. *New Media & Society, 15*(5), 695–719.

de la Peña, C. (2010). The history of technology, the resistance of archives, and the whiteness of race. *Technology and Culture 51*(4), 919–937.

Dyer, R. (1988). White. *Screen, 29*(4), 44–65.

Dyer, R. (1997). *White.* New York: Routledge.

Ensler, E. (1998). *The vagina monologues.* New York: Random House.

Ensler, E. (2013a). *In the body of the world: A memoir of cancer and connection.* New York: Metropolitan Books.

Ensler, E. (2013b, December 9). One billion rising: The 2014 campaign to end violence against women. *The Guardian.* Retrieved from http://www.theguardian.com/society/womens-blog/2013/dec/09/one-billion-rising-2014-campaign-end-violence-against-women-justice

Feagin, J. R. (2010). *The White racial frame: Centuries of framing and counter-framing.* New York: Routledge.

Feagin, J. R. (2012). *White party, White government: Race, class, and U.S. politics.* New York: Routledge.

Filipovic, J. (2013, February 13). What makes One Billion Rising's invitation to dance a radical move. *The Guardian.* Retrieved from http://www.theguardian.com/commentisfree/2013/feb/14/one-billion-rising-invitation-dance-radical

Fine, M., Weis, L., Pruitt, L. P., & Burns, A. (2004). *Off White: Readings on power, privilege, and resistance* (2nd ed.). New York: Routledge.

THE TROUBLE WITH WHITE FEMINISM | 59

Frankenberg, R. (1993). *White women, race matters: The social construction of Whiteness.* Minneapolis: University of Minnesota Press.

Frye, M. (2001). White woman feminist 1983–1992. In B. Boxill (Ed.), *Race and racism* (pp. 83–100). New York: Oxford University Press.

Girls Scout Research Institute. (2008). *Change it up! What girls say about redefining leadership.* New York: Girls Scouts of the USA. Retrieved from http://www.girlscouts.org/research/pdf/change_it_up_executive_summary_english.pdf

Goldberg, M. (2014, February 17). Feminism's toxic Twitter wars. *The Nation, 135*(7), 12–17.

Gyte, N. (2013, February 2). Why I won't support one billion rising. *Huffington Post.* Retrieved from http://www.huffingtonpost.co.uk/natalie-gyte/one-billion-rising-why-i-wont-support_b_2684595.html

hooks, b. (1992). *Black looks: Race and representation.* Boston, MA: South End Press.

hooks, b. (2013). Dig deep: Beyond "Lean In." *The Feminist Wire.* Retrieved from http://thefeminist wire.com/2013/10/17973/

Hughey, M. (2010). The (dis)similarities of White racial identities: The conceptual framework of "hegemonic Whiteness." *Ethnic and Racial Studies, 33*(8), 1289–1309.

Hull, G. T., Scott, P. B., & Smith, B. (Eds.). (1982). *But some of us are brave: Black women's studies.* New York: Feminist Press at CUNY.

Johnson, J. M. (2013). #FemFuture, history & loving each other harder. *Diaspora hypertext.* Retrieved from http://diasporahypertext.com/2013/04/12/femfuture-history-loving-each-other-harder/

Kania, J., & Kramer, M. (2011). Collective Impact. Stanford Social Innovation Review, Winter. Stanford, CA: Stanford University. Retrieved from http://c.ymcdn.com/sites/www.lano.org/resource/dynamic/blogs/20131007_093137_25993.pdf

Kendall, M. (2013, August 14). #solidarityisforWhitewomen: Women of color's issue with digital feminism. *The Guardian.* Retrieved from http://www.theguardian.com/commentisfree/2013/aug/14/solidarityisforWhitewomen-hashtag-feminism

Leonardo, Z. (2009). *Race, whiteness and education.* New York: Routledge.

Lipsitz, G. (2006). *The possessive investment in Whiteness* (2nd ed.). Philadelphia, PA: Temple University Press.

Lopez, I. H. (2006). *White by law: The legal construction of race.* New York: New York University Press.

Low, S. M. (2003). *Behind the gates: Security and the new American dream.* New York: Routledge.

Low, S. M. (2009). Maintaining Whiteness: The fear of others and niceness. *Transforming Anthropology, 17*(2), 79–92.

Loza, S. (2014). Hashtag feminism, #solidarityisforWhitewomen, and the other #FemFuture. *Ada: A Journal of Gender, New Media, and Technology, 5.* doi:10.7264/N337770V

Martin, C., & Valenti, V. (2013). *The future of online feminism.* Retrieved from http://bcrw.barnard.edu/wp-content/nfs/reports/NFS8-femfuture-Online-Revolution-Report-April-15-2013.pdf

McNatt, R. B. (2013, June 16). The cancer monologue [Review of the book *In the body of the world: A memoir of cancer and connection,* by E. Ensler]. *New York Times.* Retrieved from http://www.nytimes.com/2013/06/16/books/review/in-the-body-of-the-world-by-eve-ensler.html

McPherson, T. (2003). *Reconstructing Dixie: Race, gender, and nostalgia in the imagined South.* Durham, NC: Duke University Press.

Mills, C. W. (1997). The racial contract. Ithaca, NY: Cornell University Press.

Morrison, T. (1992). *Playing in the dark: Whiteness in the literary imagination.* New York: Vintage.

Nakamura, L. (2002). *Cybertypes: Race, ethnicity, and identity on the Internet.* New York: Routledge.

Nakayama, T. K. (2000). Whiteness and media. *Critical Studies in Media Communication 17*(3): 364–365.

Painter, N. (2010). *The history of White people*. New York: Norton.

Projansky, S, & Ono, K. A. (1999). Strategic whiteness as cinematic racial politics. In T. K. Nakayama, & J. N. Martin, (Eds.), Whiteness: The communication of social identity (p.149–174). Newbury Park, CA: Sage Publications.

Reddy, M. (1998). Invisibility/hypervisibility: The paradox of normative Whiteness. *Transformations, 9*(2), 55–64.

Roediger, D. R. (2007). *The wages of Whiteness: Race and the making of the American working class* (2nd ed.). London: Verso.

Romano, A. (2015). Rosie O'Donnell lashes out at feminists over "The Vagina Monologues." *The Daily Dot*. Retrieved from http://www.dailydot.com/politics/rosie-odonnell-eve-ensler-twitter/

Ronson, J. (2015, February 12). How one stupid tweet blew up Justine Sacco's life. *New York Times*. Retrieved from http://www.nytimes.com/2015/02/15/magazine/how-one-stupid-tweet-ruined-justine-saccos-life.html

Sandberg, S. (2010, December 21). Sheryl Sandberg: Why we have too few women leaders [Video file]. Retrieved from http://www.ted.com/talks/sheryl_sandberg_why_we_have_too_few_women_leaders

Sandberg, S. (2013). *Lean in: Women, work and the will to lead*. New York: Knopf.

Smith, S. M. (2004). *Photography on the color line: W.E.B. Du Bois, race and visual culture*. Durham, NC: Duke University Press.

Spelman, E. V. (1988). *Inessential woman: Problems of exclusion in feminist thought*. Boston, MA: Beacon Press.

Srivastava, S. (2005). "You're calling me a racist?" The moral and emotional regulation of antiracism and feminism. *Signs, 40*(1), 29–62.

Truth, S. (2009). Ain't I a woman? In Paul Halsall (Ed.), *Internet Modern History Sourcebook*. New York: Fordham University. (December 1851).

Turkle, S. (1995). *Life on the screen: Identity in the age of the Internet*. New York: Simon & Schuster.

Twine, F. W., & Gallagher, C. (2008). Introduction: The future of Whiteness: A map of the Third Wave. *Ethnic and Racial Studies, 31*(1), 4–24.

Van Deven, M. (2013). The discomfort of #solidarityisforWhitewomen. *In the Fray*. Retrieved from http://inthefray.org/2013/08/the-discomfort-of-solidarity/

Vasquez, T. (2013). Why "solidarity" is bullshit. *Bitch Magazine*. Retrieved from http://bitchmagazine.org/post/why-solidarity-is-bullshit

Ware, V. (1992). *Beyond the pale: White women, racism, and history*. New York: Verso.

Wray, M. (2006). *Not quite White: White trash and the boundaries of Whiteness*. Durham, NC: Duke University Press.

Zuberi, T., & Bonilla-Silva, E. (Eds.). (2008). *White logic, White methods: Racism and methodology*. New York: Rowman & Littlefield.

Asian/American Masculinity: The Politics OF Virility, Virality, AND Visibility

MYRA WASHINGTON

INTRODUCTION

Sometime during the waning hours of May 30, 2014, the video for Korean pop star PSY's song "Gangnam Style" surpassed two billion views on YouTube (D'Orazio, 2014). It is the first video to reach the milestone, and currently (as of this writing) the only video to do so. The "Gangnam Style" video had already previously broken YouTube's viewing record by being the first video to reach one billion views a year and half earlier (Gruger, 2012). PSY's hit not only ruled YouTube, but "Gangnam Style" was at one point nearly omnipresent, being played from military installations (Pomicter, 2013) to news programs to the White House (Feldman, 2012) and everywhere in between. PSY himself had been everywhere since "Gangnam Style" was released in July 2012. He was spotted at Major League Baseball games (Locker, 2012) while the crowd danced and sang along to his song; appeared on television, both late night (*Jimmy Kimmel Live*, 2014) and daytime talk shows (*The Ellen Show*, 2012) and *Saturday Night Live* (Harbison, 2012); and closed out the American Music Awards, sharing the stage with another former viral star, MC Hammer.

During the 2013 Super Bowl, a commercial aired for Wonderful Pistachios, a Paramount Farms product, which featured PSY performing "Gangnam Style" and doing the now familiar horse dance routine from his video with some dancing

pistachios. For the 30-second commercial, PSY slightly altered his lyrics from "oppa gangnam style" to "crackin' gangnam style." The commercial ended with the hashtag #crackinstyle aimed toward generating tweets (mentions) on Twitter. The commercial was in the same vein as the other Wonderful Pistachio commercials[1]—stark white background, popular-culture icon, and cheeky narrator who ends with a pop-culture reference, in this case: "When PSY does it, we all go nuts." At approximately $3.8 million per commercial (Steinberg, 2013), Wonderful Pistachios relied on the bankability and literal commercial marketability of "Gangnam Style" for its first Super Bowl appearance. Eight months after its release and meteoric rise in popularity, the song had maintained its sonic hold on the United States. The advertisement was popular enough to get the commercial on "Best Of" lists (Greenberg, 2013), undoubtedly legitimizing the choice to focus on PSY. While PSY is no longer saturating the public imaginary the way he was at the apex of his fame in late 2012–2013, the enduring popularity of his song and the discursive framing around its popularity offers a moment worth analyzing.

Here I am interested in analyzing and contextualizing the popularity PSY and "Gangnam Style" as an example of the virility, visibility, and virality of Asian/American masculinity. By "virality," I refer not only to those intangible markers of cool and/or weirdness that propel media objects to massive popularity through social, and then traditional, media sharing (though I touch on some of those things), but also to the insertion of PSY and "Gangnam Style" into the fabric of U.S. pop culture and the reaction created by their presence.

This examination of PSY is predicated on exploring the *conditional visibility* of Asian/Americans, which Park (2010) defines as the "ways in which certain bodies, objects, and images are sometimes visible and other times invisible in the dominant culture" (p. viii). Disguised by apparently positive allusions to culture, particularly to *hallyu*, the Korean Wave of pop-culture products including music, film, and television shows, the handwringing over the cultural domination of this Korean pop-culture artifact is revealing. Through a critical and close reading of some key media texts and articulations of the social, political, economical, and technological forces that have come together to create this new media moment for Asians/Americans, or what Grossberg (1992) terms a cultural formation, I argue that PSY and the popularity of "Gangnam Style" have become part of the latest wave of "yellow peril" discourses.

VIRILITY

To attain that milestone marker of popularity, the most-watched video on YouTube, "Gangnam Style" had to surpass Canadian teen pop star Justin Bieber. PSY both metaphorically and literally unseated White, heterosexual masculinity (as represented

by Bieber) and replaced it with what I am calling *neo-virility*. Neo-virility, embodied especially by Asian/American men, is predicated not on a physical understanding of masculinity (e.g. strength, hyper/sexuality), but rather on a neoliberal one. Asian/American men in particular are depicted as anti-sexual[2]—they are so not sexy/sexual that not only do they not get the girl, but their mere presence is taken as a joke. The neo-virility frame allows men to draw on economic utility as a way to assert their masculinity. Technology has become one of the most popular areas for generating, maintaining, and circulating that economic utility, and the arena where Asian/American men have found enormous success.

Yellow peril 2.0—I am using the 2.0 here purposely as a way to tie it into discourses around the tech sector—depicts domination by Asians/Americans as coming not from military domination,[3] nor from strictly economic domination,[4] but from areas of technology. The yellow peril 2.0 discourse is powered by the worker demographics of technology companies, to the outsourcing of essential components and labor to firms based in mainly Asian countries, to the model-minority stereotype that helps foster the belief that Asians/Americans are inherently skilled and/or well-suited for all forms of digital technology. This yellow peril 2.0 narrative connects essentialist ideas of Asian/American technological superiority with the "soft power" of Asian cultural exports and influences. Thus, underlying the viral popularity of both PSY and "Gangnam Style" is the framing of PSY's sexuality within the familiar model minority context but with the added benefit of Asian cultural coolness.

VIRALITY

Van Dijk (2009) refers to YouTube as a major symbol of contemporary participatory media culture, and the "Gangnam Style" video feels tailor-made for the platform. The video allows Internet users, and, later, traditional media folks, to constantly rework and reconfigure it, in turn allowing videos to spread globally through acts of both sharing and imitation. The video for "Gangnam Style" became so popular so quickly because as a video it is both viral and memetic. Shifman (2011) differentiates between the two as such: A viral video is "a clip that spreads to the masses via digital word-of-mouth mechanisms without significant change.... These videos are tagged as viral since they spread rapidly from person to person like an epidemic." The memetic video, on the other hand, is "a popular clip that lures extensive creative user engagement in the form of parody, pastiche, mashups or other derivative work. Such derivatives employ two mechanisms in relation to the 'original' memetic video: imitation (parroting elements from a video) and re-mix (technologically-afforded re-editing of the video)" (p. 190). "Gangnam Style," the most watched video on YouTube, is unquestionably

viral—especially after it crossed over into traditional media formats where it was further viewed, dissected, and discussed. However, the video became viral only because it was memetic, meaning that early fans of the video chose not just to watch the video but also to do something with it, which usually involved re-creating and/or mutating the visually rich scenes in their own spaces and places.

The video also offered a kinetic meme: the galloping horse dance and shuffle, easy to learn and even easier to replicate, is performed as part of touchdown dances, in flash mobs and in video game narratives, by NASCAR racers and marching bands, aboard naval ships, on popular television talk shows, and even by North Koreans, who, even with severely limited Internet access, still managed to hear/learn about "Gangnam Style" (Kwon & Mullen, 2012). The last kinetic meme to experience such global popularity was the dance that accompanied the song "Macarena," nearly two decades ago, which is even more impressive in light of the fact that the dance became popular and nearly ubiquitous pre-YouTube. The video for "Gangnam Style," unlike most other popular videos, offers no differentiation between what people were sharing (viral videos) and what they were becoming involved with through imitation and remixture (memes) because it became a meta-meme. Jenkins (2006) uses "convergence culture" to define the moment when old and new media meet; I use "meta-meme" because it epitomizes the meeting that happens once traditional (old) media begins covering digital (new) media memes. In making room for virality, Jenkins has had to redefine participatory culture. It has shifted from arguing that while everyone might not participate in digital media environments, if/when they do, that participation is valued to a more specific model, which relies on his 4 Cs: create, connect, collaborate, and, most importantly, circulate. A limit to this participatory model for virality, whose actors can include the idea of the prosumer (producer/consumer), as envisioned by van Dijk (2009), or the producer/distributor binary proffered by Baym and Burnett (2009), is that it fails to take into account the agency of networks in circulating memes. Missing in many discussions of virality is why the source material resonates enough to be remixed and/or circulated.

VISIBILITY

YouTube, hailed as a democratizing platform (Considine, 2011), has allowed Asians/Americans to find success and popularity online. At the start of this project, half of the top 10 YouTube channels belonged to Asians/Americans. Currently, only Ryan Higa's nigahiga finds itself in the top 10, though it does hold the record for the longest amount of time with the most subscribers. That YouTube

has become a place where Asians/Americans can find themselves represented, or even "hyperserved" (Takahashi, 2011), particularly given their absence from mainstream/traditional media venues, shows that there is a sizeable audience ready to consume these representations. A useful project would be to examine these representations disseminated by Asian/American YouTube producers, because a cursory glance finds that they often traffic in similar themes, aesthetics, and depictions. Additionally, male Asian/American YouTube stars have been unable to parlay their Internet fame into mainstream success like Justin Bieber or Soulja Boy. Michelle Phan is an anomaly, in that she was able to convert the popularity of her YouTube makeup channel into a Lancome spokesperson position. PSY became the first Asian/American man to launch himself from YouTube glory into U.S. mainstream consciousness.

While popular culture scholars and readers of news outlets such as the *New Yorker* or pop-culture blogs and websites might be familiar with the Korean wave and K-pop music specifically, most news and entertainment sources began their deconstruction of the "Gangnam Style" phenomenon by explaining K-pop music. Descriptions of K-pop have ranged from "highly crafted bubblegum pop" (Yang, 2012), "Technicolor delirium" (Hsu, 2012), and "accelerated versions of Western pop acts" (Barry, 2012) to "finely-tuned precision machine performers." That those descriptions of K-pop's popularity synergistically connect with descriptions of Korea as an emergent technological powerhouse is not a coincidence. Korea's growth and emergence as a player on the global economic and technological stage over the last two decades has paralleled the growth and emergence of K-pop. Nervousness over Korea's explosive growth and technological sophistication is a common theme in news discourses about K-pop. The almost palpable anxiety over the technological and economic growth of Korea feels like a return to the anti-Japanese sentiment of the late 1980s/early 1990s or to the anti-Chinese sentiment of the 2000s. By drawing attention to Korea's innovations in the realm of technology and linking those innovations to its culture industries, these discourses effectively link Korea's domination as the most wired nation to PSY's pop musical domination. (Most of these news discourses leave out the fact that U.S., and not Korean, audiences have largely driven PSY's immense popularity.)

Present in addition to apprehension over Korea's dominance, real and imagined, and the framing of PSY's music within that domination, was a confused tension over how to materially position him, and by extension Asians/Americans, within the racial hierarchy of the United States. When PSY closed out the 2012 American Music Awards with MC Hammer, a sampling of real-time tweets (Binder, 2012) demonstrates not just the tension about where to position Asians/Americans but also the racist backlash occurring in reaction to the popularity of "Gangnam Style."

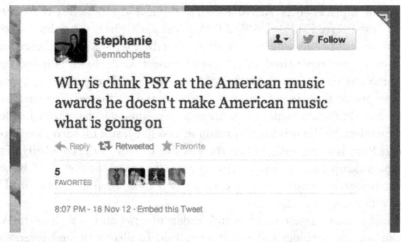

stephanie
@emnohpets

Follow

Why is chink PSY at the American music awards he doesn't make American music what is going on

↩ Reply ⇄ Retweeted ★ Favorite

5
FAVORITES

8:07 PM - 18 Nov 12 · Embed this Tweet

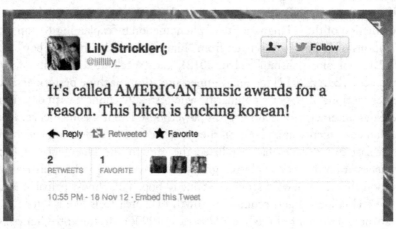

Lily Strickler(;
@lilllily_

Follow

It's called AMERICAN music awards for a reason. This bitch is fucking korean!

↩ Reply ⇄ Retweeted ★ Favorite

2
RETWEETS

1
FAVORITE

10:55 PM - 18 Nov 12 · Embed this Tweet

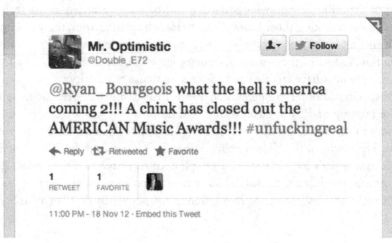

Mr. Optimistic
@Double_E72

Follow

@Ryan_Bourgeois what the hell is merica coming 2!!! A chink has closed out the AMERICAN Music Awards!!! #unfuckingreal

↩ Reply ⇄ Retweeted ★ Favorite

1
RETWEET

1
FAVORITE

11:00 PM - 18 Nov 12 · Embed this Tweet

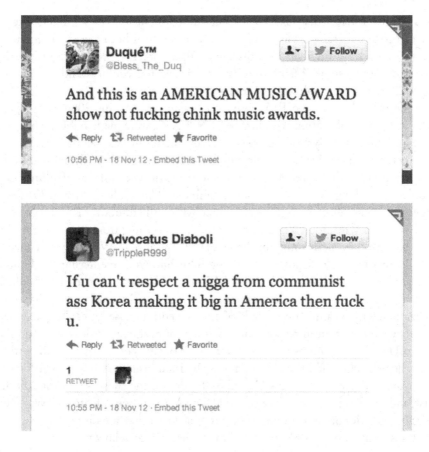

Source: Binder, M. (2012, November 19). Oppa Gangnam racist style? [Blog post]. Retrieved from
http://publicshaming.tumblr.com/post/36049416072/oppa-gangnam-racist-style-south-korean-pop-star

Despite the fact that the event included performances from British boy band group The Wanted and Canadians[5] Justin Bieber and Carly Rae Jepsen, as well as nominations of non-Americans such as Rihanna, Gotye, Shakira, Don Omar, Calvin Harris, Skrillex, David Guetta, Adele, and One Direction, the vitriol directed at PSY, and by extension Koreans, highlights the tenuous positioning of Asians/Americans in the United States. Even the one tweet in support of PSY's performance confuses the Republic of Korea (South Korea) with its communist and isolated neighbor, the Democratic People's Republic of Korea (North Korea). Though user @emnohpets uses a slur to racialize PSY and accuses him of not making "American music," there is no criticism of performance collaborator MC Hammer. So while there is recognition that "American" does not exclude people of color necessarily, such recognition stops short of the inclusion of Asian/Americans.

This "forever foreign" discourse treats Asian and American as two mutually exclusive categories, literally erasing Asian Americans out of both the music industry and the nation. Additionally, this discourse encapsulates the tension between the desire to possess some Asian/American exoticism and coolness and the fear of impending orientalist cultural imperialism.

The racist backlash to PSY continued when lyrics to his 2004 song "Dear American," a collaboration with boy band N.E.X.T., were made public. The general translation of the lyrics, one repeated across media outlets, was that the Yankee torturers of Iraqi captives and their families should be killed slowly and painfully. Other translations interpreted the lyrics as accusing the U.S. military of killing Iraqi families, not calling for the killing of the families of U.S. soldiers (Fisher, 2012)—a hugely important discrepancy, one subsumed within the furor over PSY's "obvious" "anti-American" leanings. The furor resulted in everything from petitions for him to be banned from performing in the annual "Christmas in Washington" concert, to calls for Obama to deport him and prohibit him from reentering the United States, to extremist comments that PSY himself should be tortured and killed. Missing in the uproar and flurry of news coverage was the much-needed contextualization, which came only after PSY apologized for those lyrics. He explained that they were written in response to a number of events, including the acquittal of two U.S. Army soldiers who ran over two Korean schoolgirls in 2002 with a tank, the beheading of a Korean missionary by Iraqi insurgents angry over Korea's deployment of troops to aid the United States during the latest war in the Middle East, and the continued presence of the U.S. military in South Korea. It was when news of his lyrics became ammunition for a backlash that the discursive tangents and uncertainty around PSY coalesced more clearly into yellow peril 2.0.

RESISTANCE AND SUBVERSION

Before PSY's rise to the top of the charts, the last Asian/American to achieve a similar level of visibility musically was *American Idol* contestant William Hung. It is not a coincidence that the viral success of both men was and is predicated on narratives of anti-sexuality and buffoonery. I think it unfair to root the virality of "Gangnam Style" solely within the simplistic and reductive thought that everyone was sharing it because it embodied hegemonic stereotypes of Asianness, and thus deriving pleasure and page/video views (though undoubtedly that was the case for many people spreading the video). Additionally, it stands to reason that many of the people sharing the video were doing so because they were a part of the communities and networks that recognized themselves in this piece of popular media. Furthermore, while Hung was competing on a U.S. show for an opportunity to perform for an U.S. audience, PSY's "Gangnam Style" was not intended for U.S. consumption, so its popularity in

the United States was a surprise. PSY does not mangle the English words in his song as Hung did during his cover of Ricky Martin's "She Bangs." Neither is the video itself more comical or absurd than a great many U.S.-produced music videos. Since he intended to satirize conspicuous consumption and class politics in Korea and his entire career is premised on his being the antithesis to acceptable versions of masculinity, attractiveness, topic materials, and pop stardom, I argue that reducing PSY to comic relief misses the chance to also see him an as agent of resistance and possibility.

Linking the yellow peril 2.0 discourses with the fear of Asian/American technocultural domination and the shareability of "Gangnam Style" allows for the acknowledgment that PSY gained success without having to assimilate to Western norms and ideologies. By relishing and deploying his unassimilability as a self-aware mechanism to bring about global success and market viability, we see his refusal to move from margin to center. His visibility and popularity was a challenge to a Western-dominated entertainment hierarchy. Furthermore, the ability of the song to move through borders, whether around nations or cultural groups, also suggests that he is adding to audience/consumer understandings of Asian/American masculinity. I refuse to call his masculinity flawed because that presumes a tangible loss of power and privilege. Instead, PSY and "Gangnam Style" have managed to tap into a narrative of alternative masculinity, one in which the nerds have finally gotten their revenge. If memes are a function of ideas that are replicable, then the memetic function of the "Gangnam Style" video enables others to participate in spreading a counter-hegemonic version of Asian/American masculinity globally, and that is, at the least, an act of resistance against dominant ideologies.

CONCLUSION

Virility, or the fear of Asian/American domination, as I am using it here, and the literal replacement of Whiteness as the benchmark for popularity and talent resulted in an explosion of both overt and implicit racist rhetoric in response to PSY and "Gangnam Style." The hostility toward Asians/Americans, especially as demographers attempt to pit Asian and Latino/Latina immigrants against each other in a race to be named the fastest growing immigrant group, continues to constrain and determine the discursive articulations of Asian/American experiences and representations. If participatory culture deems videos as something more than just messages—as "mediating mechanisms via which cultural practices are originated, adopted and (sometimes) retained" (Burgess, 2008)—then "Gangnam Style" gains more value as it is reworked and redistributed. "Gangnam Style" becomes a piece of spreadable media "gaining ever increasing resonance in culture and taking on new meanings, finding new audiences, attracting new markets and generating new values" (Jenkins, 2007) and sometimes by reiterating things that were already there. Much of the value in

reworking PSY and his hit "Gangnam Style" is that it results in the creation of for some and the supporting for others of a different kind of Asian/American masculinity.

NOTES

1. These commercials have previously featured stars from the reality television show *Jersey Shore*, Secret Service agents, meme favorites such as the Honey Badger and keyboard cat, Bart and Homer Simpson, and about 15 other pop-culture stars.
2. *I feel asexual* does not adequately or accurately describe what is happening around sexuality and Asian/American men (or at least hegemonic understandings of sexuality). Asexual presumes the person is not sexually interested in any other body, not that people are not sexually interested in him.
3. As per discussions of nuclear warfare in the Middle East and North Korea.
4. Any discourse on the markets of especially East Asian countries, outsourcing of jobs to South and Southeast Asian countries, and the ownership of U.S. debt by China.
5. Who I realize are Americans, but they are not from the United States, which I think is a fair reading of what these Twitter users meant in their tweets.

REFERENCES

Barry, R. (2012, December 18). Gangnam Style & how the world woke up to the genius of K-pop [Blog post]. Retrieved from http://thequietus.com/articles/11001-PSY-gangnam-style-k-pop

Baym, N., & Burnett, R. (2009). Amateur experts: International fan labor in Swedish independent music. *International Journal of Cultural Studies 12*(5), 433–449.

Binder, M. (2012, November 19). Oppa Gangnam racist style? [Blog post]. Retrieved from http://publicshaming.tumblr.com/post/36049416072/oppa-gangnam-racist-style-south-korean-pop-star

Burgess, J. E. (2008). "All your chocolate rain are belong to us?" Viral video, YouTube and the dynamics of participatory culture. In G. Lovink & S. Niederer (Eds.), *Video vortex reader: Responses to YouTube* (pp. 101–109). Amsterdam: Institute of Network Cultures. Retrieved from http://eprints.qut.edu.au/18431/

Considine, A. (2011, July 29). For Asian-American stars, many web fans. *New York Times*. Retrieved from http://www.nytimes.com/2011/07/31/fashion/for-asian-stars-many-web-fans.html?&_r=0

D'Orazio, D. (2014). "Gangnam Style" hits 2 billion YouTube views [Blog post]. Retrieved from http://www.theverge.com/2014/5/31/5767162/gangnam-style-2-billion-YouTube-views

Feldman, J. (2012). PSY is still performing at the White House, despite outrage over anti-American song [Blog post]. Retrieved from http://www.mediaite.com/online/PSY-is-still-performing-at-the-white-house-despite-outrage-over-anti-american-song/

Fisher, M. (2012, December 11). Controversy over Psy's anti-American lyrics might be based on shoddy translation [Blog post]. Retrieved from http://www.washingtonpost.com/blogs/worldviews/wp/2012/12/11/controversy-over-psys-anti-american-lyrics-might-be-based-on-shoddy-translation/

Greenberg, C. (2013). Best Super Bowl commercials 2013: Clydesdale ad, Tide "Stain," Chrysler message, Mercedes score. *Huffington Post.* Retrieved from http://www.huffingtonpost. com/2013/02/04/best-super-bowl-commercials-2013_n_2614392.html

Grossberg, L. (1992). *We gotta get out of this place.* New York: Routledge.

Gruger, W. (2012). PSY's "Gangnam Style" hits 1 billion views on YouTube [Blog post]. Retrieved from http://www.billboard.com/articles/columns/k-town/1481275/psys-gangnam-style-hits-1-billion-views-on-youtube

Harbison, C. (2012). PSY's "Gangnam Style" on SNL rerun tonight! Watch it here along with the best "Gangnam" clips [Blog post]. Retrieved from http://www.idigitaltimes.com/psys-gangnam-style-snl-rerun-tonight-watch-it-here-along-best-gangnam-clips-video-341189

Hsu, H. (2012, September 24). Why Psy's "Gangnam Style" is a hit with listeners who've never heard of K-pop [Blog post]. Retrieved from http://www.vulture.com/2012/09/psys-k-pop-crossover.html

Jenkins, H. (2006). *Convergence culture: Where old and new media collide.* New York: New York University Press.

Jenkins, H. (2007). Slash me, mash me, spread me…[Blog post]. Retrieved from http://henryjenkins. org/2007/04/slash_me_mash_me_but_please_sp.html

Jimmy Kimmel Live. (2014, June 8). *Psy, Snoop Dogg & Jimmy Kimmel karaoke* [Video file]. Retrieved from https://www.youtube.com/watch?v=LryZmYnjVkc

Kwon, K. J., & Mullen, J. (2012, September 20). North Korean video evokes "Gangnam Style" to taunt South Korean candidate [Blog post]. Retrieved from http://www.cnn.com/2012/09/20/ world/asia/north-korea-gangnam-video/

Locker, M. (2012). Watch: PSY brings "Gangnam Style" to Dodger Stadium [Blog post]. Retrieved from http://newsfeed.time.com/2012/08/22/watch-PSY-gangnam-style-dodger-stadium/

Park, J. C. H. (2010). *Yellow future: Oriental style in Hollywood cinema.* Minneapolis: University of Minnesota Press.

Pomicter, R. (2013, February 1). *US Navy and Marines in Afghanistan Gangnam Style parody* [Video file]. Retrieved from http://www.Youtube.com/watch?v=Wt7pevIvCbQ

Shifman, L. (2011). An anatomy of a YouTube meme. *New Media & Society, 14*(2), 187–203.

Steinberg, B. (2013, February 1). Who bought what in Super Bowl 2012. *Advertising Agency & Marketing Industry News–Advertising Age.* Retrieved from http://adage.com/article/spe cial-report-super-bowl/buying-super-bowl-2013/238489/

Takahashi, C. (Writer, reporter). (2011, January 26). In a small corner of the web, a star is born. In NPR, *All Things Considered.* Retrieved from http://www.npr.org/2011/01/26/133218168/in-a-small-corner-of-YouTube-a-web-star-is-born

TheEllenShow. (2012, September 10). *Surprise! Britney learns "Gangnam Style" from Psy!* [Video file]. Retrieved from https://www.youtube.com/watch?v=QZmkU5Pg1sw

Van Dijk, J. (2009). Users like you? Theorizing agency in user-generated content. *Media, Culture and Society, 31*(1), 41–51.

Yang, J. (2012, August 28). Gangnam Style's U.S. popularity has Koreans puzzled, gratified [Blog post]. Retrieved from http://blogs.wsj.com/speakeasy/2012/08/28/gangnam-style-viral-popu larity-in-u-s-has-koreans-puzzled-gratified/

Signifyin', Bitching, and Blogging: Black Women AND Resistance Discourse Online

CATHERINE KNIGHT STEELE

INTRODUCTION

Much of the early research on the Internet, particularly the blogosphere, centered the experiences of Western White men. There is increasingly an interest in discovering how marginalized groups may use blogs to further their own participation in the democratic process. Previous literature has examined the use of online media by non-dominant groups; however, the lens used for this examination is that of the dominant culture. The use of new media technology by groups that have traditionally been kept out of the public sphere requires an epistemology that allows for diverse ways of understanding the production of knowledge and meaning-making. A Black feminist epistemology centralizes the conversations of Black women that occur in settings that are often excluded as valid by academic researchers. This study seeks to examine the online gossip of Black women for its potential to contribute to a discourse of resistance. Audre Lorde (1984) writes that Black female writers manage "the external manifestations of racism and sexism with the results of those distortions internalized within our consciousness of ourselves and one another" (p. 147). Using a typology crafted from Patricia Hill Collins's (2002) model of the "matrix of domination," this study examines Black celebrity gossip blogs and the ways in which they resist or tolerate oppression at three levels: the personal, the communal, and the institutional. The analysis suggests that Black

women use these blogs to "talk back" (hooks, 1988) to the systems and structures from which they are excluded or within which they are exploited.

As a group, African American women exist in a unique position between multiple systems of oppression. This has traditionally placed the group, and discourse within the group, outside of the confines of scientific knowledge production. Therefore, it is important to explore blogs as sites where Black women interrogate the intersectionality of race and gender from a Black feminist perspective. Exclusion from the public discourse has led many marginalized groups to find alternate way to sustain themselves as a community and engage in democratic society. As new media technology expands, it is increasingly important that research takes into account the perspectives of the media users/producers being studied and the interconnectedness between online and offline spaces (Baym, 2009).

Communication research frequently explores the uses of blogs in self-expression, activism, and political organization. However, the research fails to directly address how Black women use blogs in ways that differ from the dominant culture. A Black feminist epistemology allows for an interrogation of how bloggers and their communities resist dominant discourse and offers validation for personal ways of knowing and writing, narrative, and dialogue rather than debate, validation of emotion, and personal accountability. This analysis accounts for the ways in which participating in community conversations functions as an act of resistance, even when overt political motivations and advocacy are not the primary goal. Black gossip blogs are examined using a discourse analysis, which evaluates the blogs for the ways they combat multiple levels of oppression, including the personal, the communal, and the institutional (P. H. Collins, 2000). The previous literature in the fields of communication and sociology on blogging, gossip, and African American feminist thought inform this study.

BLOGGING THE SOCIAL AND POLITICAL

African American users of online media commonly seek out community-specific content (Detlefsen, 2004; Harris, 2005; Wilson et al., 2006). African American political blogs mobilize these readers around particular political causes and issues (Byrne, 2007; Pole, 2010). Community building, especially as it relates to activism, is a tool used by bloggers to voice dissent against the political landscape, organizations, and societal institutions. Activism on the part of bloggers is revolutionary because it creates new oppositional spaces that transform everyday life and discourse (Kahn & Kellner, 2004). In these spaces, promotion of normative discourses of domination may still exist. While they exist as "contested terrain," blogs still include voices outside of the mainstream (Ekdale, Namkoong, Fung, & Perlmutter, 2010, p. 94).

While political blogs certainly act as organizing tools for communities, including marginalized groups, these groups often organize and create dialogue in spaces outside of what may be traditionally expected. Whether or not authors of blogs and their participants view their participation as political in nature, their actions may still involve resisting dominant ideology (Scott, 1990). In this sense, they function similarly to overtly political blogs, which, Farrell and Drezner (2008) explain, "frame political debates and create focal points for the media as a whole." This study uses gossip sites as sources of both intentional and unintentional subversive resistance to dominant discourse and ideology. In this context, a community can meet together and discuss and challenge oppression, both through their writing and through their existence outside of the control of popular media.

THE SOCIAL AND SUBVERSIVE USES OF GOSSIP

While gossip as a communicative practice has a history as long as human communication itself, new media technology provides a new space for exploration. Gossip is a form of cultural capital that affords those "in the loop" knowledge that contributes to power and status. Gossip manages the group identity and provides a social space for women to negotiate femininity. Celebrity gossip in particular serves to strengthen bonds and manage female relationships, but it also represents a subversive participatory act by women (Ayim, 1993; L. Collins, 1993). Because celebrity gossip is not specifically about anyone within the participant's social circle, the fear of disparagement is avoided and instead is replaced with discourse that is unifying. As Feasey (2008) explains, "The latest gossip [is] understood as, and deliberately coveted because, it act[s] as a point of conversation among young women. It [is] as if an understanding of celebrity 'trivia' served as a connection between women, with readers being united by an appreciation of a particular media text" (p. 691). While Feasey discusses readers' use of gossip magazines, the use of gossip blogs holds the same possibility for communal sharing of knowledge and for management of relationships online.

Recent research on celebrity gossip blogs discusses celebrity gossip as malicious discourse (Fairclough, 2009) or a resurgence of old practices of journalism (Meyers, 2009). This research excludes African American women's engagement in this activity and fails to note that their participation may differ from that of groups with greater inclusion in dominant American culture. This online space provides the opportunity for feedback from readers and important communal work. In the case of Black female gossip blogs, the online space may serve as a site of unification for a group of women who may otherwise be separated by geography or socioeconomic status. Since gossip has been historically linked to women, it is often assumed to be a trivial communicative act. On the contrary, gossip can function

as a subversive practice by marginalized groups (Chidgey, Payne, & Zolb, 2009; Wickham, 1998). Gossip has often been crucial to the active resistance of domination and oppression.

BLACK FEMINIST EPISTEMOLOGY

Black feminism was developed to call attention to the multiple oppressions experienced by women of color, to reflect their real-life experiences, and to enable them to define themselves in their own terms. White feminism traditionally has focused on gender oppression while ignoring issues of race, class, and sexuality (hooks, 1981; Ortega, 2006). Out of resistance to this marginalization, Black feminism and "womanism" were forged. The experiences of Black women and their unique processes of knowledge distribution through personal and mediated communication often go unexplored by researchers. The exclusion of the tradition of Black female intellectualism is not coincidental, but rather part of a complex system of oppression (P. H. Collins, 2000). Black feminist epistemology then requires scholars to grapple with ways of knowing that often fall outside of dominant societal constraints (Anderson & Collins, 1992). As womanist anthropologist Linda Thomas (1998) explains:

> Reconstructing knowledge means tearing down myths that have paralyzed communities, and recreating truths which have been buried in annals that contain vast sources of knowledge.... Inclusive construction of knowledge denotes exploring sources that culturally may be vastly different from our own epistemological points of departure. It may be knowledge based on human experience as well as theory; and it decidedly involves inclusion of the ideas, theories, orientations, experiences, and worldviews of persons and groups who have previously been excluded. (p. 496)

Such research calls on scholars to reexamine ideas of intellectualism and conceive of Black women as doing the work of intellectuals who have historically been forced outside the world of academia. Black women's writings and behaviors are philosophical statements that are both scholarly and activist in nature (P. H. Collins, 2000, p. 15). The actions of Black women that actively challenge dominant discourse serve as a means of resistance to oppression.

Previous research insists that for an action to be considered resistant it must include both action and opposition (Hollander & Einwohner, 2004). Weitz (2001) defines resistance as including "actions that not only reject subordination but do so by challenging the ideologies that support that subordination" (p. 670). As she explains, resistance should be done in public, by the collective and within sight of the powerful. Patricia Hill Collins (2000) clarifies: Racism has created separate communal structure for African Americans, within which a culture of resistance may exist apart

from the dominant structure (p. 226). This asks us to see oppression and resistance operating at multiple levels in a "both/and," rather than "either/or," manner. Groups may simultaneously experience oppression and engage in resistance discourse. Often this culture of resistance does not appear to pose a direct threat to the dominant group, as the spaces in which marginalized groups congregate are often segregated from public view. We must consider the activity of blogging, as well as the decision to read and comment on another's blog, as action in this context. This analysis focuses on the hidden spaces outside of the purview of the dominant group in which Black women congregate. This study examines blogs as a new media technology, one with which Black women may engage discourse that challenges the common narratives about Black women, Black men, and the Black community.

METHOD OF ANALYSIS

This discourse analysis examines the content of two popular celebrity gossip blogs that were established by and are written by Black female authors: The Young, Black, and Fabulous (theybf.com), started by Natasha Eubanks; and Necole Bitchie (NecoleBitchie.com), founded by Necole Kane. Both authors remain the primary contributors to the blogs. Each was selected for its popularity and the press it has received within Black media outlets. NecoleBitchie.com was rated in the Top 10 Urban Blogs on the Internet by Electronic Villager blog rankings and was nominated Best New Blog and Best Gossip Blog by the 2008 and 2010 Black Weblog Awards (Kane, n.d.). TheYBF boasts more than 13 million readers a month and describes itself as the "perfect mix of gossip, entertainment, and swagger" (Eubanks, n.d.). The blog's founder has also been selected as a "blogger you should know" by TheRoot.com (Whigham, 2011).

Discourse analysis offers an examination of texts or language in concordance with the thematic structure of the text and speech (Fairclough, 1995). The purpose of discourse analysis is to study texts "not only as form, meaning, and mental process, but also as complex structures and hierarchies of interaction and social practice and their functions in context, society and culture" (van Dijk, 1997). A careful analysis of the deployment of language and image is possible. This method of inquiry points toward an understanding of complex structure and hierarchies of interaction and social practice (van Dijk, 1997).

Using a typology crafted from what Patricia Hill Collins (2000) calls the "matrix of domination" of African American women, this study examines resistance and oppression at three levels. Within the everyday talk of Black women on celebrity gossip blogs, personal, communal, and institutional oppression and resistance are explored. This research uses the model of the matrix of domination as a means of explaining the oppression experienced and resistance enacted by women of color.

Personal/Individual

Each individual possesses a personal biography that holds within it all of the narratives, experiences, and identities that construct the unified whole. For Black women, this may include race, gender, class, sexuality, etc. Because of the unique experiences and motivations of the individual, circumstances may be understood and internalized differently. Thus, each personal biography is unique and recognizes the agency of the individual, seeing the individual body as both an object of, and agent in, social practice. At the personal level, the individual practices self-definition as the first puzzle piece in forming a cohesive resistance discourse for the collective. However, the power of these individual acts of resistance should not be understood as being of lesser importance than the work done by the community. As Patricia Hill Collins (2000) reminds us, "Black feminist thought speaks to the importance African American women thinkers place on consciousness as a sphere of freedom" (p. 227). If the individual has the power to restructure her own biography and, in essence, free herself from the dominant narrative, she has in fact resisted oppression at the personal level. Blogging may provide the space for Black women to participate in the retelling of personal narrative and restructuring of individual stories.

Communal/Cultural

Blogging also acts as a means of learning on the part of the cultural group and creates a shared sense of meaning through collective action. This level is particularly powerful, as community ideology can become infiltrated by dominant ideology that works to oppress Black women from within. The power to control and dominate a group from within has been explored by Fanon (1963) and Woodson (1933). While these authors explore the oppression of people of color at the communal level in brilliant ways, Patricia Hill Collins (2000) complicates this literature by expressing the unique capacity of African American women to be communally oppressed at both racial and gender levels. Communal resistance by African American women exists in the *relationships* formed where experiences are both validated and challenged in the larger system of oppression.

Institutional

While Jim Crow racism was rooted in biologically based notions of inferiority of certain races, and usually overtly expressed by the public, Bonilla-Silva (2006) explains that covert behaviors and words are now used to reinforce discrimination, segregation, and inequality at an institutional level. Oppression at the institutional levels marginalizes the lives of Black women in spaces that could and should be

used for empowerment, such as schools, churches, media, and other formal organizations (P. H. Collins, 2000, p. 228). Black women have historically produced, and continue to produce, work that challenges the hegemonic order and provides critique within these institutions. Resistance of such institutions is inherently political in nature, as it seeks to undermine the dominant legal or social structures that keep racism and sexism intact. Themes that emerge at each level are explored for their potential to resist oppression and/or reify systems of domination and control.

The data were collected over a six-month period in 2011. This period was selected as each of the blogs began shifting to an advertiser-driven model, which increased page views and comments in 2011. Original posted content was archived, which included pictures and text posted on the main blog page, as well as content links provided in the text. Links included archived content categorized by topic. On each site, reader comments were totaled at the bottom of each blog entry. Comments were considered and explored for common themes that emerged and were analyzed with the bounds of the typology presented above. The architectural structure of sites was considered along with frequency, type, and distribution of advertising content. Each site was updated with new blog posts with an average frequency of 5–6 times per day, for a total of 300–500 posts per site and more than 3,000 reader comments. Blog posts ranged in length from 100 to 600 words. Every post contained visual imagery or video, most often depicting a celebrity. Emergent themes at each level of oppression as outlined by Patricia Hill Collins (2000) are explored.

The Individual—Stepping in and out of the Feminist Box

Oppression at the individual level limits self-definition. Resistance discourse at this level contrasts dominant discourse about Black women with personal narratives and rejects negative labeling and oppressive representations. Bloggers writing for Necole Bitchie and TheYBF use the celebrity's words to clarify media rumors or negative press. Posts such as "Jennifer Hudson clears up rumors" or "Halle Berry says she's not the marrying kind" include the voice of Black women discussing their careers and relationships from their own perspectives, often shunning public opinion. Necole Bitchie begins an April 18, 2011, post about Halle Berry with a photo of the actress and her boyfriend Olivier Martinez (Kane, 2011a). Blogger Necole writes five lines to contextualize the photo and offers this lead: "Halle recently revealed that the traditional form of marriage is not for her, and she won't be getting married again." An extended quotation from the star herself follows. Berry explains her distrust of marriage based on past experience and her childhood relationship with her father. She states:

> "I WISH I had known then that I was not the marrying kind. It would have saved me a
> lot of time, heartache and grief over the years. I made all the wrong choices when it came

to love. I have been an idiot. But, now, it is like a gift to myself—seeing more clearly and making better decisions. One thing was unavoidable. My father left us when I was young and that did affect my life. If I had a good father in my life, growing up, then I do not think I would have made the mistakes I made. I would not have been lost in love. I would have had a good role model and known what to look for. As it is, I had to find out about marriage from the men I've married. I have done it twice and I am not going to do it again. The traditional form of marriage is not for me."

Blogger Necole follows this quotation with another from Oprah Winfrey, who also resists normative ideas of marriage. The post wraps with "Interesting. I guess marriage isn't for everybody." This open ended and nonjudgmental conclusion allows for Berry and Winfrey's words to stand on their own as the discussion is opened up to the community. The use of personal narrative combats dominant discourse and provides the opportunity for Black women to use their own voices in resistance of marginalization.

Self-definition on the part of Black women is a political tool used as the first means of combating oppression. Self-definition on the blogs is not limited to celebrities only. The founder of NecoleBitchie.com is prominently featured in pictures on the site and is self-referential in her posts. Necole explains in her "contact" page:

> This is a blog site, not a news site. All posts are based on **my opinions and thoughts** on what may already be reported in the media. I am not a journalist nor do I aspire to be. I am a blogger who created this site as a hobby. And yes, I am bias. I only report on artists/celebrities that I like or find interesting. Thanx—Necole (NecoleBitchie.com; emphasis in original text)

The acknowledgment of subjectivity provides the opportunity for both the blog's author and its readers to create and articulate meaning for themselves outside of the constraints of mainstream media. Each post is signed "by Necole Bitchie," again demonstrating the voice of the author. Following each post, a link to reader comments is represented by the number of people posting replies and the word *bitching*, for example, "75 people bitching." The tie-in of the word *bitching* links the author and readers, giving each a unique and equivalent voice on the site. In this way the readers participate in storytelling by crafting their own narratives. Guendouzi (2001) explains that even in the midst of cooperation and collaboration in gossiping behaviors, bitching is "underpinned by a need to discursively claim symbolic capital through competition for socially acceptable images of femininity" (p. 29). While "bitching" online is sometimes considered defamatory in nature (Rowland, 2006), it must also be considered as "talking and gazing back at popular culture…in this case a valued/valuable feminist act" (Bailey, 2003).

Acts of self-definition and individual resistance on the part of the bloggers, commenters, and celebrities emerge along two themes: beauty and mothering.

Beauty

While research demonstrates the cultural relativity of beauty, Western concep-
tions of beauty permeate American media content and are often internalized
by sub-cultures in the United States. Posts and discussions of beauty on both
sites focus on fashion, hair, and makeup. Singer/songwriter Solange receives
praise from authors on both sites for deviating from traditional fashion attire
and her decision to remove hair weaves and "go natural." Celebrity decisions
to show their natural, unprocessed hair occurred with some frequency. Posted
April 23, 2011, blogger Natasha writing for TheYBF highlights actress Gabri-
elle Union's Twitpic of her hair without hair extensions or chemical relaxers with
the headline: "SHE IS NOT HER HAIR: Gabby Union Shows Off Her Nat-
ural Un-Relaxed, Un-Weaved Hair" (Eubanks, 2011). Union's original tweet,
which reads, "All done...I've been reunited with my scalp...and it feels soooo
good (peaches and herb voice). No weave, no relaxer, no hot comb," follows the
picture. Commenters went on to both support Union by comparing their own
hair journey with hers and to cast doubt upon the validity of her claim that this
was her hair in its natural state. Commenter kaydub says, "she probably didn't
relax it during this beauty visit...but Gabby is relaxed, her hair texture is like
the average blk person...coarse. When Jill Scott says she's natural it's believable
because we've seen her with natural curly or kinky hair...since Gabby's been
in Hollyweird her hair has been str8...maybe styled real nice w/ a curling iron
but she's relaxed & there's nothing wrong w/ that but she's def not natural." An
anonymous commenter responds, "That look can be obtained without chemicals
as I do it every week when I get my hair done! I havent used a relaxer in almost
2 years. However, to achieve the straight look, my beautician has some FLAT
IRONS that are THE TRUTH!! They will straighten the GAYEST MAN!!
LMAO, but seriously, her hair not chemically relaxed, if you a thing or two
about HAIR, you could see that! She still a 10 with or without weave and SHE
DATES DWADE, GO GABBY!! Lol."

The comments quickly turn to the significance of hair in representing Black
identity. Another anonymous commenter explains, "Now see this is sad (no[t]
the post, great post) when a person showing their own hair is news...lol. I'm a
natural sistah rocking it short and curly but now letting it grow out. It's so liber-
ating. Not knocking weaves or wigs or braids, they have their place, but take so
much work and money to maintain. Natural hair needs maintenance too, but to
me, is much preferable." This community explores the broader implications of
"going natural" and has a debate about the lingering desire for chemically relaxed
hair by many in the community. The initial blog did not offer an opinion regard-
ing the debate, which does not give insight into blogger Natasha's perspective.
However, the site often features Carol's Daughter, a beauty line exclusively for

women of color that promotes natural hair, in posts. Advertisements for the product line can also be found on the site. These posts signal resistance in their use of personal narrative to define beauty by the individual.

Mothering

Personal narratives regarding Black mothering are another salient theme in the blog posts. In the dominant media landscape, professional women, including celebrities, are often judged and/or castigated for failing to adhere to social norms regarding mothering. Blogs written by and for African American women provide the space to discuss mothering within a communal context but with implications for the individual. Mothers are discussed in a variety of contexts; however, personal narrative is used primarily to explain how mothering affects a female celebrity's success or failure. Mothers of celebrities are discussed in relation to the success of their children. Women bearing children of celebrities are given a voice on the sites. In the dominant media landscape, often these women are relegated to stereotypic depictions of "baby mommas" with little attention or respect given to their own personal endeavors. Both NecoleBitchie. com and TheYBF make a point of telling the personal stories of these individuals. NecoleBitchie frequently features interviews with Toya Carter, the ex-wife of rapper Lil' Wayne. Under the section heading "On holding her own," one blog post features this quote: "People thought Tiny and I were going to do a baby momma show. They only knew that I was married to Lil Wayne. But once we did season 2, they knew more about me. My life has changed, and I'm more in the public's eye. I hear from people who are inspired by my story." This use of personal narrative reverses the dominant script, giving agency to the individual and promoting resistance to the oppressive nature of having one's identity fashioned by others.

The Communal—Re-centering Black Relationships

Communal/cultural oppression is most damaging for its ability to operate from within. Resistance to this form of oppression for Black women becomes possible through the nurturing of relationships and through challenges to popular myths and stereotypes about the relationships between African Americans. Each of the blogs has recurring themes of representing positive relationships of Black women with each other and with Black men. When reporting on issues of violence within the community the authors frequently take an overt stand against such actions. However, as is often the case, oppression is often internalized and rearticulated in Black women's writing as well.

The Black Male Hero

Hegemonic masculinity is a pattern of practice that allows men to dominate women. It is not a personality trait of certain men, but a way of normalizing gender stratification through institutions, culture, and interpersonal dialogue (Connell & Messerschmidt, 2005). Even those not enacting hegemonic masculinity per se are often still complicit in its existence. Both blogs have frequent posts that celebrate the mythical Black male hero. The prototype celebrated on the sites is often one that holds fast to the patterns of hegemonic masculinity. This is particularly true in terms of the physical appearances of Black men in photos. Male athletes and entertainers are pictured with minimal clothing and their sexual exploits are described in entertaining and favorable ways. Men like former professional athlete Eric Williams are given a pass for violent and aggressive behavior. Williams's ex-wife, featured on the reality show *Basketball Wives*, often complained on the show about her husband's aggressive behaviors. Much of this critique was met with skepticism from blogger Necole and her followers. Following an on-air incident where Eric Williams throws a glass at his then wife, she appears to subtly change her view (Bitchie Staff, 2011b). She writes, "Basketball Wives fans really don't like Eric Williams, and I could see why but I always gave him the benefit of the doubt. On the show, it appeared as though he was hurt by his failed relationship with Jennifer Williams but just didn't know how to express it in the right way. Of course, that perspective changed on Monday night." In this post from August 3, 2011, she showcases a picture of the violent act and a link to the full video. Offering a tempered critique, she concludes by stating, "I'm more than convinced he was neglected as a child. Sad."

Clinging to a hegemonic representation of masculinity creates an archetype of a Black male hero. Black men are frequently disparaged in the mass media in ways that challenge traditional notions of masculinity (status, wealth, employment). Celebrated representations of hegemonic masculinity emerge as a way to validate Black men in the larger cultural context. This validation comes at the expense of the protection of Black women, as witnessed in the above example. Therefore, while acting to resist mainstream stereotypes of a lazy, irresponsible Black man that date back to the antebellum South, the creation of the Black male hero works against the safety and security of Black women. The patriarchal narrative of masculinity does not give the freedom to Black men to be fully formed and emotionally responsible beings.

Sister Friends

A frequent recurring post on Necole Bitchie is "Bitchie or Not," wherein a Black celebrity is featured. The celebrity's wardrobe is up for review by the community who determines at large whether the community approves. A similar recurring post is "Who owned the look." This post is similar in type to TheYBF's "Who ran

it?" in which two celebrities (almost always women) are shown wearing the same or similar attire and the readers determine the celebrity who wore it best. While this is similar to mainstream celebrity sites, the tone and tenor of reader responses are an interesting indicator of the use of the sites to provide communal sharing. On both sites, the authors provide an array of pictures with captions including the celebrity's name, a description of the outfit in full, and the location where the picture was taken. Readers were always divided on who should "win the contest." In the comments section following these "battles," a secondary battle emerges among readers. These battles are ones of wit and humor and can be closely tied to signification, a common practice in Black oral culture.

The term *signifyin(g)* in popular English vernacular (usually pronounced and sometimes spelled *signifyin'*) refers to denotation of meaning through the use of a sign or word. Within the African American community the term generally refers to a contest in which the most imaginative user of indirection, irony, and insult wins (Lee, 1993). Bell (1987) defines it as an elaborate, indirect form of goading or insult that generally makes use of profanity, while Gates (1999) quotes Abrahams's explanation of signifyin(g) as "implying, goading, or boasting by indirect verbal or gestural means." Gates (1989) explains that signification happens in two forms: oppositional (or motivated) and cooperative (or unmotivated). Signifyin(g) "functions as a metaphor for formal revision, or intertextuality, within the Afro-American literary tradition." In this context, authors reuse motifs from previous works but alter them and "signify" upon them so as to create their own meanings. Signifyin(g) is not only a possible form of expression for African Americans, but a necessary tool used to manage identity and community. Therefore, it must be acknowledged in this context, rather than as a lesser form of language use (Lee, 1993, p. 11).

Women tend to use more indirect means of signifyin(g), avoiding more direct means of confrontations (Abrahams, 1976; Garner & Calloway-Thomas, 2003). In an unsigned post from February 2011, YBF bloggers post pictures of singers Nicki Minaj and Keri Hilson both wearing extravagant leopard prints (_YBF, 2011a). After describing the garments, who designed each, and the occasions on which each were worn, the author opens the conversation with "Who ran it?" The community sometimes responds with a brief vote for one or the other, for example, "Keri Hilson Killed this look" and "I love you nicki but keri definitely got this." Others use this as an occasion to offer more commentary on Minaj more broadly. Blog community member "Tropicana" says, "Somebody shoulda came in a egg!" An anonymous poster chimes in "Sigh. Is the cartoon character even IN the running?" referencing the view that Minaj is commonly over-the-top and not to be taken seriously. Two other commenters compare the dresses to Halloween costumes while one likens Minaj to a gender-ambiguous Chris Tucker character from the sci-fi film *The Fifth Element*. Few commenters are direct. Instead, subtle

jabs are more common and demonstrate the communal sharing component of signifyin(g). The ability to signify must be paired with a sense of familiarity between parties. Signifyin(g) is done among the familiar and only within the confines of the community. Outside of this context, the same discourse becomes malicious. The use of signifyin(g) in celebrity gossip must be situated contextually or the behavior may be misunderstood.

Black Love Relationships

A recurring theme on both blogs regards the romantic relationships between Black celebrities. In cases where Black men are involved in intra-racial relationships, blog posts tend to be more positive in tone and frequent in occurrence. Discussion of these relationships often begins with the use of the husband's surname. For examples, entertainers Jay-Z and Beyoncé are often discussed as "The Carters" on TheYBF. The deference to patrilineage is simultaneously resistant of and compliant with the hegemonic order. Celebrating Beyoncé as a "proper wife" combats the narrative of Black women's promiscuity and lack of suitability as mates for Black men. The use of "Mrs. Carter" (subsequently adopted by Beyoncé herself in promoting her brand) also shows the desire to replace the imagery of absentee Black men that permeates mainstream media. In attempting to craft the marriage of these two celebrities as a model, the bloggers and community also participate in reifying heteronormativity and patriarchy.

Both blogs follow the relationship of NBA player Carmelo Anthony and longtime girlfriend (now wife) LaLa. Their wedding and subsequent move to New York received multiple blog postings over the period of three weeks. Posts showing LaLa cheering on the sidelines of NBA games appear at least once a week. Coverage of the relationships of Kim and Khloe Kardashian, sisters who have both dated (or married) Black male athletes/entertainers, do not evoke the same celebratory tone. Stories on the sisters included mockery of their musical endeavors and ridicule of their fashions and appearances. Black women as a group have the most negative views of interracial pairings between Black men and White women (Childs, 2005). Often the resentment toward Black man/White woman pairings is dismissed as jealousy. Childs's research indicates it is in fact more readily explained as a reaction to White racism, Black internalization of racism, and what interracial relationships represent to Black women and signify about Black women's worth (Childs, 2005, p. 558). Therefore, celebration of Black love relationships within these contexts acts as a community act of resistance to popular discourse that discounts the worth of Black women as relational partners for successful Black men. In posts and comments concerning the Kardashians, commenters interrogate the women and the larger community issues regarding their fame and their crossover to the Black media market by means of interracial pairing.

The Institutional—Fighting the Power

Institutional oppression serves to provide justification for the separation of marginalized groups from organizations and institutions that serve the public good. When institutional oppression functions at its most oppressive, institutions in place to serve society act with specific detriment to certain groups within. Because laws often justify such oppression, resistance at this level challenges not only popular discourse or societal norms, but laws and regulations as well. The gaze of the law is not only Western, but as MacKinnon (1989) argues, male as well. MacKinnon asks us to interrogate how laws become normalized and unchallenged in society, acting to the benefit of some groups and the detriment of others. Values of dominant society are mandated as law and for those outside the dominant group, the problem with this correlation is obvious.

Defending Black Men

Legal issues faced by celebrities are a frequent theme in blog posts on both sites, with TheYBF devoting a category section to "Legal Woes." Within this area, most of the posts discuss celebrities involved in civil disputes or being fined or given jail time because of tax issues. Often, disdain is reserved for celebrities rather than the government. The blogger and community commenters show sympathy for rapper Ja Rule as he faces charges of tax evasion. Instead of focusing on the charges, the post and subsequent comments instead shift attention to a Twitter war waged between Ja Rule and longtime rival 50 Cent. A March 2011 unsigned post concludes with "back in the day, rappers would be ready to shoot each other and knock each other's heads off over a few choice words…now they just take the spectacle to twitter" (Bitchie Staff, 2011). This reads as a disappointment in the two for failing to live up to the hegemonic ideals of aggressiveness, violence, and competition attributed to masculinity. More significantly, no challenge is posed to the system of taxation; the bloggers and commenters critique Ja Rule as a tax evader.

Music artist Fantasia Barino was featured in an August 2011 post wherein YBF bloggers discussed the singer being sued by a collections agency for $25,000 (_YBF, 2011b). The post concludes with "Oh Fanny…I hope Antwuan helps her figure this out…*eyebrows raised*." The blogger is referencing an ongoing controversy regarding Barino's intimate relationship with a married man. Commenters are critical of Barino in this situation. Many blame a "lack of home training" or "lack of education." One post summarizes the sentiments of the majority of the commenters:

> I feel bad for Fantasia because she just had no home training. Fantasia, money and fame cannot buy class. The best example you can set for Zion and the newborn is to further your education, even to the Community College level. How are you even able to help with

homework and understand the progress reports the teacher sends home? I guess that is why you hooked up with a college educated man. Unfortunately, you went about it the wrong way and will reap the fruits of those seeds. Please try to better yourself intellectually, spiritually and emotionally. My prayers are with Zion and the unborn. (jabe)

Poster "Mabel" responds by signifyin(g) Barino's perceived issues with literacy stating: "Wow! Well said! Unfortunately she can not read so…let us hope someone who cares about her harvest your words of wisdom and enlighten the 'poor child.'" This example shows how the author simultaneously signifies both Barino and the poster. The use of quotes around "poor child" indirectly calls out the posters for their belittling of Barino. In this and other cases, the systems under which the celebrities find themselves in trouble with the law largely go unchecked. The banking industry and systems of taxation are left intact as both the bloggers and commenters focus on the poor money management or inappropriate conduct of the celebrities.

The absences of Black protectionism when Black celebrities are accused of "white collar" crimes signals an acceptance of a level of governmental control. Katheryn Russell-Brown (2004) explains that Black protectionism is a form of group self-interest, wherein African Americans actively seek to protect other African Americans (usually men) from negative stereotypes or mistreatment by Whites. Black protectionism operates regardless of the group's perception of innocence or guilt. When a Black celebrity is accused of non-white-collar crimes, the discourse on the blog posts tends to include the elements of Black protectionism. Russell-Brown (2004) explains that Black protectionism usually incorporates the following challenges:

> Did he commit the offense? Even if he did commit it, was he set up? Would he risk everything he has to commit this offense? Is he the only person that has committed this offense? Are White people accused of committing this offense given the same scrutiny and treatment? Is this accusation a part of a government conspiracy to destroy the Black race? (p. 60)

Protection by Black women is particularly significant in the ways it is used to challenge social and legal institutions on behalf of Black men. Blogs within the sample period discussed prosecution and incarceration of Black men for crimes including weapons charges, violent crimes, prostitution, and drug offenses. Rappers Rick Ross, Big Boi, and Soulja Boy were all arrested on various drug possession charges. An unsigned YBF blog post in March of 2011 details Rick Ross's arrest for marijuana possession in Shreveport, Louisiana (_YBF, 2011c). Four separate yet related threads emerge in the comments section. The first condemns Ross, not for possession of narcotics but for conducting himself in a way that would draw the suspicion of officers. The second is a debate as to whether Ross was required under Louisiana law to show identification. The third questions the merits of drug laws and suggests marijuana

should be legalized. The final is an indictment of racism in the Shreveport Police Department. Commenters posit that Ross's arrest was an example of DWB (Driving While Black). Though possession of marijuana is against the law, the common protection theme of the comments suggest that the community sees Ross as being under scrutiny that a White counterpart would not be.

The new Jim Crow, according to Michelle Alexander (2010), is a system of criminal prosecution and incarceration that prevents African Americans from becoming full participants in dominant U.S. society. Through unfair and discriminatory law enforcements practices, sentencing laws, and access to adequate defense, African Americans are disproportionately imprisoned for minor drug offenses. The new Jim Crow affects housing, education, access to government resources, voting, and jury participation. Each of these means of participating in the economy and in the social fabric of this country has been historically taken away from African Americans as a population since the formation of the United States. The new Jim Crow emerges as a means to both redact laws and civil rights for a population and ensure the economic fortitude of the dominant group through the prison-industrial complex. Commenters who challenge unfair arrests and position those arrested for crimes as victims of the system do so within this context.

POSSIBILITIES AND PROMISE

The blogosphere provides a platform for marginalized groups to seek and sustain voice in a society where they are prevented from meaningful participation. Too often scholars have also participated in this exclusion by ignoring how these groups interact with media differently than the dominant culture. The blogs in this study demonstrate that as Black women negotiate the intersection of their gender and racial identities, gossip is used as a tool to resist oppression. At the same time, self-monitoring and adherence to hegemonic control is present as well. At the individual, communal, and institutional levels bloggers and the community of commenters engage in rhetorical strategies and narratives that resist the dominant culture's view of Black femininity, the Black family, and Black communal practices. At the institutional level the blogs challenge systemic issues while also reifying systems of patriarchy, hegemonic masculinity, and an unjust legal system.

Two of the most common ways gossip has been discussed in anthropology, psychology, and communication are as a malicious act among acquaintances or as a means of social control. Previous ethnographic studies have explored the ways in which various cultural groups have used gossip as a means of social control. A resounding finding significant from such work is the idea that gossip is a tool used to keep the masses subservient socially, politically, and economically. As a means of social control, communities monitor themselves and their own behaviors

through means of shame (Kluckhohn, 1944; Pitt-Rivers, 1977). Those in control reside outside of the actual acts of gossip, instead allowing the masses to police themselves and relinquish power (Merry, 1997, p. 28). This view of gossip ignores the agency of the individual in the decision to participate. It is certainly important from a historical perspective to understand the role gossip has played in crafting social structure, but we must also be concerned with the ways in which groups have used gossip to serve alternate purposes for the individual and community.

Gossip is often considered within a malicious context (Fairclough, 2009). Even in extensive studies of cultural understandings of gossip, gossip is regarded as negative and even deviant behavior. As Merry (1997) expresses, "gossip not only attacks a person's honor and social prestige…but also leads to tangible political, economic and social consequences" (p. 56). This means of understanding gossip assumes a negative intent on the behalf of the gossipers. It leaves little to no room for the possibility of other motivations that do not seek to harm the subjects of gossip. One sure motivation may be the maintenance of relationships and community building. This is especially the case when the gossip occurs about strangers. When we stop dismissing gossip as purely malicious it is possible to see that gossip can expand the opportunity for cultural learning and foster community connection (Baumeister, Zhang, & Vohs, 2004).

Celebrity gossip in particular serves a specific function in strengthening bonds. Gossip blogs hold the possibility for communal sharing of knowledge and management of relationships online. Because this gossip is not specifically about anyone within the participant's social circle, the fear of disparagement is avoided and instead is replaced with discourse that can serve alternate purposes. Gossip is a form of cultural capital that affords those "in the loop" with knowledge that provides power and status.

Gossip may be used in online spaces to create a sense of digital community for offline communities separated by geographic or social distance. Because this online space provides the opportunity for feedback from readers, the communal work done in such a space becomes even more apparent. In the case of Black female gossip blogs, the online space may serve as a site of unification for a group of women who may otherwise be separated by geography or socioeconomic status. The writers and readers of celebrity gossip blogs exist within a different socioeconomic group than those they gossip about. In these online spaces, the gap between the producers, consumers, and subject nearly vanishes. Since most readers of celebrity gossip sites have never interacted offline with the celebrities they write about, their use of pejoratives and personal referents is largely symbolic. Research separates the community function from ideas of "bitching." Guendouzi (2001) explains that even within the midst of cooperation and collaboration in gossiping behaviors, bitching is "underpinned by a need to discursively claim symbolic capital through competition for socially acceptable images of femininity which reproduce a hegemonic ideology of gender" (p. 29).

While "bitching" online is highlighted as being defamatory in nature (Rowland, 2006) it must also be considered as "talking and gazing back at popular culture, is in this case a valued/valuable feminist act" (Bailey, 2003).

Black women's writing often happens in spaces outside of Eurocentric positivist systems of knowledge. Writers such as Audre Lorde and Alice Walker insist that theory and systems of knowledge that exist outside of what is normalized as scientific, such as narrative, poems, and songs, should be considered valuable as well. Patricia Hill Collins (2000) explains: "Subjugated knowledges, such as a Black women's culture of resistance, develop in cultural contexts controlled by oppressed groups" (p. 230). Beyond showcasing community conversation and resistance discourse, this study posits that Black female bloggers must be considered as part of the historical legacy of marginalized Black women writers. They also act as agents of innovation in a new media context. The bloggers and blogging community use narrative construction, signifyin(g), and playing the dozens, features of Black oral culture, to "talk back" (hooks, 1988) to systems and structures from which they are excluded or exploited. In this case, the authors' and readers' existence within the matrix of domination directs a methodological choice that gives space for the discussion of the complexity of experience and expression.

This study provides validation for a space outside the boundaries of what is traditionally considered appropriate for political discourse and intellectual discussion. While limited in scope, focusing on these two sites allows for a deeper reading of the context and construction of community that exists in these spaces. Beyond the boundaries of academic positivist research are the everyday conversations through which communities navigate identity and culture. Future research must continue to investigate the use of nontraditional spaces as sites of inquiry and interrogation by Black women and other marginalized groups. As scholars, a shift in epistemology creates the potential for incorporation of new ideas and possibilities of resistance to oppression through participation in political discourse.

REFERENCES

_YBF (2011a, February 14). Who RAN IT?: Nicki Minaj vs. Keri Hilson [Blog post]. Retrieved from http://theybf.com/2011/02/14/who-ran-it-nicki-minaj-vs-keri-hilson

_YBF (2011b, August 6). Money woes: U.S. Bank SUES Fantasia for $25,000! [Blog post]. Retrieved from http://theybf.com/2011/08/06/money-woes-us-bank-sues-fantasia-for-25000

_YBF (2011c, March 26). ARRESTED: Rick Ross spitting bars behind bars for marijuana possession [Blog post]. Retrieved from http://theybf.com/2011/03/26/arrested-rick-ross-spitting-bars-behind-bars-for-marijuana-possession-philly-eagles-balle

Abrahams, R. D. (1976). *Talking Black*. Rowley, MA: Newbury House.

Alexander, M. (2010). *The New Jim Crow*. New York: New Press.

Anderson, M., & Collins, P. H. (1992). *Race, class, and gender: An anthology*. Belmont, CA: Wadsworth.

Ayim, M. (1993). Knowledge through the grapevine: Gossip as inquiry. In R. F. Goodman & A. Ben-Zeev (Eds.), *Good gossip* (pp. 25–34). Lawrence: University Press of Kansas.

Bailey, C. (2003). Bitching and talking/gazing back: Feminism as critical reading. *Women and Language, 26*(2), 1–8.

Baumeister, R. F., Zhang, L., & Vohs, K. D. (2004). Gossip as cultural learning. *Review of General Psychology, 8*(2), 111–121.

Baym, N. K. (2009). What constitutes quality in qualitative research? In A. N. Markham & N. K. Baym (Eds.), *Internet inquiry: Conversations about methods* (pp. 173–189). Los Angeles, CA: Sage.

Bell, B. (1987). *The Afro-American novel and its traditions*. Amherst: University of Massachusetts Press.

Bitchie Staff. (2011a, March 24). Ja Rule and 50 Cent are beefing again [Blog post]. Retrieved from http://necolebitchie.com/2011/03/ja-rule-50-cent-are-beefing-again/

Bitchie Staff. (2011b, August 3). Eric Williams on throwing a drink in Jen's face: 'I tried to cast [the demon] out' [Blog post]. Retrieved from http://necolebitchie.com/2011/08/eric-williams-on-throwing-a-drink-in-jens-face-i-tried-to-cast-the-demon-out/

Bonilla-Silva, E. (2006). *Racism without racists: Color-blind racism and the persistence of inequality in the United States*. Lanham, MD: Rowman & Littlefield.

Byrne, D. N. (2007). Public discourse, community concerns, and civic engagement: Exploring Black social networking traditions on BlackPlanet.com. *Journal of Computer-Mediated Communication, 13*(1), 319–340.

Chidgey, R., Payne, J. G., & Zolb, E. (2009). Rumours from around the bloc. *Feminist Media Studies, 9*(4), 477–491.

Childs, E. C. (2005). Looking beyond the stereotype of "angry Black woman": An exploration of Black women's responses to interracial relationships. *Gender and Society, 19*(4), 544–561.

Collins, L. (1993). A feminist defense of gossip. In R. F. Goodman & A. Ben-Zeev (Eds.), *Good gossip* (pp. 25–34). Lawrence: University Press of Kansas.

Collins, P. H. (2000). *Black feminist thought: Knowledge, consciousness and the politics of empowerment*. New York: Routledge.

Connell, R. W., & Messerschmidt, J. W. (2005). Hegemonic masculinity: Rethinking the concept. *Gender and Society, 19*(6), 829–859.

Detlefsen, E. G. (2004). Where am I to go? Use of the Internet for consumer health information by two vulnerable communities. *Library Trends, 53*(2), 283–300.

Ekdale, B., Namkoong, K., Fung, T. K., & Perlmutter, D. D. (2010). Why blog? (then and now): Exploring the motivations for blogging by popular American political bloggers. *New Media Society, 12*(2), 217–234.

Eubanks, N. (n.d.). TheYBF.com: About [Blog page]. Retrieved from http://theybf.com/about

Eubanks, N. (2011, April 23). SHE IS NOT HER HAIR: Gabby Union shows off her natural un-relaxed, un-weaved hair [Blog post]. Retrieved from http://theybf.com/2011/04/23/she-is-not-her-hair-gabby-union-shows-off-her-natural-un-relaxed-un-weaved-hair

Fairclough, K. (2009, May 25). *The bitch is back: Celebrity gossip blogging, postfeminism, and bitch narratives*. Paper presented at the International Communication Association, Chicago, IL.

Fairclough, N. (1995). *Critical discourse analysis*. Boston, MA: Addison-Wesley.

Fanon, F. (1963). *The wretched of the earth*. New York: Grove Press.

Farrell, H., & Drezner, D. (2008). The power and politics of blogs. *Public Choice, 134*, 15–30.

Feasey, R. (2008). Reading heat: The meanings and pleasures of star fashions and celebrity gossip. *Journal of Media and Cultural Studies, 22*(5), 687–699.

Garner, T. & Calloway-Thomas, C. (2003). African American Orality: Expanding Rhetoric. In R. L. Jackson & E. B. Richardson (Eds.), *Understanding African American rhetoric: Classical origins to contemporary innovations* (pp. 43–55). New York: Routledge.

Gates, H. L. (1989). *The signifying monkey: A theory of African-American literary criticism*. Oxford, UK: Oxford University Press.

Gates, H. L. (1999). Signifyin(g): Definitions [and theory]. In H. A. Ervin (Ed.), *African American literary criticism, 1773 to 2000* (pp. 259–267). New York: Twayne.

Guendouzi, J. (2001). "You'll think we're always bitching": The functions of cooperativity and competition in women's gossip. *Discourse Studies, 3*(1), 29.

Harris, K. L. (2005). *Searching for Blackness: The effectiveness of search engines in retrieving African-American websites*. Doctoral dissertation, Howard University, Washington, D.C.

Hollander, J. A., & Einwohner, R. L. (2004). Conceptualizing resistance. *Sociological Forum, 19*(4), 533–552.

hooks, b. (1981). *Ain't I a woman: Black women and feminism* (15. print. ed.). Boston, MA: South End Press.

hooks, b. (1988). *Talking back: Thinking feminist, thinking Black*. Boston, MA: South End Press.

Kahn, R., & Kellner, D. (2004). New media and Internet activism: From the "Battle of Seattle" to blogging. *New Media Society, 6*(1), 67–85.

Kane, N. (n.d.). About NecoleBitchie [Facebook page]. Retrieved from https://m.facebook.com/offi cialnecoleb?v=info&expand=1

Kane, N. (2011a, April 18). Halle Berry says she's "not the marrying kind." Blames father [Blog post]. Retrieved from http://necolebitchie.com/2011/04/halle-berry-says-shes-not-the-marrying-kind/

Kluckhohn, C. (1944). *Navaho witchcraft*. Boston, MA: Beacon Press.

Lee, C. (1993). *Signifying as a scaffold for literary interpretation: The pedagogical implications of an African American discourse genre*. Urbana, IL: National Council of Teachers of English.

Lorde, A. (1984). *Sister outsider*. Trumansburg, NY: Crossing Press.

MacKinnon, C. (1989). *Toward a feminist theory of the State*. Cambridge, MA: Harvard University Press.

Merry, S. E. (1997). Rethinking gossip and scandal. In D. Klein (Ed.), *Reputation: Studies in the voluntary elicitation of good conduct* (pp. 47–74). Ann Arbor: University of Michigan Press.

Meyers, E. (2009, May 25). *Walter, Louella, and Perez: A historical perspective on the celebrity and gossip in "old" and "new" media*. Paper presented at the International Communication Association, Chicago, IL.

Ortega, M. (2006). Being lovingly, knowingly ignorant: White feminism and women of color. *Hypatia, 21*, 56–74.

Pitt-Rivers, J. (1977). *The fate of Shechem: or, The politics of sex: Essays in the anthropology of the Mediterranean*. New York: Cambridge University Press.

Pole, A. (2010). *Blogging the political: Politics and participation in a networked society*. New York: Routledge.

Rowland, D. (2006, January 1). Griping, bitching and speaking your mind: Defamation and free expression on the Internet. *Dickinson Law Review, 110*(3), 519–538.

Russell-Brown, K. (2004). *Underground codes*. New York: New York University Press.

Scott, J. C. (1990). *Domination and the arts of resistance*. New Haven, CT: Yale University Press.

Thomas, L. (1998). Womanist theology, epistemology and a new anthropological paradigm. *Cross Currents, 48*(4), 488–499.

van Dijk, T. (1997). *Text and Context.* Amsterdam: Longman Linguistics Library.

Weitz, R. (2001). Women and their hair: Seeking power through resistance and accommodation. *Gender and Society, 15*(5), 667–686.

Whigham, K. (2011, April 5). 30 Black bloggers you should know [Blog post]. Retrieved from http://www.theroot.com/photos/2011/04/30_Black_bloggers_you_should_know.html

Wickham, C. (1998). Gossip and resistance among the medieval peasantry. *Past and Present, 160*(1), 3–24.

Wilson, J. J., Mick, R., Wei, S. J., Rustgi, A. K., Markowitz, S. D., Hampshire, M., & Metz, J. M. (2006). Clinical trial resources on the Internet must be designed to reach underrepresented minorities. *Cancer Journal, 12*(6), 475–481.

Woodson, C. G. (1933). *The mis-education of the Negro.* Washington, DC: Associated Publishers.

Video Stars: Marketing Queer Performance IN Networked Television

AYMAR JEAN CHRISTIAN

INTRODUCTION

"Identity is not what you are so much as what you do."

—KOBENA MERCER[1]

In 2010, a local news team in Huntsville, Alabama, interviewed a young man named Antoine Dodson about the attempted rape of his sister. Dodson's defiant response sparked a cavalcade of Web commentary, going "viral" on its own, then spreading further after the Gregory Brothers of *Auto-Tune the News* remixed it into a song. "Bed Intruder Song" became an iTunes hit and the most-watched YouTube video of that year, raking in millions of views and thousands of dollars for its producers (Lyons, 2010). As spectacular as it sounds, the Dodson affair was far from new. The history of the Web includes scores of such incidents, in which people who are historically underrepresented became suddenly and spectacularly visible. Only three years prior, queer YouTuber Chris Crocker created one the most iconic YouTube videos in its history with his performance of empathy for Britney Spears (Christian, 2010a; Weber, 2009). Mr. Pregnant, a deep parody of Black and African minstrelsy, went viral that same year (Sabatini, 2007).

The "viral" nature of these videos has drawn scholarly and media attention to proliferating representations of marginalized people online. Yet focusing on how users interpret and spread these images masks a profound fact: Many of these videos were deliberately marketed to Web audiences by their stars. Chris Crocker had already built up a strong following of viewers, drawn to his sincerity and his story of coming of age as queer in Tennessee, long before *Leave Britney Alone! Auto-Tune the News* was a highly profitable independent Web series under a network umbrella, Next New Networks, acquired by Google/YouTube in 2011 (Roettgers, 2011).

With lower barriers to distribution online, independent filmmakers and creators have access to wider audiences, but open markets create greater burdens of representation. Performers can acquire skills, either on their own or through formal training, and self-distribute representations of marginalized groups that cross lines of class, gender, race, and sexuality to a large portion of the population. In a marketplace where corporations provide the most efficient means for reaching viewers, these images become packaged and sold, both by companies such as Google and by performers eager to create for a living. These questions arise: What happens when identities corporations have not valued—the queerest, most ambiguous, and most difficult to define—suddenly have the opportunity to "market" (i.e., create value for) themselves? How do video stars and independent entrepreneurs sell themselves to the public? Finally, what does this market say about the political potential or limitations of new media?

In the new media landscape, historically marginalized voices rely on difference, that is, the Othered body and voice, along with discourses of the "self," to present themselves to mass audiences on networked television. Historically, television networks have had an ambivalent relationship with performances of cultural difference. Felicia Henderson (2011), drawing from autoethnographic experiences in corporate television writers' rooms, describes this as the "uni-cultural" tendency in Hollywood media production, derived from its historical oligopoly that packages national culture as a transparent, mass commodity. Black and queer performers excluded from this vision of culture and its production embrace their difference in culture and its distribution. The "networked" aspect of Web television—that is, its ability to facilitate theoretically infinite amounts of connections between producers and consumers—aids their identification with television's business and disidentification with its cultural strategy. This aberration, as Roderick Ferguson (2004) might describe it, creates powerful cultural formations easily exploited by network intermediaries such as YouTube, along with other producers and cultural distributors. This chapter explores the increasingly less "amateur" space of YouTube, the primary venue for individuals creating videos about their lives, before and after 2010, as that site gradually increased its focus on marketing its users. Using interviews with producers and analyses of videos, this chapter explores various identities performed for networked television, focusing on the intersection of Black, queer, and woman.

THE PERIL AND PROMISE OF QUEER PERFORMANCE IN
AN OPEN MARKET

To be marginal is to exist outside. To have an intersecting identity is to exist in between. Intersectionality and marginality are concepts uniquely suited to studying the ambivalences of the new media economy and its capacity to create opportunity from the bottom while reinforcing hierarchies at the top; its openness to a broad range of identities that it then burdens with self-marketing; and its ability to monetize niches in ways that help both major corporations and independent producers. The "digital" sometimes disturbs the business models of multinational corporations and occasionally offers possibilities to individual and independent producers to make money and build community. Outsiders, we are often told, are getting in (Jenkins, 2006; Shirky, 2008). Yet barriers still remain for many who want to fully participate in new media economies and profit as much as existing institutions and individuals with connections to them (Hindman, 2009; Marwick, 2013; Terranova, 2000; Turner, 2010).

The users and producers in this chapter render visible the networked economy's contradictory discourses of self and society, art and market, independent profit and corporate dominance. This free, open market demands more of citizens, allowing them to create new cultural formations and niches in the marketplace while also inciting clashes and paradoxes along lines of identity in culture and politics (Duggan, 2004; Harvey, 2005; Miller, 2007). Queer of color critique can illuminate how performers and producers resolve these paradoxes through networked television, a technological paradox in which the cost of distribution has been lowered, but access to capital for complex productions still rests with the companies that have historically created television written and starring White, straight men. Television's power to represent attracts Black, queer, and feminine-identified producers, historically marginalized from its vision of nation: "As it fosters identifications and antagonisms, culture becomes a site of material struggle" (Ferguson, 2004, p. 3). By using the Internet to produce a vision of themselves, they upset television's history and reality, disidentifying with its cultural form through the open network (Muñoz, 1999). This attracts attention, which can produce value through technology designed to facilitate many-to-many connections (Webster, 2014).

These ambiguities within markets and categories, then, force scholars to look at practices. What do users and producers do with marginal and intersecting identities? How do they navigate the open market? How do they balance affective desires to be seen and heard against the need for marketing? Marketing requires simplicity; it has little use for deconstructing categories, because categorizing people is the easiest way to sell products to them. This is true, perhaps especially so, online. Intersectionality, meanwhile, is ambiguous: "precisely the vagueness

and open-endedness of 'intersectionality' may be the very secret to its success" (Davis, 2008, p. 69). Yet identity-based categorization, and the political security and community it provides, remain useful and powerful. For those at the margins, reclaiming identities could be a form of empowerment if one does not negate how multiple identities can intersect: "At this point in history, a strong case can be made that the most critical resistance strategy for dis-empowered groups is to occupy and defend a politics of social location rather than to vacate and destroy it" (Crenshaw, 1991, p. 1297). As will be shown, indie creators variously eschew and claim categorizations, which is a necessary dance in a digital marketplace open to the nation and media corporations, along with marginalized communities.

Faced with the possibility—if not quite the reality—of profiting off their identities in a market that does not value them, creators use the Web to represent themselves sincerely and disrupt television's formulas for serializing culture to make it consumable in short doses over long periods of time.

YOUTUBE: SELLING YOURSELF ON THE OPEN MARKET

YouTube is a vexing, fascinating space. For decades, after the introduction of television, having one's own network has been the dream of many a filmmaker, producer, or aspiring celebrity. "YouTube," as the name implies, offers this promise: "broadcast yourself," and, by selling oneself, make money, build fans, and support artistic or political projects. YouTube, then, is a key site for examining how producers—or producers, etc.—negotiate the self and the market. In part because of its brand, which encourages individuals to become producers, YouTube has risen above other video sites such as Justin.tv, Vimeo, Blip, Funny or Die, and a host of others as the preeminent space for lo-fi video production; for nearly all of its early history, YouTube outpaced all other streaming sites across metrics such as viewership, videos posted, and total streams.

YouTube was always commercial, but it started as a more "personal" space, and much early media coverage focused on the user's ability to watch home videos of the sort shot on vacation or during the holidays (Graham, 2005; Kirsner, 2005; Ojeda-Zapata, 2005). After the popular Lonely Island digital short "Lazy Sunday" went "viral" on the site in 2005, however, the use of YouTube as a vehicle for more market-oriented content became clear (Burgess & Green, 2009). Google purchased the network a year later, making clear its split identity as a place for the personal and commercial (Jarrett, 2008).

For many years YouTube has remained a rich, dense environment: It is a social networking site with community building tools, an (increasingly corporate) entertainment venue, and a venue for self-publicity. "Vlogging," or video blogging, was, in the beginning, the site's bread and butter; it was a way for individuals to

cheaply make videos, either about themselves or culture and politics. Users such as Philip DeFranco and Michael Buckley used the vlogging practice of looking to the camera and speaking directly to audiences to build large fan bases for their pop-culture commentary.

In its earliest years, the site offered users numerous strategies to manage their personal space, similar to peer sites Myspace and Facebook. YouTube offered a number of features for identity management, publicity, and social networking. In terms of identity management, users can delete videos they have posted in the past, and they can make certain videos private (though this is not a popular option). On their videos' pages, vloggers can delete comments they don't like, bar discussion on a video entirely, and block users who do not fit their standards. For social networking, the primary methods of connecting with others are subscribing to others' channels, friending, and messaging. Subscribing is the most common method of connecting; some users subscribe to a lot of channels, while others do not. Most accept friendships liberally, though a few are more careful. As for private messages on the site, a few vloggers, especially more popular ones who receive them regularly, do not use YouTube's emailing tools and instead redirect viewers to a social networking page or alternative email, either personal or professional. Users can also dictate who sends them messages; a few, though a minority, require an offer of friendship before someone sends them a private message on the site. In general, YouTube's customizable features allow users a great deal of control over how they are seen and presented, further encouraging individualization and the existentialist project.

Yet "personal" management quickly segued into "brand" management when the site introduced the partner program in 2007 (Kirkpatrick, 2007). In the beginning, select YouTube creators, those with a large number of subscribers and a record for consistently publishing "quality" content (i.e., safe, consistent, and popular), were invited to allow advertisements to be placed on their videos. These advertisements were automatically placed on videos through advertising networks, which mined tags, video descriptions, and audience demographics to match the correct 15- or 30-second spot with the video. Eventually brands started to contact YouTubers directly for product placement and branded entertainment. YouTube rapidly expanded the partner program. Within a few years the company claimed thousands of creators were making a living off the site, with a substantial number making more than $100,000 (Albrecht, 2008; Wei, 2010). YouTube continually refined ad delivery and sales, though not always to the satisfaction of either its corporate partners, whom it privileged, or independent producers.

Even as it supports independent and amateur creators with some basic infrastructure, Google has consistently courted the traditional media and higher-budget independent production companies. After initially suing YouTube for copyright violations, mainstream media companies such as Disney eventually

entered million-dollar distribution deals with the site (Child, 2011). In 2010, YouTube bought new media studio Next New Networks, looking to harness low-budget but more sophisticated videos (than vlogging) to develop a slate of programming much more like a traditional television network. By late 2011, the site had invested more than $100 million in upgrading its "channels," money that went straight to the pockets of its top homegrown talent, as well as traditional celebrities, new media studios, and brands (Nakashima, 2011). That project fizzled, and Google then promised to sell the audiences of "preferred" channels (the top 5 percent), including corporations both traditional and new (multichannel networks) and some producers who had been developing their channels since the early years.

The producers named in the first half of this chapter came of age in the earlier days of YouTube, when fewer channels existed, collaboration was more common, and its "stars" were much less focused on branding and more engaged in managing the self and the growing community. Dodson came of age in a later stage in the Web video market, which was by then heavily curated by companies such as YouTube, and in which marginalized identities had to do more work to sell their intersectional selves. I conducted 17 interviews on the phone and via instant message with Black vloggers with intersectional identities—mostly Black women, gay/bi male, or Latin@ performers, though I did speak to four straight men. I asked participants why they started producing, what kept them going, and what their experiences on YouTube said about it as a site for social interaction and video marketing. Creators expressed ambivalence about authenticity, negotiating the complexities of their work, and the online market through discourses of "sincerity" (Jackson, 2005).

CHANNELING DIFFERENCE INTO THE SELF

The home for marketable "amateur" user production in online video is YouTube. YouTube continues to be the platform for diverse groups of individuals, many of which have incredibly large, if not commercially valuable, audiences—Dodson and Crocker, for example, had subscriber bases well in excess of 100,000 in 2011.

How have users sold themselves to a large, unknown public? Vloggers sell both "the self," the idea of an individual who is sincere and independent, and "quirk," the marks of cultural difference that separates them from the thousands of YouTubers on the site. YouTube has birthed a number of these stars, all of whom have managed to build audiences both despite and because of their intersectional identities. These include B. Scott, an androgynously queer talk show host of mixed race identity; Mr. Pregnant, whose channel offers a challenging performance of minstrelsy; and TonyaTKO and Jia, two Black women who have managed to build stable audiences,

even as Black women remain relatively absent from the site's top users. Other vloggers will also be discussed.

Vlogging renders more visible and powerful the drive to articulate a singular identity in a networked world, one not necessarily, but often, based on notions of collective identity. YouTube space compels a centered narrative—"Broadcast Yourself"—such that their videos reflect self-conceived ideas and representations. Always weighed against the desire to assert difference and the realities of diverse audiences, personal authenticity, or sincerity—which, as argued by John Jackson (2005), stands in opposition to images of people or representations—remains the most marketable currency among vloggers, an interesting turn in the history of media representation (pp. 14–15). Perhaps the best way to demonstrate this is through two radically different yet popular vloggers: Mr. Pregnant and Jia of JiaTV.

By turning himself into a caricature and emphasizing his quirks to the extreme, Mr. Pregnant is among the most problematic Black vloggers on the site, but he has also been one the most popular. By 2011, his videos had been viewed nearly 45 million times and his channel had about 60,000 subscribers. Yet his channel is avowedly, or satirically, obscene, transgressing racial and sexual boundaries that few performers, even the most daring, would transgress. Coupled with his accent—the network VH1 identifies him as Adelston Holder, a Nigerian immigrant living in New Jersey—he performs "otherness" (WebjunkTV, 2007). When I interviewed him via instant message, he said he was White, male, and 100 years old. To anchor his identity with anything resembling the truth would ruin the irony of the performance.

Mr. Pregnant must be seen to be understood, but a quick sample of his videos includes his most popular video, *Big Girls Don't Cry* (Holder, 2006a), in which he, wearing lipstick and cinching his dreads into two ponytails, cries to the famous pop song for an uninterrupted four minutes. The videos are clear from their titles: *Big Belly Man*, in which he shows and jiggles his enormous belly (Holder, 2007); *Manboobs*, in which he raps the simple refrain "titties like a woman" (Holder, 2006c); *I Am Stupid* (Holder, 2006b); and *The Internet Freak*, a label he wears proudly (Holder, 2008a). In a recent video, *A Rape Story* (Holder, 2008b), he dresses as a thug and "rapes" himself. At the end of the video, he, the raped woman, cries, but then yawns. In each video he wears fake teeth with enlarged gums and opens his eyes wide, as if in the blackface tradition. He has catchphrases, including "Schnaker Schnaw!"

This would be a traditional case of minstrelsy, except Mr. Pregnant is not in traditional blackface. It is a version of his actual face that he is broadcasting. He is tenaciously unwilling to break character and, in our interview, denied the existence of a character altogether. This refusal to differentiate between the "character" and self is unusual on YouTube. To get views, the site's most popular users are willing to acknowledge they exaggerate their personalities at least a bit, and many of them

are careful to show more "human" sides. Many popular YouTubers such as Michael Buckley, LisaNova, and DaneBoe have separate channels where they post more subdued videos about their thoughts and feelings. Yet trying to peel back from the obscene extravagance of Mr. Pregnant was impossible:

AJC:	how did you come up with mr pregnant?
MP:	i am Mr Pregnant..!
AJC:	so mr pregnant isn't a "character" (or you are him *right now*)
MP:	It's an insult…How did George Bush, Paris Hilton and Britney Spears come up with their Characters??

Realizing I would be talking to Mr. Pregnant, I asked him about his thought process:

AJC:	so how do you come up with ideas/topics on what to post?....you have a lot of videos
MP:	they're aren't ideas…Just my regular thoughts..!...never saw them as ideas because they required no mental work.
AJC:	sort of stream-of-consciousness-like?
MP:	Neither…what is required from you to talk to me?...a stream of consciousness?

Mr. Pregnant would not admit to any active construction of his image or his videos, a rhetorical strategy employed by vloggers who want to be perceived as "real" or authentic (Christian, 2009). In an interview with VH1, Mr. Pregnant said: "I see the Internet as a medium of expression, where I can go there and just express my true feelings to the entire world and just be me" (WebjunkTV, 2007). This "just being me," a common refrain among other vloggers, who are all more believable as human beings than is Mr. Pregnant, is the single clearest linguistic evidence that vlogging on YouTube is an existentialist practice. Even among vloggers whose videos would suggest parody—a postmodern division of the individual self as a fallacy, a representation to be toyed with—there are appeals to sincerity amid the obvious existence of a web of lies. Some aspect of the "self" must be true, or at least superficially present, to fit within the YouTube motto. Mr. Pregnant's plea to be understood as an honest individual is likely part of the act, a commentary on YouTube's privileging of naturalism and self-expression. His invocation of it says something important about the site and about being in the world, the demands that (Black) individuals be seen as wholly constituted.

When I asked Jia about how she managed to get so many subscribers—almost 15,000—without employing the histrionics of someone like Mr. Pregnant, she gave a remarkably similar answer: "I dont use my body to get people to watch, I dont

speak one way or dress a certain way to attract viewers…I just shoot from the hip and to most people, thats being real." To "shoot from the hip" is to not really think about or deliberately construct an image too far in advance, to "be real" by way of honesty and an implied lack of forethought, just as Mr. Pregnant told me.

Jia is the opposite of spectacular. The vast majority of her more than 400 videos are unedited, and many of them are extraordinarily long by YouTube standards (more than five minutes, with some even more than 10 minutes). In these videos she merely speaks in front of the camera and gives her opinion on a subject, which can range anywhere from pop culture and music to relationships and sex to Black hair, racial politics, and Black women. She rarely even wears makeup.[2] "I think that its a great place for [talking about issues] b/c it allows a person to not only voice their opinions but to also 'show' their passion and emotion," she told me via instant message. Emotional sincerity is very important to Jia—and she does not let others interfere with that or impinge on her identity: "I dont let other people dictate my emotions. My conclusion is that people are going to say and do whatever they want…you can't let what others have planned dictate your emotions or what you will/wont do," she said when I asked her about people's negative responses to her videos.

How can Jia and Mr. Pregnant be alike in any way? The discourse of personal sincerity on YouTube, much more prevalent in the earlier days of the site, is powerful. It animates everything users do and undergirds their production practices. This fierce sense of self and honesty in many ways connects all the users on the network. It allows them to "do their thing" without guilt and without having to answer for what they do (usually). It even connects the postmodern sensibility of Mr. Pregnant with Jia's more pre-modern performance, which is romantic, effusive, singular, and unironic.

MANAGING THE SELF AND STARDOM

Still, the "self" on YouTube is neither pure performance or simple evocation. It must be managed. The simplicity of vlogging—talking to the camera—might lead to pronouncements that videos express unmediated "true" selves. Indeed, some earlier YouTube videos and vloggers employed this rhetoric when they describe their practices (Christian, 2009). Presenting a version of the self that is legibly sincere is important to gain and maintain fans, but no vlogger is purely transparent. As a space for edited video with a large degree of functionality—unlike, for instance, late 1990s webcams that merely broadcasted unedited streams of individual lives—YouTube has allowed for its stars to manage their presentation of self in a number of ways.

When I asked sketch comedy vlogger Barrett of BarrettTV—whose sexuality is unknown but is often read as queer by fans—if his channel in any way reflects who he is, he gave me an answer commensurate with the density of his page: "It is me, but more of an extension. People like to assume that's how I am all the time. It's more of a persona. I have to put on a little for the camera. But it still is really me." His answer is equivocal, and scanning through his videos, it is clear why. Barrett has done skits mocking church ladies, satirical videos that mock the limits of labels—like *Cuz I'm Black,* among others—and more opinionated personal vlogs. He is both funny and serious. So it makes sense that he both "exaggerates" and expresses himself honestly: It is all there for the viewer to see. Yet to justify his participation, he ends up at "it still really is me"; the explanation wraps up the political, comedic, and personal into a neatly digestible sense of self. Johnathan Gibbs, or BlasianFMA, also says his channel—in which he plays different "sides" of himself, the Black side, the Asian side, and the "real" side—is an exaggeration, which is why he created another channel, johnathangibbs, for matters more personal to him. Still, to Claxton J. Everett, this practice is silly: "i kno people who have their YouTube characters and themselves…that's so deceiving to me…just be yourself." For Everett, "being oneself" includes keeping videos relatively light on editing and focusing more on being serious, not over-the-top. However a user frames it, all of these tools for self-management are framed around projecting a sincere self in all its complexity.

The work of self-management is an all-consuming activity among vloggers on YouTube. Vloggers decide how and where to be seen and what those questions mean. B. Scott, a mixed-race, genderqueer pop-culture commentator and talk-show personality, probably best exemplifies how hard YouTubers work to sell their identities. B. Scott used his YouTube vlog and written blog, both called "Love B. Scott," along with a radio show and cosmetics line, to amass tens of thousands of fans—100,000 YouTube subscribers, 80,000 Twitter followers. Along with TV appearances on TV One, Fox, and Oxygen, B. Scott has interviewed Mariah Carey, Jennifer Lopez, and Chaka Khan, among other stars, and has been mentioned by A-list celebrities such as Rihanna and Jamie Foxx.

How did he achieve such success? B. Scott brought in viewers by talking about pop culture and created a personality through self-help-style reflections on his own life. A spring 2011 video about his hearing the daughter of his first-grade teacher refer a young boy to his YouTube channel reveals his skill at harnessing neoliberal notions of the self:

I was once that little boy in her mother's class…. For her to go and show that little boy my videos and say: "You can be happy. You can be successful. You can achieve and you can exist and there's nothing wrong with being who you are." It means so much to me. [Here he starts to cry]. It wasn't easy being that little boy and sometimes it's still not easy being who I am today. But moments like that. It makes it worth it. (Scott, 2011)

B. Scott, revealing his own emotions, funnels a deeply personal experience into a story about how queer, "different" people can achieve success. B. Scott's performance, including numerous instances of classic camp, from lip-synching to drag-like glamour, has allowed him to attract eyeballs (Christian, 2010a). But his viewers have stayed for his personal sincerity.

These YouTubers maintain strict requirements on how they present themselves based on a perceived audience and make compromises based on what reactions they receive. Both Jia and TonyaTKO, two of the most popular Black female vloggers on YouTube, said that they regulate their appearances as women. In one of Jia's early videos, she wore a tube top and makeup as she discussed the issue of rich older women dating younger men. She told me she dresses down now and rarely shows her breasts because

> In the past when I have been all "done up," thats the first thing people say.... "Oh Jia, you're pretty . . ." and they avoid what I said in the vid...so I give em tshirts, scarves and usually no makeup lol. so they have no choice but to pay attention to the ugly girl.

Jia adapted her image as an attractive Black woman to her audience to make sure her voice was heard. After getting comments like "slut" and "jezebel," Tonya, too, altered her appearance: "the mainstream is really not ready for sexy Black females," she said to me. "People on YouTube love them some breasts.... YouTube is just notorious for breast hunters." After starting her channel with very personal stories, she has since moved to discussing issues and talking about self-empowerment: "I'm really trying to keep a professional distance.... You realize that the stuff that you say online have greater impact."

Another way users create boundaries around the self is video deletion. Many viewers delete past videos if they no longer think it represents who they are. Dancer and slightly less popular vlogger Marcus Bellamy, a New Yorker with roles in prominent shows such as *Spider Man: Turn Off the Dark*, told me he goes through regular "purges" and will delete videos in bulk (I had added one video, in which he discussed the complexities of his open sexuality, to my favorites, only to find it gone months later). Popular-culture commentator Alonzo Lerone deleted most of his videos at one point so he could refocus the message of his channel, shifting it from personal content to criticisms and analyses of stars and music videos.

On YouTube, presumably noncommercial activities such as vlogging meet the market demands of building an audience and selling advertising for revenue, a market the vloggers above are all engaged with. While YouTube's motto "Broadcast Yourself" is increasingly out-of-step with the site's focus on independent producers and traditional media content, it remains an accurate description of how thousands of producers, including those of color and of various sexualities, have been able to build careers: by selling and sharing the self.

GRAPPLING WITH SPREADABILITY, THE MAINSTREAM, AND THE LIMITS OF SELF-MARKETING

By 2011, YouTube had significantly changed, as Google began doing many more deals with traditional media outlets and deemphasizing amateur vlogging in favor of higher quality, "produced" content. Few better examples of this growing tension between the self and the market exist than in the case of Antoine Dodson, the "Chris Crocker"-esque meme of the late 2000s. If Crocker's video spread by funneling his personal obsession with Britney Spears into a camp commentary on mainstream culture, Dodson's was the inverse: The mainstream thrust his personal commentary into the broader market and turned it into camp. The story is revealing about the limits of personal marketing in an increasingly complicated and corporatized Web space. Dodson's saga from the margins to the center reveals how the Internet marketplace increasingly relies on mainstream media corporations and new media networks to create its entertainment, and how previously unseen individuals can get caught in the middle. Put in that situation, they have little option but to assert the self and manage their stardom with what few resources they have.

Unlike many of the previous examples, Dodson is that rare video star whose audiences ballooned without his consent. Dodson performed for the camera not, like most vloggers, because he sought a dedicated audience (though one assumes he sought a little bit of fame), but because he was angry about violence in his neighborhood. That we even know about Dodson is the work of producers for the Huntsville, Alabama NBC affiliate WAFF-48, who decided he was more camera-friendly than his distraught sister, who was, perhaps, too traumatized to be entertaining. Black queer activist Kenyon Farrow, who expressed conflicted feelings about Dodson's queer performance, directed pointed criticism at the station: "Also, the news station intentionally included more footage of Antoine than Kelly, who was the actual survivor—were they going for ratings here? Did they stick this on YouTube?" (Farrow, 2010). For decades, news reporters have framed what is important for viewers to see, but in the age of the Web, others can amplify that curation. The Black queer Dodson became the story.

The video of Dodson spread rapidly. Yet it was not until another operation picked it up, this one YouTube-grown, that Dodson's image spread like wildfire. The Gregory Brothers had themselves become "viral video" stars years earlier, when they started to "Auto-Tune the News." At the time, auto-tuning had reached a climax in hip-hop, as the young White men (and one woman) used its saturation to mock it. They did not, however, stop there. By 2010, the Brothers were being distributed by an increasingly powerful Web video network, Next New Networks (NNN), which had a broad slate of programs such as Barely Political (of

"Obama Girl" fame), Key of Awesome (spoof videos), and IndyMogul. The loose network was able to aggregate hundreds of millions of views on a regular basis, all based on low-cost, consistent content that "spreads" because of the ways in which marginal identities motivate sharing and participation from a plethora of groups (Jenkins, Ford, & Green, 2013). The Brothers had been producing consistently, too, but their auto-tune of Dodson upgraded them from jokesters to impresarios. "Bed Intruder Song" would become their biggest hit, and the video was the most-watched of the year on YouTube (Banks, 2010). The success of the song catapulted NNN's already high profile, and the following year, as part of a broader plan to ramp up independent production on the site, YouTube bought the company for a reported $50 million (Roettgers, 2011). The Gregory Brothers became superstars, booking gigs with *The Cleveland*, the BET Awards, and the Academy Awards, while being feted in the *New York Times Magazine* for their "old-fashioned musical ability, high-tech skills and the do-whatever-you-want spirit of the World Wide Web" (Itzkoff, 2011). As of this writing, they have more than one million YouTube subscribers, making them one of the site's leading acts.

I narrate this story to make clear the marketability of caricatures of outsiders in a "viral" or "spreadable" marketplace. It was precisely the problematic nature of Dodson's performance that attracted so much attention. For his part, Dodson was able to capitalize on his fame, but not nearly to the extent of YouTube, the Gregory Brothers, and Next New Networks, who, as distributors and producers, have the clout to integrate consistency into the chaos of the Web. Because Dodson was given rights to "Bed Intruder Song," which sold enormously well, he was able to "move his family out of the projects" (LaCapria, 2010). Dodson also released an EP, *Love Is More Than a Song*, along with a hip-hop collaboration with Lady G called "Gucci Bag." He started his own YouTube channel—now at more than 100,000 subscribers—started selling clothes and costumes, and acted as a pitch-man for some humorous products, like the Sex Offender App (Dodson, 2011b). He signed to star in a reality show, though without a network distribution deal in place (Molloy, 2011).

Dodson's independent efforts represent an attempt to assert his particular identity within the dominant media system. With the Internet, he is able to do that—to a point. On his YouTube channel, Dodson's videos, which followed his life around the height of the buzz, were viewed hundreds of thousands of times.[3] A year later, however, when he tried to blog about his personal opinions and his life—he'd been arrested for possession of marijuana in April 2011, then again in September for not appearing in court—those videos were much less popular, raking in views in the low tens of thousands. Dodson appeared sobered in these videos, post-fame:

> The next problem. I'm just going to be doing videos and everything since I'm on chill mode and all that, you know, they got me doing drug classes I guess. "I'm on drugs" and stuff and I "can't handle what's going on," I'm "a crackhead," you know what I'm saying. I'm "ugly"....
> They just say everything and it's so funny to me.... They always said that the world is cruel...
> but never ever have I got to experience the world in this type of way. (Dodson, 2011a)

Dodson was clearly affected by some of the negative press around the arrests, and the fact that by all accounts, the public had moved on. Having not built his fame from the ground up, like Chris Crocker, Jia, or even Mr. Pregnant, his channel was not necessarily a destination, and he had little recourse to control his narrative. Users were not seeking him out. He may yet be able to market himself outside the mainstream media, but having achieved stardom outside of his control, he may be even less equipped to sustain it. As YouTube becomes even less about "you" and expressing personality, outsiders find themselves with fewer tools to manage and streamline their images.

WHEN INDEPENDENTS MEET THE MARKET

The market is supposed to stand in opposition to progressive cultural politics. Yet throughout history, companies and minorities have tried to harness the market for political ends, using marketing to assert the importance of difference (Weems, 1998). The epigraph of this chapter invokes Kobena Mercer's notion (1993) of identity as practice, and the independent producers in this chapter "do" their identities by trying to make inroads into the new media market.

What kind of liberation can come from this? Mercer praised the Black queer experimental films of the late 1980s and early 1990s, which reimagined genre and cinematic form to express the tensions and irreconcilabilities of being Black and gay. Those filmmakers did not have the level of access to capital and mass audiences digital practitioners believe they have today. The Web series producers and vloggers in this chapter came after the rise of niche marketing and media conglomeration, some of which commodified previously unseen identities from LGBT people (Viacom's Logo) to Latino-Americans (NBC's Univision, HBO Latino, etc.). With profit in sight, amateurs and independents saw little value in the less commercial forms of experimentation Mercer described, instead relying on firm notions of the self, genre, and form to carve a space in markets. As Maurice Jamal, founder of the Web's first Black gay video network, GLO, said in an interview: "Its about economic empowerment, our community showing if we can

flex our muscle not only creatively, but also economically" (M. Jamal, personal communication, October 6, 2010).

Yet, as gay consumers have realized after the growth of the LGBT market in the 1990s, there are limits to visibility. The fundamental problem stems from the difference between consumers and citizens, economic subjects and social subjects. As Rosemary Hennessey (1994–1995) writes:

> Not only is much recent gay visibility aimed at producing new and potentially lucrative markets, but as in most marketing strategies, money, not liberation, is the bottom line.... Visibility in commodity culture is in this sense a limited victory for gays who are welcome to be visible as consumer subjects but not as social subjects. (p. 32)

Written after the advent of "Don't Ask, Don't Tell" in the 1990s, Hennessey's warning bears some weight. Markets, indifferent to transformational politics, are a scary space for marginal identities. For Arlene Dávila (2001), the rise in Latin@ representation around the same time held little currency for true political change: "Latinas are undoubtedly gaining visibility…but only as a market, never as a people, and 'markets' are vulnerable; they must be docile; they cannot afford to scare capital away." Beretta Smith-Shomade's (2008) work on BET shows how access to mass distribution for Black communities did little to quell representational grievances.

Lacking marketing teams, these independents must follow the logics of markets, and so rely on formulas and proven tropes to sell less visible "others"—in this case, their "selves," the one resource they will never lose. True independence, then, is a bit of an illusion; any attempt to achieve audiences and raise money through advertising means aspirations must conform to the dominant culture, which controls the flow of capital.

What this chapter has shown, however, is that difference is not lost in transition, but comes in from the side, sometimes as an afterthought, sometimes superficially. When othered groups and bodies produce and market their own representations, they cannot completely erase their identities and bravely insert those differences into the wider new media market. This is meaningful. Hennessey perhaps could not have predicted that the economic subjects in the 1990s would become politicized a decade later.[4] The efforts of the producers in this chapter may have unintended consequences; they are hoping the market might hold the same weight as noncommercial spaces, offering another way to interject meaning into cultural difference and carve out more room for identities historically too troubling to fit comfortably within the American media landscape.

NOTES

1. Mercer, K. (1993). "Dark and lovely too: Black gay men in independent film," in M. Gever, P. Parmar, & J. Greyson (Eds.), *Queer looks: Perspectives on lesbian and gay film and video* (p. 240). New York: Routledge.
2. Dodson YouTube channel.
3. Another user, Claxton Everett, who knows Jia, confirmed my analysis: "take jia...she does VERY little editing...and she is VERY popular...just because it's her...she is very well spoken, and she never holds back...she always speaks her mind."
4. Whether this politics—anti-"Don't Ask, Don't Tell," pro-gay marriage—is progressive is another debate. For critiques of contemporary gay politics, see Duggan, 2004; and Warner, M. (1999). *The trouble with normal: Sex, politics, and the ethics of queer life.* Cambridge, MA: Harvard University Press.

REFERENCES

Albrecht, C. (2008, November 18). "Fred" cranks up the YouTube views and ad dollars [Blog post]. Retrieved from http://www.businessweek.com/technology/content/nov2008/tc20081118_508970.htm?chan=top+news_top+news+index+-+temp_technology

Andrejevic, M. (2004). *Reality TV: The work of being watched.* Lanham, MD: Rowman & Littlefield.

Banks, E. (2010, December 13). "Bed Intruder" was most-watched independent YouTube video of 2010 [Blog post]. Retrieved from http://mashable.com/2010/12/13/YouTube-most-watched-2010

Burgess, J., & Green, J. (2009). *YouTube: Online video and participatory culture.* Cambridge, UK: Polity Press.

Child, B. (2011, November 24). Disney and YouTube strike reel deal. *The Guardian.* Retrieved from http://www.guardian.co.uk/film/2011/nov/24/disney-YouTube-rent-films

Christian, A. J. (2009). Real vlogs: The rules and meanings of online personal videos. *First Monday, 14*(11). Retrieved from http://firstmonday.org/ojs/index.php/fm/article/view/2699/2353

Christian, A. J. (2010a). Camp 2.0: A queer performance of the personal. *Communication, Culture and Critique, 13*(3), 352–376.

Christian, A. J. (2010b, December 14). Robert Townsend: The future of television, importance of social justice, and working with committed collaborators (full interview) [Blog post]. Retrieved from http://blog.ajchristian.org/2010/12/14/robert-townsend-the-future-of-television-importance-of-social-justice-and-working-with-committed-collaborators-full-interview

Christian, A. J. (2010c, March 29). On cable, long live the anti-hero [Blog post]. Retrieved from http://blog.ajchristian.org/2010/03/29/on-cable-long-live-the-anti-hero

Christian, A. J. (2010d, February 22). "Real girls" are more diverse, less frivolous [Blog post]. Retrieved from http://blog.ajchristian.org/2010/02/22/making-web-shows-real-girls-are-more-diverse-less-frivolous

Christian, A. J. (2011, February 11). The problem of YouTube. *Flow, 13*(8). Retrieved from http://flowtv.org/2011/02/the-problem-of-YouTube

Collins, P. H. (2000). *Black feminist thought: Knowledge, consciousness, and the politics of empowerment.* New York: Routledge.

Crenshaw, K. (1991). Mapping the margins: Intersectionality, identity politics, and violence against women of color. *Stanford Law Review, 43*(6), 1241–1299.

Dávila, A. (2001). *Latinos, Inc.: The marketing and making of a people*. Berkeley: University of California.

Davis, K. (2008). Intersectionality as buzzword: A sociology of science perspective on what makes a feminist theory successful. *Feminist Theory, 9*(1), 67–85.

Dodson, A. (2011a, August 9). *Next problem* [Video file]. Retrieved from http://www.YouTube.com/watch?v=9crSadVRYJI&feature=plcp&context=C2715cUDOEgsToPDskKitbHDae 1juBhauZ8Fk9jB

Dodson, A. (2011b, August 25). *Antoine Dodson turns pitchman for sex offender tracker app outtakes* [Video file]. Retrieved from http://www.YouTube.com/watch?v=yCjY_xgn8sA&list= UUE-RZy7awTwDY2x0LG4fIHg&index=2&feature=plcp

Duggan, L. (2004). *The twilight of equality: Neoliberalism, cultural politics, and the attack on democracy*. Boston, MA: Beacon Press.

Dunn, S. (2008). *"Baad bitches" and sassy supermamas: Black power action films*. Chicago: University of Illinois Press.

Farrow, K. (2010, August 4). Antoine Dodson: Internet star or homophobic joke? [Blog post]. Retrieved from http://kenyonfarrow.com/2010/08/04/antoine-dodson-internet-star-or-homophobic-joke

Ferguson, R. A. (2004). *Aberrations in Black: Toward a queer of color critique*. Minneapolis: University of Minnesota Press.

Freitas, A. (2007). Gay programming, gay publics: Public and private tensions in lesbian and gay cable channels. In S. Banet-Weiser, C. Chris, & A. Freitas (Eds.), *Cable visions: Television beyond broadcasting*. New York: New York University Press.

Graham, J. (2005, November 21). Video websites pop up, invite postings. *USA Today*. Retrieved from http://www.usatoday.com/tech/news/techinnovations/2005-11-21-video-websites_x.htm

Harvey, D. (2005). *A brief history of neoliberalism*. London: Oxford University Press.

Henderson, F. (2011). The culture behind closed doors: Issues of race and gender in the writers' room. *Cinema Journal, 50*(2), 145–152.

Hennessy, R. (1994–1995). Queer visibility in commodity culture. *Cultural Critique, 29*, 31–76.

Hindman, M. S. (2009). *The myth of digital democracy*. Princeton, NJ: Princeton University Press.

Holder, A. F. [Mr. Pregnant]. (2006a, October 2). *Big girls don't cry* [Video file]. Retrieved from http://www.YouTube.com/watch?v=i3x4C1fJcUk

Holder, A. F. [Mr. Pregnant]. (2006b, October 6). *I am stupid* [Video file]. Retrieved from http://www.YouTube.com/watch?v=9js0dD8Kbrw

Holder, A. F. [Mr. Pregnant]. (2006c, November 6). *Manboobs* [Video file]. Retrieved from http://www.YouTube.com/watch?v=Zs1DsNBvEoc

Holder, A. F. [Mr. Pregnant]. (2007, August 31). *Big Belly Man* [Video file]. Retrieved from http://www.YouTube.com/watch?v=miBQIjfIiLw

Holder, A. F. [Mr. Pregnant]. (2008a, February 11). *The Internet freak* [Video file]. Retrieved from http://www.YouTube.com/watch?v=-4wVFhrhxLM

Holder, A. F. [Mr. Pregnant]. (2008b, September 23). *A rape story* [Video file]. Retrieved from http://www.YouTube.com/watch?v=cI93mOvKY6c

Itzkoff, D. (2011, August 11). The Gregory Brothers auto-tune the Internet. *New York Times Magazine*. Retrieved from http://www.nytimes.com/2011/08/14/magazine/the-gregory-brothers-auto-tune-the-internet.html

Jackson, J. (2005). *Real Black: Adventures in racial sincerity*. Chicago, IL: University of Chicago Press.

Jarrett, K. (2008). Beyond "broadcast yourself": The future of YouTube. *Media International Australia, 126*, 132–144.

Jenkins, H. (2006). *Convergence culture: Where old and new media collide*. New York: New York University Press.

Jenkins, H., Ford, S., & Green, J. (2013). *Spreadable media: Creating value and meaning in a networked culture*. New York: New York University Press.

Kirkpatrick, M. (2007, December 10). YouTube partner program opens to all; "Chocolate Rain" guy gets ad deal [Blog post]. Retrieved from http://www.readwriteweb.com/archives/YouTube_partner_program_opens.php

Kirsner, S. (2005, October 27). Now playing: Your home video. *New York Times*, p. C9.

LaCapria, K. (2010, August 20). Viral "bed intruder" video gets Antoine Dodson's family up out the projects [Blog post]. Retrieved from http://www.inquisitr.com/82624/antoine-dodson-charts-itunes-billboard

Lyons, M. (2010, December 13). YouTube's most popular videos of 2010: Bieber fever and Antoine Dodson [Blog post]. Retrieved from http://popwatch.ew.com/2010/12/13/YouTube-most-watched-bed-intruder-bieber

Marwick, A. (2013). *Status update: Celebrity, publicity, & branding in the social media age*. New Haven, CT: Yale University Press.

Mercer, K. (1993). Dark and lovely too: Black gay men in independent film. In M. Gever, P. Parmar, & J. Greyson (Eds.), *Queer looks: Perspectives on lesbian and gay film and video* (p. 240). New York: Routledge.

Miller, T. (2007). *Cultural citizenship: Cosmopolitanism, consumerism, and television in a neoliberal age*. Philadelphia, PA: Temple University Press.

Mittell, J. (2006). Narrative complexity in contemporary American television. *The Velvet Light Trap, 58*, 29–40.

Molloy, T. (2011, January 21). Antoine Dodson, of "Bed Intruder" fame, gets reality show pilot [Blog post]. Retrieved from http://www.thewrap.com/tv/column-post/antoine-dodson-bed-intruder-fame-gets-reality-show-pilot-24107

Muñoz, J. E. (1999). *Disidentifications: Queers of color and the performance of politics*. Minneapolis: University of Minnesota Press.

Nakashima, R. (2011, October 29). YouTube launching 100 new channels. *USA Today*. Retrieved from http://www.usatoday.com/tech/news/story/2011-10-29/YouTube-original-programming/50997002/1

Needham, G. (2009). Scheduling normativity: Television, the family, and queer temporality. In G. Davis & G. Needham (Eds.), *Queer TV: Theories, histories, politics* (pp. 143–158). New York: Taylor & Francis.

Ojeda-Zapata, J. (2005, August 27). Video sharing made easy. *Saint Paul Pioneer Press*, p. 1E.

Roettgers, J. (2011, March 7). It's official: YouTube buys Next New Networks [Blog post]. Retrieved from http://gigaom.com/video/YouTube-buys-next-new-networks

Sabatini, V. (2007, January 3). The DL: Learn about Mr. Pregnant [Blog post]. Retrieved from http://www.spinner.com/2007/01/03/the-dl-learn-about-mr-pregnant/

Scott, B. (Producer, Star). (2011, March 28). *A Full Circle Moment* [YouTube broadcast]. https://www.youtube.com/watch?v=XmYRHrENqn0

Sender, K. (2004a). *Business, not politics: The making of the gay market*. New York: Columbia University Press.

Sender, K. (2004b). Neither fish nor fowl: Feminism, desire, and the lesbian consumer market. *Communication Review, 7*(4), 407–432.

Shirky, C. (2008). *Here comes everybody: The power of organizing without organizations.* New York: Penguin Books.

Smith-Shomade, B. E. (2004). Narrowcasting in the new world information order: A space for the audience? *Television & New Media, 5*(1), 69–81.

Smith-Shomade, B. (2008). *Pimpin' ain't easy: Selling Black entertainment television.* Los Angeles: University of California Press.

Terranova, T. (2000). Free labor: Producing culture for the digital economy. *Social Text, 18*(2), 33–58.

Turner, G. (2010). *Ordinary people and the media: The demotic turn.* London: Sage.

Weber, L. (2009, April 13). Chris Crocker, "Leave Britney Alone!"—#5—The 100 Most Iconic Internet Videos [Blog post]. Retrieved from http://www.urlesque.com/2009/04/13/the-100-most-iconic-internet-videos-5-leave-britney-alone/#ixzz1MMWekwss

WebjunkTV. (2007, March 18). Behind the scenes with Mr. Pregnant [Blog post]. Retrieved from http://www.spike.com/video/behind-scenes-with/2833664

Webster, J. G. (2014). *The marketplace of attention: How audiences take shape in a digital age.* Cambridge, MA: MIT Press.

Weems, Jr., R. E. (1998). *Desegregating the dollar: African-American consumerism in the twentieth century.* New York: New York University Press.

Wei, W. (2010, August 19). Meet the YouTube stars making $100,000 plus per year [Blog post]. Retrieved from http://www.businessinsider.com/meet-the-richest-independent-YouTube-stars-2010-8

Black Women Exercisers, Asian Women Artists, White Women Daters, AND Latina Lesbians: Cultural Constructions OF Race AND Gender Within Intersectionality-Based Facebook Groups

JENNY UNGBHA KORN

INTRODUCTION

Race and gender are common means for identification, offline and online. In this study, I look at how race and gender are constructed on Facebook, the dominant online social network site in the United States, with 67 percent of online American adults using Facebook (Rainie, Smith, & Duggan, 2013). Facebook is an ideal social network for a study focused on the intersectionality of race and gender. The Pew Research Center's Internet and American Life Project shows that Facebook is especially appealing to women, with women more likely than men opting to use Facebook. Women are also more likely than men to report increased importance of Facebook and to spend greater time on the site (Duggan & Brenner, 2013).

In addition to attracting women, Facebook is popular with communities of color. While the public may be aware of a "Black Twitter" (Brock, 2012; Koh, 2014; Korn, 2013), a "Black Facebook" and "Latin@ Facebook" also exist, though

they have received less attention. Latin@s account for 14 percent of Facebook's American users, making them the social network's largest minority group. That number also exceeds the proportion of Latin@s that are online within the United States, with 14 percent on Facebook in contrast to 13 percent online. Similarly, 10 percent of American Internet users are Black, while more than 11 percent of Facebook users are Black. Unfortunately, relevant statistics on Asian American online activity are lacking (Koh, 2014; Rainie et al., 2013).

With so many women and minority users, Facebook Groups is a section of the online social networking site that is active with evolving intersectional representations of race and gender. Facebook Groups serve as popular, practical, and public meeting places for group posts and mass polling among Facebook users who share common interests and activities (Facebook, 2013a; Korn, in press; Park, Kee, & Valenzuela, 2009). As users create and join Facebook Groups, they contribute to changing depictions of cultural groups that are salient to them, including ones based on race and gender (Tynes, Garcia, Giang, & Coleman, 2011). Facebook Groups serve as a way to align with an intersectional identity publicly and to signal belonging to others who share the identity through online discourse (Korn, in press). While constructions of race and gender in individual identity performance online have been examined (Kendall, 1998; Nakamura, 2008), race and gender combined into group-based intersectional identities for cultural classification online remains underexplored. This study focuses on Facebook Groups as a site for intersectional identity, digital discourse, and cultural classification.

In this chapter, I present a brief summary of self-categorization and intersectional identity as my theoretical framework. After an overview of the data and methods, I then discuss findings from my analyses of intersectional Facebook Group discourses, highlighting differences across racial categories for women's Facebook Groups and distinctions within cultural constructions of Asian, Black, Latina, and White women's Facebook Groups.

SELF-CATEGORIZATION AND INTERSECTIONAL IDENTITY THEORY

Stemming from the 1980s, self-categorization identity theory preceded intersectional theory by at least a decade. The act of an individual's identification with particular groups is the process of self-categorization. Self-identification of the individual with a group provides the individual with a social identity that the individual may acknowledge and affirm through a variety of markers, including those affiliated with race and gender (Korn, in press; Turner, Hogg, Oakes, Reicher, & Wetherell, 1987; Turner & Reynolds, 2011). Racialized and gendered categories

are socially constructed, and while racialized group designations such as African American, Asian American, Caucasian, and Latina have lasted as important markers in the United States (Chao, Hong, & Chiu, 2013), the meanings attached to such categories have changed with time on legal, historical, cultural, and socioeconomic bases. The categories by which individuals label themselves are dependent upon the context, such that a person's race may supersede the person's gender in one setting, but the person's gender may become more salient in other social environments.

Such multiplicity in self-categorization is key to intersectionality theory. During the last two decades, intersectional identity theory has risen to prominence, particularly in Black feminist and women's studies research (Collins, 2000; Crenshaw, 1989, 1991; Korn & Kneese, 2015). Focused on the concurrence of identities from mutually reinforcing categories of difference, intersectionality includes instances when neither race nor gender might be activated more strongly than the other. Intersectional identity research highlights how race and gender operate simultaneously in terms of subjectivities, experiences, and identities. Rather than a single, central category, intersectionality calls for analysis along multiple dimensions. The choices that people make for group belonging have real consequences on thinking and behavior because society is based on a socially structured system. For individuals to choose to be part of an intersectional group is to accept race and gender as parts of a person's social identity in simultaneity, and markers for such self-identification may occur politically, socially, and now electronically (Korn, in press; McCall, 2005; Nash, 2008).

Choices abound online for individual self-categorization. Identity-based online interactions within electronic spaces devoted to race, gender, and intersectional identities help to inform and unify individuals across geographically lived space. Such identity-focused areas provide practice for "racialized role-taking" online as individuals choose to adopt and enact race-related identities, reflecting their cultural understandings of race (Tynes, 2007). The choice to join intersectionally identified online spaces is a process of interpellation, as Internet users respond to the hail of electronic places that target women of color (Althusser, 1971; Senft & Noble, 2013). The act of a woman subscribing to intersectional identity groups online is deliberate, political, and meaningful. The digital composition of intersectionality is experiencing different representations as individuals self-categorize as racialized and gendered. Facebook Groups are cultural representations of the way that individuals understand their intersectional identity group membership (Korn, in press; Rockquemore & Arend, 2002).

While Facebook has been the site of study for individual behavior (Ellison, Steinfield, & Lampe, 2007; Zhao, Grasmuck, & Martin, 2008), Facebook Group behavior has been understudied (Park et al., 2009). Though some cultural labels in

the Internet environment may be tinged with racial stereotype, Facebook Groups offer users the ability to create freeform categories of intersectional identification that reflect their raced and gendered experiences more accurately and less stereotypically (Hogg & Reid, 2006; Mastro & Kopacz, 2006). Because any Facebook user may found a Facebook Group, Facebook Groups may be considered more egalitarian in facilitating the creation of cultural markers online. A Facebook Group's discourse may specify additional axes of difference, along with race and gender. For example, a Black women's Facebook Group may hail occupation or hobby as a way to build identity, like the case of *Black Women Artists*. Intersectional identity categorization processes are captured when Facebook users determine that race is a salient part of cultural identity for Facebook Group discourse (e.g., *Black* as a racial category for Facebook Group membership) and that gender and hobby are also important parts of racial construction (e.g., *Black Women Rock* and *Black Women in Fitness*) (Collins, 1998; Proudford & Smith, 2003).

Together, these intersectional factors for identity may be understood as part of "culture," or "the sum of the available descriptions through which societies make sense of and reflect their common experiences" (S. Hall, 1980, p. 59). The creators of every Facebook Group decide which features of cultural identity to promote as the focus of that socially constructed group. The discourse of *Black Women Artists* also demonstrates the way in which the cultural system has affected the linguistic rule system, in that "Black," as the first adjective listed, is given primacy as the most salient cultural identifier, even over "women" and "artists" (Bernstein, 1972). Formed as a function of "societal culture" (Erez & Earley, 1993, p. 69), Facebook Groups consist mainly of digital text and thus represent an ideal site for cultural study as "the culture of a people is an ensemble of texts, themselves ensembles" (Geertz, 2005/1972, p. 85). Within this chapter, I adopt a critical humanist perspective, in that I view culture as interpretive and socially constructed, which means culture is open to power struggles, contested meanings, and evolving identifications (E. T. Hall, 1959; Korn, in press; Martin & Nakayama, 1999).

In earlier research (Korn, in press), I conducted a study of Facebook groups to examine intracultural differences among Asians/Asian Americans, Blacks/African Americans, and Whites/Caucasians. These racialized terms are among the most commonly used in the United States but are rarely empirically defined (Bhopal & Donaldson, 1998; Glenn, 1999). The term "Asian" is used as shorthand for "Asian Americans." "Black" is often exchanged with "African American." "White" represents "Caucasian" in popular parlance. The results from that study revealed that specific keywords in racialized Facebook groups affect the results. For example, Facebook group searches using the keyword "Asian" yielded identity focused on Asia as a continent, not Asian Americans. Similarly, "Caucasian" in Facebook searches led to identity tied to the region of the Caucasus Mountains,

but not White Americans. In contrast, "Black" as a key term within Facebook group searches produced similar results to "African American" as a key search term. Building upon my previous work, to capture Facebook groups focused on American understandings of race as part of intersectionality, I use "Asian American," "Black," and "White" as search terms in the present study, in conjunction with women as the gender component. To examine intersectional identities of women and race within Facebook groups, I use keyword phrases "Asian American women," "Black women," "Latina," and "White women."

These representations of race online afford an opportunity for critical engagement with presumptions about race that have been taken for granted. As a racial category, "White" has been built historically upon an "othering" of non-White races, particularly in terms of social control of African Americans as part of the racist legacy of slavery (Brock, 2006). Including White women's Facebook groups provides the opportunity to analyze the construction of the intersection of race with gender reflective of the dominant discourse online. By including Asian Americans, I address criticism that communication studies research is often Eurocentric and neglectful of Asian and Asian American studies (Miike, 2006). Asian American women may also represent different identification claims than other intersectional identity groups because previous research has demonstrated that more than European-based and African-based cultures, Asian-based cultures are hailed as high-context and collectivistic in that Asian-based cultures are verbally more understated and indirect (Leetz, 2003).

The intersectional identity question of what it means to be a Black woman, Asian American woman, Latina, or White woman online has not been explored deeply in the context of the Facebook Group research site, even though sociality in which offline behavior and online behavior around race and gender are enmeshed and imbricated is increasingly moving online (Daniels, 2012; Sassen, 2002). The factors that create intersectional identity online as captured by Facebook Groups provide critical insight into digital representations of race and gender that are no longer tied to the body but that are still attached to offline expectations about racialized and gendered behavior that may reinforce stereotypic and prototypic ideals, reaffirm Whiteness as normative, or depict the "othering" of races (Daniels, 2012; Hogg & Reid, 2006; Mastro & Kopacz, 2006; Nakamura, 2002).

DATA AND METHODS

Facebook Groups differ from Facebook friends and Facebook Pages. Facebook Groups consist of people who may not be Facebook friends of each other, but are members of the same Facebook group, or "close circles of people that share and keep in touch on Facebook" (Facebook, 2013a, 2013b). Unlike Facebook

Pages, Facebook Groups may be created by any Facebook user around a wide array of topics and may grow to an unlimited membership (Facebook, 2013a). Facebook Group creators have a natural incentive to create Facebook Group titles and descriptions that are accurately representational to leverage Facebook user searches for groups that are relevant to their group's focus and to capitalize on Facebook's own algorithms that recommend Facebook Groups to users outside of user-initiated searches. Facebook Groups that appear in a search allow immediate access to group descriptions and membership number, which are both useful pieces of information with which the Facebook public may use to decide to join— or even to create additional Facebook Groups.

As other Facebook users might do to discover salient Facebook Groups, I approached finding these groups by submitting one of four intersectional identity phrases in English ("Asian American women," "Black women," "Latina," and "White women") into Facebook's search box. By focusing on such already constituted social groups that result from the search on Facebook, I adopt the intersectional methodology of "categorical approach," utilizing existing intersectionally based categories to record contemporary constructions of online intersectionality along multiple dimensions (McCall, 2005).

I then analyzed the discourse of intersectional classification within Facebook Groups. Discourses are social interactions embedded within text and language by actors (van Dijk, 1985). I apply critical discourse analyses to the data, with particular attention paid to linguistic dynamics across different social groups. Critical discourse analyses view language as a form of social practice and focus on the ways social and political domination are reproduced in text and talk (Fairclough, 1995; Rasti & Sahragard, 2012; van Dijk, 1993). I explore intersectional discourse interculturally across Asian American women, Black women, Latinas, and White women, while also highlighting intracultural, discursive constructions of intersectional identity among Asian American women, Black women, Latinas, and White women. Through critical discourse analyses, I examine how intersectional identities reproduce oppression found within dominant discourse and how intersectional identities present counter-narratives to stereotypical mass media depictions involving women of color.

CROSS-INTERSECTIONAL RESULTS

In this study, I captured data from Facebook Groups for Asian American women, Black women, Latinas, and White women on December 13, 2013. These groups varied in size of membership and in date of founding. Based on Facebook's search algorithms, I recorded the groups as they appeared in order. As a representative

example, a couple of Facebook Groups that were culturally categorized as Black women's groups are shown in Figure 6.1.

Black Women Artists (BWA)
Open Group

● We are a group of women artists of African descent committed to creating and exhibiting our work. Members of BWA (Black Women Artists) not only explore personal aesthe...

👥 497 members

[+1 Join] [🔍]

Black Women in Europe™
Closed Group

● The Black Women in Europe™ Social Network is for sisters living in Europe: This is a safe, hostile-free zone and a place for sharing information. This is not an adverti...

👥 568 members

[+1 Join] [🔍]

Figure 6.1. Example of Black Women's Facebook Groups.

Intersectional Facebook Groups reflect the solidity of race and gender as socio-cultural categories that offer meaningful starting points for finding similar others. By far, Black women are represented in Facebook Groups more strongly than any other racialized group: Facebook Groups for Black women numbered more than 1,000. In contrast, White women Facebook Groups totaled 162, Latina Facebook Groups equaled 75, and Asian American women Facebook Groups numbered only 32.

Significant is the predominance of Black women's Facebook Groups reaching four digits, while only one racialized Facebook group broke three digits, and the other two racialized women's groups hit only two digits. The traditional answers to questions about the popularity of Twitter among African Americans—high cell phone usage, minimalist aesthetic, and ease of material access—do not account for why Facebook Group popularity, and not Facebook usage in general, is so high among Black women. In fact, this finding is surprising because it counters the argument that unique structural aspects of Twitter necessarily facilitate deeper penetration within the African American community (Brock, 2012; Koh, 2014).

One explanation centers on *invention* within Black discursive culture, which refers to the *call* aspect of the call-and-response tradition within the African American community. Re-framing Facebook Groups as a type of digital call-and-response, these groups may serve as a call to Facebook users for self-identification. The response comes in the form of the growth of these groups, as additional Facebook users classify themselves as Black women online. As Black women Facebook users experience Facebook Groups, they may choose to create another call to like-minded Facebook users to subscribe to a new or similar group that may even share the same target audience as the group they just joined. The former Facebook Group limit on the number of groups a person may join was 300, which has since been raised to 6,000. With such a high limit, a person may be the creator, administrator, and member of thousands of Facebook Groups, including ones with overlapping identities. Inventing (*call*) and joining (*response*) intersectionality-based groups may be an electronic implementation of church culture as a strategy of action in the Black community (Pattillo-McCoy, 1998).

Implicit within the call-and-response of the Black community online is a shared belonging to the racial identification as Black. While thousands and thousands of Facebook Groups exists for Black women, cultural categories for Asian American women and Latinas are limited. This limit may reflect a stronger salience for Black Americans with race over Asian Americans and Latinas who may identify more intensely with ethnicity. For example, a Thai American woman may consider her cultural identification as shaped more by her Thai ethnic background than by her American racial classification as Asian American. The same logic may apply to those with multiracial backgrounds, who would join Facebook Groups that emphasize multicultural characteristics, instead of a singular race (Lee & Bean, 2004).

In contrast to previous research on gender online (Rellstab, 2007), little gender "queering" or disrupting norms (Gray, 2009) was found within intersectional identities in Facebook Group discourse. While Facebook Groups tend to attract individuals who share homophilous viewpoints (McPherson, Smith-Lovin, & Cook, 2001), a dominant theme emerged that unites most intersectionally based Facebook Groups: Women construct their online identities around heterosexuality. Overwhelmingly within Facebook Group titles, descriptions, and content, the combination of race and gender creates a narrative around finding, courting, and marrying women of all races by straight men and women. Rather than objectification of women depicted in such a sexualized manner, Facebook Groups serve to emphasize the commonality of interracial dating and unify likeminded others who identify as "White Women Who Love Their Black Men," "Black Women and White Men," "Latino/a and Black Love," and "Black Men + Asian Women = Love." Some romantic groups specified additional identity components besides race and gender to their sexuality, like religion ("Christian

Black Women for Christian White Men") and age ("Black Women and White Men 40 Plus").

INTRA-INTERSECTIONAL RESULTS

The dominant narrative within Asian American women's groups centered on affirming the intersectionality of race with gender as a general category, for example, "Asian American Women's Alliance" and "Asian American's Women's Circle." Belonging was an important theme. Nearly a third of all Asian American women's Facebook Groups focused on solidifying American women of Asian descent as a viable racial classification. Also significant was the lack of sexuality for Asian women, particularly same-sex attraction, which may reflect cultural stigma (Poon & Ho, 2008).

In addition, strong within Asian American women's Facebook Group online discourse is an emphasis on activism ("National Asian Pacific Asian American Women's Forum"), which counters mass media representations of Asians as politically disengaged (Guillermo, 2014). Other intersectional identity constructions of Asian American women online included entrepreneurship ("Asian American Business Women Association"), domestic violence ("Protecting Asian American Women's Voices"), hobby ("Asian American Women's Running & Fitness Group"), and occupation ("Asian American Women Writers," "Asian Pacific American Women Lawyers Alliance").

As mentioned earlier in this chapter, Facebook Groups may facilitate interpellation and act as a way of hailing homophilous others to coalesce. Such call-and-response has been well documented in the Black community and church-based cultures (Pattillo-McCoy, 1998). Black women's Facebook Groups contained diversity in intersectionality, from general racialized and gendered classification ("Black Women Rock") to occupation ("Black Women Film Network"), creativity ("Black Women Artists"), spirituality ("Black Women of Faith Network"), hobby ("Black Women in Fitness"), beauty ("Black Women and Our Journey Towards Healthy Hair"), romance ("Black Women and White Men"), and location ("Black Women UK," "Black Women in Europe").

Latina Facebook Groups resembled Asian American women's Facebook Groups in that a prevalent theme in the discourse was political consciousness of their intersectional identity on a general level, such as "Wise Latinas Linked" and "Latinas in Motion." In contrast to Asian American women's discourse, Latina online identity construction included lesbianism ("Latina Lesbians") and lesbianism in specific states ("LesbyAnas Latinas en Texas"). The only example of race, gender, and fanaticism for a musician within this data set appeared in "Beliebers Latinas," a group for self-identified Latinas who are fans of pop star

Justin Bieber, whose public relationship with Latina Selena Gomez was a favorite of tabloids.

White Facebook Group discourses made identification claims based on race, but within the narrow confines of romantic interest. Nearly all of the Facebook Groups that referenced White women did so as a racialized and gendered category that spoke to dating attractions and sexual preference, for example, "Freaky White Women for Black Men," "Asian Men and White Women Only," and "White Women Who Love Their Hot Chocolate" (meaning race, not the drink). Within Facebook Groups, intersectional identities of Whiteness with gender revealed acknowledgment of racial differences and sometimes of the privilege attached to Whiteness (McIntosh, 2003; Nakayama & Krizek, 1995). For example, classification as White women was defined not only as threatening to Black women, but actually relishing the socially privileged position that White women have over Black women in the Facebook Group, "Black Women's Worst Nightmare: Sexy Thick White Women." In this Facebook group, the discursive identity of White women is in opposition to that of Black women. The "danger" implied in this construction of White women is that Black men will prefer White women over Black women romantically, particularly White women with curves. While the aforementioned constructions of intersectionality with relationships celebrated transracial attractions, this example portrayed White women's sexuality as competitive and superior to Black women's sexuality. As a contrast, the Facebook Group "Classy Thick White Women Looking to Find a Good Black Man" emphasized the same romantic interests as the aforementioned Facebook Group, but its discourse is not incendiary. Much more rare were other constructions of White women online, which included motherhood ("White Women With Black Babies"), activism ("White Women Against Racism"), and location ("White Southern Women Gone Wild").

LIMITATIONS AND FUTURE DIRECTIONS

Future directions of this research will examine differences among ethnic categories, in addition to race. Specific comparisons among Facebook Group discourses will determine how much similarity exists among ethnic categories that share race-naming practices. For example, in popular discourse, Asian is presumed to represent Chinese, Japanese, Korean, Indian, and Thai, among other ethnicities. Similarly, individuals from Mexico, Spain, and Cuba, among other ethnicities, are considered Latin@. I will analyze the empirical evidence within Facebook Groups to see how much actual crossover exists among the discourses of these ethnic, self-identification markers online. In this manner, I will study inter-ethnic cultural

differences within racialized, online identity groups. Concurrently, I will compare ethnic-based discursive identities with race-based discursive identities online.

This study serves as a benchmark for the salience of intersectional identities online. Facebook Group numbers, descriptions, and membership may change in the future, reflecting transitions in racialized and gendered identification that is context-dependent (Lee & Bean, 2012). This baseline is important in capturing serial changes in the future. In building upon this research, I will collect data using "Asian American women," "Black women," "Latina," and "White women" in five-year periods to examine how time may introduce variance into the data. Among different times, I expect that the number of intersectional identity-based Facebook Groups will vary as online groups may be created and deleted easily. In a future study, I will also examine the intersectionality of race and gender for self-classified Asian, Black, Latino, and White men online to contribute to masculinity studies.

CONCLUSIONS

While scholars use intersectionality as a critical framework for research, my study examines how intersectionality and self-categorization appear in practice online. Race and gender endure as organizing principles in the United States (Chao et al., 2013), and this study demonstrates how offline articulations of intersectionality feed into the construction of online communities based on such persistent, cultural markers of race and gender within group discourse in Facebook. As users choose to join intersectional Facebook groups, sociocultural identities become affirmed in the electronic environment. In this chapter, I show how Facebook women users of color contribute to the "new cultural politics of difference" (West, 1993).

The cultural conversation of race on Facebook, like Twitter, is undergoing transformation through the actions of individuals of color (Brock, 2012; Guo & Lee, 2013; Hogg & Reid, 2006; Mastro & Kopacz, 2006). Facebook Group discourses around race and gender, those built for us by us, reflect societal under-standings of identities that are salient to intersectionality, ones that are attached to religion, sexuality, occupation, and politics. Users collectively and individually define what it means to be Asian women, Black women, Latina, and White women by creating and joining online groups that reflect behaviors affiliated with our category membership. Online identities are rewritten as users practice self-categorization within racialized and gendered Facebook Group options for cultural identification. Women of color are hailing to each other through identity-based discourses within Facebook Groups. Social interactions increasingly are computer-mediated. This study enhances our understandings of women's group culture and contributes to how race and gender matter online.

REFERENCES

Althusser, L. (1971). Ideology and ideological state apparatuses (notes towards an investigation). In B. Brewster (trans.), *Lenin and philosophy and other essays* (pp. 127–186). New York: Monthly Review Press.

Bernstein, B. (1972). Social class, language, and socialization. In P. P. Giglioli (Ed.), *Language and social context* (pp. 157–178). Harmondsworth, UK: Penguin.

Bhopal, R., & Donaldson, L. (1998). White, European, Western, Caucasian, or what? Inappropriate labeling in research on race, ethnicity, and health. *American Journal of Public Health, 88*(9), 1303–1307.

Brock, A. (2006). "A belief in humanity is a belief in colored men": Using culture to span the digital divide. *Journal of Computer-Mediated Communication, 11*(1), 357–374.

Brock, A. (2012). From the Blackhand side: Twitter as a cultural conversation. *Journal of Broadcasting & Electronic Media, 56*(4), 529–549.

Chao, M. M., Hong, Y.-Y., & Chiu, C.-Y. (2013). Essentializing race: Its implications on racial categorization. *Journal of Personality and Social Psychology, 104*(4), 619–634.

Collins, P. H. (1998). It's all in the family: Intersections of gender, race, and nation. *Hypatia, 13*(3), 62–82.

Collins, P. H. (2000). *Black feminist thought: Knowledge, consciousness, and the politics of empowerment.* New York: Routledge.

Crenshaw, K. (1989). Demarginalizing the intersection of race and sex: A Black feminist critique of antidiscrimination doctrine, feminist theory, and antiracist politics. *1989 University of Chicago Legal Forum,* 139.

Crenshaw, K. (1991). Mapping the margins: Intersectionality, identity politics, and violence against women of color. *Stanford Law Review, 43*(6), 1241–1299.

Daniels, J. (2012). Race and racism in Internet studies: A review and critique. *New Media & Society, 15*(5), 695–719. doi:10.1177/1461444812462849

Duggan, M., & Brenner, J. (2013, February 14). *The demographics of social media users—2012* (Pew Research Center's Internet & American Life Project). Retrieved from http://www.pewinternet.org/2013/02/14/the-demographics-of-social-media-users-2012/

Ellison, N. B., Steinfield, C., & Lampe, C. (2007). The benefits of Facebook "friends": Social capital and college students' use of online social network sites. *Journal of Computer-Mediated Communication, 12*(4), 1143–1168.

Erez, M., & Earley, P. C. (1993). *Culture, self-identity, and work.* New York: Oxford University Press.

Facebook. (2013a). Groups. *Facebook Groups.* Retrieved from https://www.facebook.com/help/groups

Facebook. (2013b). Friends. *Facebook Friends.* Retrieved from https://www.facebook.com/help/friends

Fairclough, N. (1995). *Critical discourse analysis: The critical study of language.* Harlow, UK: Longman Group.

Geertz, C. (2005/1972). Deep play: Notes on the Balinese cockfight. *Daedalus, 134*(4), 56–86.

Glenn, E. N. (1999). The social construction and institutionalization of gender and race. In M. M. Ferree, J. Lorber, & B. B. Hess (Eds.), *Revisioning gender* (pp. 3–43). Walnut Creek, CA: AltaMira Press.

Gray, M. L. (2009). Negotiating identities/queering desires: Coming out online and the remediation of the coming-out story. *Journal of Computer-Mediated Communication, 14*(4), 1162–1189.

Guillermo, E. (2014, November 3). Power at CA polls growing, so why don't Asian Americans vote? *NBC News*. Retrieved from http://www.nbcnews.com/news/asian-america/power-ca-polls-growing-so-why-dont-asian-americans-vote-n238261

Guo, L. & Lee, L. (2013). The critique of YouTube-based vernacular discourse: A case study of YouTube's Asian community. *Critical Studies in Media Communication, 30*(5), 391–406. doi:1 0.1080/15295036.2012.755048

Hall, E. T. (1959). *The silent language*. New York: Doubleday.

Hall, S. (1980). Cultural studies: Two paradigms. *Media, Culture, and Society, 2*, 57–72.

Hogg, M. A., & Reid, S. A. (2006). Social identity, self-categorization, and the communication of group norms. *Communication Theory, 16*(1), 7–30.

Kendall, L. (1998). Meaning and identity in "cyberspace": The performance of gender, class, and race online. *Symbolic Interaction, 21*(2), 129–153.

Koh, Y. (2014, January 20). Twitter users' diversity becomes an ad selling point. *Wall Street Journal*. Retrieved from http://online.wsj.com/news/articles/SB10001424052702304419104579323442 346646168

Korn, J. U. (2013). Clever, political, and powerful racialized discourse: Online civic action and #PaulasBestDishes. Unpublished manuscript, Department of Communication, University of Illinois at Chicago, Chicago, Illinois.

Korn, J. U. (in press). Black nerds, Asian activists, and Caucasian dogs: Online race-based cultural group identities within Facebook Groups. *International Journal of Intelligent Computing in Science & Technology*.

Korn, J. U., & Kneese, T. (2015). Feminist approaches to social media research: History, activism, and values. *Feminist Media Studies, 15*(4), 707–710.

Lee, J., & Bean, F. D. (2004). America's changing color lines: Immigration, race/ethnicity, and multiracial identification. *Annual Review of Sociology, 30*, 221–242.

Lee, J., & Bean, F. D. (2012). A postracial society or a diversity paradox? *Du Bois Review: Social Science Research on Race, 9*(2), 419–437.

Leetz, L. (2003). Disentangling perceptions of subtle racist speech: A cultural perspective. *Journal of Language and Social Psychology, 22*(2), 145–168.

Martin, J. N., & Nakayama, T. K. (1999). Thinking dialectically about culture and communication. *Communication Theory, 9*(1), 1–25.

Mastro, D. E., & Kopacz, M. A. (2006). Media representations of race, prototypicality, and policy reasoning: An application of self-categorization theory. *Journal of Broadcasting & Electronic Media, 50*(2), 305–322. doi:10.1207/s15506878jobem5002_8

McCall, L. (2005). The complexity of intersectionality. *Signs, 30*(3), 1771–1800.

McIntosh, P. (2003). White privilege and male privilege. In M. S. Kimmel & A. L. Ferber (Eds.), *Privilege: A reader* (pp. 147–160). Boulder, CO: Westview Press.

McPherson, M., Smith-Lovin, L., & Cook, J. M. (2001). Birds of a feather: Homophily in social networks. *Annual Review of Sociology, 27*, 415–444.

Miike, Y. (2006). Non-Western theory in Western research?: An Asiacentric agenda for Asian communication studies. *Review of Communication, 6*(1–2), 4–31.

Nakamura, L. (2002). *Cybertypes: Race, ethnicity, and identity on the Internet*. Bristol, PA: Taylor & Francis.

Nakamura, L. (2008). *Digitizing race: Visual cultures of the Internet*. Minneapolis: University of Minnesota Press.

Nakayama, T. K., & Krizek, R. L. (1995). Whiteness: A strategic rhetoric. *Quarterly Journal of Speech*, *81*, 291–309.

Nash, J. C. (2008). Re-thinking intersectionality. *Feminist Review, 89*, 1–15.

Park, N., Kee, K. F., & Valenzuela, S. (2009). Being immersed in social networking environment: Facebook Groups, uses and gratifications, and social outcomes. *CyberPsychology & Behavior, 12*(6), 729–733.

Pattillo-McCoy, M. (1998). Church culture as a strategy of action in the Black community. *American Sociological Review, 63*(6), 767–784.

Poon, M. K.-L., & Ho, P. T.-T. (2008). Negotiating social stigma among gay Asian men. *Sexualities, 11*(1–2), 245–268.

Proudford, K. L., & Smith, K. K. (2003). Group membership salience and the movement of conflict: Reconceptualizing the interaction among race, gender, and hierarchy. *Group Organization Management, 28*(1), 18–44. doi:10.1177/1059601102250014

Rainie, L., Smith, A., & Duggan, M. (2013, February 5). *Coming and going on Facebook* (Pew Research Center's Internet & American Life Project). Retrieved from http://www.pewinternet.org/2013/02/05/coming-and-going-on-facebook/

Rasti, A., & Sahragard, R. (2012). Actor analysis and action delegitimation of the participants involved in Iran's nuclear power contention: A case study of "The Economist." *Discourse Society, 23*(6), 729–748.

Rellstab, D. H. (2007). Staging gender online: Gender plays in Swiss Internet relay chats. *Discourse & Society, 18*(6), 765–787.

Rockquemore, K. A., & Arend, P. (2002). Opting for White: Choice, fluidity and racial identity construction in post civil-rights America. *Race and Society, 5*(1), 49–64.

Sassen, S. (2002). Towards a sociology of information technology. *Current Sociology, 50*(3), 365–388.

Senft, T. M., & Noble, S. U. (2013). Race and social media. In J. Hunsinger & T. M. Senft (Eds.), *The social media handbook* (pp. 107–125). New York: Routledge.

Turner, J. C., Hogg, M. A., Oakes, P. J., Reicher, S. D., & Wetherell, M. S. (1987). *Rediscovering the social group: A self-categorization theory*. Cambridge, MA: Basil Blackwell.

Turner, J. C., & Reynolds, K. J. (2011). Self-categorization theory. In P. A. M. Van Lange, A. W. Kruglanski, & E. T. Higgins (Eds.), *Handbook of theories of social psychology* (vol. 2, pp. 399–417). London: Sage.

Tynes, B. M. (2007). Role taking in online "classrooms": What adolescents are learning about race and ethnicity. *Developmental Psychology, 43*(6), 1312–1320.

Tynes, B. M., Garcia, E., Giang, M., & Coleman, N. (2011). The racial landscape of social network sites: Forging identity, community & civic engagement. *I/S: A Journal of Law and Policy for the Information Society, 7*(1), 71–101.

Van Dijk, T. A. (1985). Introduction: Levels and dimensions of discourse analysis. In T. A. van Dijk (Ed.), *Handbook of discourse analysis* (pp. 1–11). London: Academic Press.

Van Dijk, T. A. (1993). Principles of critical discourse analysis. *Discourse Society, 42*, 249–283.

West, C. (1993). The new cultural politics of differences. In S. During (Ed.), *The cultural studies reader* (pp. 203–220). London: Routledge.

Zhao, S., Grasmuck, S., & Martin, J. (2008). Identity construction on Facebook: Digital empowerment in anchored relationships. *Computers in Human Behavior, 24*(5), 1816–1836.

Grand Theft Auto V: Post-Racial Fantasies AND Ferguson Realities

DAVID J. LEONARD

INTRODUCTION

To much fanfare and anticipation, Rockstar Games released versions of *Grand Theft Auto V* (*GTA: V*), its flagship game, for the Sony PlayStation 4 and Microsoft Xbox Live gaming systems on November 19, 2014. (The game was originally released for PlayStation 3 and Xbox 360 in September 2013, and sales from the game had already reached an estimated $2 billion. As of May 2014, 33 million copies had been sold, setting all kinds of world records.) Within two short weeks, this new version was the number one selling game in both the United States and Great Britain (Thier, 2014).

While Rockstar counted its money, and gamers across the nation and beyond sat down to take part of a world of crime, violence, and mayhem, Ferguson, Missouri, erupted in protest. Reacting to the November 24, 2014, announcement of the grand jury's decision not to prosecute Darren Wilson for the killing of Mike Brown, as well as countless other killings, hypersegregation, and systemic racism, the protest was bigger than this one moment. Yet when looking at my White friends' Facebook pages, examining "White Twitter," seeing news reports on who was shopping on Black Friday, and otherwise listening to the topics of conversation within White America, a level of detachment and denial was clear. Maybe they were busy playing *GTA: V*.

In the same week that Rockstar released a game that has come to define "ghettocentric games," where White kids can fulfill their insatiable desires to become Black, to experience the danger of "ghetto life," we saw yet again the devaluing of Black life (Watkins, 1998). As the video game industry released its most successful game, one that traffics in anti-Black stereotypes, creates a world of "demons" and "angels," finds pleasure in Black death and sexual violence, and seemingly turns inner-city communities into war zones where the police are the only moral compass and source of safety, protesters took to the streets and social media to say #BlackLivesMatter. While President Barack Obama chided protesters to "behave," and other so-called leaders lamented the lack of parental role models, gamers transported themselves into a space "play," a virtual sandbox of destruction and death. As commentators, news media outlets, political leaders, and countless numbers of people in social media described Mike Brown as a "thug," painted Ferguson (or Baltimore) as a lawless ghetto, and denied the racial realities of police violence, millions of gamers surely found pleasure in robbing, brutalizing, and murdering in the fictional city of San Andreas.

In the same week that Tamir Rice and Akai Gurley became yet two more victims of police-on-Black violence, gamers undoubtedly descended to the "safety of their homes" to become Franklin, one of three characters within *GTA: V*, and the lone player-controlled Black character. The narrative and biographical background afforded Franklin Clinton is telling. Having never met his father, and having seen his mother die from a drug addiction, Franklin brings to virtual life the dominant narratives of contemporary Black families. Kicked out of high school for assaulting a teacher, he turned to a life of gangs and crime before his 18th birthday. From drug dealing to murder, from bank robberies and carjackings, Franklin engages in a range of criminal activities before he is sent to prison. This is what we know about Franklin and how the game introduces him to players. After his release, while on a "righteous path," he is sucked back into a life of crime. His true character and his upbringing are too hard to overcome. He is unredeemable and incapable of being a law-abiding citizen. Sounding like Fox News, and those who rationalize stop and frisk, and the brutal killing of all too many Black youth, *GTA: V* brings to life the criminalized Black body, ready and available to substantiate hegemonic narratives and White pleasure.

With this in mind, this chapter explores the dialectics that exist between the narrative and representational discourse offered through *Grand Theft Auto V* and within the Ferguson rebellion. Arguing that the game itself and the surrounding discourse of reception signifies the hegemonic nature of contemporary racial discourse, this chapter concludes that in America, whether within those virtual landscape or everyday realities, Black lives still don't matter. The power of colorblindness and hegemonic White fictions of Black criminality and a pathology rooted in violence and sexism are central to games such as *Grand Theft*

Auto V, as well as the mainstream imaginaries of Ferguson and the public discourse surrounding each. The "ghettocentric imagination" that governs so much of gaming simultaneously operates through and within discourse around police violence, inequities, and the struggle for justice. Focusing on the signifying of "ghettocentric gaming" and the connections between games and the politics of this moment, this chapter explores the power in both color-blind and Black criminalizing narratives. The allusive humanity of Black lives within gaming culture should be of little surprise, as games merely reflect the ideological and representational landscape of society as a whole.

VIRTUAL PLAYGROUNDS, REAL PLAYGROUNDS

The nature of race in 21st-century America (and its entrenched racism and sexism) is on full display here. *GTA: V* and the entire Grand Theft Auto franchise, alongside of the video game industry as a whole, has relied on hegemonic anti-Black stereotypes as the anchor of its virtual playgrounds. According to Lisa Nakamura (2002), new media, with its circulation of "cybertypes," "propagates, disseminates, and commodifies images of race and racism" (p. 3).

Similarly, Tanner Higgin (2009) argues, "The game world is not simply a sandbox where entirely new sociopolitical situations are designed and enacted and then exported into the physical world. Games are also necessitated and deeply informed by the epistemic contours of contemporaneous American culture and its history" (p. 23). He further notes:

> Stuart Hall's (1996) call for a shift in Black cultural critique "from a struggle over the relations of representation to a politics of representation itself"…serves a timely purpose in the current historical moment of video games wherein representations are a primary site of contestation. Hall asserts that representations within games are both reflective and constitutive of culture but also that the mere recognition of the existence of these stereotypes is not enough. Instead, the scholarly community must be tasked to revise critiques that judge representations as good or bad based on an essential ideal that solidifies and thus entraps raced identity. Representations must be analyzed in regard to how they are constructed as well as the structural and political circumstances that generate and support them. Only when these regimes and practices are exposed can they be systematically demolished. (p. 20)

Despite the retort that games are not "real," and how it is "just a game," the origins and meanings of these representations have consequences. That is, the line between the virtual and the real, the representational and the lived, the imagined and the realized, and the satiric and the stereotype is neither clear nor impenetrable. These images are socially produced and consumed within an environment of mass incarceration, stop-and-frisk, and the hyper-criminalization of Black bodies. According to Burgess, Dill, Stermer, Burgess, and Brown (2011):

It is important to note that the stereotypical images of Black video game characters are not even real people, but they can still provide fodder for negative social judgments and negative reactions to real Black men. Support for this notion comes from Slusher and Anderson (1987), who found that even when people are simply asked to imagine stereotypes such as a rich lawyer, they do not distinguish between what they have imagined and what they have seen in reality. Slusher and Anderson call this a failure of reality monitoring. People treat their imaginary vision as they would a real-life image and it supports their stereotypes. If this is true, then it follows logically that seeing another type of imaginary or fantasy image—a picture of a video game character—might also be treated as confirmation of a stereotype. There will be little difference from seeing a Black thug in a video game and seeing a real Black criminal—both will be taken as evidence confirming the culturally held stereotype of the Black male criminal. (p. 293)

Creating worlds of crime, gangsters, prostitution, drugs, guns, and violence fulfills an insatiable desire to enter into the world of the Other; to control, master, and dominate these "uncivilized" spaces. This is not simply an American tradition, which fulfills the masculine yearning to dominate and destroy, but one that reinforces a dominant racial schema. In other words, the appeal and the popularity of games such as *GTA* emanates not simply through circulation of Americana—guns, sex, materialism, violence—but through its deployment of dominant ideologies of Whiteness, Blackness, and race.

Embodying a neoliberal economy of multiculturalism and diversity, while recycling the longstanding traditions of minstrelsy, games such as *GTA: V* traffic in race—stereotypes, racial narratives, racial signifiers—and colorblindness. While normalizing racial frames that imagine Black bodies as criminal and aggressive, it turns these frames into spaces and sources of play and pleasure. Not about hate but fascination and fetishization, such virtual projects embody the traditions of White supremacy and consumption—commodity racism (McClintock, 1995). In 2003, I wrote about the place of video games within larger history of minstrelsy. Focusing on *GTA: III*, I saw games as yet another space that privileged White pleasure derived from the dehumanization of Black bodies and spaces:

Games elicit pleasure, play on White fantasies, and affirm White privilege through virtual play. According to Lott (1993), minstrelsy was a "manifestation of the particular desire to try on the accents of 'Blackness' and demonstrates the permeability of the color line" (qtd. in Rogin, 1998, p. 35). Blackface "facilitate[s] safely an exchange of energies between two otherwise rigidly bounded and policed cultures" (qtd. in Rogin, 1998, p. 35). Video games operate in a similar fashion, breaking down boundaries with ease, allowing players to try on the other, the taboo, the dangerous, the forbidden, and the otherwise unacceptable. (Leonard, 2003, p. 5)

Yet, the types of narratives, the representations, and the worldview are specific to our current moment. It reflects the hegemony of multiculturalism that sees diversity and visibility as power. Inclusion in the marketplace is positioned as

acceptance and making it. Writing about the unfulfilled promises of the "race conversation" amid persistent inequality, segregation, and criminalization, Jeff Chang (2014) describes a nation defined by cultural desegregation and hyper-segregation, inclusion and exclusion, popular cultural integration and material exclusion, and a world of "us" versus "them" where race is everywhere but nowhere:

> That might seem like a counterintuitive idea in a culture that appears desegregated, when you need only turn your TV to ABC for *Black-ish* on Wednesdays or three hours of *Shondaland* on Thursdays to see families and women of color in central roles. But one kind of representation does not automatically lead to the other. Our politics still reconcile themselves under the long shadow of the Southern Strategy, the Nixon-era political realignment that has left us with a two-party system that mirrors patterns of resegregation and produces the pendulum swings of "wave elections". Such swings inevitably turn on White anxiety over demographic and cultural change. Our silence gets filled by demagogues who profit from the politics of division.

Writing about the late Stuart Scott, who seemingly transformed the landscape of sports media in general and ESPN specifically with his infusion of hip-hop aesthetics, Guthrie Ramsey (2015) similarly highlights the ascendance of Black popular culture in a post-Reagan moment:

> The 1990s will be remembered as a boom decade for Black popular culture. One might say that like New Negroes in the 1920s, African American performers are in vogue. By the century's end, Black expressive culture had become a pervasive factor in American society, fixed indelibly to the country's cultural profile. African American entertainers of all stripes are a commanding presence in the culture.... Hip-hop culture has taken on the profile of a cottage industry because of aggressive corporate commodification. The post industrial decline of United States urban centers, a downward turn that ironically spawned Hip-Hop's developments, has been co-opted by corporate America and represented as a glossy, yet gritty complex of music idioms, sports imagery, fashion statements, racial themes, danger, and pleasure. While history shows us the persistence of the exploitation of African American culture in the United States, Hip-hop represents an exemplary case in this regard.

Our 1990s popular culture sought to capitalize on societal yearning for diversity and multiculturalism, which meant converting signifiers of failed dreams and lost lives, of a post-industrial, hyper-segregated, and racially stratified America, into sources of pleasure and profit. As noted by Robin D. G. Kelley (1998), "[c]orporate imagination, post industrial employment, few employment opportunities for African Americans and a White consumer market eager to be entertained by the Other, Blacks have historically occupied a central place in the popular culture industry." Focusing on shoe companies, Kelley concludes:

> Nike, Reebok, L.A. Gear, and other athletic shoe conglomerates have profited enormously from post industrial decline. TV commercials and print ads romanticize the crumbling

urban spaces in which African American youth must play, and in so doing they have cre-
ated a vast market for overpriced sneakers. These televisual representations of "street ball"
are quite remarkable; marked by chain-link fences, concrete playgrounds, bent and rusted
netless hoops, graffiti-scrawled walls, and empty buildings, they have created a world where
young Black males do nothing *but* play.

Chang, Ramsey, and Kelley could easily be writing about the 2014 video game
industry, and the ways that it has capitalized on a marketplace emanating from the
embers of post-industrial segregation.

SAN ANDREAS: RACE EVERYWHERE BUT NOWHERE

Amid claims of colorblindness, *GTA: V* is a game about race; it is a game that sells
stereotypes of body and place; it circulates a narrative anchored by ideologies and
tropes of race, gender, and class. It relies on a worldview that sees the Black com-
munity as devoid of morality or humanity. It necessitates a world without fathers
and mothers, one that makes poverty visible and invisible and otherwise strips
away the everyday experiences of communities throughout the nation. It relies
on the assumptions and hegemonic fictions circulated across the media, all while
embracing narratives of virtuality and post-raciality.

One review made clear how the game does not simply circulate the hegemonic
stereotypes of "blackcriminalman" (Russell, 1998), but imagines inner-city Black
communities as wastelands of poverty, criminality, and moral bankruptcy:

> Franklin is the first playable character. Similar to CJ in *San Andreas*, Franklin is well-meaning
> gangster who lives with his aunt in the ghetto and is trying to make a better life for himself.
> Clearly more intelligent than his known associates, Franklin is confined to being a repo
> man for a shady car dealer who plays the race car to get customers into vehicles they can't
> afford, only to have Franklin repo them weeks later thanks to ludicrous financing. After
> one of the customer's father, Michael, gets a whiff of this little scam, he comes down to pay
> the dealer a little visit. Impressed by his attitude, Franklin decides to reach out to Michael
> to see if they could work together. (Hannley, 2014)

Predicting criticism for a franchise that has gained immense popularity because
of it dissemination of racial stereotypes, through objectification of women, and
through its "ghettocentric imagination," the gaming industry and its proxy rep-
resentatives within the media preemptively sought to silence opposition with
the release of *Grand Theft Auto V* with the predictable "it is just a game," "all the
characters are stereotypes," and "every community is flattened" to disarm any crit-
icism. Ignoring the ways that the "sincere fictions" around African Americans,
whether ideas about "Black on Black crime" or "children born out of wedlock,"

both normalize inequality and erase the implications of racism, such arguments reflect the nature of color-blind racism (Vera, Feagin, & Gordon, 1995).

A foundational element of the race-denying gamers has been claiming that *GTA: V* is "satire." For example, in a review in the *Guardian*, Keith Stuart (2013) argues, "Rockstar North has built an extraordinary universe that functions not only as an exciting, diverse setting but also as a pulverising, nihilistic satire on western society." Erik Klain (2013) made similar argues within a *Forbes* review:

> The game gives you the freedom to drive like a madman, mow down pedestrians, and engage in various other activities most people would never dream of doing in real life. Like play golf. And it's all good, reckless fun.
>
> But as you move through the game's story, or listen to its commercials and talk radio, or even eavesdrop on the chatter of passersby, the satirical side comes out. Sometimes it's just for laughs; at other times it's darker and more cutting.
>
> Whether it's just a jab at Nashville—modern country music is described as "twangy pop music sung by frat boys"—or a much more pointed shot at Facebook and other big tech companies with the game's Life Invader company, whose CEO (shortly before you assassinate him) brags about the number of child workers it employs across the globe, the game revels in social commentary.

Focusing on the game's radio commercials, billboards, TV commercials, and invoking of talk radio, Dennis Scimeca (2013) makes a similar point, concluding that the game mirrors the cultural interventions offered by Jon Stewart and Stephen Colbert in that all three spotlight "the hypocrisies and lunacy of American society paraded on national television." He further notes:

> For now, the satire of "Grand Theft Auto V" is made all the richer by the obliviousness of the majority of its audience. We can count on most of the people who play "GTA V" to fail to realize how thoroughly they're being dismissed as empty and extraneous extensions of vacuous consumer culture or, even if they do realize, count on their failing to care—which makes the game's argument more pointedly than any fake website, billboard or television program ever could. And as with a television show like South Park, almost nobody comes out unscathed. Conservatives and liberals are chastised with equal gusto; the game's FBI is called the FIB; and so on and so forth.

Such defense of games like *GTA* is not limited to the media discourse but is also commonplace within comment sections that seemingly scoff and deny any criticisms directed at games and gamers. For example, Remy Carreiro (2013) defends *GTA: V* with ease and simplicity: "It is fucking satire, every inch of the entire game, and an amazing satire at that. A satire of a pop culture obsessed world that has gone down the shitter. I thought this was just me, but yes, this is very much intentional on the part of Rockstar.... The game is a satire of our world, and the best satire holds up a

mirror, so if you are 'mad' at this game for being racist and fucked up, you need to look at the bigger picture. Us, as a whole."

First, the racial denials through claims of satire reflect a questionable understanding of satire. According to Lisa Guerrero, satire is "a form of literature, performance, or visual art that ridicules human folly as a means of social criticism in an effort to foment change and/or to serve as an admonition" (qtd. in Leonard, 2014). There are certainly examples within the GTA series that fits such a definition; the game's commentary on hyper-materialism, American exceptionalism, or even gun culture, given its extreme orientation and its potential to advance social criticism and change, points to elements of satire. It has satirical elements. It most certainly offers a satiric look at the state of the American Dream within today's neoliberalist economy. Despite its elusiveness and the lack of happiness that comes with "making it," the American Dream remains the dominant cultural trope. The presence of satire doesn't preclude critical examination and it does not give its auteurs, or those who find pleasure in its consumption, a pass that erases the destructive and troubling racial and gender narratives and representations. The satirical elements are not totalizing and fall short with respect to race and gender. The presence of satire or its notation is not absolution for the game's sins; yet the "satire card" clearly works to silence and constrain any criticism.

Second, it seems to make no distinction between the game's representation of culture, ethnicity, gender, and race. That is, the satirizing of American culture, or White anarchists holding "Down with capitalism" signs, cannot be simply read along the same plane as the deployed stereotypes governing the representation of Black bodies or the sexualization of women. To flatten wealthy White communities as yoga-practicing, kale-eating, tennis-playing dens of materialism and shallowness has a different history and social/political/racial/economic context from imagining inner-city communities as lawless war zones defined by poverty, drugs, violence, and immorality. To portray rural Whites within the game as tractor-driving and overall-wearing hicks is not on par with the games' reduction of women to sexual objects. Edward Smith (2013) highlights the level of misogyny within the game:

> Michael's daughter has a tattoo that says "Skank." A radio station advertises a college where women can learn to screw better. There's a level where you're chasing an actress because a paparazzi friend wants to get a photo of her "low-hanging muff."
>
> Almost everything in *Grand Theft Auto 5* is at the expense of women. The constant gags about female bodies are one thing, but the game consistently marginalizes women and their sexuality:
>
>> Franklin's auntie wants to start a feminist discussion group at her house. The game refers to her constantly as a "crazy bitch."

> After discovering he cheated on her, Michael's wife sleeps with her tennis instructor. It's later revealed that she used to be a stripper and now has fake breasts, as if women who own their sexuality have to be sluts.

> Sometimes you'll be flagged down by a woman at the side of the road who's screaming for help because her neighbor is beating his wife. If you pull over, you'll discover it's a ruse, and she's actually a gangbanger leading you into an ambush. Accusations of domestic violence, it seems, always hide some ulterior motive on the behalf of the complainant.

It is hard not to think about sexual violence on college campuses, or the epidemic of domestic violence in connection to these games, especially as we look at the violence directed at women who dare to spotlight the entrenched misogyny within these games and the industry that produces them. Given the rampant sexism within the video game industry, and gamer culture, as evident by GamerGate, it is crucial to create spaces to examine the representational field and the material and ideological conditions of production and consumption (Smith, 2014). The dialectics between the game's constructions of Black masculinity and the dehumanization of women of color points to the necessity of intersectional analysis (Crenshaw, 1991; Shaw, 2015). The pleasure derived from becoming and controlling Black male bodies, and the pleasured power resulting from the objectification and violation of women of color, highlights the connectivity of anti-Blackness, misogyny, and heteronormativity, and the demonization of the poor. Obscuring the pain and humanity of both the criminalized Black male body and the sexualized and abused Black woman's body, the game and the resulting discourse imagines a world rife with sexism, misogyny, and violence that is "foreign" to communities illegible to much of San Andreas. In doing so, the gaming landscape also obscures Whiteness, all while centering it as index of civility and order.

At the same time, in looking at these examples, not to mention the dehumanization of prostitutes and strippers, one must ask, What and where is the satire? Rather than rendering sexism in its extreme or representing sexual violence in exaggerated terms, it normalizes misogyny, giving voice to hegemonic ideas about sexual violence and intimate partner violence. Embodying rape culture and a society that values women for sexualized body parts, the satire defense falls on its face. Read alongside of startling numbers of sexual violence on college campuses and within the military, or the issue of domestic violence throughout society, it is clear that there is nothing extreme or transformative about these representations (Jeltsen, 2012; Kutsch, 2014). Rather they normalize and find pleasure in sexual violence and in the daily assault on women's bodies.

To further illustrate the game's failed attempt at satire or, better said, the nature of the "satire dodge," I want to turn attention to the game's representation of the police in that *GTA: V* is a public service announcement for more cops on the

street, bigger prisons, more militarized police forces, and a culture of impunity for the entire criminal justice system.

At one level, we can see how the game attempts to satirize the police. The game's description of police and its societal role embraces the aesthetics of satire: "The Los Santos Police Department is famous for tackling crime in the most aggressive and unhinged way possible. This is through community outreach like stop and frisk, spectacular police chases and liberal use of stun guns and service revolvers" (Rockstar Games, n.d.). Through the transparency of rhetoric and the irony of describing stop-and-frisk as community outreach or police shootings as "liberal use of guns," the game seems to be poking fun at the police in an attempt to highlight the injustices of police violence. Yet, there is no extreme here; in fact, the description downplays the level of violence, the militarization of today's police force, and the level of racism.

At another level, the game reinforces the ideas that police face a difficult job, one that is reiterated in almost every defense of the police. In the wake of police shootings or instances of police brutality, the public discourse often focuses on the difficulty and danger that police officers face, seemingly rationalizing any response as understandable at worst, and justifiable at best. This is the message of the *GTA* series. Los Santos is a war zone, with criminals, gun-toting gangsters, and immorality at every turn. Police face a difficult and dangerous job. Such a narrative is commonplace in the justification of police-on-Black violence with ubiquitous references to how police risk their lives. *GTA: V* depicts a world where cops are merely reacting to the violence, the criminals, and the shootings initiated by the player. Police are always the victims. It is not a world where the police descend on a kid with toy gun at park and within one to two seconds shoot him multiple times. It is not a world where police harassment over "loose cigarettes" leads to be being choked to death. It is a world of good and bad, where the police are innocent and the protectors of innocence. Moreover, in the narrative, because the game is one where players engage in and commit crimes, the police are always responsive to criminality and choices; denial of racial profiling and the game's positioning of police as passive is important.

Despite these built-in defense mechanisms that give voice to entrenched color-blind racism, the release of *GTA: V* has elicited significant pushback from gamers, who highlighted its gratuitous violence, sexism, and racism. Not surprising, given the insidious levels of racism, sexism, and violence within gaming culture both in representation and its production ranks (Campbell, 2013; Conditt, 2015; Isaacson, 2012), this counter-narrative manifests in unique ways for this game. At one level, the emergence of social media has transformed the interventions, resulting in critiques that flow with ease through the Web. Whereas 10 years ago, these critiques were siloed within academic journals, progressive magazines, and oppositional websites, the disruptions are commonplace within

Twitter, YouTube, Vine, and Facebook. More than the ease and the resulting ubiquity, these social media interventions allow for in-the-moment gaming research. In other words, social media allow gamers to share their real-time experiences with virtual microaggressions and macroaggressions. From Twitter to YouTube, gamers have documented the game's uncritical use of racism and sexism. Of particular interest here is the ways that gamers have highlighted racial profiling within the game. One commenter noted:

> "Cops are racist towards the black character, Franklin." So, I was strolling down a boulevard, innocuous as any upstanding citizen, and suddenly, a white man begins assaulting me, making me flee as he pursued me with his frantic violence. Abruptly, I have 1 star—absolutely no reason besides the fact a citizen reported the situation and I was presumed the culprit…and the cops arrive. As I'm innocent, I raise my hands, knowing they'll understand, but they abruptly say 'HE HAS A WEAPON' whilst I'm unarmed, opening fire…
>
> 2 minutes later, I'm running down an alley as eight LAPD cops are behind me, GUNS DRAWN, and I still have absolutely no clue as to why. "Is it because I am black? Is this what happens? They think I am immediately guilty? I am armed? I am a huge threat? I've done something?" I see an escape, a rooftop with a ladder up it, and I begin climbing, but the police murder me—shooting me in the back multiple times as an 'armed suspect'… execution-style as I have my back to them.

Another noted:

> "The main thing I've learned while playing this game (GTA 5)": I was driving around as Franklin and stopped at a gas station in a more rural part of town. Got out of my car, walked up to this white trash woman. The fella she was with punched her in the face, ran away, she looks at me, calls the cops. 1 star.

Gamers took to Twitter to document the injustices felt by Franklin:

> Walked up to a cop as Franklin, cop dropped his coffee and said "back the f*** up". Then shot me in the face. For no reason. #Racist #GTAV
>
> Anytime I'm franklin, I get chased by cops for "a disturbance." this never happens with Michael or Trevor. The gta cops are racist (Bossip Staff, 2013).
>
> White chicks in GTA V are RACIST! they call the cops and run away from Franklin just because he's black. I just…
>
> GTA V police are racist I swear, I was cruising as franklin, one police car runs me off my bike, I get 2 stars and the Feds killed me (Thier, 2014).

The examples were endless; each would spotlight hyper-surveillance, profiling, and brutality from the cops within the game's inner-city neighborhoods and when playing Franklin. Yet, the other characters, especially when in the wealthy parts

of San Andreas or the rural spaces, faced diminished police interest, even when engaging in disruptive (honking a horn) or criminal behavior.

Straddling the line between hyperrealism and "it is just a game," between social commentary and virtual playgrounds, between racial satire and colorblindness, Rockstar responded to these criticisms swiftly, noting that there was nothing to the accusations of racial profiling. "This is absolutely false, the in-game police don't treat one lead character any differently from the others" (Bossip Staff, 2013).

Others agreed, demonstrating how the game was color-blind and that conversations about racial profiling were superfluous. For example, Abel Nunez noted in the comment section of a piece about accusation of the virtual racial profiling of *GTA: V* as follows:

> Rockstar has a point, now…this is the most realistic and immerse gta game so far, everything in this game is supposed to be as real as it can get, and guess what, they have accomplished that! if you to Groove Street as Franklin, ballas probably wont even look at you, but if you go as Trevor or Michael they will seriously look at you, approach and if you do not run away or flee you will be shot, or robbed, because that's what happen! This supposed racism form LSPD is a reality in LA, if you go to the most wealthy part of LS happens the other way around, people will look at you differently, also cops, i have almost half of the storyline complete, not counting the free roaming, and i have never experienced this so called "racist profiling" besides, ITS A GAME, if you're going to get this upset upon a game then why did you bought it? Stop playing it. (Bernstein, 2013)

Others were not so subtle, denying that race matter at all. "I've noticed that they behave very aggressively no matter who you are, which might account for some of the stories that are popping up," wrote Dave Their in "Rockstar: 'GTA 5' Cops not racist." "In this world, loitering is punishable by instant execution. It says something about the depth of the world that Rockstar has built that players start to see this sort of emergent behavior even when it's not actually there" (Thier, 2014).

As with the real world, the denial was swift, with protests dismissed as irrational and reflecting people's desire to "play the race card." The incredulous denunciation of the mere suggestion of the possibility of virtual racial profiling reflects the hegemony of colorblind narratives amid the entrenched and systemic uses of race. It reflects a world where race matters but racism doesn't exist. It reflects the absurdity of claims of satire in that had the game embraced satire, an aesthetic of the extreme in an effort to spotlight injustice, its creators would have acknowledged the existence of racial profiling, making it a more prominent part of the game. If the game was invested in social commentary, in shedding light on the injustices surrounding racial profiling, there would be neither denial nor ambiguity because as constructed *GTA: V* reflects a muted construction of anti-Black racism within America's policing.

It also embodies a denial of the existing research on the impact of representations as it relates to racial profiling, implicit bias, and police shootings. The cultural propensity to criminalize Black victims, whether those who die at the hands of police or as the result of ongoing gang violence, reveals the difficulty in claiming satire here. In a world where Black men and women, boys and girls, not to mention communities, are seen as inherently suspect and criminal, the production of San Andreas mirrors dominant ideologies and narratives. There is no exaggeration but rather recapitulation of existing stereotypes and narratives; it recycles a worldview that imagines inner-city community as warzones of Black criminals and heroic police, as places of "thugs" and gangsters, suspects and no angels. These are not simply cultural inscriptions limited to popular culture and virtual playgrounds, but the frames and narratives that govern both political structures and policing institutions.

CONCLUSION

It is no surprise that #BlackLives don't matter in San Andreas, in Los Santos, and in the video game industry. They don't matter in Baltimore, Ferguson, or in America. Systemic racism is the most dominating controller inside and outside of virtual reality, a world produced by the White male dominated video game industry. Games merely reflect the ideological and representational landscape of society as a whole.

While recapitulating anti-Black narratives and ideologies, the gaming world provides players with the opportunity to mock, play with, kill, and otherwise control Black bodies. It offers the ideological comfort that rationalizes more police and prisons to control these war zones. It offers a world of colorblindness because "some of my favorite characters are Black." It provides the language of colorblindness from "it is just satire" to "everyone is stereotyped." All of this is done while turning poverty, crime, police violence, deindustrialization, and Black life into a neoliberal playground, a virtual sandbox that traffics in stereotypes and a commodified Black life that can be both inhabited and controlled from the safety of White homes.

While Black organizers, activists, and community members continue to protest, taking to the streets to demand justice and a culture that values Black life, White kids sat at home playing with Black lives. While Ferguson and New York and Los Angeles were brought to a standstill through occupations of malls and freeways, White gamers sped across their virtual freeways as they escaped police seeking their arrest for looting and destruction of the community. While media commentators and political elite dismissed the protests as criminal, symptoms of

dysfunction, and evidence of a culture of "race cards," Rockstar and its gaming partners capitalized financially on the entrenched fictions of Black criminality and dysfunction, even as it denied the racial text and context of its narrative offering.

Playing *GTA: V* amid a moment of protest should elicit pause. The dialectics between the real and the virtual, between the narrative and the everyday, between the playground of violence and the shattered dreams of all too many Black boys and girls, men and women, highlights what's at stake. So does the constrained imagination. *GTA: V* offers a world of immense crime and police empowered to control the war zone; there are no alternatives, there are no protests; there is no place for the articulation of "freedom dreams" (Kelley, 2003). Maybe that will come with *GTA: VI* or *GTA: X* or better yet within games that offer a counter-narrative, that challenge the hegemony of the gaming world and its partner inside and outside of the pernicious playgrounds. As protestors voic,e their rage about systemic divestment from urban communities, whether in Chicago or Baltimore, in Ferguson Flint, or Detroit, the hyper-visibility and invisibility of these spaces is startling. Present as virtual playgrounds, as lessons about the values of hard work and the importance of family, as evidence of the frayed bootstraps and pathological choices, yet invisible as spaces of humanity, of rage, of hope, community, and family, Baltimore and Los Santos remain figments of the White hegemonic imagination. They exist as useful sources of play and legitimation, so long as they can be controlled, turned off and tuned out, affirmations of the American Dream and White exceptionality.

If there is ever a space for reimagined policing, urban communities, and race in the 21st century, the gaming world holds that potential. #BlackLivesMatter; it is about time that gamers embrace that idea because the consequences of its complicit place in the realities of anti-Black racism are deadly.

REFERENCES

Bernstein, J. (2013, September 26). The Franklin Conspiracy: Why gamers decided the police in 'GTA V' are racist [Blog Post]. Retrieved August 10, 2015 from http://www.buzzfeed.com/josephbernstein/the-franklin-conspiracy-why-gamers-decided-the-police-in-gt#1e33zsc

Bossip Staff. (2013, September 28). Really??? Grand Theft Auto 5 developers defend game against racial profiling programming toward black character [Blog post]. Retrieved from http://bossip.com/842089/really-grand-theft-auto-5-developers-defend-game-against-racial-profiling-programming-toward-black-character-43081

Burgess, M. C. R., Dill, K. E., Stermer, S. P., Burgess, S. R., & Brown, B. P. (2011). Playing with prejudice: The prevalence and consequences of racial stereotypes in video games. *Media Psychology*, *14*, 289–311.

Campbell, C. (2013, September 16). How to tackle gaming's lack of racial diversity [Blog post]. Retrieved from http://www.polygon.com/2013/9/16/4728320/how-to-tackle-gamings-lack-of-racial-diversity

Carreiro, R. (2013, September 27). The Franklin conspiracy: Why gamers decided the police in "GTA V" are racist [Web log comment]. *BuzzFeed*. Retrieved from http://www.buzzfeed.com/josephbernstein/the-franklin-conspiracy-why-gamers-decided-the-police-in-gt?fb_comment_id=fbc_531276236941637_4228112_531431030259491

Chang, J. (2014, November 29). America wiped out years of progress. Let's have "the race conversation" for real this time [Blog post]. *The Guardian*. Retrieved from http://www.theguardian.com/commentisfree/2014/nov/29/america-race-conversation-ferguson-commission

Conditt, J. (2015, January 16). Gaming while Black: Casual racism to cautious optimism [Blog post]. Retrieved from http://www.joystiq.com/2015/01/16/gaming-while-black-casual-racism-to-cautious-optimism/

Crenshaw, K. (1991). Mapping the margins: Intersectionality, identity politics, and violence against women of color. *Stanford Law Review, 43*(6), 1241–1299.

Hannley, S. (2014, November 17). Review: Grand Theft Auto V (PS4) [Blog post]. Retrieved from http://www.hardcoregamer.com/2014/11/17/review-grand-theft-auto-v-ps4/117718/

Higgin, T. (2009). Blackless fantasy: The disappearance of race in massively multiplayer online role-playing games. *Games and Culture, 4*(1), 3–26.

Isaacson, B. (2012, November 29). Betsy Isaacson, #1ReasonWhy reveals sexism rampant in the gaming industry [Blog post]. *The Huffington Post*. Retrieved from http://www.huffingtonpost.com/2012/11/29/1reasonwhy-reveals-sexism-gaming-industry_n_2205204.html

Jeltsen, M. (2012, December 27). Military sexual assaults in combat zones happen frequently: Study. *Huffington Post*. Retrieved from http://www.huffingtonpost.com/2012/12/27/military-sexual-assaults_n_2370099.html

Kelley, R. D. G. (1998). Playing for keeps: Pleasure and profit on the postindustrial playground. In W. Lubiano (Ed.), *The house that race built* (pp. 195–231). New York: Vintage.

Kelley, R. D. G. (2003). *Freedom dreams: The Black radical imagination*. New York: Beacon Press.

Klain, E. (2013, September 9). "Grand Theft Auto V" torture scene is satire [Blog post]. *Forbes*. Retrieved from http://www.forbes.com/sites/erikkain/2013/09/21/grand-theft-auto-v-torture-scene-is-satire/

Kutsch, T. (2014, January 22). Obama targets campus sexual assault. *Al-Jazeera America*. Retrieved from http://america.aljazeera.com/articles/2014/1/22/obama-targets-campussexualassault.html

Leonard, D. J. (2003). "Live in your world, play in ours": Race, video games, and consuming the Other. *SIMILE: Studies in Media & Information Literacy Education, 3*(4), 1–9.

Leonard, D. J. (2014, April). Colbert logic [Blog post]. Retrieved from http://newblackman.blogspot.com/2014/04/colbert-logic-by-david-j-leonard.html

Lott, E. (1993). *Love & theft: Blackface minstrelsy and the American working class*. New York: Oxford University Press.

McClintock, A. (2005). *Imperial leather: Race, gender, and sexuality in the colonial contest*. New York: Routledge.

Nakamura, L. (2002). *Cybertypes: Race, ethnicity, and identity on the Internet*. New York: Routledge.

Ramsey, G. The Boo-Yah! and Stuart Scott's style in context [Blog post]. Retrieved from http://musiqology.com/blog/2015/01/06/the-boo-yah-and-stuart-scotts-style-in-context-2/

Rockstar Games. (n.d.). "Grand Theft Auto V": San Andreas Security and Peace of Mind [Video game information page]. Retrieved from http://www.rockstargames.com/V/lsbc/security-and-peace-of-mind

Rogin, M. (1998). *Blackface, White noise: Jewish immigrants in the American melting pot*. Berkeley: University of California Press.

Russell, K. K. (1998). *The color of crime: Racial hoaxes, White fear, Black protectionism, police harassment, and other macroaggressions.* New York: New York University Press.

Scimeca, D. (2013, September 20). "Grand Theft Auto" hates America. *Salon.* Retrieved from http://www.salon.com/2013/09/20/grand_theft_auto_hates_america/

Shaw, A. (2014). *Gaming at the edge: Sexuality and gender at the margins of gamer culture.* Minneapolis: University of Minnesota Press.

Smith, E. (2013, September 18). "Grand Theft Auto 5" [Review]. *International Business Times.* Retrieved from http://www.ibtimes.co.uk/grand-theft-auto-5-review-507050

Smith, E. (2014, December 19). Gamergate: Swedish gaming companies tackle sexism in video game. *The Guardian.* Retrieved from http://www.theguardian.com/sustainable-business/2014/dec/19/gamergate-swedish-gaming-companies-tackle-sexism-in-video-games

Stuart, K. (2013, September 16). GTA 5 review: A dazzling but monstrous parody of modern life [Review]. *The Guardian.* Retrieved from http://www.theguardian.com/technology/2013/sep/16/gta-5-review-grand-theft-auto-v

Thier, D. (2014, May 13). "Grand Theft Auto 5" has sold nearly $2 billion [Blog post]. *Forbes.* Retrieved from http://www.forbes.com/sites/davidthier/2014/05/13/grand-theft-auto-5-has-sold-nearly-2-billion-at-retail/

Vera, H., Feagin, J. R., & Gordon, A. (1995). Superior intellect?: Sincere fictions of the White self. *The Journal of Negro Education, 64*(3), 295–306.

Watkins, S. C. (1998). *Representing: Hip hop culture and the production of Black cinema.* Chicago, IL: University of Chicago Press.

Part Two:
Cultural Values as the Machine

Commercial Content Moderation: Digital Laborers' Dirty Work

SARAH T. ROBERTS

WHAT IS CCM?

Social media platforms are essentially empty vessels that need user-generated uploads to fuel visits to and participation in their sites. Other companies whose specialties are not in the social or digital media arena at all may simply have an interactive portion of their website to monitor, a Facebook page to maintain, or a Twitter account to contend with. For all of these companies, online brand and reputation management is a key part of their business practice. To guard against digital damage to their brand that could be caused by lewd, disturbing, or even illegal content being displayed and transmitted on their sites, companies use the services of commercial content moderation (CCM) workers and firms, who screen the content. They may screen the content before it gets posted or deal with it after, when another user flags something as being in violation of site guidelines, local tastes or norms, or even the law.

Yet CCM is not an industry unto itself, per se. Rather, it is a series of practices with shared characteristics that take place in a variety of worksites (e.g., in-house at large tech firms; online via microlabor websites such as Amazon Mechanical Turk). Workers are dispersed globally (Chen, 2014), and the work is almost always done in secret for low wages by relatively low-status workers, who must review, day in and day out, digital content that may be pornographic, violent, disturbing, or

disgusting. The workers act as digital gatekeepers for a platform, company, brand, or site, deciding what content will make it to the platform and what content will remain there. In this sense, and despite their relatively low status wherever they toil, they play a significant role in crafting the flavor of a site and deciding what is permissible and what crosses lines into removable territory.

CCM workers are therefore indispensable to the sites for which they labor. They curate site content and guard against serious infractions contained in user-generated content (UGC) that might do harm to a social media platform or a company's digital presence. This often includes content rife with racist, homophobic, or misogynist imagery, language, or violence. CCM workers are the arbiters and adjudicators of which content violates taste, rules, or sociocultural norms, and which content should be kept up on a site. These tasks often involve complicated matters of judgment and thus require a moderator be steeped in the social norms and mores of the places in the world for which the content is destined, frequently a place and an audience different from the worker himself or herself. For many workers, this typically requires a reliance on presuppositions about an imagined audience, taking on or embodying a set of values, and making judgments that may vary from their own moral codes and personal and cultural values. It is a phenomenon of cultural and linguistic embodiment familiar in related kinds of work, such as that of the outsourced and globalized call center (Huws, 2009; Mirchandani, 2012; Poster, 2007).

In this chapter, I will introduce both the concept of CCM work and workers, as well as the ways in which this unseen work affects how users experience the Internet of social media and user-generated content. I will tie it to issues of race and gender by describing specific cases of viral videos that transgressed norms and by providing examples from my interviews with CCM workers. The interventions of CCM workers on behalf of the platforms for which they labor directly contradict myths of the Internet as a site for free, unmediated expression, and highlight the complexities of how and why racist, homophobic, violent, and sexist content exists, and persists, in a social media landscape that often purports to disallow it.

DOING A GOOD JOB IN THE CCM WORLD

Moral and ethical codes of individual CCM workers are superseded by the mandates and dictates of the companies that hire them and/or the platforms for which the content is destined. The sign of a good CCM worker is invisibility—a worker who leaves no trace. This makes it seem as though content just magically appears on a site, rather than there being some sort of curation process and a set of logics by which content is determined to be appropriate or inappropriate. When the content contains racist, homophobic, or sexist aspects, this invisibility is particularly

problematic. It can appear that such content just naturally exists, and should exist, in the digital ecosystem, rather than it often being the result of a decision-making process that has weighed the merits of making it available against the results of removing it, or a system that simply has not been able to deal with it yet. When those in-house processes are kept from users, as they almost always are, the logic for the existence of the material on a site becomes opaque and the content becomes normalized.

While egregious or obvious racist, homophobic, or threatening content is typically prohibited, or at least limited, on more mainstream sites, this does not mean that the sites are not still rife with such material. On many UGC-reliant platforms, the sheer volume of uploaded content means that CCM reviewers will only view content once it has been flagged by a user as inappropriate. This means that the default state for such content is to be on the site; it takes free user labor, in the form of filing a report or flagging content, for the review process to even begin. In other words, the content goes up first, is flagged, and then comes down, which means it existed on a given site for some period of time where people accessed, viewed, and experienced it.

Not all content is simple or easy for CCM workers to spot or to adjudicate, either. For example, workers reported that hate speech is difficult to deal with, because they have to listen to or view a potentially lengthy video to make a determination about the user's intent and the content it contains—content that may be only a small portion of the whole. When CCM work is outsourced to other parts of the world, it creates an additional challenge, in that those workers must become steeped in the racist, homophobic, and misogynist tropes and language of another culture. Finally, as one longtime CCM worker (and now manager) told me, working in CCM means putting aside one's personal belief system and morality. It also means that workers are exposed to content that is personally deleterious or damaging, including content that may impugn the CCM worker's own identities.

There are additional pressures on CCM workers beyond finding and removing objectionable content. For instance, there are real monetary and other kinds of value that can be assigned to content that is sensationalistic, often on the grounds of being prurient, disturbing, or distasteful. In other words, it is this content that can often be a hit, driving eyeballs and clicks to a site or platform. For this reason, CCM workers find themselves in a paradoxical role, in which they must balance the site's desire to attract users and participants to its platform—the company's profit motive—with demands for brand protection, the limits of user tolerance for disturbing material, and the site rules and guidelines.

The existence of CCM workers and the necessity of their work to the social media production chain disrupt comfortable myths about the Internet as a site of one-to-one relationships between user and platform. As one CCM worker put it to me bluntly and succinctly, to experience an Internet without CCM would be

to experience it as "a cesspool." It is in this digital cesspool that CCM workers spend their shifts every day. The daily immersion in this environment has tangible effects on the platforms where workers labor, in the curation and decision-making processes through which content is made available, and on the CCM employees themselves, who do the dirty work of social media.

CONTENT GOES VIRAL

CCM workers are uniquely positioned as gatekeepers, weighing numerous complex issues at once: What is the nature of this content? What meaning does the language, symbols, or images it contains convey? What is the content's cultural context at its point of origin, at the locale and Internet site for which it is destined, and in the locale where it is being moderated? What are the policies that their company or the platform for which the content is destined have set out, regarding tolerance for controversial, disturbing, racist, sexist, homophobic, or sexually or violently graphic content?

These questions are juxtaposed with other issues, including the popularity of a video or particular piece of content. CCM workers must deal with its popularity as they weigh the merits of keeping content up or taking it down, particularly in cases when the content is flagged for review after it has already circulated in a significant way. Additionally, in the world of social media platforms, this user-generated and uploaded content is a commodity to which financial and other kinds of value can be assigned. The value to the host site, and possibly to the content creator (who may be a professional engaged in attempting to create popular content), is generated when users visit a site and interact with advertising associated with the content they are viewing. Popular content drives viewers to a site or platform to view it, and its value as a lure to attract viewers increases. Once content, such as a video on a site such as YouTube, becomes a hit, attracting millions of views, likes, reposts, and imitations or homages, it is called "viral." Digital media scholar Jean Burgess (2008) describes the characteristics that such viral hits share, including the impetus to extend their reach and meaning by others repurposing them:

> there is much more going on in viral video than "information" about a video being communicated throughout a population. Successful "viral" videos have textual hooks or key signifiers, which cannot be identified in advance (even, or especially, by their authors) but only after the fact, when they have been become prominent via being selected a number of times for repetition.... Because they produce new possibilities, even apparently pointless, nihilistic and playful forms of creativity are contributions to knowledge. This is true even if (as in the case of the "Chocolate Rain" example) they work mostly to make a joke out of someone. (p. 105)

In many cases, the joke and conceit of such content is predicated on distasteful humor. In the case of "Chocolate Rain" (Zonday, 2007), the video cited by Burgess above, the racially politicized, yet amateurish, lyrics and theme of his original song, in combination with the persona of the singer (Tay Zonday) and his unconventional physical appearance, exceptionally deep voice, and unorthodox delivery, turned his anthem about racial injustice into spectacle, and spectacle into viral video. Burgess goes on to describe the outcome of "Chocolate Rain" and its subsequent uptake in the social media world:

> It is arguably the combination of oddness and earnest amateurism that made "Chocolate Rain" such a massive YouTube hit.... But the *uses* of "Chocolate Rain" as part of participatory culture ended up far exceeding the intentions of either the original producer or the original disseminators. There was a relatively brief but highly creative flurry of parodies, mashups and remixes as Chocolate Rain's popularity spiked. These derivative works reference "Chocolate Rain" by imitating or re-using parts of it, and frequently combining them with many ideas from other sources, building on layers of knowledge built up in previous Internet "phenomena" as well as broadcast media fandom (like Star Wars). (pp. 104–105)

Although the humor that rocketed "Chocolate Rain" into viral status may have been only partially due to its racialized themes and its creator's unexpected presentation of his Black identity, a great deal of other popular UGC trades directly on its disturbing racist, homophobic, or misogynist tropes and images. While social media platforms perpetuate the myth that such content may simply arrive on a site and become a hit due to serendipity or other intangible factors, the reality is much more complex and is predicated on a long tradition in American popular culture of capitalizing on media content that degrades and dehumanizes.

DIGITIZING MINSTRELSY: RACIST CONTENT SELLS

There is a long history in the American context of racialized and racist material used as humor, in which punchlines are predicated on the denigration of people based on characteristics ascribed to them by virtue of their racial or ethnic identities (Ferris State University, n.d.). In popular culture, this brand of humor has appeared across numerous media, including popular music, theater, literature, and cinematic representations. The participatory Internet, perhaps once seen as a potential site of escape from the racist tropes or sexism and misogyny (Light, 1995) embedded in American popular culture, has largely failed to deliver on foregrounding mass critical engagement with these issues at all. Rather, it has served as another outlet for much of the same kinds of racist imagery, simultaneously providing new technological avenues for its production, dissemination, and consumption. As critical race and digital scholar Jessie Daniels (2013) puts it:

The Internet has not provided an escape route from either race or racism, nor has the study of race or racism proven to be central to the field of Internet studies. Instead, race and racism persist online in ways that are both new and unique to the Internet, alongside vestiges of centuries-old forms that reverberate both offline and on. (p. 696)

The empirical research I conducted with CCM workers in a major Silicon Valley social media firm[1] touched on these issues. An employee described the ways in which internal policy regarding racially charged, misogynist, or homophobic content was enacted and deployed:

It was a meeting with my team (the Enforcement team), and SecPol,[2] the team above us. And SecPol is only like 4 or 5 people.... So we would all sit in one of the bigger conference rooms and basically there were, we would go to quite a few meetings throughout the week, and sometimes it would be specific meetings on, you know, the blackface policy, or whatever policy. But then weekly we had, what did we call it? I don't remember. But as [CCM employees] were in the queue during the week they could send videos to SecPol saying "I don't know why this is ok" or "why this video is not ok" or "this doesn't fall under a policy specifically but I don't think it should be up" or vice versa. (M. Breen, MegaTech CCM Worker)

In conversations with the workers, a number of them expressed the frustration that arose when they had to allow content that featured notorious racist imagery, such as blackface, to stand. Max Breen, a White male worker, age 24, explained:

We have very, very specific itemized internal policies…the internal policies are not made public because then it becomes very easy to skirt them to essentially the point of breaking them. So yeah, we had very specific internal policies that we were constantly, we would meet once a week with SecPol to discuss, there was one, blackface is not technically considered hate speech by default. Which always rubbed me the wrong way, so I had probably ten meltdowns about that. When we were having these meetings discussing policy and to be fair to them, they always listened to me, they never shut me up. They didn't agree, and they never changed the policy but they always let me have my say, which was surprising. (Max Breen, MegaTech CCM Worker)

The MegaTech example is an illustration of the fact that social media companies and platforms make active decisions about what kinds of racist, sexist, and hateful imagery and content they will host and to what extent they will host it. These decisions may revolve around issues of "free speech" and "free expression" for the user base, but on commercial social media sites and platforms, these principles are always counterbalanced by a profit motive; if a platform were to become notorious for being too restrictive in the eyes of the majority of its users, it would run the risk of losing participants to offer to its advertisers. So MegaTech erred on the side of allowing more, rather than less, racist content, in spite of the fact that one of its own CCM team members argued vociferously against it and, by his own description, experienced emotional distress ("meltdowns") around it.

Virality that trades on racialized and other kinds of stereotyped content can make a subject of the content an instantly recognizable celebrity. Such was the case for Antoine Dodson, a young Black man from Huntsville, Alabama, whose appearance on a local news program (Crazy Laugh Action, 2012) was taken up, remixed, and set to an R&B soundtrack by the Gregory Brothers, a team of young White males who created content on YouTube under the brand of "Auto-Tune the News" (Gregory Brothers, 2010). The subsequent song and video, entitled "Bed Intruder," became a viral hit, attracting millions of views and shares and spurring volumes of other content and media featuring his likeness or the song (e.g., ringtones; iTunes downloads). While Dodson entered into a partnership with the Auto-Tune producers that would provide him financial remuneration for his participation and use of his likeness and video (Mackey, 2010), his videos nevertheless caused controversy, as many alleged that the "humor" of the video traded on the linking of perceived attributes of Dodson's to upsetting racial and gay stereotypes; critics argued that, whatever Dodson's intent, it was in effect a case of YouTube minstrelsy—and as history has shown, racist popular culture can indeed be lucrative.

Dodson's instant ascent to Internet celebrity status even gave rise to Halloween costumes ("Bed Intruder Costume," n.d.) intended to convey his likeness, via a headscarf (or "do-rag") and wig mimicking a natural Black hairstyle, and numerous people uploaded content to various social media platforms showcasing themselves in Dodson costumes, complete with blackface (Rivas, 2010). That the entire situation was predicated on sexual violence toward women was also lost in the subsequent shuffle; the original local news item was a report on the fact that Dodson's sister had been attacked in her bedroom by a man attempting to rape her. The humor that traded on Dodson's identity markers of Blackness, poverty, and effeminate gender presentation reduced the complexities of those intersectional identities into pastiche and erased Dodson's own agency in both the protection of his family and the subsequent negotiation of his business dealings with Auto-Tune.

Digital media scholar Amber Johnson (2013) offered this nuanced critique of Dodson's media portrayals that lauded his subversive identity, suggesting that his popularity opened up a space to challenge dominant, negative assumptions:

> Antoine Dodson is both a celebrity and target for exploitation because of the specific ways his identities intersect. His Black, gay, southern, lower-class, seemingly unintelligent identities create space for media to exploit him as a homo coon, a sexualized form of the zip coon that frames Black, homosexual masculinity negatively, and appropriates a stereotype that denies it authenticity by reducing it to coonery. However, if we see Dodson through a critical lens, his story complicates notions of class, education, access, femininity, and masculinity. His business-savvy marketing moves and self-promotion challenge stereotypical notions of poor, undereducated people. His feminine performance coupled with his ability to care for his family physically, emotionally, and financially complicate gender roles. (p. 156)

Johnson's assessment is indeed compelling, but the uptake of Dodson's image and its reappropriation in overtly racist presentations (e.g., blackface) suggest that it is a critique lost on many. Further, the viral success of the Dodson remix inspired numerous copycats, similar in tone to the Dodson footage, in which the humor came at the expense of the video's racialized subjects. In one such case that closely mimicked the Dodson trajectory, a middle-aged Black woman named Sweet Brown was interviewed on a local news program after escaping an apartment fire in her building. Remixers latched onto the footage, which was again set to music, and used her statement, "Ain't nobody got time for that," as the song's refrain. The tune and video played out over a thumping drumbeat and against the backdrop of a variety of racist video and still images, including dancing gorillas and an amateur Photoshop mashup of Don King and Antoine Dodson barbecuing together. In this way, this cruder, more crass, and more overtly racist video was directly tied to that of "Bed Intruder." Indeed, one begat the other: without Antoine Dodson there would have been no Sweet Brown. Without "Bed Intruder," there would have been no "Ain't Nobody Got Time for That." As Daniels (2013) asserts, "The Internet is a site of political struggle over racial meaning, knowledge and values" (p. 704), where well-worn racist tropes still have a great deal of purchase in highly circulated and extremely popular content.

ADVOCACY FOR THE MARGINALIZED: WHEN UGC BREAKS THE RULES

In 2004, a White teenager in a small Texas town was caught by her parents accessing content online for which she hadn't paid, an act that enraged her father and prompted her to turn on a camera she had hidden in her room to capture just such an event (apparently the beating caught on video in this incident was not without precedent). Several years later, an adult Hillary Adams used YouTube to post the 2004 video she captured of her own savage beating at the hands of her father, a family court judge. Just two days after she posted it, the video had received more than two million views on YouTube alone.[3]

In it, Judge Adams unleashes a torrent of verbal and physical abuse so profoundly violent and disturbing that I was unable to take any more after only 70 seconds. Hillary Adams endured the beating for seven minutes. According to published reports across the Web, the video captures the entirety of that beating, during which Judge Adams threatens to hit his daughter in the face with a belt, enlists his now ex-wife to assist in the abuse (this is common behavior in those family abuse situations in which a tyrannical adult holds an entire family hostage),

and actually leaves the room only to come back for a second round with another belt and possibly a board.

And while this tragic and sickening event may not have been an unusual occurrence in the Adams home—by all accounts, an upper-middle-class, suburban household in a town on Texas's Gulf Coast—the fact that Adams herself posted the video to expose her father's abuse highlighted YouTube's potential as an outlet for advocacy for marginalized and abused people of all sorts. Of particular note was the fact that the video itself seemed to contravene a number of YouTube's "Community Guidelines" ("YouTube Community Guidelines," n.d.), which prohibit shocking and disgusting content and content featuring dangerous and illegal acts or violence against children. After becoming a viral hit, for the content to stay up, Hillary Adams must have had someone in YouTube's CCM group on her side.

Hillary Adams's video upload is just one example of the ways in which people have used disturbing and shocking content—UGC that would otherwise seem to be in violation of many sites' policies—for advocacy purposes. Actor, hip-hop star, and social justice activist Yasiin Bey (formerly known as Mos Def) willingly endured a nasal tube force-feeding of the type used on prisoners at Guantánamo Bay (*The Guardian*, 2013). The highly shocking, upsetting, and violent outcome of that video, uploaded to YouTube by the *Guardian* newspaper, has remained on the site for almost two years and been viewed more than 6.3 million times. By subjecting his racialized Black body to the forced feeding, using his Muslim name, and appearing in the orange jumpsuit worn by prisoners at the "Gitmo" prison, Bey offered up the spectacle of his own abuse as advocacy to draw attention to the plight of prisoners, humanizing them through his own dehumanization and degradation.[4] Again, based on the site's published guidelines, this video could well have been flagged for deletion and may well have been at times. It nevertheless remains on the site, available for viewing, circulated via links and tweets on other platforms, and has been written about in news and other reports, achieving the advocacy and attention it sought.

User-uploaded video distributed via social media platforms has also been used to point blame at the police in several cases of racially motivated shootings of unarmed citizens by police officers. The violent deaths of Black men and youth, such as Oscar Grant at Oakland's Fruitvale BART station (*Los Angeles Times*, 2010), of Eric Garner on a Staten Island street (POETIC, 2014), and of 12-year-old Tamir Rice (WEWS NewsChannel5, 2015), killed by police at a playground in Cleveland, as captured by surveillance cameras or by bystanders, have circulated on YouTube and elsewhere. In many cases, these types of videos directly contradict police claims about the circumstances of the deaths of the victims (*Cleveland Plain Dealer* Editorial Board, 2014). Indeed, without the video evidence, any accounts contradicting those official police claims would likely have received little

to no traction, especially when victims have been young men and even children of color killed by White police officers who claimed that the victims were engaged in wrongdoing.

While it may seem that the ubiquity of mobile video and image-capturing devices, coupled with the distribution power of massive social media platforms, would serve as a slam-dunk for justice seekers of all kinds, reality is much murkier. Have Hillary Adams and those like her brought to light an empowering new mechanism for victims of abuse, who may be able to capture evidence that could later be used to charge and convict those responsible for their torment? Or does this capturing of abuse by the powerful suggest a new burden to be placed on the shoulders of those abused (think "pix or it didn't happen")? In a world where an abused person's word is frequently not enough to free him or her from the abuser, could capturing video evidence offer a way for victims to equalize power in a decidedly imbalanced situation? Or is the risk so great that there is too much potential danger—especially in the cases of minors—to suggest to them that they must be responsible for having to document their own abuse in this way if they are to have any hope of being believed and/or being freed? And what of those young people who don't have the access to the equipment or the knowledge of how to use it to document their torment? How many children use computers that are also used and monitored by the adults in their homes?

Meanwhile, what is the social media platforms' role in the vetting and hosting of this content? How did Adams's video, and the others discussed, pass the YouTube screening process? Assuming they were, in fact, directly vetted (and not just missed by CCM eyes trained to catch unsuitable content), it would seem that YouTube has at least tacitly accepted an advocacy role by hosting these videos in some cases. Yet things are not quite so simple; questions remain about the moral and ethical implications of videos with this kind of content driving millions of views to a commercial, profit-driven site. As I rewatched some of the upsetting videos described in this article in preparation for its writing, I noted that a number of them were preceded by commercial advertising. Views for some of them are in the hundreds of millions, and Google, the parent company of YouTube, is currently trading at more than $535 per share ("NASDAQ:GOOG: 537.01 -5.86 (-1.08%) – Google Inc.," 2015). Simply put, the decision for what stays up and what comes down must, at some level, be a monetary one.

CONCLUSION

The hidden labor of CCM workers is a critical component to the curation and creation of social media sites and the content they disseminate. CCM workers view and deal with material that is racist, homophobic, sexist, and disturbing as a

regular part of their daily work. In many cases, content of this type does not just end up on a site without any intervention; when it has been reviewed and deemed fit to post, it is, in essence, curated.

The Internet as racialized space is not a new concept; scholars have been demonstrating the functions and manifestations of race online for decades now. But the practices of CCM offer special insight into the ways in which racist, homophobic, and misogynist language and imagery are deployed in contemporary social media, and how that deployment is predicated on a series of factors, including the palatability of that content to some imagined audience and the potential for its marketability and virality, on the one hand, and the likelihood of it causing offense and brand damage, on the other. In short, it is evaluated for its potential value as commodity.

My own research into CCM shows that the CCM process at large social media firms is governed by policies meant to strike a balance among attracting user-participants and advertisers, responding to jurisdictional norms and legal demands, and remaining profitable and appealing to shareholders. Internal policies regarding permissible content therefore serve these purposes, first and foremost, rather than responding to, say, social justice or advocacy-related goals.

Because of the secrecy and invisibility surrounding CCM policies and practices, however, the presence of racist or racially charged, provocative content on a site typically appears to reflect something other than the results of weighing those demands. In this way, racist, homophobic, and misogynist imagery and content becomes reified as a norm, and the structures that abet it are cloaked and invisible, suggesting that the existence of content is just some kind of natural order of things and not, for example, potentially hugely profitable. Companies' desire to keep CCM work in the shadows therefore gives the impression that such content is just what is out there in the culture in some kind of natural, organic way and hides the human decision-making processes and curation work from the view of their user-participants. Further, as long as CCM work and workers remain hidden from view, the ramifications of spending a work life in the squalid sectors of the Internet, sifting through its detritus and its most disturbing content, will remain unknown. When the sign of being an effective CCM worker is to be able to stomach the content without complaint and to endure it day in and day out, it is unlikely that this paradigm will change anytime soon.

In a recent essay, Oxford Internet Institute head William Dutton (2012) lamented the increasingly fleeting potential of the Internet to serve as a sort of "fifth estate" and underlined its potential to offer a site of pushback on powerful institutions. Yet to come anywhere near to what Dutton believes is possible—that the Internet can serve as a site of pressure significant enough to qualify as a "fifth estate"—a true accounting of all of the actors involved must be rendered and their motives (e.g., profit-seeking; brand protection) more completely understood. In

unveiling CCM workers' practices and the mandates and pressures under which they labor, we can apprehend a more realistic and fuller view of the social media landscape and how content makes its way to it, and to us.

NOTES

1. The firm's name, MegaTech, as well as other names referenced from interviews I conducted, are pseudonyms used to protect participant privacy.
2. "SecPol," or Security and Policy, was the department above the CCM workers at MegaTech whose purview it was to set policy and make ultimate decisions about what content could stand and what had to be removed.
3. The original video, posted by Adams herself, now seems to have disappeared from YouTube, but there are numerous other videos that show either portions of it or the video in its entirety, often with accompanying commentary.
4. It bears mentioning that the capturing of a man's forced feeding on film or video for advocacy purposes has precedence; the American documentary filmmaker Frederick Wiseman shot disturbing scenes of a patient in a mental hospital being force fed in a similar way. Those scenes from his film *Titicut Follies* (Wiseman, 1967) led to a censorship battle when the state of Massachusetts attempted to enjoin him from showing the film, which Wiseman intended as a document of the deplorable conditions in state homes for the mentally ill.

REFERENCES

BED INTRUDER COSTUME | Antoine Dodson Halloween Costume. (n.d.). Retrieved from http://www.bedintrudercostume.com/

Burgess, J. (2008). "All your Chocolate Rain are belong to us"? In G. Lovink & S. Niederer (Eds.), *Video Vortex reader responses to YouTube* (pp. 101–110). Amsterdam: Institute of Network Cultures.

Chen, A. (2014, October 23). The laborers who keep dick pics and beheadings out of your Facebook feed. *WIRED*. Retrieved from http://www.wired.com/2014/10/content-moderation/

Cleveland Plain Dealer Editorial Board. (2014, November 26). Video of Cleveland police shooting of Tamir Rice raises disturbing questions: Editorial. Retrieved from http://www.cleveland.com/opinion/index.ssf/2014/11/video_of_tamir_rice_shooting_b.html

Crazy Laugh Action. (2012, April 11). *Antoine Dodson funny news blooper (original)* [Video file]. Retrieved from https://www.YouTube.com/watch?v=EzNhaLUT520&feature=YouTube_gdata_player

Daniels, J. (2013). Race and racism in Internet Studies: A review and critique. *New Media & Society*, 15(5), 695–719. doi:10.1177/1461444812462849

Dutton, W. H. (2012). The Internet and democratic accountability: The rise of the fifth estate. In F. L. F. Lee, L. Leung, J. L. Qiu, & D. S. C. Chu (Eds.), *Frontiers in New Media Research* (pp. 39–55). New York: Routledge.

Ferris State University. (n.d.). Jim Crow Museum: Home. Retrieved from http://www.ferris.edu/jimcrow/

Gregory Brothers (2010, July 31). *BED INTRUDER SONG!!! (now on iTunes)* [Video file]. Retrieved from https://www.YouTube.com/watch?v=hMtZfW2z9dw&feature=YouTube_gdata_player

The Guardian [TheGuardian]. (2013, July 8). *Yasiin Bey (aka Mos Def) force fed under standard Guantánamo Bay procedure* [Video file]. Retrieved from https://www.YouTube.com/watch?v=z6ACE-BBPRs&feature=YouTube_gdata_player

Huws, U. (2009). Working at the interface: Call-centre labour in a global economy. *Work Organisation, Labour and Globalisation, 3*(1), 1–8.

Johnson, A. (2013). Antoine Dodson and the (mis)appropriation of the Homo Coon: An intersectional approach to the performative possibilities of social media. *Critical Studies in Media Communication, 30*(2), 152–170. doi:10.1080/15295036.2012.755050

Light, J. S. (1995). The digital landscape: New space for women? *Gender, Place & Culture, 2*(2), 133–146.

Los Angeles Times [LosAngelesTimes]. (2010, July 24). *Court releases dramatic video of BART shooting* [Video file]. Retrieved from https://www.YouTube.com/watch?v=Q2LDw5l_yMI&feature=YouTube_gdata_player

Mackey, R. (2010, August 19). "Bed intruder" rant earns family a new home. Retrieved from http://thelede.blogs.nytimes.com/2010/08/19/bed-intruder-rant-buys-family-a-new-home/

Mirchandani, K. (2012). *Phone clones: Authenticity work in the transnational service economy.* Ithaca, NY: ILR Press.

NASDAQ:GOOG: 537.01 -5.86 (-1.08%) - Google Inc. (2015, February 20). Retrieved February 20, 2015, from http://www.google.com/finance?q=goog&ei=5F7nVIj_NoqGqgGLx4GABA

POETIC. (2014, July 18). *ERIC GARNER NYPD CHOKEHOLD DEATH—NO INDICTMENT!* [Video file]. Retrieved from https://www.YouTube.com/watch?v=GhqHEgIgSGU&feature=YouTube_gdata_player

Poster, W. (2007). Who's on the line? Indian call center agents pose as Americans for US-outsourced firms. *Industrial Relations: A Journal of Economy and Society, 46*(2), 271–304.

Rivas, J. (2010, November 8). Antoine Dodson's Halloween costumes went horribly wrong. Retrieved from http://colorlines.com/archives/2010/11/antoine_dodsons_facebook_page_sparks_black_face_discussion.html

Roberts, S. T. (forthcoming). *Behind the screen: Digitally laboring in social media's shadow world.*

WEWS NewsChannel5 [WEWSTV]. (2015, January 7). *EXTENDED VIDEO Tamir Rice shooting incident* [Video file]. Retrieved from https://www.YouTube.com/watch?v=xIvQVU_pmBg

Wiseman, F. (1967). *Titicut follies.* [s.n.].

YouTube Community Guidelines. (n.d.). Retrieved from https://www.YouTube.com/t/community_guidelines

Zonday, T. [TayZonday]. (2007, April 22). "Chocolate Rain" original song by Tay Zonday [Video file]. Retrieved from https://www.YouTube.com/watch?v=EwTZ2xpQwpA&feature=YouTube_gdata_player

Love, Inc.: Toward Structural Intersectional Analysis OF Online Dating Sites AND Applications

MOLLY NIESEN

INTRODUCTION

This chapter discusses what I call Online Dating Sites and Applications (ODSAs), and traces the brief history of ODSAs, from their earliest digital forms to today's onslaught of mobile geosocial applications. I will provide a taxonomy of the industry and suggest areas for structural intersectional research to fill the lacuna in existing scholarship. I use the term *dating* broadly, to describe all types of connections for either romantic partnership or those that are purely physical. Some ODSAs are marketed to consumers as a way to find long-term romantic partnership, while others are purely for ephemeral encounters.

ODSAs are different from other social networking sites (SNS) for two main reasons. First, connections on ODSAs are typically facilitated by the application or website; they do not connect preexisting non-virtual relationships, like Facebook or Instagram, for instance. Second, unlike other SNS, ODSAs have the upfront stated goal of facilitating one-on-one connections for the sole purposes of sex, romance, and partnership, not merely platonic friendship or business relationships. According to Finkel et al. (2012), online dating offers three major services. First is *access*, or " exposure to and opportunity to evaluate potential romantic partners." Second, ODSAs offer *communication* with users; and third, they offer *matching*. ODSA's marketing techniques hinge on their claims to better matching methods

than real-world encounters, and they are constantly changing and emphasizing these three services to varying degrees (Finkel et al., 2012).

ODSAs constitute a multibillion-dollar media industry enmeshed in intersectionality: they arbitrate and profit from issues of identity and often reinforce marginalization, oppression, and discrimination. Furthermore, ODSAs provide a service for arguably one of the most difficult and emotionally wrought experiences: finding romantic partnership and connection. ODSAs claim to make the process of dating less painful, taking out much of the affective labor in making a match. And yet, participants populate these vessels, serving to commodify this process further. As the industry becomes more concentrated, the balkanization and marginalization of identities perhaps becomes more entrenched. Rather than connecting people based on commonalities, ODSAs have the potential to enhance differences, providing platforms for specific groups based on intersections of identity. More importantly, racism, sexism, homophobia, and body shaming have become normalized on the world of ODSAs, inviting practical questions about if, and how, to make ODSAs more inclusive.

Most existing research on ODSAs constitutes quantitative empirical studies from social and cognitive psychology as well as computer-mediated communication, computer sciences, economics, and marketing. OkCupid has conducted its own studies about dating trends and released these to the public. A number of studies have looked at the ways in which participants in ODSAs manage their online self-presentation as compared to face-to-face interactions (Toma, Hancock, & Ellison, 2008). Others have explored the algorithms, testing the viability of matches, and some have surveyed the characteristics of participants themselves (Hitsch, Hortaçsu, & Ariely, 2010; Valkenburg & Peter, 2007). Several quantitative studies have demonstrated processes of "racial exclusion" on heterosexual ODSAs (Feliciano, Robnett, & Komaie, 2009; Robnett & Feliciano, 2011). Further investigations are needed on both the political economy of the industry itself (structure, profit basis, labor, data collection, and the historical trends) as well as an intersectional analysis of power and difference in this ever-changing industry.

As with most structural analyses, a political economic approach runs the risk of erasing the subjectivities and lived experiences of those who participate and contribute affective labor to ODSAs. While an intersectional lens is ideal in accounting for systems of oppression and discrimination, it is often criticized for its tendency to emphasize categories of overlapping identities rather than the ways in which structural power has created inequality (Cho, Crenshaw, & McCall, 2013). Barbara Tomlinson (2013) captures the false dichotomy of identity and power put forth by the critics of intersectionality, claiming, "If critics think intersectionality is a matter of identity rather than power, they cannot see which difference makes a difference." A structural intersectional lens accounts for the centrifugal and centripetal power dynamics of ODSAs—both in terms of identity and the makeup of the industry

itself. A structural intersectional analysis is particularly important for ODSAs because, unlike traditional forms of media, the users themselves are both the consumer and the commodity, exchanging labor and money with hopes to find the tangible benefit of human connection. Intersectionality as "more a nodal point than a closed system," according to Cho et al. (2013), acknowledges "overlapping and conflicting dynamics of race, gender, class, sexuality, nation, and other inequalities" (p. 788). Studies have shown that the experiences of ODSA participants are different depending on one's identity, and a structural intersectional analysis considers how structural inequality values some identities over others.

TOWARD A POLITICAL ECONOMY OF ODSAS

A History and Taxonomy of the ODSA Industry

The history of digital matchmaking technologies helps us appreciate how the existing system operates and how it relates to the broader political economy of Web 2.0. The field of political economy of communication focuses on social change and history to understand how structure is constituted through ongoing processes (Mosco, 2009). Scholarship on the history of ODSAs is scarce, and what does exist can be mostly pieced together from various online accounts. It is clear that as soon as one of the earliest form of digital technologies emerged—the punch card—researchers have attempted to harness this technology for the purposes of commodifying romantic matchmaking.

In 1965, students at Harvard developed a computerized matchmaking service called *Operation Match*. Participants paid $3 and the program used lengthy questionnaires analyzed by an IBM 1401 computer (Bercovici, 2014; Leonhardt, 2006). Harvard's student newspaper predicted that three founders "have plotted since last spring to overthrow a whole way of life" (Matthews, 1965). Although Operation Match did not create a whole new way of dating, venture capitalists have since attempted to commodify the matchmaking potential of digital technology. Since the early days of the World Wide Web, Internet service providers such as Prodigy and America Online promoted their chatrooms for singles. By 1996, Yahoo! registered around 16 dating websites. In 1998, old media helped boost online dating into the mainstream with the release of the film *You've Got Mail*, in which two young urban professionals fall in love over the Internet. This coincided with the dot.com boom of the 1990s, when Yahoo! and AOL attempted to establish their own dating platforms for ISP customers. The arrival of SNS and Web 2.0 boosted non-ISP based dating websites, rendering ISP-owned ODSAs obsolete.

ODSAs in the era of Web 2.0 began as merely matchmaking services: to aid the search for a potential partner. Sites such as Match.com and eHarmony touted their superior algorithms to facilitate the process of matchmaking. ODSAs are now a $2 billion industry, growing about 5 percent each year. According to a Pew Research Study, in 2005, 44 percent of Americans thought online dating was "a good way to meet people," and this number jumped to 59 percent in 2013. The success of the industry is not only due to changes in technology and attitudes toward online dating but also recent demographic shifts. In 1970, just 28 percent of American adults were single; today, the share is around 47 percent. Between 2005 and 2012, more than a third of U.S. couples reported having met through an ODSA (Smith & Anderson, 2015).

A history and Taxonomy of the ODSA Industry

Match, eHarmony, and Chemistry—*subscription-based relationship*—constitute a majority of the ODSA market share. Match.com, the leader in this category, has one third of the total ODSA market share and had 1.7 million subscribers in 2014 (Bercovici, 2014). These sites claim to facilitate finding a long-term partner, and they charge a monthly fee to subscribe. eHarmony and Perfectmatch. com are the most expensive among these (approximately $60 per month), while the others are a close second (Match and Chemistry are around $40 per month) (Consumersearch.com, n.d.). All of these subscription-based relationship services, to varying degrees, promote their superior matchmaking technologies. Perfect-match.com and eHarmony have extensive compatibility tests, claiming to take most of the labor out of finding a potential match through their proprietary algorithms. eHarmony, for instance, boasts that it has led to 600,000 marriages and counting (eHarmony, n.d.).

Subscription-based relationship ODSAs can credit their popularity to their large ad budgets on television, enabled by their greater revenue streams from subscriptions. Television advertising allows the companies to compete with each other and their free-of-charge counterparts. The industry spent more on TV ads in the first five months of 2014 than it did during all of 2013. eHarmony's commercial "Granddaughter" takes on the competition directly. The spot shows a conversation between the eHarmony founder and his granddaughter, who assures viewers that eHarmony's relationships last longer than those generated from other ODSAs, and as an added bonus, eHarmony "has all the hot babes" (Tadena, 2014). As the competition continues in the ODSA duopoly, it is unlikely that TV ads will disappear anytime soon. There is a great dissertation to be written on the larger cultural assumptions that underlie the discourse on matchmaking and marriage in ODSA advertising and marketing.

The second group of ODSAs can be categorized as *free dating services*. These include OkCupid, PlentyofFish, and DateHookUp. OkCupid, a leader in this category, relies on user-generated questions. These services are different not only in cost but also because the stated goal is not necessarily to find long-term partnership, but also includes more casual romantic connections. These free sites also cater more to the LGBT community (eHarmony does not allow same-sex connections). The free dating services allow users to choose which questions they answer and, to some extent, determine whether or not they are a potential match themselves. Some of the questions on OkCupid include "Do you think women have an obligation to keep their legs shaved?" "Would the world be a better place if people with low IQs were not allowed to reproduce?" and "Would you strongly prefer to go out with someone of your own skin color/racial background?" (Salam, 2014). The co-founder of OkCupid, Christian Rudder, published a book in 2014 called *Dataclysm: Who We Are*, heralding the potential for big data to "show us how we fight, how we love, how we age, who we are, and how we're changing. All we have to do is look" (Rudder, 2014a). Though user-generated questions are hyped as a way to help users find matches, they also support OkCupid's profit basis: targeted advertising and marketing (users can pay a premium and bypass the advertising, but most users opt for the free version). Advertisers online are always struggling to reach a profile they can actually tie to a real person. Unlike traditional SNS, where participants can easily opt out of supplying demographic information with little consequence, matchmaking success on an ODSA supposedly relies on the quality and quantity of what one reveals. Online dating profiles and questionnaires are a gold mine for advertisers because they include information about our political beliefs, sexual and romantic desires, and *what we value in human connections.*

The third major category is *niche ODSAs*, which cater to groups based on shared interests and identities. There are a number of LGBTQA serving ODSAs, including PinkSofa (for lesbians), OneGoodLove (relationship-oriented), and Grindr (for men who have sex with men—this app served as a model for similar geosocial services discussed below). The lists of niche ODSAs are nearly endless. These include BlackPeopleMeet, JDate (for Jewish singles); Blues Match (for Oxbridge graduates); Luxy (for millionaires and millionaire hopefuls); SeniorPeopleMeet; FarmersOnly; Meet-an-Inmate; TrekPassions; RedheadWorld; Tallfriends; PURRfect (for cat lovers); and Ashley Madison (for people seeking to have extramarital affairs). There are also a number of niche ODSAs connecting people based on shared illnesses and disabilities including Dating4Disabled, POZPersonals (for HIV-positive people), and CancerMatch.

Though niche ODSAs claim to provide better matchmaking for specific groups, these are part of a broader system of market segmentation, micro-targeting, and surveillance. This is particularly salient for ODSAs catering to the gay community, which in 1991 the *Wall Street Journal* referred to as the "dream market"

(as quoted in Badgett, 1997, p. 467). Prior to the existence of niche online communities, commercial spaces had catered to gay and lesbian clientele, including bookstores, cafes, bars, and clubs. What makes these new platforms different is the ways in which their existence is linked to forms of surveillance and target marketing. Campbell's (2005) structural intersectional study illuminates the ways in which online LGBT communities such as PlanetOut.com and Gay.com are "beholden to mainstream corporations for their continued existence" and thus "must convince marketers that they are capable of delivering advertisements to economically desirable audiences" (p. 666). As is the case with broader online communities and more heteronormative ODSAs, some participants in ODSAs are rendered less valuable to advertisers and fuel the perceived desirability of some populations over others.

In 2014, the percentage of online dating through mobile apps was nearly 40 percent, and this continues to grow (Iovation, n.d.). Based on complaints from consumers that participation in online dating takes up too much time, as well as the move toward ODSAs on mobile devices, the industry has responded by creating a new category called *geosocial*, intended to help people move from virtual to physical space much more rapidly. Tinder is the leader in this category, with 30 million registered users who reportedly view 1.2 billion profiles per day (Lapowsky, 2014). Tinder, like all geosocial ODSAs, relies on geolocative technologies to help facilitate matches in particular locations and allow users to view profile images, then quickly swipe past those less than desirable matches—based almost entirely on physical appearance and scant demographic information. Tinder also requires a double opt-in, where both parties have to express interest in each other to make contact. Rather than promote its reliable algorithms or matchmaking potential, Tinder relies on users themselves to make decisions about potential matches. Additionally, following a growing trend in the ODSA industry, Tinder uses social authentication through Facebook, creating more synergy with existing new media conglomerates. Tinder's popularity grew following the 2014 Winter Olympics, when a popular microblog on Tumblr SOCHI ON TINDER (2014) collected screenshots of various Olympic athletes who were using the app, and news outlets picked up the story (Huffington Post UK, 2014). Whether it was accidental or contrived, the event generated great publicity for Tinder using "perfect bodies" to underscore the promise of hooking up with "good looking" and "athletic" people. Tinder continues to market itself as the service for a tryst as well as entertainment for usually young, straight millennials, rather than as a way to find long-term romantic partnership. In fact, its recent advertising campaign features a young woman on vacation, who uses the application to have short-lived romances with men as she travels through Europe. More research is needed to understand the ways in which Tinder offers a social entertainment experience, unlike other ODSAs, where users engage more privately. For example, students

in my classes have told me stories about how they look at Tinder apps together at bars as a form of entertainment, and one student described a drinking game whereby friends drink when a mutual opt-in was generated.

IAC: A MEDIA CONGLOMERATE

The endless choice in ODSAs beguiles the fact that the industry structure is heavily concentrated, and a great portion of it is, in fact, controlled by a single media conglomerate: IAC/InterActiveCorp. Media scholars such as Ben Bagdikian (2004) and Robert W. McChesney (McChesney & Nichols, 2010) have written critical exposés about the ways in which industrial concentration in the media sector leads to substandard journalism and hyper-commercialization. Little is known, however, about the media conglomerate IAC. The current CEO of IAC, Barry Diller, is an experienced media mogul; he was the previous head of Paramount Pictures, Fox Broadcasting, and USA (Forbes.com, n.d.). IAC owns a majority stake in the ODSAs market as well as travel sites (HotWire, Expedia, TripAdvisor), financial services (LendingTree), information/educational services (Dictionary.com, Thesaurus.com, About.com, Tutor.com, The Princeton Review, and Reference.com), and news/entertainment (*The Daily Beast*). While the subscription-based relationship ODSAs have a duopoly structure (between Match and eHarmony), IAC owns the bulk of the rest of the ODSA market share, which is over a $2 billion market (Bercovici, 2014). In 2011, IAC acquired OkCupid for $50 million, as well as Meetic, the top ODSA in Europe. IAC also bought up a number of niche dating sites and platforms, including BlackPeopleMeet, SinglesMeet, and Tinder. IAC is also intertwined with Google, as it outsources its search technologies and advertising to Google on sites like Ask.com (Rao, 2011).

As of 2015, IAC owns 50 different ODSAs in 40 countries. IAC's full acquisition of Tinder coincided with a shift to a new funding model, which offers a premium paid for service to its users (Lapowsky, 2014). Geolocative applications such as Tinder have great "data potential for businesses," according to the advertising trade publication *Ad Age*, because they require "users to give their age, gender and location, and [are] linked with Facebook's social log-in" (Bergen, 2015). Fee-based services also increasingly rely on hybrid funding models that are predicated on direct user micropayments for premium services and upgrades (Bercovici, 2014). In short, the value to a company that owns or operates an ODSA is not only in its subscription fees but also in the data it aggregates about users for advertisers and marketers.

THE AUDIENCE COMMODITY

Like traditional SNS, the commodity form in ODSAs are the participants them-selves, masked by claims that algorithms or advanced geolocative applications are what's for sale. Users are drawn to providing this commodity in the form of their participation, which is solicited on the basis of their identity markers on sites that fracture user communities based on their race, ethnic, sexual, or other identities. In 1977, Dallas Smythe, in his influential article "Communications: Blindspots of Western Marxism," called on communications scholars to consider the commod-ity form in commercial media; which, according to Smythe, is not the message, but audiences and readerships. Through their labor, the audiences perform both the marketing function for the production of consumer goods and the (re)production of labor. Eileen Meehan (1990, 1991) elaborated on Smythe's theory, arguing that the audience ratings industry is an important aspect of commodity exchange in mass media by allowing the networks to set prices and maintain their monopoly status. Christian Fuchs (2012) has applied the audience commodity framework to social media, arguing that SNS are a "means of production for the creation of value and profit" (p. 704). Fuchs sees the audience commodity as a particularly useful concept in the context of digital media and SNS. Rather than view participants on SNS as merely consumers, or traditional laborers, Fuchs uses the term *Internet prosumer commodity* to describe the exploitation of users on SNS: "labour generates content and transaction data are surveilled and sold to advertising clients that get access to the attention of specifically targeted groups." In this light, it becomes clear that the fracturing of users based on identity categories is, in fact, a key mechanism of capital to provide such data to advertisers, rather than a mechanism to necessarily lead to better matches in dating or sexual relationships. An analysis of the audience commodity in ODSAs is part of an ongoing, broader discussion about the exploitation of digital labor in the Internet prosumer economy.

Like any new media industry, ODSAs offer an interesting case study about how citizen/consumer activists have attempted to and succeeded in pressuring legislators and courts to regulate the industry. When it was launched in 2000, eHarmony.com, one of the leaders of the traditional matching services, relied pri-marily on its so-called superior algorithm for predicting and matching based on "29 matches of compatibility." Its algorithm, the company claimed, came with some restrictions. For example, although a 33-year-old man could be matched with a woman who was as young as 23, women of the same age could only be matched with men who were older than 27. Gay, lesbian, and bisexual partic-ipants were rejected out of hand, as well those who had been married four or more times. People who did not pass eHarmony's "dysthymia scale," indicating depression, were also rejected (Slater, 2013). In 2010, eHarmony agreed to settle a lawsuit claiming it discriminated against gays and lesbians, requiring the company

to pay $500,000 to those named in the lawsuit (Associated Press, 2010). Part of the settlement also included a mandate that eHarmony set up an alternative site for gay and lesbian clients called CompatiblePartners, and to give the first 10,000 members free subscriptions. While many recent U.S. court decisions have given greater freedom of expression to media conglomerates and their advertisers, the legal decisions involving eHarmony point to an ongoing debate about, and resistance to, institutionalized exclusion within the ODSA industry. More scholarly research into these legal battles is needed to better understand the ways in which power and domination are rationalized and resisted in ODSAs.

ONLINE DATING: AN INTERSECTIONAL ANALYSIS

As with any new media platform, ODSAs do not transcend difference, privilege, and oppression, and an intersectional lens helps us further understand and resist these dynamics. In some cases, ODSAs only heighten the same intersectional power differentials that exist in the non-virtual world. Darwindating.com, a website for "beautiful people," relies on tropes of eugenics and of traditional standards of beauty favoring Whiteness, youth, normative beauty standards, and body types. Darwindating.com's rules includes a ban on "saggy boobs, fat rolls, patchy skin, and acne." In the corner of this lengthy list of undesirable characteristics users see a picture of a gorilla (see Figure 9.1). Another ODSA, Cherryblossoms.com, is the self-proclaimed "leading Asian website" where men can find "online dating with Asian women from countries such as China, Philippines, Korea, Thailand, Cambodia, Vietnam, and Malaysia with our advanced search database." The website features highly sexualized and infantilized images of Asian women (see Figure 9.2).

It is clear that sexism, racism, and elitism run rampant on ODSAs. Robnett and Feliciano (2011) demonstrated the ways in which women of color experience a gendered process of racial exclusion, where their opposite-sex counterparts were more likely to eliminate them as a possible match. OkCupid has released data analytic trends based on its own data, and has shown similar patterns of discrimination on its site. In 2009, OkCupid's cofounder Christian Rudder claimed, "despite what you might have heard from the Obama campaign and organic cereal commercials, racism is alive and well." OkCupid released a "Reply by Race" Table (see Figure 9.3) where it showed that while Black women reply the most, they by far get the fewest replies. Rudder's blog post also revealed the statistics on the answer to its question "Would you strongly prefer to date someone of your own skin color/racial background?" revealing that both White men and women preferred to date within their own race (54 percent and 40 percent, respectively) as compared to non-Whites combined (20 percent).

Another OkCupid study, released in 2014, revealed the extent to which the race bias had intensified in the five-year period. When Rudder (2014b) was asked "Are people on OkCupid just racist?" he responded, "No. I mean, not any more than anywhere else. All the dating data I've seen fits OkCupid's pattern: Black people and Asian men get shrift."

Along with the data analytics, the experience of women of color illuminates racism and sexism on ODSAs. Zeba Blay (2015), a blogger, recounted her experience as a Black woman on an ODSA:

> The narrative about Black women and dating, about our lack of desirability and date-ability, has been one I've actively tried to unlearn, despite a constant, nagging feeling that the reason I couldn't get a date was because of the so-called stigma. But in my first major foray into the world of online dating, what struck me wasn't so much this idea of not being wanted, but the kind of men who apparently wanted me.

Blay reported the many offensive messages she received, including "Do you taste like chocolate?" and "I'd love to slap dat big juicy booty." One man asked her "Do you act black?" and explained that his reason for asking was because he liked "black women minus the attitude." Many bloggers have taken screenshots of the messages they received, chronicling their experiences on Tumblr. The blogger for NoKCupes has collected a variety of messages, including "hello, I like curvy ladies with a bit of color," and "are you black and white like a cookie?" These experiences suggest that it is not only the quantity of messages but also the types of communications women of color receive. Although Asian and Latina women receive the most messages on ODSAs, it is likely that the responses they receive tend to objectify, fetishize, and exotify.

BuzzFeed writer Anne Helen Petersen (2014) has researched class, race, and education-level preferences on Tinder, using 50 stock photos. She found that preferences, though mediated by race, were overwhelmingly linked to class markers: for example, straight white teeth, exotic locations, and clothing. The most "swipeable" (in other words, most selected) woman, with an 89 percent swipe yes rate, was Yasmin (see Figure 9.4). Why did Petersen's study not confirm OkCupid's studies showing that Black women are the least likely to receive messages? In part, Petersen says "race was irrevocably linked to class. It wasn't that people didn't find others of a certain race attractive; rather, they didn't find people whose image suggested a lower class—specifically working class—attractive." The stock image of Yasmin is one of Getty's most popular images and has been used in a number of other advertising campaigns, and the advertising community has justified the use of racially ambiguous stock photos because audiences of various ethnic backgrounds can see themselves in the image.

There's another element—colorism—that plays a role in online dating as well. A number of intersectional scholars have looked at the ways in which colorism,

what Hunter (2007) defines as a "process that privileges light skinned people of color over dark in areas such as income, education, housing, and the marriage market." Colorism is directly related to broader systems of racism and discrimination (Harris, 1993) and certainly plays a role in the intersectional dynamics of ODSAs. Thus, user preferences for Yasmin's photo are not only influenced by the class markers in her photo (straight teeth, high-end clothing, and artful background), but her skin color and hair texture as well. This is directly linked to intersectionality's relationship to White supremacy as economic and cultural capital, where skin tones and other features with greater proximity to a White phenotype are the basis of colorism (Hall, 2005). What is often described as tastes, preferences, and choices on ODSAs are thus explicitly tied to and manifestations of a system where Whiteness has more value. The ODSA, as a platform, is embedded with the values of structural inequality, because the aggregation and segregation of types of daters has value and some bodies/biopower are/is more valuable than others. This is directly related to what Patricia Hill Collins (2004) refers to as the "color blind ideology of new racism," under which "Blackness must be SEEN as evidence for the alleged color blindness that seemingly characterizes contemporary economic opportunity." Collins's concept of new racism is particularly salient for Web 2.0, where reinventions of historical ideologies take on new forms that normalize social exclusion and discrimination.

Consumer culture has always placed value on some identities more than others, and now perhaps more than ever, there is more value on staying and looking young, particularly for women. Thus, there is great potential for studies on ageism on ODSAs, both as they relate to user preferences and of institutionalized forms through the business models themselves. For example, in March 2015, Tinder announced the rollout of its paid-for premium upgrade "Tinder Plus," which, for a fee, allows users to choose the location in which they would like to search and undo swipes they had previously selected (Dewey, 2015). This made headlines because the upgrade came with a catch: Users over 30 were charged more than their younger counterparts: $9.99 if under 30, and $19.99 if older (Sanders, 2015). Although Tinder claims the impetus behind the decision was because younger users tend to have less disposable income, the company has been accused of trying to exclude older users from its premium service, in the ever-accelerating race to attract younger and younger users. The popular WordPress blogger Soon2BeCatLady has called on an all-out boycott of Tinder because of its ageist policies with the hashtag campaign #BoycottTinder (Soon2BeCatLady, 2015). Whether or not the public outcry will force Tinder to change its policies is yet to be determined. Tinder's move, and the ensuing criticism, point to the importance of an intersectional analysis to explore and understand these discursive debates, as well as the industry itself, particularly the

ways in which youth is to the benefit of men, not to women, under the structure of patriarchy.

There are many stories of racism, homophobia, ageism, and sexism on more mainstream ODSAs, such as OkCupid and Tinder. Do more niche ODSAs offer participants safer, more empowering spaces to date? Certainly niche ODSAs can empower those who are the most marginalized. There are sites for the HIV positive, hearing impaired, and for people living with terminal cancer. If colorism plays such a significant role on more mainstream ODSAs, how does skin tone, class, and gender play a role on niche ODSAs as well as those operating in a national and transnational context? Jha and Adelman's (2009) research demonstrates the ways in which preference for lighter skinned females is intensified on Indian matrimonial websites, wherein men were more likely to state their preference for lighter skinned women, and to describe them as more positively with words such as "beautiful" and "lovely." Furthermore, the "success stories" featured on the sites were much more likely to show lighter skinned women with darker skinned men, rendering darker skinned women invisible and further contributing to marginalization and oppression through the "technology-abetted intensification of colorism" (Jha, 2009, p. 65).

Similar forms of discrimination play out in the niche geosocial application Grindr, which is the most popular ODSA in the gay community. A number of bloggers have collected screenshots of images from Grindr profiles, which include on the participant's screen a short description of preferences (a simple image search of Grindr and racism generates thousands of examples). Many include derogatory racial slurs like "No Rice and Spice" and "No Curry" (Bertaux, 2014). While others are less pejorative, upfront stated racial preferences are common on Grindr: "Masculine white guy looking for MASCULINE WHITE" (all caps in original) and "not into black dudes...sorry."[2] Many include preferences for more traditionally masculine men, including statements like "no queens," "no flamers," and "str8 acting men only," while others frequently list body type preferences by requesting "no fatties." Here, dating preferences are blurred with racism, sexism, fat shaming, and transphobia. Brandon Andrew Robinson (2015) analyzed how race affects interactions on the gay-serving ODSA Adam4Adam, demonstrating how the neoliberal discourse about preferences results in an overall filtering system, whereby users "cleanse racial bodies from their viewing practices." Though participants may excuse these statements by hiding behind their need to express "honest preferences," intolerance and xenophobia have recurrently been justified by claims of practicality (Rodriguez, 2014). Racial preferences and racial slurs on Grindr mirror broader criticisms of racism within White gay communities (Bérubé,

2001; Caluya, 2008), and surely the communities created by ODSA participants help to normalize and institutionalize discrimination.

One could argue that these tendencies within ODSAs merely reflect reality, and like all media content, ODSAs will shift alongside more progressive and inclusive public opinions. However, ODSAs do more than simply provide media content; they provide a means to finding partnership and human connection. Many of these niche and more mainstream ODSAs—from BlackPeopleMeet, SeniorPeopleMeet, Tinder, Match.com—are owned by the same media conglomerate, IAC Interactive Corp. The enormous growth in popularity of geosocial ODSAs tell us that they will become more intertwined in the daily lives and rituals of new generations, and continue to shape our lived realities of dating. While aspects of dating have always been associated with consumer culture, ODSAs commodify the process itself. Geosocial ODSAs, because they rely on quick decisions based almost entirely on physical traits, invite questions about the ways in which intersectional power dynamics become more commodified, and thus normalized. ODSAs such as Grindr and Tinder do have "decency" standards, which exclude photos of male genitalia, underwear, and women's breasts, so it certainly seems plausible for the company to regulate hate speech as well. Activists have challenged the policies of homophobia on eHarmony and ageism on Tinder, but when bigotry is generated through the labor of users themselves, what is the responsibility of the parent company? This is a question for ODSAs, but also a broader question for the media conglomerates that commodify user-generated content in the neoliberal era of Web 2.0 (Noble, 2013). These structural intersectional questions must be the starting point for future analyses of ODSAs.

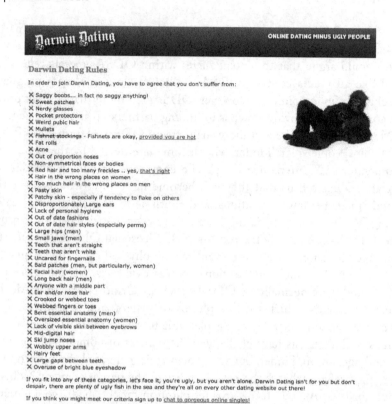

Figure 9.1. A list of rules from DarwinDating.com, an ODSA for "beautiful people".

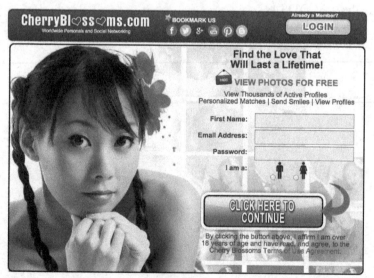

Figure 9.2. From Cherry Blossoms, an ODSA for men looking for Asian women.

Reply Rates By Race
female sender

	Asian - Male	Black - Male	Hispanic/Latin - Male	Indian - Male	Middle Eastern - Male	Native American - Male	Other - Male	Pacific Islander - Male	White - Male	
Asian - Female	48	55	49	50	53	49	50	46	41	43.7
Black - Female	31	37	36	37	40	41	41	32	32	34.3
Hispanic/Latin - Female	51	46	48	45	50	45	48	48	40	42.5
Indian - Female	51	51	43	55	51	45	36	44	40	42.7
Middle Eastern - Female	51	55	54	63	56	63	52	48	47	49.5
Native American - Female	45	50	47	47	47	44	47	52	40	42.3
Other - Female	52	52	43	54	52	51	47	50	42	44.4
Pacific Islander - Female	51	57	49	35	60	53	50	46	44	46.0
White - Female	48	51	47	48	49	48	48	47	41	42.1
	47.3	46.9	46.4	48.2	49.7	47.3	47.5	46.2	40.5	42.0

Figure 9.3. Replies by Race by Female Sender, from http://blog.okcupid.com/index.php/your-race-affects-whether-people-write-you-back/.

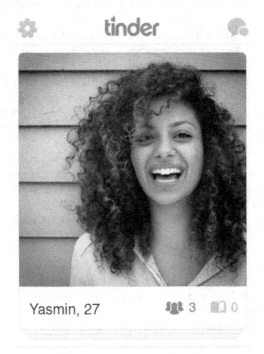

Figure 9.4. A stock photo of "Yasmin" used in an informal study about race and class preferences on Tinder, from http://www.buzzfeed.com/annehelenpetersen/stock-images-always-political#.er1X 9PlxD.

NOTES

1. This history has been pieced together from various online sources. More scholarly research is needed on this area. See "A History of Online Dating," http://brainz.org/history-online-dating/; The History of Online Dating in 12 Photos, http://thechive.com/2014/10/14/the-history-of-online-dating-12-photos/.
2. Douchebags of Grindr, https://www.tumblr.com/tagged/douchebags-of-grindr.

REFERENCES

Associated Press. (2010, March 30). eHarmony forced to merge gay, straight dating sites in discrimination lawsuit [Newswire story]. Retrieved from http://www.huffingtonpost.com/2010/01/28/eharmony-forced-to-merge-_n_440853.html

Badgett, M. V. L. (1997). Thinking homo/economically. In M. Duberman, *A queer world: The Center for Lesbian and Gay Studies reader* (pp. 467–501). New York: New York University Press.

Bagdikian, B. (2004). *The new media monopoly: A completely revised and updated edition with seven new chapters*. Boston, MA: Beacon Press.

Bercovici, J. (2014, February 14). Love on the run: The next revolution in online dating [Blog post], *Forbes*. Retrieved from http://www.forbes.com/sites/jeffbercovici/2014/02/14/love-on-the-run-the-next-revolution-in-online-dating/

Bergen, M. (2015, April 3). Watch the first video ad on Tinder: Video for Bud Light's Whatever USA [Blog post]. *Ad Age*. Retrieved from http://adage.com/article/digital/tinder-launches-paid-ads-bud-light-s-usa/297906/

Berteaux, A. (2014, February 21). Grindr: A full course meal in racism [Blog post]. Retrieved from https://medium.com/@anthonyberteaux/grindr-a-full-course-meal-in-racism-8edf081d5e33

Bérubé, A. (2001). How gay stays White and what kind of White it stays. In B. B. Rasmussen, I. J. Nexica, E. Klinenberg, & M. Wray (Eds.), *The making and unmaking of Whiteness* (pp. 234–265). Durham, NC: Duke University Press.

Blay, Z. (2015, January 13). I wasn't prepared for the horror story that is online dating while Black [Blog post]. *xoJane*. Retrieved from http://www.xojane.com/sex/online-dating-as-a-black-woman

Caluya, G. (2008). The Rice Steamer: Race, desire, and affect in Sydney's gay scene. *Australian Geographer, 39*(3), 283–292.

Campbell, J. E. (2005). Outing PlanetOut: Surveillance, gay marketing, and Internet affinity portals. *New Media & Society, 7*(5), 663–683.

Cho, S., Crenshaw, K. W., & McCall, L. (2013). Toward a field of intersectionality studies: Theory, applications, and praxis. *Signs, 38*(4), 785–810. doi:10.1086/669608

Coffey, L. T. (2013, August 5). From farmers to salad toppings: 26 weirdly niche dating sites [Blog post]. Retrieved from http://www.today.com/health/farmers-salad-toppings-26-weirdly-niche-dating-sites-6C10843053

Collins, P. H. (2004). *Black sexual politics: African Americans, gender, and the new racism*. New York: Routledge.

Consumersearch.com. (n.d.). Best matchmaking site reviews [Web page]. Retrieved from http://www.consumersearch.com/online-dating/best-matchmaking-sites

Dewey, C. (2015, March 5). Tinder's age tax is just one small piece of online dating's massive age problem. *The Washington Post.*

eHarmony. (n.d.). eHarmony.com [Web site]. Retrieved from http://eharmony.com

Feliciano, C., Robnett, B., & Komaie, G. (2009). Gendered racial exclusion among White Internet daters. *Social Science Research, 38*(1), 39–54.

Finkel, E. J., Eastwick, P. W., Karney, B. R., Reis, H. T., & Sprecher, S. (2012). Online dating: A critical analysis from the perspective of psychological science. *Psychological Science in the Public Interest, 13*(1), 3–66, doi:10.1177/1529100612436522

Forbes.com. (n.d.). Barry Diller [Biography]. Retrieved from http://www.forbes.com/profile/bar ry-diller/

Fuchs, C. (2012). Dallas Smythe today: The audience commodity, the digital labour debate, Marxist political economy, and critical theory. Prolegomena to a digital labour theory of value. *tripleC: Communication, Capitalism, & Critique: Open Access Journal for a Global Sustainable Information Society, 10*(2), 692–740.

Hall, R. E. (2005). From the psychology of race to the issue of skin color for people of African American descent. *Journal of Applied Psychology, 35*, 1958–1967.

Harris, C. I. (1993). Whiteness as property. *Harvard Law Review, 106*(8), 1707–1791.

Hitsch, G. J., Hortaçsu, A., & Ariely, D. (2010). Matching and sorting in online dating. *The American Economic Review* (2010), 130–163.

Huffington Post UK. (2014, February 2). Winter Olympians on Tinder: Sochi athletes flood "hook-up app" [Blog post]. *Huffington Post U.K.* Retrieved from http://www.huffingtonpost. co.uk/2014/02/18/winter-olympics-tinder_n_4806823.html

Hunter, M. (2007). The persistent problem of colorism: Skin tone, status, and inequality. *Sociology Compass, 1*(1), 237–254.

Iovation (n.d.). Mobile dating usage [Web page]. Retrieved from https://s3.amazonaws.com/content. iovation.com/press-releases/pr-iovation-mobile-growth-usage.png

Jha, S., & Adelman, M. (2009). Looking for love in all the white places: A study of skin color preferences on Indian matrimonial and mate-seeking websites. *Studies in South Asian Film & Media, 1*(1), 65–83.

Lapowsky, I. (2014, November 4). IAC proves its dating industry dominance with Tinder CEO ouster [Blog post]. *Wired.* Retrieved from http://www.wired.com/2014/11/tinder-ceo-ouster/

Leonhardt, D. (2006, March 28). The famous founder of Operation Match. *New York Times.* Retrieved from http://www.nytimes.com/2006/03/28/business/29leonside.html

Matthews, J. T. (1965, November 3). Operation Match. *Harvard Crimson.* Retrieved from http://www. thecrimson.com/article/1965/11/3/operation-match-pif-you-stop-to

McChesney, R. W., & Nichols, J. (2010). *The death and life of American journalism: The media revolution that will begin the world again.* New York: Nation Books.

Meehan, E. R. (1990). Why we don't count: The commodity audience. In P. Mellencamp (Ed.), *Logics of television: Essays in cultural criticism* (pp. 117–137). Bloomington: Indiana University Press.

Meehan, E. R. (1991). "Holy commodity fetish, Batman!": The political economy of a commercial intertext. In R. Pearson & W. Uricchio (Eds.), *The many lives of the Batman* (pp. 47–65). New York: Routledge.

Mosco, V. (2009). *The political economy of communication.* Los Angeles, CA: Sage.

Noble, S. U. Google search: Hyper-visibility as a means of rendering Black women and girls invisible. *InVisible Culture, 19.* Retrieved from http://ivc.lib.rochester.edu/google-search-hyper-visibility-as-a-means-of-rendering-black-women-and-girls-invisible/

Petersen, A. H. (2014, December 8). A fake Tinder profile followed me around the Internet and taught me about race and class [Blog post]. *BuzzFeed.* Retrieved from http://www.buzzfeed.com/annehelenpetersen/stock-images-always-political

Rao, L. (2011, April 11). IAC asks for more Google, please. *TechCrunch.* Retrieved from http://social.techcrunch.com/2011/04/11/iac-asks-for-more-google-please/

Robinson, B. A. (2015). "Personal preference" as the new racism: Gay desire and racial cleansing in cyberspace. *Sociology of Race & Ethnicity, 1*(2), 317–330. doi:10.1177/2332649214546870

Robnett, B., & Feliciano, C. (2011). Patterns of racial-ethnic exclusion by Internet daters. *Social Forces, 89*(3), 807–828.

Rodriguez, M. (2014, January 10). Is discrimination on Grindr killing gay sex? [Blog post]. Retrieved from http://www.huffingtonpost.com/mathew-rodriguez/is-discrimination-on-grindr-killing-gay-sex_b_4558989.html

Rudder, C. (2009, October 5). How your race affects the messages you get [Blog post]. Retrieved from http://blog.okcupid.com/index.php/your-race-affects-whether-people-write-you-back/

Rudder, C. (2014a). *Dataclysm: Who we are.* New York: Crown.

Rudder, C. (2014b, September 10). Race and attraction, 2009–2014 [Blog post]. Retrieved from http://blog.okcupid.com/index.php/race-attraction-2009-2014/

Salam, R. (2014, April 22). Is it racist to date only people of your own race? *Slate.* Retrieved from http://www.slate.com/articles/news_and_politics/politics/2014/04/okcupid_and_race_is_it_racist_to_date_only_people_of_your_own_race.2.html

Sanders, S. (2015, March 2). Tinder's premium dating app will cost you more if you're older [Blog post]. *NPR.org.* Retrieved from http://www.npr.org/blogs/alltechconsidered/2015/03/02/390236051/tinders-premium-dating-app-will-cost-you-more-if-youre-older

Slater, D. (2013). *Love in the time of algorithms: What technology does to meeting and mating.* New York: Current.

Smith, A., & Anderson, M. (2015, April 20). 5 facts about online dating [Blog post]. *Pew Research Center.* Retrieved from http://www.pewresearch.org/fact-tank/2015/04/20/5-facts-about-online-dating/

Smythe, D. W. (1977). Communications: Blindspot of western Marxism. *CTHEORY, 1*(3), 1–27.

SOCHI ON TINDER. (2014). Web site. Retrieved from http://sochiontinder.tumblr.com

Soon2BeCatLady. (2015, March 3). BOYCOTT TINDER!! [Blog post]. Retrieved from http://soon2becatlady.com/2015/03/03/boycott-tinder

Tadena, N. (2014, June 4). What Match.com's ad spending says about online dating [Blog post]. *Wall Street Journal.* Retrieved from http://blogs.wsj.com/cmo/2014/06/04/what-match-coms-ad-spending-says-about-online-dating

Toma, C. L., Hancock, J. T., & Ellison, N. B. (2008). Separating fact from fiction: An examination of deceptive self-presentation in online dating profiles. *Personality and Social Psychology Bulletin, 34*(8), 1023–1036. doi:10.1177/0146167208318067

Tomlinson, B. (2013). To tell the truth and not get trapped: Desire, distance, and intersectionality at the scene of argument. *Signs, 38*(4). doi:10.1086/669571

Valkenburg, P. M., & Peter, J. (2007). Who visits online dating sites? Exploring some characteristics of online daters. *CyberPsychology & Behavior, 10*(6), 849–852.

The Nation-State in Intersectional Internet: Turkey's Encounters With Facebook AND Twitter

ERGIN BULUT

INTRODUCTION[1]

After meeting with the Turkish president Tayyip Erdogan, Joel Simon (2014), the head of the Committee to Protect Journalists (CPJ), wrote an article for the *Guardian* emphasizing the extremely poor level of freedom of expression in the country. In his piece, Simon was confirming the findings of a comprehensive report on media policy and media freedom in Turkey that revealed the following: "The ideological conservatism of the judiciary; the institutional weakness of the parliament; and the lack of democracy within political parties render the government—and future governments—too powerful vis-à-vis the society and the media" (Kurban & Sözeri, 2012). Indeed, Turkish media is under such symbiotic state and corporate control that it has been defined as a "neoliberal media autocracy" (Akser & Baybars-Hawks, 2012). In this picture, social media has been useful to overcome conditions of state censorship. The Internet also produced outlets where journalists fired from mainstream media were able to write. However, the usefulness of social media has been equally precarious[2] and this is linked to one of Joel Simon's remarks that received less attention than it deserved. Simon highlighted how Erdogan differed from other heads of the state whom he regularly meets. According to Simon, the strategy of other politicians is to juxtapose the "responsible international press" vis-à-vis "reckless and irresponsible domestic media." Erdogan, Simon wrote, did not have any praise for international media

and actually "expressed plenty of disdain for them." Moreover, the Turkish president had said that he was "increasingly against the Internet."

Against this national context of censorship, this chapter examines the relationship between social media companies (specifically Facebook and Twitter) and the Turkish state. This task is important for a variety of reasons. First, this chapter examines the struggle over the Internet from a transnational perspective by situating globalization within theories of intersectionality. Theories of intersectionality investigate and subvert the ways in which different identities operate and deepen marginalization. By way of looking at the constitution of private property (Harris, 1993), legal domain, gender, ethnicity, class, and sexuality, intersectionality "has played a major role in facilitating consideration of gender, race, and other axes of power in a wide range of political discussions and academic disciplines" (Cho, Crenshaw, & McCall, 2013, p. 787). Despite these fruitful interventions of intersectionality, critical studies of the Internet, unfortunately, have mostly ignored the multiplicity of struggles and focused only on concentration of wealth and exploitation of digital labor (Scholz, 2012). While providing highly useful insights into and for political economy, this literature has constructed the Web in such a way to marginalize people's struggles against the nation-state in the Global South.

To this end, this chapter uses intersectionality to dissect Turkey, the nation-state with the second largest army in NATO. Turkey's recent anti-Western rhetoric and politics, as well as its unwillingness to fight ISIS, have undermined the country's position as a candidate for the EU and as a long-time ally of the United States. Yet these grand constructions reduce the multiplicity of identities and power struggles in the country. Turkey's population has historically been highly heterogeneous. A major Kurdish population has been struggling for political and cultural rights. Alevi people have been fighting for recognition and educational exemption from mandatory religion classes. While low in numbers, Turkey has Christian and Jewish citizens who have been marginalized as well. Demands for sexual freedom are also on the rise, as the recent social uprisings have clearly revealed. Murders of women and rape are major national problems vis-à-vis increasing conservatism and official anti-feminist rhetoric.

In such a dynamic and fluid materiality, intersectionality enables us to identify differential power relations that define populations in the country. While defined as a predominantly Muslim country in the West, Turkey's societal dynamics highlight the complexities of social struggles over the Internet.

There are other reasons for examining the struggle over the Internet. Claims regarding the withering of the nation-state and liberating aspects of new media technologies need to be double checked, especially in a country like Turkey, where the freedom of journalists is protected quite precariously, through highly paternalistic guarantees. It is not unusual to hear a top official, such as Prime Minister Ahmet Davutoglu, say, "If any journalists are under threat, they can turn to my

office and we will provide protection." Second, there needs to be a sustained discussion on how the nation-state and social media companies such as Facebook and Twitter are negotiating power in the aftermath of the Arab Spring and the NSA scandal. As this chapter will demonstrate, social media companies' assumed neutrality and support for activists is to be seriously rethought, because their willingness to cooperate with the nation-state reveals that they are far from constituting a potential post-Fordist NWICO (Chakravartty & Sarikakis, 2006), given the global/financial nature of their operations. While the history of collaboration between tech companies and the state go back to the Cold War (Hirsch, 2013; Mattelart, 2010) and, similarly, the link between modernization and communication networks has a long history (Shah, 2011), it is important to investigate the current emphasis on social media, democracy, and the role of the nation-state for at least two reasons.

First, in contrast to previous top-down modernization approaches, current discourse is heavily invested in the digital as a mode of empowerment for the global populous and emphasizes the creativity of grassroots politics (Chakravartty, 2009, Fisher, 2010). Additionally, while contemporary concerns regarding privacy and surveillance might echo the calls for a new world information order of the 1970s, the world-system model based on the core-periphery distinction has considerably changed, where today's citizens place their global demands not *through* their governments, but *from* them. While the updates and the original insights of cultural imperialism and media imperialism are too precious to discard (Fuchs, 2010; Jin, 2013; Schiller, 1991/2006), we also need to be aware of the fact that today's global struggles are not necessarily carried out with the assumption that national governments protect their citizens against the First World countries. On the contrary, there is a fluid and complex relationship between imperial (i.e., the United States and the EU) and sub-imperial zones (i.e., Turkey) that is further complicated with the advent of social media companies, the services of which activists use to organize and challenge the system. In a way, as corporate power becomes concentrated, resistance goes international but is also highly fragmented through social media.

The role of social media in uprisings in the aftermath of the Arab Spring has been studied from a variety of angles: the importance of histories of nation-states and their genealogies within the relations of uneven and combined development (Matar, 2012); youth and social media (Herrera, 2012); space and material practices within the everyday (Aouragh, 2012; Gerbaudo, 2012; Tawil-Souri, 2012); the correlation between online and offline activism (Sayed, 2011); nation-branding and Twitter (Uysal, Schroeder, & Taylor, 2012); and blogging and politics (Khalili, 2013; Riegert & Ramsay, 2013).

What seems to be missing from these dynamic and critical discussions is a "socio-legal" (Verhulst & Price, 2013) interrogation of the relationship between

social media companies and the state. While there have been studies on Internet freedom and cyber crackdowns (Comminos, 2011; Howard, Agarwal, & Hussain, 2011), we need investigations of how the state is increasingly trying to make social media companies comply with its own national legal framework, as well as how social media companies are also emerging as serious political actors in the New Middle East (Herrera, 2014). Indeed, despite the assumptions that social media companies are neutral and suprapolitical agents, it is becoming clear that they consider themselves to be (and act as if they are) major political actors. Would Mark Zuckerberg otherwise specifically call Barack Obama to express his frustration regarding Internet freedom, saying, "The US government should be the champion for the Internet, not a threat" (Pagliery, 2014)? As Tarleton Gillespie (2010) has warned us in the case of YouTube, these technological infrastructures are constructing themselves as "curators of public discourse" and neutral "platforms," but we, as scholars and citizens, need to be aware of the politics pertaining to the infrastructure and interventions of social media companies as far as democracy or Internet regulation is concerned.

An examination of the power struggle between the state and social media companies is also important because the authoritarian states in the region are learning from each other as to how they can reduce freedom of expression and activism through cooperation on legal grounds—for example, through limiting content or putting pressure on service providers. In addition, the technical infrastructure of social media companies as foundational organs of contemporary informational imperialism is to be unpacked. As William Lafi Youmans and Jillian York (2012) remind us with specific emphasis on Facebook and YouTube, social media companies operate on the basis of code, which according to Larry Lessig's famous formulation "constitute cyberspace" where "the selections about code are therefore in part a selection about who, what, and most important what ways of life will be enabled and disabled" (Lessig, 2006, p. 88). Indeed, "code is law"[3] and it "permits and forbids the uses set out by an application's sponsoring firms" (Grimmelmann, 2004, cited in Youmans & York, 2012). This means that the architecture of the code of publicly traded social media companies was "not designed to cater to activist users" and "that social media governance, both in terms of code-as-law and the rule of policies and user terms, is driven by necessary commercial consideration, namely, monetization" (Youmans & York, 2012, p. 317). Then, especially given Turkey's relationship with the United States in the construction of a "New Middle East," it is important to look at the evolving relationship between social media companies and the state because social movements challenging the Empire will be highly affected by "changes in platform architecture" of social media, which "may introduce new or expand previous constraints for activist users, thus affecting the risks and effectiveness of their efforts" (Youmans & York, 2012, p. 317).

Taking this technical and legal framework into consideration can further help us reveal how the state's power is far from being weakened. It is undeniable that the field of social media is so fluid and "under construction" in the sense that nation-states, citizens, and technology companies are "seeking a vocabulary of change and a set of laws and institutions that provide legitimacy, continued power or the opportunity to profit from ongoing change" (Verhulst & Price, 2013, p. 5).

Within this evolving picture, it is vital to remember that, with respect to social media services and repressive regimes, the legal terrain is not as solid as to the export of "certain technologies such as cryptographic software to repressive regimes" (Youmans & York, 2012, p. 324). In addition to this uncertainty, social media companies might have to comply with the power of the nation-state because "business considerations may trump civic considerations" (p. 324) and the condition of social media companies is further complicated when they have capital and employees in a certain country, an issue that this chapter will explore. This kind of work is especially needed after the NSA scandal and the uprisings in the New Middle East, particularly in the case of Turkey, a major country for the U.S. interests in the region. In this sense, regulating social media companies and concerns for censorship is a major issue across the countries in the region. The task here is to look at how this contested terrain—of law, technologies, code, infrastructure, history, and people—has been shaped in the aftermath of the Gezi Uprising.

TURKEY, "THE ROLE MODEL:" "WE WILL ERADICATE TWITTER"

The branding of Turkey as "role model" has recently been replaced by skepticism due to the political and economic uncertainty in the country. Freedom of speech has been under major threat, due not only to media concentration but also to the government's concentrated efforts to create its own media (Aladag, 2013) to curtail the power of the army and pacify dissident journalists (Kurban & Sozeri, 2012). Even as this chapter was being written, counterterror police targeted Fethullah Gülen–linked media, precisely the same outlets that once helped Erdogan attack the opposition. Indeed, Western commentators were awed by uneven urban growth and rise of conservative middle classes but a different picture lay behind the country's economic boom. While the Justice and Development Party–led (*Adalet ve Kalkınma Partisi*, or AKP) government provided social aid and ways of survival for the impoverished proletariat in major cities, there were major problems with respect to freedom of press. The level of pro-government journalism is such that state-owned Turkish Radio and Television Corporation (TRT) promoted the hashtag #edenbulur, meaning "those responsible will pay the

price," right after targeting Gülen-related media. In addition to traditional media, social media has been severely restricted as an outcome of corruption scandals that erupted on December 17, 2013. Following a power struggle between AKP and the Gülen Movement,[4] phone conversations among Erdogan, his son, and some ministers regarding money transfers and expensive purchases were leaked to the public, along with Erdogan's direct calls to media outlets for censorship. Twitter and YouTube were banned in the country to prevent more tapes from being leaked.

However, the state's concentrated efforts in regulating and censoring social media go back to the Gezi Uprising.[5] Getting stricter, this control regime has implications for the future operations of social media companies in the country. Indeed, regulations and implementations regarding social media are tied personally to President Tayyip Erdogan, who stated on March 7, 2014 (he was then the prime minister), that, "If necessary, we will shut down Facebook and YouTube" (Hurriyet, 2014) and ended up declaring, "We'll eradicate Twitter. I don't care what the international community says" on March 20, 2014. It was only a couple of hours later that access to Twitter was blocked.

As part of this emergent control regime, there are certain issues and events to be underlined since these features reveal hints as to how the relationship between social media companies and the state can be reformulated in a highly restrictive way in the future. These events and legal issues also provide clues about how Facebook and partly Twitter have strategically chosen to act in accordance with national policies of the government and may actually continue to do so in the future, even though Twitter is more resistant to cooperation. Then, let us explore how Facebook and Twitter's encounters with the Turkish state unfolded in each specific condition. These cases reveal important points to consider, given the changing geopolitical relations and Turkey's desire to transform itself into a big regional actor.

Case 1: It's the Law! Legalizing Censorship

One of the major issues to consider when exploring the relationship between social media companies and the Turkish state is the broader legal picture, a brief background to which I provided above. On February 19, 2014, as a response to corruption scandals in the country, Internet law (5651) was amended[6] to prevent further tapes to be released. The amended law is comprised of certain parts that bear potential consequences as far as social media/nation-state relations are concerned.

The amendments introduced Internet filtering through "Union for Service Providers." To operate in the Internet market, the new law stipulates that one needs to be a member of this union. What Union for Service Providers (Union for ISP) will really do is to block URLs as demanded by the state's Telecommunication Information Directorate (TIB) and keep track of Internet traffic for

two years. Internet hosting providers can be blocked even if they are abroad, and changing your DNS will not be enough to have access to the website. Additionally, "Twitter, Facebook, and other platforms defined as 'hosting providers' under the law will also be required to obtain a certificate in order to operate in Turkey" (Freedom House, 2014, p. 6).

This new law is hinting at what one might call "centralization of content supervision," where the government will have the final call in deciding what can exist online. Indeed, even though this union is comprised of free enterprise companies, the constituents are then told by the government what to provide and not to provide online. Moreover, the revenues of this Union come from 0.05 percent of Internet service providers, and amount to 12–15 million Turkish liras (about $7 million USD) (Nebil, 2014).

There has already been a controversy regarding the operations of the Union and one of its members. A couple of days after the Twitter blockage on March 20, 2014, TTNET, the largest service provider and a subsidiary of Turkish Telekom, declared that some customers in certain areas would not have Internet access due to maintenance on March 25, 2014, the day major tape scandals were scheduled to be released (and prior to highly important local elections). In other words, there was speculation that service providers were acting in line with the government, even though TTNET then had to make a statement, saying that warning messages regarding service reduction were sent only to 131 users (T24, 2014).

In one sense, this formation stands at odds with the discourse of social media companies regarding deregulation, neutrality, and Internet democracy, because if a Tweet or Facebook page is regarded as illegal by the Telecommunication Information Directorate, then the service providers will need to shut that page down. As of now, it remains to be seen as to how the social media giant Facebook could potentially react if "Union for Service Providers" were to ask Facebook to shut down a page, especially because Facebook has millions of users in Turkey. On the other hand, what we are seeing following the corruption scandal is that Twitter had to accept the government's decision to block certain accounts *and then* engage in a legal struggle.

What also emerged as part of the amended Internet law is that the Turkish state started forming a "Blue Room" through which fake accounts on Facebook and Twitter would be monitored. Here, Facebook has responded positively to potential collaboration while Twitter did not (T24, 2013).

Ultimately, the Turkish government is transforming the infrastructure of the cyberspace through legal terms in its attempt to contain corruption scandals and dissidence through the seemingly benevolent discourse of "secure" Internet. At the same time, quite vague definitions of "national security" are being used for constraining online and offline protest to the dismay of the European Court for Human Rights (ECHR), which finds the regulatory framework devoid of sound legal foundations.

Case 2: Facebook Bans Kurdish Pages

Right after the Gezi protests, between July 6, 2013, and August 12, 2013, Facebook shut down more than 10 Facebook pages (Basaran, 2013), which were Kurdish politicians' Facebook pages, including the page of the Peace and Democracy Party (*Barış ve Demokrasi Partisi*, hereafter BDP) Central Office. The argument was that this page included the word "Kurdistan."

Figure 10.1: The statement from Facebook regarding banning the BDP page.

There were also other pages that produced news regarding minorities in Turkey, such as *Otekilerin Postasi* (The Others' Press) and *Yeni Ozgur Politika* (New Free Politics). In his interview with liberal newspaper *Radikal*, Richard Allan, director of Facebook policy in Europe, clearly described Facebook's policy. Facebook completely complies with the international definition of terrorism and closes a page if it compliments an organization or a person that is on the international list of terrorism. In this sense, Allan stated that "if there is the flag or a symbol regarding PKK [the Kurdistan Workers' Party[7]], then it is enough for Facebook to decide to close that page"[8] (Basaran, 2013). For Facebook, what mattered then was the "Internet laws of the country within which it operates. Otherwise, the nation-state has the right to close the website."

It wasn't without any reaction this censorship took place. The pro-Kurdish BDP asked Binali Yildirim, former Minister of Transportation, Maritime Affairs, and Communication, about the link between shutting down their Facebook pages right after his statement, "Facebook has been cooperating with Turkish authorities and we do not have a problem with them" (Gündem, 2013). BDP's other questions involved the extent of information sharing between Facebook and the Turkish government, and the taxation of Facebook.

What makes Facebook's intervention controversial is the fact that these shutdowns took place at a time when the Turkish government was carrying out peace negotiations with PKK. Additionally, some of the pages had nothing to do with PKK and were related to BDP politicians. In this sense, Facebook was choosing not to interpret the political context and prioritizing the interests of the nation-state.

Case 3: Gezi Uprising and Corruption Tapes: Inviting Twitter to Turkey

The Gezi Uprising constituted the first moment of regulation crisis of social media companies. The government invited Facebook and Twitter to open offices in the country. Binali Yildirim stated that Facebook was collaborating with the government and had units in Turkey, whereas Twitter did not (Hurriyet, 2013). He added: "If you have operations in this country, you need to cooperate with the judiciary and police force in relation to criminal cases.... Why don't you be part of Turkish legal system? That would not harm anybody. When a tax officer, a police officer or somebody else contacts us for information, we would like to see your unit in Turkey, which would provide that information. We cannot express our concern via phone, Internet or e-mail given the eight-hour time difference" (Hurriyet, 2013).

The relationship between Twitter and the government took a radical turn when the government, as mentioned above, blocked access to Twitter on March 20, 2014. Even though it got extremely hard (blockage for Google DNS, and further blockage based on IP addresses), citizens ultimately found ways to get on Twitter. The government's interest in having a Twitter office intensified following the corruption scandal.

After the blockage, Twitter sent a legal team to Turkey and Binali Yildirim provocatively said, "While Twitter wasn't initially willing to cooperate, they have now hastily hired a lawyer" (Radikal, 2014). In other words, Twitter had decided to comply with court decisions, even if temporarily. What Yildirim mentioned is important in terms of the learning curve of the nation-state with respect to regulating social media companies. When YouTube refused to ban videos insulting Ataturk years ago, the Turkish state—learning from German officials and hoping that this might actually work—filed a complaint regarding copyrights with respect to Ataturk's voice and images. YouTube now has a representative for Turkey (Radikal, 2014).

The Twitter ban received a great deal of political attention. Using Twitter despite the ban, former president Abdullah Gul said that appointing a lawyer was a positive step, even though this lawyer cannot be described as a representative between Twitter and Turkey (CnnTurk, 2014). Former minister of transportation Lutfi Elvan stated that it was encouraging to see Twitter collaborating with the Turkish state by blocking accounts that were subject to court decisions, adding that "Twitter needs to open an office in Turkey" (Istanbulhaber, 2014).

During the period it was blocked, Twitter emphasized its commitment to its users by making an official announcement, underlining the following:

1. No IP or email address will be shared with the Turkish government.
2. Twitter blocked an account (@oyyokhirsiza, trans. *no vote for the thief*) that made claims with respect to corruption[9] regarding former minister Binali Yildirim, but then filed a counter lawsuit against the court decision that stipulated the suspension of the account.
3. For the first time in Turkey, Twitter was implementing account suspension on country basis (Country Withheld Content).
4. Twitter's law advisor Vijaya Gadde said: "Twitter blockage in Turkey is based on claims with respect to three claims. Two of these three claims are already against our principles. The account where we have disagreement is the account that accuses a former minister of corruption. This has caused concerns for us. If political statements are concerned with corruption, this is very important for us. Therefore, we filed a lawsuit for that account to be opened. On the other hand, Turkey sent us the legal decisions regarding the controversial accounts after it implemented the blockage" (IMC TV, 2014; Twitter, 2014).

Then, the struggle for social media started where Twitter found itself having to respond to the demands of the Turkish government. Currently, the outcome of this legal struggle is open-ended.

CONCLUSION: SOCIAL MEDIA AS COLD WAR 2.0?

Where do these developments leave us? What do we make of the relationship between the nation-state and social media companies?

First, it is undeniable that the Internet and social media are to be seen as highly political—not just technical—platforms, and the case of Turkey reveals the complex ways in which the nation-state is responding to social media revolutions through legal and extra-legal means.

Second, because it is harder to regulate Facebook and Twitter, it seems that Turkey is trying to figure out a way to control and mainstream the operations of these companies through national law. Facebook is more willing to cooperate with the state, at least in terms of providing data for child molesters, or directly closing pages of Kurdish politicians or releasing data for fake accounts to facilitate the state's control over Internet. Twitter, on the other hand, is proving to be more resistant to the demands of the nation-state. In a way, Twitter has actually chosen to engage in the legal battle into which the Turkish state has attempted to draw them.[10]

Third, because it is relatively hard to negotiate with these companies, the Turkish state is monopolizing control over service providers, just like Egypt did.

What we are seeing is that countries in the region and social media companies are still within that learning curve, where each wants to maintain their own interests and control over information, power, or profits. On the one hand, they feel obliged to comply with the laws of the country within which they operate. If social media companies choose to block access to "controversial content," this would mean censorship in line with the demands of the nation-state and that would damage the public perception of these companies and harm their economic positions.

There are also global conclusions to be drawn from this case in Turkey, specifically in the United States where freedom of speech is under attack even in major public universities such as University of Illinois at Urbana-Champaign.

While all the giant media companies denied being involved in the NSA scandal, their existence is highly linked to the politics of the Cold War. Indeed, there are strong signs as to how these media companies are actively involved in contemporary politics. For instance, in the case of Egypt, both "Google and Twitter set up a system of voice tweets whereby people could call a foreign number and leave messages that were instantly posted on Twitter under the hashtag, "#egypt" (Freedom House, 2012, p. 6). This makes it clear that social media companies are emerging as major political actors, not just technical platforms. As Linde Herrera (2014) demonstrates, the United States especially draws heavily on new ICTs and social media as part of operating its soft power and channels of public diplomacy in the Middle East.[11]

There is no denying that social media giants such as Facebook, Twitter, and Google are powerful political actors. Although social media companies denied collaboration, the NSA scandal made it clear that "the private sector effectively built NSA's surveillance system, and got rich doing it" (Hirsh, 2013). As a private sector official, speaking under condition of anonymity, said, the collaboration doesn't require the social media companies to be punished if they don't. Rather, "it's the good little Indian that gets rewarded." Indeed, these companies historically had to open offices in Washington in spite of their anti-government and libertarian attitudes toward politics and walk the thin line of "patriotism and public image." Furthermore, the NSA had a "major presence when the nation's [USA] telecom industry went through a revolution, moving from the Bell system to a flurry of start-ups and a blizzard of mergers" (Hirsh, 2013).

Then, this history is highly important to remember for not only highlighting the ways in which the myth of the free market is to be deconstructed, but also to once again address how the emergence of the social media companies in Silicon Valley is tightly linked to national security interests and global geopolitics. History and contemporary developments remind us again and again of the need to be cautiously optimistic with respect to claims that the digital is an easy way to circumvent the state apparatus. On the contrary, the realm of the digital is yet another way for the nation-state, as the case of Turkey demonstrates, to suppress ideas and practices that are not aligned with its own interests.

NOTES

1. Case study sections of this chapter are taken from an article to be published in *Media, Culture and Society*.

2. This precarity is not specific to Turkey. Recently, the Egyptian government hired an online company (See Egypt), "the re-seller of U.S.-based Blue Coat's products," for "extensive monitoring of Internet communication on various social platforms such as Skype, Facebook, Twitter and YouTube" (Al Arabiya News, 2014).

3. Concrete examples of this would be that one cannot be anonymous on Facebook since "the commercial interest is that real identities are easier to monetize" (Youmans & York, 2012, p. 320). Similarly, Facebook's attitude toward controversial content (such as violent videos from the Syrian civil war) will be flexible depending on the case.

4. The Gülen movement, led by Fethullah Gülen, is a charity organization with a heavy presence in politics, security forces, and the judiciary. Since 2002, the Gülen movement and AKP worked together to reduce the role of army in politics. Having defeated the common enemy through a number of contentious lawsuits, these two actors are now competing for political power. When Erdogan declared to close private educational institutions (*dershane*) of the Gülen movement, corruption tapes—arguably by the Gülen movement—were leaked. Cihan Tugal's (2013) article on *Jadalliya* aptly summarizes the characteristics of the movement and the fallout.

5. Since 2007, the government's interest in regulating the Web (Law No. 5651) first used child pornography as an excuse to have a hard hand in the regulation of Internet. This was followed by the discourse of "secure Internet" as it was demonstrated in BTK's (Information and Communication Technologies Authority) arbitrary attempts to produce filters to enable that "secure" Internet (Oz, 2011). The final blow came when the government did not even consult social partners in revising Law No. 5651 (February 2013, explored more in detail below) and actually put this highly important item as part of a giant legal package, legalizing it in a one-sided way, without any support from opposition parties.

6. European Court of Human Rights (ECHR) ruled that this law "lacked a strict legal framework for blocking orders and their contestation," implying that the framework was arbitrarily political (Freedom House, 2014).

7. Kurdistan Workers' Party, which has fought the Turkish state for years to gain autonomy and political rights for the Kurdish population in Turkey. Currently, the peace resolution process between the government and PKK is stalled.

8. However, BDP's spokesperson Cem Bico made a statement that was contrary to Facebook's claims regarding PKK and terrorism: The main page came down following the group posting of an interview with BDP's MP Sabahat Tuncel calling for political autonomy in Kurdistan. There is no mention of armed groups. In this text you cannot find any specific expression that supports PKK or terrorism as an activity (Deutsche Welle, 2013).

9. Following the corruption scandal, critics and supporters of the AKP government were involved in an immense social media war. For a detailed discourse analysis of these tweets, see Doğu et al. (2014).

10. One also needs to note that Facebook has a more biased attitude than Twitter in the sense that Zuckerberg's company will let people of a nation organize a day of rage against their own state but will not allow a page called "third Palestinian Intifada" (Comminos, 2011).

11. Indeed, the links between Google and the State Department is such that activist Wael Abbas's videos regarding police torture, previously banned on YouTube, were reinstated after a request from the

State Department to Google. Similarly, it is in this spirit that the cyber dissident diplomacy efforts of the United States rely heavily on the participation of social media companies such as Google and Facebook as far as summits such as Alliance of Youth Movements (AYM) are concerned. In such globally mediated events, dissidents from across the world meet and discuss politics and inspire social change in countries such as Egypt and Turkey, which are both allies and crucial sites for the United States. Indeed, when James Glassmann was launching—along with Jared Cohen (Director of Google Ideas)—the first summit of Alliance of Youth Movement in Egypt, he was asked whether the allies of the United States would like the level of their involvement. Glassmann responded by saying that these governments may not be happy but "that's what we do in public diplomacy" (Herrera, 2014, p. 36). Herrera's analysis goes beyond the scope of this chapter but she aptly points to the ways in which AYM marries "activism and consumerism" to "deradicalize and even depoliticize politics" as a "partnership between the State Department and US corporations working in high tech, advertising, youth media, and food, and beverage service" (Herrera, 2014, p. 38).

REFERENCES

Akser, M., & Baybars-Hawks, B. (2012). Media and democracy in Turkey: Toward a model of neoliberal media autocracy. *Middle East Journal of Culture and Communication, 5*(3), 302–321.

Aladag, A. (2013). *Hegemonya yeniden kurulurken: Sol liberalizm ve yaraf.* İstanbul: Patika.

Al Arabiya News. (2014, September 18). Egypt heightens surveillance of online communication. Retrieved from http://english.alarabiya.net/en/media/digital/2014/09/18/Egypt-monitors-social-media-on-unprecedented-scale-.html

Aouragh, M. (2012). Social media, mediation and the Arab Revolutions. *Triple C: Communication, Capitalism & Critique. Open Access Journal for a Global Sustainable Information Society, 10*(2), 518–536.

Basaran, E. (2013, August 29). PKK'ya ait hersey kapatma nedenidir. *Radikal.* Retrieved from http://www.radikal.com.tr/yazarlar/ezgi_basaran/pkkya_ait_her_sey_kapatma_nedenidir-1148259

Chakravartty, P. (2009). Modernization redux?: Cultural studies & development communication. *Television and New Media, 10*(1), 37–39.

Chakravartty, P., & Sarikakiks, K. (2006). *Media policy and globalization.* Edinburgh: Edinburgh University Press.

Cho, S., Crenshaw, K., & McCall, L. (2013). Toward a field of intersectionality studies: Theory, applications, and praxis. *Signs, 38*(4), 785–810.

CnnTurk. (2014). Gül: "Dinlenmedim diyemem." Retrieved from http://www.cnnturk.com/haber/turkiye/gul-dinlenmedim-diyemem

Comminos, A. (2011). Twitter revolutions and cyber crackdowns: User generated content and social networking in the Arab Spring and beyond. Presented at the Association for Progressive Communications (APC). Retrieved from https://www.apc.org/en/system/files/AlexComninos_MobileInternet.pdf

Deutsche Welle. (2013, November 2). Facebook censorship of pro-Kurdish political party. *DW.DE.* Retrieved from http://www.dw.de/facebook-censorship-of-pro-kurdish-political-party/a-17199752

Doğu, B., Aydemir, A. T., Özçetin, B., İslamoğlu, G., Bayraktutan, G., Binark, M., & Çomu, T. (2014). *Siyasetin yeni hali: Vaka-i sosyal medya.* İstanbul: Kalkedon Yayınları.

Fisher, E. (2010). Contemporary technology discourse and the legitimation of capitalism. *European Journal of Social Theory, 13*(2), 229–252.

Freedom House. (2012). *Freedom on the Net 2012: Egypt.* Washington, DC: Freedom House. Retrieved from http://www.freedomhouse.org/sites/default/files/Egypt%202012.pdf

Freedom House. (2014). The struggle for Turkey's Internet. Retrieved from https://freedomhouse.org/sites/default/files/The%20Struggle%20for%20Turkey%27s%20Internet.pdf

Fuchs, C. (2010). New imperialism: Information or media imperialism? *Global Media and Communication, 6*(1), 33–60.

Gerbaudo, P. (2012). *Tweets and streets: Social media and contemporary activism.* London: Pluto Press.

Gillespie, T. (2010). The politics of platforms. *New Media & Society, 12*(3), 347–364.

Grimmelmann, J. (2004). Regulation by software. *Yale Law Journal, 114,* 1719–1775.

Gündem, Ö. (2013, July 24). BDP Facebook sansürünü Bakan Yıldırım'a sordu. Retrieved from http://www.ozgur-gundem.com/index.php?haberID=78932

Harris, C. (1993). Whiteness as property. *Harvard Law Review, 106*(8), 1707–1791.

Herrera, L. (2012). Youth and citizenship in the digital era: A view from Egypt. *Harvard Educational Review, 82*(3), 333–352.

Herrera, L. (2014). *Revolution in the age of social media: The Egyptian popular insurrection and the Internet.* London: Verso.

Hirsh, M. (2013, July 25). How America's top tech companies created the surveillance state. *National Journal.* Retrieved from http://www.nationaljournal.com/magazine/how-america-s-top-tech-companies-created-the-surveillance-state-20130725

Howard, P., Agarwal, S., & Hussain, M. (2011). When do states disconnect their digital networks? Regime responses to the political uses of social media. *The Communication Review, 14*(3), 216–232.

Hurriyet. (2013, June 26). "Bakan binali yıldırım: Twitter bizi geri çevirdi". *Hurriyet.* Retrieved from http://www.hurriyet.com.tr/ekonomi/23588625.asp

Hurriyet. (2014, July 3). Başbakan: Gerekirse YouTube ile Facebook'u kapatırız. *Hurriyet.* Retrieved from http://www.hurriyet.com.tr/gundem/25956479.asp

IMC TV. (2014). Twitter'dan Türkiye'ye özel uygulama. *İMC TV.* Retrieved from http://www.imctv.com.tr/2014/03/26/twitterdan-turkiyeye-ozel-uygulama/

Istanbulhaber. (2014, March 23). Lütfi Elvan: Twitter mutlaka Türkiye'de ofis açmalı. İstanbul *Haber.* Retrieved from http://www.istanbulhaber.com.tr/haber/lutfi-elvan-twitter-mutlaka-turkiyede-ofis-acmali-191759.htm

Jin, D. (2013). The construction of platform imperialism in the globalization era. *Triple C, 11*(1), 145–172.

Khalili, J. (2013). Youth-generated media: A case of blogging and Arab youth cultural politics. *Television & New Media, 14*(4), 338–350.

Kurban, D., & Sözeri, C. (2012). *Caught in the wheels of power: The political, legal, and economic constraints on independent media and freedom of the press in Turkey.* İstanbul: TESEV Publications.

Lessig, L. (2006). *Code: And other laws of cyberspace. Version 2.0.* London: Basic Books.

Matar, D. (2012). Contextualising the media and the uprisings: A return to history. *Middle East Journal of Culture and Communication, 5,* 75–79.

Mattelart, A. (2010). *The globalization of surveillance*. London: Polity Press.

Nebil, F. S. (2014, March 5). İnternet, "sivil toplum örgütü" maskesi taşıyan Erişim Sağlayıcıları Birliği ile sansürlenecek! *T24*. Retrieved from http://t24.com.tr/haber/internet-sivil-toplum-orgu tu-maskesi-tasiyan-erisim-saglayicilari-birligi-ile-sansurlenecek/252671

Oz, I. (2011). Prof. Binark: Güvenli Internet adıyla kamuoyu yanıltılıyor. Retrieved from http://t24. com.tr/haber/prof-binark-guvenli-internet-adiyla-kamuoyu-yaniltiliyor,165071

Pagliery, J. (2014). Mark Zuckerberg calls Obama to complain about NSA. *CNNMoney*. Retrieved from http://money.cnn.com/2014/03/13/technology/security/mark-zuckerberg-nsa/index.html

Radikal. (2014, March 21). Binali Yıldırım: Burnundan kıl aldırmayan Twitter avukat tayin etti. *Radikal*. Retrieved from http://www.radikal.com.tr/politika/binali_yildirim_burnundan_kil_ aldirmayan_twitter_avukat_tayin_etti-1182574

Riegert, K., & Ramsay, G. (2013). Activists, individualists, and comics: The counter-publicness of Lebanese blogs. *Television & New Media, 14*(4), 286–303.

Sayed, N. (2011). Towards the Egyptian revolution: Activists' perceptions of social media for mobilization. *Journal of Arab & Muslim Media Research, 4*(2/3), 273–298.

Schiller, H. (1991/2006). Not-yet the post-imperial era. In M. G. Durham & D. Kellner (Eds.), *Media and cultural studies: Keyworks* (pp. 295–311). Hoboken, NJ: Wiley-Blackwell.

Scholz, T. (Ed.). (2012). *Digital labor: The Internet as playground and factory*. New York: Routledge.

Shah, H. (2011). *The production of modernization: Daniel Lerner, mass media and the passing of traditional society*. Philadelphia, PA: Temple University Press.

Simon, J. (2014, November 4). International journalists are in danger as never before. *The Guardian*. Retrieved from http://www.theguardian.com/commentisfree/2014/nov/04/international-jour nalists-danger-media-reporters-social-media

T24. (2013, July 3). Sosyal medyaya denetim için "mavi oda" kurulacak. Retrieved from http://t24. com.tr/haber/sosyal-medyaya-denetim-icin-mavi-oda-kurulacak/233408

T24. (2014, March 24). TTNET: Ülke genelinde Internet erişiminin kesileceği haberleri gerçeği yansıtmıyor. Retrieved from http://t24.com.tr/haber/ttnet-yarin-bolgesel-olarak-bazi-noktalar da-internet-kesilecek/254255

Tawil-Souri, H. (2012). It's still about the power of place. *Middle East Journal of Culture and Communication, 5*, 86–95.

Tugal, C. (2013). Towards the end of a dream? The Erdogan-Gülen fallout and Islamic liberalism's descent. *Jadaliyya*. Retrieved from http://www.jadaliyya.com/pages/index/15693/towards-the-end-of-a-dream-the-erdogan-Gülen-fallo

Twitter. (2014). Challenging the access ban in Turkey [Blog post]. Retrieved from https://blog.twit ter.com/2014/challenging-the-access-ban-in-turkey

Uysal, N., Schroeder, J., & Taylor, M. (2012). Social media and soft power: Positioning Turkey's image on Twitter. *Middle East Journal of Culture & Communication, 5*(3), 338–359.

Verhulst, S., & Price, M. (2013). Introduction. In M. Price, S. Verhulst, & L. Morgan (Eds.), *Routledge Handbook of Media Law* (pp. 1–15). New York: Routledge.

Youmans, W. L., & York, J. (2012). Social media and the activist toolkit: User agreements, corporate interests, and the information infrastructure of modern social movements. *Journal of Communication, 62*(2), 315–329.

The Invisible Information Worker: Latinas IN Telecommunications

MELISSA VILLA-NICHOLAS

INTRODUCTION

Recent research has focused on the lack of Latinas in science, technology, engineering, and math (STEM), information technology (IT), and computing fields. As of 2013, only 3 percent of Latinas were represented in STEM fields (Jackson, 2013), and in 2011, Latina/os made up 7 percent of the STEM workforce (Landivar, 2013). However, few look at the historical causes of the underrepresentation of Latinas in tech-related fields, and those Latinas who do work with information technologies often remain unseen. Historically, Latinas have worked as invisible information laborers in telecommunications, providing the infrastructure that supports contemporary new media systems. In 1973, the consent decree between the Equal Employment Opportunity Commission (EEOC) and the American Telephone and Telegraph (AT&T) Company led to the employment of Latinas, White women, and blue-collar information workers. But the *EEOC v. AT&T* case suggests a historical precedent of Latina exclusion in STEM, IT, Internet, and telecommunications related fields. The *EEOC v. AT&T* consent decree, an equal employment affirmative action mandate for underrepresented people, settled decades-long filings of employment discrimination toward White women and women and men of color. Latinas entered the lower levels of the telecommunications field with the consent decree settlement, beginning lifelong careers under the Bell System[1] as telephone operators, customer service representatives, data entry

operators, and electrical engineers, to name a few. Latinas have long been over-looked in telecommunications and IT fields more broadly, as demonstrated by the EEOC report *A Unique Competence*, the case proceedings, and the consent decree.

This study argues that as a result of the *EEOC v. AT&T* case, Latinas entered the lower levels of the Bell System as invisible information laborers. The *EEOC v. AT&T* case contributed to the underdevelopment of Latinas in management and highly skilled positions of STEM, IT, and telecommunications. A focus on the *EEOC v. AT&T* case with an eye toward Latinas (1) contextualizes the environment in which Latinas entered technological fields; (2) suggests the importance of intersectional race, gender, and class considerations of affirmative action movements; and (3) uncovers the invisible Latina labor in telecommunications and Internet support. Because of the stagnation of Latinas as White and blue-collar low-wage workers in information technology fields, we do not see the effect of Latinidad on IT and Internet companies in visible ways.

This article also explores the historical circumstances surrounding Latinas' information labor employment during this monumental impact of affirmative action on telecommunications. I first consider the historical context of the Chicano rights movement,[2] which was heavily labor-focused but often-neglected the gender and race experiences of Latinas. Second, as emphasized by historian Venus Green, I look at how women's rights organization NOW and the EEOC erased color with the EEOC report *A Unique Competence*. Next, I question the effectiveness of the case proceedings for Latinas with regards to evidence. Finally, I examine the consent decree and its results to gain an understanding of the discourse excluding Latina information workers.

Although a current recognition of the underrepresentation of Latinas in larger tech corporations has come to the public's attention (Feliú-Mójer, 2014), the process of exclusion and inclusion (through affirmative action) of Latinas into related private sectors reaches back to Civil Rights era protests and legislation (Acuña & Compeán, 2008). The 1970s saw a significant entrance for Latinas into telecommunications after such monumental cases as the Civil Rights Act of 1965, the Voting Rights Act, and the creation of the EEOC under Title VII, "which prohibits employment discrimination on the basis of race, color, religion, national origin, and sex" (Green, 2012). Once omitted from employment in jobs such as the telephone operator and clerk positions, Latinas were eligible for AT&T positions after the mandate of the consent decree. Considering the racial and gendered contexts of telecommunication policy acknowledges Latinas in technological spaces built on Whiteness (de la Peña, 2010) and supplanted by gender-only discourse. Including intersectional backgrounds of Latinas in the United States shifts the history of telecommunications and technology into multidimensional accounts.

Because of the shifting racial constructions in America, Latinas' entrance into the telecommunications sector has not fit easily into the racial binary framed by

the AT&T-EEOC consent decree.[3] Due to the "gender first" priorities of NOW and the EEOC's legal approach, Latinas were especially neglected (Green, 2012, p. 45). Main players involved in the consent decree made Latinas' entrance into telecommunications peripheral. As a result, Latinas entered the lower levels of the field of the Bell System as an invisible minority. The *EEOC v. AT&T* case contributed to the groundwork of a field presently underrepresented by Latinas working with sophisticated technological skills, and oversaturated with Latinas in blue-collar information worker positions. As Green maintains, the disregard for women of color's intersectional needs set a precedent of inadequate "inclusions" into technological spaces. This article searches for Latinas within the *EEOC v. AT&T* case, outlining how Latinas were made further invisible in telecommunications, and acknowledging the historical moment that Latinas became information laborers.

Latinas Enter Tech Fields

Although a dearth of scholarship explores Latinas' work with, analysis of, and resistance to information technologies, recent research has engaged Latinas' work in information technology–related fields. But often these narratives, important to a body of work emphasizing Latina presence in a tech-centric industry, neglect accounts of crucial legislative and corporate history that led to openings into technology-heavy fields for underrepresented people. Within the scholarship on *EEOC v. AT&T*, the subject on Latinas is unwritten.

Few sources account for the lack of Latinas in technological fields, though some authors promote Latina narratives of STEM and IT experiences to supplant the thin history. Despite the increasing access to technologies, Latinas infrequently graduate from STEM fields or work in high-profile technology jobs. Norma Cantú (2008) engaged the oral history of successful Latinas in STEM to learn from their experiences. Cantú's research tells women's stories on their own terms:

> What the stories uncover is a web of caring and support that propelled these Chicanas— predominantly working class, first generation in college, of Color, and women—into spheres previously uninhabited by people like them. Noting their embeddedness in social relations, rather than simply focusing on their achievements as individuals, reveals a much more complex and textured explanation for their success.

Burnett, Subramanian, and Gibson (2009) interviewed high-ranking Latinas in information technology (IT) to demonstrate their experiences. Though the authors neglect the racial structural discriminations in the IT workforce, they find four trends in Latina narratives: Interviewees were cognizant of negative gender social typing in their IT participation. All women chose to pursue technical degrees in college. Prior to entering the field, four women were minimally exposed

to computers, the Internet, and IT. All five women described positive support from peers, family, or other members of their social network as critical to their success (Burnett et al., 2009). According to these studies, Latinas working with information technologies engage cultural, gendered, and racial identities with their careers.

Although a solid foundation of scholarship exists around the history of the *EEOC v. AT&T* consent decree, a deficit of analysis around Latina presence weakens the body of literature on telecommunications. Venus Green (2012) conducted the most thorough investigations into the ways in which the EEOC, influenced by NOW in particular, separated gender and race, resulting in the benefit of White women the most. Green named this "gender first" approach as a large cause as to why Black working-class women's complaints were neglected in the post-consent decree years at AT&T. Green contends that NOW minimized the differences among women's testimonies, therefore erasing Blackness from complaints filed by African American women against AT&T, instead taking the approach of universalizing women (p. 50). Marjorie Stockford's (2004) historical account argues that the EEOC focused solely on race, neglecting gender altogether. Despite the EEOC leading the suit against AT&T, tensions were high between NOW and the EEOC. Women from NOW, as well as women staff at the EEOC, found the EEOC dismissive of issues around gender; Stockford recalls, "For the EEOC's part, NOW, a feminist organization only three years old, was hardly in its lawyers' consciousness. Theoretically the two groups were working toward the same goal, but they had little respect for each other" (Stockford, 2004, p. 23). Stockford recollects White feminist influence on EEOC attorneys as a necessary step in awareness. However, according to Green, feminist organizations such as NOW would turn a blind eye to race as a result of lobbying the EEOC (Stockford, 2004, p. 23; Green, 2012, p. 45). But Stockford universalized "women," presented as receiving the same discriminations when convenient for the argument.[4] Louis Katheryn Herr (2003) gives a similar gender-centric retelling of the history leading up to the consent decree, with particular emphasis on NOW's role in pressuring AT&T through protests and organizing female employees.

The class divides within the affirmative action movements also work against women of color, whose working-class needs were different than middle-class feminists. Emily Zuckerman's research focuses on the employment discrimination case *EEOC v. Sears, Roebuck, & Co.*, a 1973 investigation that went to trial in 1985. Zuckerman's work displays how different class ideologies within feminism might benefit middle-class feminists and neglect lower-class feminists (Zuckerman, 2008, pp. 6–7). MIT professor and former EEOC researcher Phyllis Wallace examined the results of the case from various disciplines including industry, psychology, economics, sociology, business, and management. Among the collection, Berkmann-King analyzed occupational segregation by race and sex, looking at the employment disparities among White men, White women, Black women, and

Black men. Berkmann-King found that "employment discrimination within the Bell system was by occupation and not by wage within occupation" (as qtd. in Wallace & Nelson, 1976, p. 3). Due to the limited information available, research on Latinas was thin in Wallace's collected essays.

Latinas now lag drastically in representation in STEM fields, IT workplaces, and telecommunications (Jachik, 2014). This history struggles with race not only as an epistemology[5] but also as a fluid scale, upon which Latinas are positioned depending on the historical, social, gendered, and political moment. The *EEOC v. AT&T* case, framed by a racial Black and White binary and re-organized with "gender-first" arguments that neglected race (Green, 2012), demonstrates the undertones of impossibility for Latinas entering into technological spaces. Within the *EEOC v. AT&T* case, Latinas identified as one- or two-dimensional subjects—by national origin or as Spanish-speaking minorities—had no entrance into the *EEOC v. AT&T* moment.

The history of Latinas in telecommunications is unfortunately scant, and the evidence has yet to be engaged, especially on race and gender. Little attention has been paid to Latinas in telecommunications during these critical shifts in affirmative action and the onset of the neoliberal era. My study seeks Latinas during the *EEOC v. AT&T* case, pinpointing how Latinas have been made preliminarily invisible and often illegible[6] in a major information technology workplace.

Labor and the Chicano Rights Movement Preceding the Consent Decree

Multiple national events in the 1960s and early 1970s contextualize the opening of telecommunications to minorities, as well as the ongoing exclusion of Latinas in information technology spaces. The political, social, racial, gender, and labor history precluding the consent decree is significant to the *EEOC v. AT & T* case.

In post–World War II America, structural racisms were challenged to include previously marginalized groups, especially affecting Latinas in the United States. After the Civil Rights Act of 1964, the 1960s continued to be a tumultuous time of activism for Latinas in multiple sectors of U.S. society, confronted by the Chicano rights movement. In 1968, East Los Angeles student walkouts and community meetings indicated the discontent among the Mexican community regarding the treatment of Latina/os in schools. Latina/o culture developed political momentum with literature, poems, and film. Street theater performed to urban populations expressed the rural labor conditions of migrant workers, led by charismatic leaders such as Cesar Chavez and Dolores Huerta, and Chicano community spaces developed incubators of activism. On August 29, 1970, some 20,000–30,000 Chicanos marched through East Los Angeles in the National Chicano Moratorium March Against the War in Vietnam (Oropeza, 2000).

A disregard for Latina leadership within the Chicano rights movement, in parallel with a neglect of intersectional identities in the feminist movement, became a source of political isolation for Latinas. Chicanas[7] identified reform as a change to all forms of social inequality, insisting upon an intersectional approach to social change. But Chicanas within the Chicano movement were designated to traditional gender roles. Resisting American nationalism, Chicanismo relied on a cultural nationalist ideology. Chicanas were positioned as "caretaker" roles in the larger movement, accused of breaking up the "family" when challenging Chicanismo with feminist critiques (Pesquera & Segura, 1998, p. 106). Chicanas also resisted White feminism because of its tendency to overlook race-ethnic, class, and cultural divisions between women, claiming instead to unite as "sisters" (Pesquera & Segura, 1998, p. 106). White American feminists approached race and class inequality as issues from the previous decade's Civil Rights Movements, leaving Chicanas excluded from both groups. Omitted by these social movements, Latinas were designated peripheral laborers and activists.

In the recently formed western United States, racial constructs around Latina identity were fluid and unstable. The question as to whether Mexicans considered themselves White was contested within and outside of the community. Although labeled White since the Treaty of Guadalupe Hidalgo in 1848, Mexicans were often treated as second-class citizens by Anglo society, not fitting easily into the Black-White racial binary that structures the United States (MacLean, 2006). Despite some advantages Mexican Americans gained as White-identified, they lacked higher education institutions of any kind compared to historically Black colleges and had no civil rights organizations comparable to the NAACP. Though historically important for minorities in the United States, the Voting Rights Act (VRA) of 1965 did not directly affect Latina/os until 1975, when expanded to language minorities (Garcia, 1997, p. 75). Despite evidence that favored separating Spanish-surnamed people as a group, the historical records, such as a census, grouped Latinas as "other minorities," with American Indians and Asians. Title VII of the Civil Rights Act provided Latinas/os the opportunity to identify as people of color, recognizing their differences from Anglos and ethnic White European immigrants.

Although Latina/o labor history focused on the larger labor struggles of agricultural and domestic work, Latinas found themselves shifting into various employment sectors throughout the 1960s and 1970s. Taken together, these events are important for reflecting on the percentage of Latinas in each field during transitioning periods. However, in the 1960s, Latina/os were not surveyed as a separate racial group, so the possibility of comparing numbers is difficult. Besides working as migrant farmworkers, Latina/os were heavily involved in the steelworkers sector, the automobile industry, smelter workers, steel mills, and the rubber industry (Acuña & Compeán, 2008, p. 345). Despite winning more labor rights in the

previous decade, the post–World War II era saw disinvestment of the unionized industries where Latina/os had just arrived, leading to the neoliberal era.[8] These changes resulted in shifting jobs away from manufacturing and into the service sector, increasing high technology industry jobs, and the beginning of jobs sent overseas (Gómez-Quiñones, 1994, p. 332). In the 1960s, Latinas worked overwhelmingly in operatives, service work, food processing, and electronics (including telecommunications and the garment industry (Hesse-Biber, Carter, & Lee, 2005, p. 58). In 1960, 8.6 percent of Latinas worked in professional occupations, such as teaching, nursing, librarianship, and social work; however, most Latinas worked in the "secondary" sector of the labor market, such as sales, clerical, operatives, non-farm labor, household work, low-level (other) service work, and farm labor (Hesse-Biber et al., 2005, p. 57). In 1970, Latinas made up 33.9 percent of the secondary sector occupations, compared to 43.4 percent White women, 21.4 percent African American women, and 30.2 percent Native American women (Hesse-Biber et al., 2005, p. 54). For Latinas, the *EEOC v. AT&T* time period marked shifts in identity markers such as race, gender, labor,[9] and political identities.

"A Unique Competence"

Latinas were grossly underrepresented within the clerical positions throughout the 1960s and 1970s, leading up to the consent decree. In Felix M. Lopez's Bell System report (1976), Spanish-surnamed workers were significantly lower in numbers among telephone operators. In 1966 at Pacific Telephone, only 7 percent of Directory Assistance Operators were Spanish-surnamed. Out of 348 subjects in 1969, Southern Bell employed no Spanish-surnamed toll operators, with 70 percent White women and 23 percent Black women making up the ethnic grouping. From 1970 to 1971, 11 percent of toll, directory assistance, and traffic service staffers at 12 different locations were Spanish-surnamed, compared to 43 percent White women and 46 percent Black women. In clerical occupations from 1970 to 1971, at 12 different locations in the Bell System, 20 percent of Spanish-surnamed employees held positions, compared to 40 percent White and 40 percent Blacks. In spite of the drastic evidence of exclusion, the EEOC report filed against AT&T, *A Unique Competence*, did not explore Latinas beyond linguistic and national-origin discriminations. Latinas were presented as one-dimensional victims, excluding the nuances of race and gender.

From the beginning, the EEOC and collaborating ethnic organizations fell short in including Latinas into the *EEOC v. AT&T* preliminary proceedings. The case that became *EEOC v. AT&T* began in 1970, when the Federal Communication Commission (FCC) blocked AT&T's attempt at raising long distance rates until the company agreed to stop employment discrimination practices. The EEOC conducted an investigation into the ways in which AT&T's discrimination

was executed. They found that the systematic discrimination by race, sex, and national origin affected advertising, hiring, training, promotions, pay, benefits, career promotion, and vacation leave. The report also analyzed the gendered classifications at work, "Every single wage-earning job was classified as male or female…'The Bell monolith,' the government study found, 'is, without doubt, the largest oppressor of women workers in the United States'" (Maclean, 2006, p. 132). As a constituency, Latina/os accounted for nearly all of the complaints filed with the EEOC labeled as "national origin" (p. 155). An especially significant method of discrimination, which AT&T defended as good business, was the "word-of-mouth" approach to recruiting. This tactic inevitably led to excluding minorities, especially Spanish-speaking people.

On December 1, 1971, the EEOC filed *A Unique Competence: A Study of Equal Employment Opportunity in the Bell System*, a large manuscript detailing AT&T discrimination with footnotes, charts, tables, and testimonies (Herr, 2003, p. 63). According to the report, "Spanish-surnamed Americans"[10] were excluded from employment in numerous ways. The EEOC named Spanish-surnamed Americans as the "Invisible Minority" in the Bell System (Herr, 2003, p. 67), finding that Spanish-surnamed Americans were specifically excluded from Bell employment. While the primary focus was sex discrimination, the EEOC acknowledged Black women and Latinas as the most neglected or outright discriminated against (Wallace & Nelson, 1976, p. 248). Out of the 12 Standard Metropolitan Statistical Areas (SMSA) where the Latina/o population was the largest, Bell's employment rates were nowhere close to the industry average:[11] "In none of the twelve SMSA's which had a substantial Hispanic population was their employment by the operating companies at rates near their representation in the workforce" (Wallace & Nelson, 1976, p. 259). The reasons for underrepresentation of Latina/os was because the pre-employment criteria, including paper credentials and test scores, "tended to screen out a disproportionate number of minorities" (Wallace & Nelson, 1976, p. 259). The major complaints filed in *A Unique Competence* solely focus on Latina/os as language minorities of "Spanish ancestry,"[12] engaging the Bell System discriminations against Latinas/os without racial or gendered components.

A Unique Competence addressed the employment discrimination toward Latina/o customers and employees in the final chapter of the report. Although concluding the report with "The Invisible Minority," the EEOC disregarded the nuances of the "Spanish-surnamed" group. The EEOC came to five conclusions about Spanish-surnamed Americans employed by Bell: They were employed at a rate significantly lower than their proportion to the population; Spanish-surnamed Americans employed at Bell were working in the lowest paid classifications and excluded from all management; Spanish-surnamed American positions in Bell were equal to Blacks in Southern companies in the previous decade; Bell's recruitment and hiring policies, aimed at restricting/

excluding Black employment, had a greater impact on Spanish-surnamed Americans; and finally, Bell had made no efforts to improve the employment states of Spanish-surnamed Americans.[13] Spanish-surnamed Americans were estimated to have lost more than $137 million annually due to their positions in the lowest-paying jobs or outright denial of employment altogether.[14] Of the 12 SMSAs identified in the report, Spanish-surnamed employees did not rise above 1 percent of employees at AT&T, and those few employed made 78 percent earnings of their White counterparts.[15] *A Unique Competence* discussed the lack of services as particularly problematic. The investigation found that Bell had only one Spanish-surnamed interviewer and that the interview process itself held cultural biases, allowing for many reasons to disqualify a Latina/o candidate from hiring.[16] The Bell companies, with the exception of New Jersey Bell, hired installers with fluent English proficiency, who could pass the Wonderlic Test[17] in English and could meet the height standards for the average Anglo.[18] *A Unique Competence* found all of these demands worked against the recruitment of Latina/o employees of the Bell System. Although *A Unique Competence* ends with AT&T's astounding tactics of discrimination, the report grouped Latinas and Latinos into a monolithic contingent of the "Spanish-surnamed," neglecting to investigate intersectional bias of race and gender unique to Latinas.

The report, though detailed on the deficit of Latina and Latino employees within AT&T, at no point defines the unique discriminations against Latinas and Latinos. *A Unique Competence* overlooked specific genders until the last page of the report, ending with the famous poem "I am Joaquin," by Chicano activist Rodolfo Gonzalez:

> I am Joaquin/Lost in a world of confusion/Caught up in the whirl of an Anglo society,/Confused by the rules,/Scorned by attitudes,/Suppressed by manipulations,/And destroyed by modern society./My fathers have lost the economic battle,/And won the fight for cultural survival.

> In a country that has wiped out all my history, sifted all my pride/In a country that has placed a different indignity upon my ancient burdens. Inferiority is the new load.[19]

For Chicana feminists and scholars, "I am Joaquin" represented the empowered Chicano, an existential Latino male hero who faced Anglo-dominated spaces as a revolutionary figure. Chicana scholar Angie Chambram (1992) analyzes the implications of "I am Joaquin" alongside similar cultural productions of the Chicano rights movement. Chambram argues that the Chicano male literary subjects, written in the o/os linguistic qualifier, "subsume the Chicana into a universal ethnic subject that speaks with the masculine instead of the feminine and embodies itself into a Chicano male" (p. 82). Without the consideration of Latinas' needs as information workers and customers within the preliminary report,

A Unique Competence dichotomized Latina identity into the "gender first" ideology foregrounded by now (Green, 2012, p. 50), and the male-centric Chicano rights movement priorities that "I am Joaquin" performed. Though *A Unique Competence* identifies discriminations against Spanish-surnamed people, it continued the invisibility of Latinas by keeping them unnamed. With "I am Joaquin" concluding the report, Latino men were the default "invisible minority."

The preliminary filings of *A Unique Competence* framed the oncoming proceedings of *EEOC v. AT&T*, opening up the largest company of private sector employees to underrepresented people at the onset of job loss in previously flourishing industries. Discourse around the inclusion of Latinos in the subsequent EEOC report *A Unique Competence* favored the recruitment of Latino men into the Bell System. The hegemonic disposition of Latinas within the Chicano rights movement set the precedents for oversight within ethnic legal rights organizations.

TESTIMONIES AND EVIDENCE

Despite the weighty evidence, proceedings continued to treat Latinas as solely language and national origin minorities, neglecting racial and gendered components. These complaints were filed through ethnic organizations born out of the Civil Rights Movements, working on the state and national level in various sectors of U.S. politics, education, and employment. Ethnic organizations and NOW brought political pressure on the EEOC during the 1960s and 1970s to enforce Title VII of the Civil Rights Act, leading to major cases such as *EEOC v. AT&T*. Though the EEOC was created to enforce Title VII, it did not gain the political momentum it needed until the early 1970s, when it targeted AT&T as the largest private sector employer and the largest overall employer of women. AT&T's discriminations against Latina/os were racially motivated; however, because the case was built on a framework with race discussed as "White and Black" and gender universalized to benefit White women, Latinas had little more ground than language and national origin complaints.

Previous to the *EEOC v. AT&T* case, Latina/os and Mexicans in particular had a tense relationship to the EEOC. In a regional EEOC conference in San Francisco in 1966, executive director Hermen Edelsberg told a Mexican American audience that the EEOC did nothing about Mexican American problems because "Mexican Americans were 'distrustful of agencies,' so little could be done. He even told his listeners that Mexicans had 'no such proverb as 'the wheel that squeaks the loudest gets the grease'" (MacLean, 2006, p. 169). A few weeks later at an Albuquerque conference, "50 Mexican American leaders gathered to meet with the EEOC chairperson Franklin Delano Roosevelt Jr., but Roosevelt sent Edelsberg

instead. The leaders met until 3 a.m., walking out on the EEOC the next day as a united body" (MacLean, 2006, p. 170). This walkout simultaneously demonstrated a rejection of the state of the EEOC as well as the unity of a Mexican American constituency, which became the Mexican American Ad Hoc Committee on Equal Employment.

The Mexican American Legal Defense and Education Fund (MALDEF) was one of the organizing entities crucial to Latina/o engagement in this case. Founded in 1967 in Los Angeles, California (Vigil, 2000, p. 238), MALDEF used several strategies to gain rights for Latina/os, including litigation, advocacy, educational outreach, law school scholarships, immigration policy, and leadership development (p. 239). But MALDEF and other ethnic organizations were unprepared to incorporate gender into their proceedings.[20] MALDEF's involvement in the EEOC case advocated for further recruitment of Latina/o employees in higher paying jobs at the Bell System and better services to Spanish speaking customers and challenged exploitation of current Latina/o employees. The nature of the witness testimonies in MALDEF records neglected Latinas, primarily focusing on bilingual services, problems with employment services, the Bell System's participation in the Spanish speaking community, regional attitudes of Mexican Americans toward the Bell System, effects of media and communication on the Chicano image, community organization's experience with Bell, customer experience within the Spanish-speaking community, education among the Spanish-speaking community, and bilingual services and Bell employment.[21] None of the testimonies focused specifically on Latina needs, employment experiences, customer experiences, or overall impact of Latinas in particular.

From April 17 to April 21, 1972, MALDEF and the California Rural Legal Assistance (CRLA) held testimonies of witnesses in the case, concerned with the Pacific Telephone and Telegraph (PT&T) (Wallace & Nelson, 1976, p. 249) Company's treatment of Latinas/os and Asian Americans.[22] Testimonies were also taken from representatives of Spanish-speaking communities from May 8 to 12 in New York. The testimonies came from Latina/o customers and employees of the Bell System, "All these potential speakers shared one goal: to document orally why the phone company should itself suffer in exchange for the suffering it had caused its own employees" (Stockford, 2004, p. 114).

Due to the lack of Latina AT&T employees, Latina customer testimonies were the dominant witnesses on record. However, they do indicate markers of racial and gendered experiences. Dolores Martinez of Healdsburg, California, testified that she was involved in an accident. Unable to reach help on the telephone, Martinez walked three miles for emergency help.[23] Maria Torres, also from Healdsburg, had a child with heart problems whose doctor was located in San Francisco. On days when she expected calls from the doctor, Torres had

to keep her children home due to the lack of bilingual phone services. Domitila Reyes of Windsor, California, had a number of negative incidents with the phone company. Reyes received a series of erroneous bills from the phone company that had been previously paid. She was unable to call police during an auto accident and unable to get her son out of jail in San Diego because of a lack of telephone services in Spanish.[24] The witness list also contained one testimony from Maria Marquez, a rejected applicant of AT&T. Although sparse, the types of issues testified on AT&T services demonstrated the intersectional gender roles of Latinas.

The FCC hearing's evidence was further presented as solely linguistic, neglecting race and gender. During the FCC hearings, CRLA lawyer Albert Moreno proposed the FCC place a call in Spanish to Sonoma County. The caller claimed to have an emergency in order to see the results of service to Spanish speakers. Guido del Prado, a Spanish-speaking client of Moreno's, called information in Sonoma County. The transaction was passed to two different telephone operators, totaling six minutes and forty seconds of wait time before del Prado got the information he needed (Stockford, 2004, p. 119). This session ignored the real-life circumstances described above by Latinas, overlooking gendered and racially organized situations experienced by Latinas unable to use the telephone.

The Attitudinal Survey of Latina/o experiences of Pacific Telephone & Telegraph revealed great dissonance with the phone company, demonstrating racially motivated biases experienced by Latina/os. Prepared by Manuel Alvarado, former Director of Community Education for South Alameda County, this survey detailed the results of a door-to-door survey conducted in Alameda County among Mexican Americans "to determine their attitudes, impressions, and experiences in regard to Pacific Telephone & Telegraph service and employment."[25] Eighty-six random respondents were surveyed on Bell services to Mexican Americans and Spanish services. Respondents of the survey overwhelmingly required Spanish-speaking telephone operators, indicating that Anglos were more likely to receive better PT&T services and jobs. Respondents acknowledged that the telephone company discriminated against Mexican Americans in service and jobs, finding it difficult to make telephone calls and pay telephone bills because of the English-only services. Despite the employment discrimination, 79 respondents would apply for installer, operator, and management jobs if the telephone company really advertised to hire Mexican Americans. Finally, 81 out of 83 respondents favored a Mexican American owned and operated company in Alameda County because it would offer Spanish-speaking services. Although the survey neglected gender, it reveals a racial

consciousness in Latina/o respondents' experience as potential employees and customers.[26]

The resulting PT&T objectives, though lofty in promises of employment and improved services, continued to neglect the intersectional needs of Latinas. In a press release in March 1972, PT&T announced major goals to include Spanish-speaking and/or Mexican American employees and customers. PT&T's promises included doubling the amount of "Spanish-Americans"[27] in its employment by 1975 and to triple the number of "Spanish-Americans" by 1980. PT&T also guaranteed that 25 percent of all new hires would be "Spanish-American" employees including 30 percent of all new college management hires. PT&T guaranteed to take responsibility for hiring 1,000 Spanish-speaking-only persons. The "Press Summary of Bell Telephone Hearings on Spanish-Speaking Employment Problems" omitted Latina employment recruitment, services, or training at PT&T.

The Impact of the Consent Decree for Latinas

White women and women of color in particular were discriminated against in a number of ways at the Bell Companies. However, Latinas were made invisible because of the dual neglect of intersectionality by federal laws and political organizing group politics (Green, 2001, p. 61). Notwithstanding numerical evidence, NOW and the EEOC's arguments lost the nuanced experiences of women of color by becoming gender focused.[28] NOW identified race discrimination as a problem within the Bell System, but did not use African American women's testimony as charges of sex discrimination, labeling their statements as racially motivated discriminations (Green, 2001, p. 53). Thus, the consent decree fell short, dichotomizing Latinas' identity as only significant with respect to language services.

On January 18, 1973, the consent decree was handed down before the U.S. District Court for the Eastern District of Pennsylvania (Wallace & Nelson, 1976, p. 252). The consent decree put into place collective bargaining rights, a pay-promotion plan, and more promotion opportunities for "females and minorities"; changed standardized testing so that scores could not discriminate against potential employees; ensured that college graduate females were hired directly into management; and guaranteed pay adjustments and back pay for previous discrimination.[28] Reports, surveys, and testimonies from Latina/o communities went unacknowledged, lumping Latinas into the "women or minorities" category essential to the consent decree. Latinas continued to be made invisible to the end of the EEOC v. AT&T case.

Table 11.1. Regional Increase of Latina employees at AT&T after the consent decree (Northrup & Larson, 1979, pp. 172–185).

Year/Region	% Latina employees at AT&T	% Total Latina/o employees at AT&T
1973, Mountain Region	White Collar: 12.1% Blue Collar: 10.6%	White Collar: 9.9% Blue Collar: 10.8%
1979, Mountain Region	White Collar: 13.3% Blue Collar: 12.0%	White Collar: 11.6% Blue Collar: 10.1%
1973, Pacific Region	White Collar: 8.2% Blue Collar: 6.8%	White Collar: 7.3% Blue Collar: 8.0%
1979, Pacific Region	White Collar: 9.9% Blue Collar: 10.1%	White Collar: 9.2% Blue Collar: 9.7%

The direct impact of the consent decree on Latinas is difficult to index, due to the discrepancies in censuses. Although no longer categorized as "White" on surveys, Latinas were still reported as "other" with all minorities except African Americans. Herbert R. Northrup and John A. Larson's (1979) *The Impact of the AT&T-EEOC Consent Decree* noted, "Minority group members achieved the greatest gains in regions where they represent a relatively significant proportion of the population" (p. 98). According to Northrup and Larson, males and females of the same racial group tended to do well in the same job category, and different racial groups had success in different sectors of AT&T. Although there was a shortage of technically trained Blacks, their numbers far exceeded the available supply of Hispanics and other minorities, particularly American Indians. Hispanics suffered the additional handicaps of language and cultural differences, thereby compounding the problem of assimilating them into the AT&T labor force (Northrup & Larson, 1979, p. 98).

Northrup and Larson detail Latinas' AT&T presence by regions where the numbers of Latina/o employees were significant; their results find a slow and steady incline in the percentage of Latina employees in the Mountain and Pacific region. Table 11.1 demonstrates the small increase of Latina employees in the Mountain region, within a 1–2 percent range in both the white and blue-collar jobs. In the Pacific Region, the greatest significant increase in employment was for Latinas in blue-collar jobs. Over the six years surveyed, the increase of Latina information worker jobs was minor. Despite the circumstantial oversight of inter-sectional needs for Latina employees, Latinas did become information laborers in the Bell System. Many Latinas began employment as telephone operators, and as their work became automatic, they transferred into such jobs as data entry, customer service, clerks, and technicians (Villa-Nicholas, 2014). Latina information workers provided the backbone and hidden information labor that contributed to

popular access to the Internet, building infrastructure such as laying cable-wireless networks and customer support that all underwrites the creation, evolution, and access of the supporting hardware and software of the Internet.

CONCLUSION

How do we account for the underrepresented Latina in information technology fields, especially when considering the lack of diversity in Internet startup companies that now dominate the political economy? While the 1972 AT&T-EEOC consent decree made historic changes to opening up the largest private jobs sector to underrepresented people, the historical record on how Latinas were made a part of this three-year process is sparse. Because the case disregarded Latinas, considered only as consumers, "language minorities," and by national origin, the history of Latina involvement in the EEOC-AT&T hearings requires recovery. Despite lengthy academic works published around the *EEOC v. AT&T* case, nuanced records on the Latina experience is widely neglected.

Embedded within the proceedings to include underrepresented people, racial and gendered politics intertwine into the timeline of telecommunications (de la Peña, 2010, p. 921). Further academic work must recognize where Latinas have become employed in technological labor and their impact on the development of information technologies and underlying support of the Internet today. Latinas' history in telecommunications must be contextualized by the events that took place during the Affirmative Action legislations of the 1960s and 1970s. To move Latinas out of the "invisible minority" category, additional research must be conducted on Latina information labor and its impact on Internet history.

NOTES

1. Comprised of AT&T and its associate companies.
2. I use "Chicano rights movement" to describe the political movements involving Latina/os during this time period. See Oropeza, L. (2000). Making history: The Chicano movement. In R. I. Rochin & D. N. Valdes (Eds.), *Voices of a new Chicana/o history*. East Lansing: Michigan State University Press.
3. This study uses the term *Latina* to identify women whose cultural, social, and political experiences have often been similar in the United States; however, it resists a narrative that all Latinas might respond the same to their experience as information workers or navigators of information technologies. The use of the term *Latina* is not a neutral or simply descriptive term, but includes a politically engaged debate about the status of Latinas as subjects in the United States.
4. Stockford's account of *EEOC v. AT&T* paints a clear picture between the racial and gendered dichotomies that EEOC oscillated around, but could not intersect. EEOC Attorney David

Copus was presented as gender-blind, unconvinced that middle-class women suffered discriminations; while Stockford's protagonist Susan Ross represented and advocated the contemporary White feminist approach in interpreting AT&T discriminations, see Stockford, *The Bellwomen*.

5. Larger structures of race that Carolyn de la Peña names as "at play in all technological production and consumption." De la Peña names Whiteness as a racial epistemology that acts invisibly and goes unnamed in histories of technology. De la Peña, The history of technology, the resistance of archives, and the Whiteness of race, p. 921.

6. Lisa Cacho looks at African American and Latina/o subjects of the United States deemed as "illegible" because they did not fit socially valuable categories. See Cacho, L. M. (2012). *Social Death: Racialized Rightlessness and the Criminalization of the Unprotected*. New York: New York University Press.

7. Chicana feminism emerged during the 1960s and 1970s social movements in an intersectional way that was neglected in mainstream second-wave feminism, usually represented as non-raced White women, and the Chicano movement, usually domineered by Latino men neglecting to consider gender. See Pesquera, B., & Segura, D. (1998). *A Chicana Perspective on Feminism*. Berkeley, CA: Third Women Press, p. 194. I use the label "Chicana" to indicate a political, race, and gender identity that some Latinas named themselves during these critical years through today.

8. Many scholars have written on this time period as a complete divestment in public services and the move to give private corporations more rights and access to wealth. David Harvey, in the most famous work around neoliberalism, *A Brief History of Neoliberalism*, makes the point that the neoliberal project disembedded capital from the constraints of state-led planning and state ownership, therefore increasing international capitalism as a "utopia project" and re-establishing capitalism as a political project "to restore the power of economic elites." See Harvey, D. (2005). *A brief history of neoliberalism*. Oxford, UK: Oxford University Press, pp. 11, 19. Lisa Duggan examines the values of the neoliberal project as privatization and personal responsibility. Neoliberalism totes privatization as a critical point of freedom for citizens under capitalism and reaches far beyond the United States, prioritizing the protection of class power and "freedom" to accumulate wealth, See Duggan, L. (2003). *The twilight of equality? Neoliberalism, cultural politics, and the attack on democracy*. Boston, MA: Beacon Press, p. 12.

9. Unions were hesitant to get involved, and EEOC employees as well as Stockford attributed this to an anti-Black and anti-women sentiment that had long resonated within unions such as the Communications Workers of America (CWA) and the International Brotherhood of Electrical Workers (IBFW) (Wallace). The unions defended their hesitancy to get involved as representing more than just minorities and women, a win for the EEOC would mean a possible loss of promotions and raises for their White male members. Unions, as a result of decades old bias, stayed silent and on the sidelines building up to the case. The CWA announced support after *A Unique Competence* hit the media. See Wallace, *Equal Employment Opportunity and the AT&T Case*.

10. The term "Spanish-surnamed Americans" is used throughout *A Unique Competence* to denote Latina and Latino employees, customers, and potential customers. These numbers may be inadequate in recognizing the actual differentiation among Latina/o employees in the Bell System, considering not all Latina/os have Spanish-surnames and those with Spanish-surnames may not necessarily be Latina/o.

11. Papers of Marjorie Stockford. (1971). A unique competence. The Civil Rights Litigation Clearinghouse, University of Michigan Law School (UMLS), p. 284.

12. Papers of Marjorie Stockford. (1972). A unique competence (as reprinted in the Congressional Record), E1267. The Civil Rights Litigation Clearinghouse, University of Michigan Law School (UMLS).

13. Papers of Marjorie Stockford. (1971). A unique competence. The Civil Rights Litigation Clearinghouse, University of Michigan Law School (UMLS), p. 286.

14. Ibid., p. 288.

15. Papers of Marjorie Stockford. A unique competence (as reprinted in the Congressional Record), p. 1266.

16. Ibid., p. 1276.

17. One of the most controversial components of AT&T's hiring practices was their use of psychological tests on selected potential employees. These tests served to systematically stop many underrepresented people from getting through the job-hiring process, and gave AT&T management justifications toward discriminatory practices. The two tests widely distributed were the Wonderlic Personnel Test and the Bennett Test of Mechanical Comprehension. These tests were deemed by the Supreme Court as completely unrelated to job performance, however often engaged to specifically discriminate against Black applicants. A number of aptitude tests and job performance prediction tests were also used adversely to work against Black employment. See Ash, The Testing Issue, pp. 203, 208. Bell replaced the Wonderlic with the Bell System Qualification Test I (BSQT I), and on the Wonderlic and BSQT 70 percent of Whites and 20 percent of Black applicants met the recommended standards. See Lopez, F. (1976). The Bell system's non-management personnel selection strategy. In P. A. Wallace (Ed.), *Equal employment opportunity and the AT&T case*. Cambridge, MA: MIT Press, p. 231.

18. Papers of Marjorie Stockford. A unique competence (as reprinted in the Congressional Record), p. 1276.

19. Papers of Marjorie Stockford. A unique competence, p. 289.

20. Ethnic organizations such as MALDEF that were involved in the case had deferred to NOW for gender discriminations, having no feminist component of their own. See Green, Flawed remedies, p. 48.

21. MALDEF Records "Alameda County Survey," 1972, Box 653. Stanford University Libraries. Department of Special Collections and University Archives.

22. Asian American experience as employees and customers, prior to and during this case, has yet to be explored deeply within academic scholarship. This research echoes Venus Green's appeal for the investigation into poor women, lesbians, differently abled women, transgender women, and others. See Green, "Flawed Remedies," Footnote 17.

23. MALDEF records "Witnesses," 1972, Box 653. Stanford University Libraries. Department of Special Collections and University Archives.

24. MALDEF records "Witnesses," 1972, Box 653. Stanford University Libraries. Department of Special Collections and University Archives.

25. Alvarado, "An Attitudinal Survey," 1972, Box 653, Folder 3, Stanford University Libraries. Department of Special Collections and University Archives.

26. Ibid.

27. MALDEF Records. "Press Summary of Bell Telephone Hearings on Spanish-Speaking Employment Problems," 1972, Box 655. Stanford University Libraries. Department of Special Collections and University Archives.

28. Papers of Marjorie Stockford. (1973). Consent decree, EE-PA-0227-0006. The Civil Rights Litigation Clearinghouse, UMLS.

REFERENCES

Archival Sources

Alvarado, M. (1972). Mexican American Legal Defense and Education Fund Records. An attitudinal survey: Alameda county survey of Mexican American subscribers, and potential subscribers, to Pacific Telephone and Telegraph services. M0673. Box 653. Folder 3. Stanford University Libraries. Department of Special Collections and University Archives.

Mexican American Legal Defense and Education Fund Records. Alameda county survey, M0673. Box 653. Folder 3. Stanford University Libraries. Department of Special Collections and University Archives.

Mexican American Legal Defense and Education Fund Records. (1972). Witnesses, M0673. Box 653. Stanford University Libraries. Department of Special Collections and University Archives.

Papers of Marjorie Stockford. Consent decree. The Civil Rights Litigation Clearinghouse, EE-EE-PA-0227-0001. University of Michigan Law School. Ann Arbor, Michigan. Retrieved from http://www.clearinghouse.net/detail.php?id=11146.

Papers of Marjorie Stockford. Copus, D., Gartner, L., Speck, R., Wallace, W., Feagan, M., and Mazzaferri, K. A unique competence: A study of equal employment opportunity. The Civil Rights Litigation Clearinghouse, EE-PA-0227-0003. University of Michigan Law School. Ann Arbor, Michigan. Retrieved from http://www.clearinghouse.net/detail.php?id=11146.

Papers of Marjorie Stockford. Copus, D., Gartner, L., Speck, R., Wallace, W., Feagan, M., and Mazzaferri, K. A unique competence: A study of equal employment opportunity congressional record. The Civil Rights Litigation Clearinghouse, EE-PA-0227-0004. University of Michigan Law School. Ann Arbor, Michigan. Retrieved from http://www.clearinghouse.net/detail.php?id=11146.

Published Sources

Acuña, R., & Compeán, G. (Eds.). (2008). *Voices of the U.S. Latino experience*. Westport, CT: Greenwood Press.

Ash, P. (1976). The testing issue. In P. A. Wallace (Ed.), *Equal employment opportunity and the AT&T case*. Cambridge, MA: MIT Press.

Beltrán, Cristina. (2010). *The trouble with unity: Latino politics and the creation of identity*. New York: Oxford University Press.

Burnett, K., Subramanian, M., & Gibson, A. (2009). Latinas cross the IT border: Understanding gender as a boundary object between information worlds. *First Monday, 14*(9), n.p.

Cacho, L. M. (2012). *Social death: Racialized rightlessness and the criminalization of the unprotected*. New York: New York University Press.

Cantú, N. (2008). *Paths to discovery: Autobiographies from Chicanas with careers in science, mathematics, and engineering*. Los Angeles, CA: UCLA Chicano Studies Research Center Press.

Chabram, A. (1992). I throw punches for my race, but I don't want to be a man: Writing us Chica-nos (Girls/ Us)/Chicanas into the movement script. In L. Grossberg, C. Nelson, & P. Treichler (Eds.), *Cultural Studies* (pp. 81–95). London: Routledge.

de la Peña, C. (2010). The history of technology, the resistance of archives and the Whiteness of race. *Technology and Culture, 51*(4), 919–937.

Duggan, L. (2003). *The twilight of equality? Neoliberalism, cultural politics, and the attack on democracy.* Boston, MA: Beacon Press.

Feliú-Mójer, Mónica I. (2014, November 7). Toward a tipping point for Latinas in STEM. *The Scientific American.* Retrieved from http://blogs.scientificamerican.com/voices/2014/11/07/toward-a-tipping-point-for-latinas- in-stem/

Garcia, C. F. (Ed.). (1997). *Pursuing power: Latinos and the political system.* Notre Dame, IN: University of Notre Dame Press.

Gómez-Quiñones, J. (1994). *Mexican American labor, 1790–1990.* Albuquerque: University of New Mexico Press.

Green, V. (2001). *Race on the line: Gender, labor, and technology in the Bell system, 1880–1980.* Durham, NC: Duke University Press.

Green, V. (2012). Flawed remedies: EEOC, AT&T, and Sears outcomes reconsidered. *Black Women, Gender, and Families, 6*(1), 43–70.

Harvey, D. (2005). *A brief history of neoliberalism.* Oxford, UK: Oxford University Press.

Herr, K. L. (2003). *Women, power, and AT&T: Winning rights in the workplace.* Boston, MA: Northeastern University Press.

Hesse-Biber, S., Carter, N., & Lee, G. (2005). *Working women in America: Split dreams.* Oxford, UK: Oxford University Press.

Jachik, S. (2014, November 3). Missing minority Ph.D.s. *Inside Higher Ed.* Retrieved from https://www.insidehighered.com/news/2014/11/03/study-finds-serious-attrition-issues-Black-and-latino-doctoral-students

Jackson, M. (2013). Factsheet: The state of Latinas in the United States. *Center for American Progress.* Retrieved from https://www.americanprogress.org/issues/race/report/2013/11/07/79167/factsheet-the-state-of- latinas-in-the-united-states/

Landivar, L. C. (2013). Disparities in STEM employment by sex, race, and Hispanic origin. *American Community Survey Reports.* Retrieved from http://www.census.gov/prod/2013pubs/acs-24.pdf

Lopez, F. (1976). The Bell system's non-management personnel selection strategy. In P. A. Wallace (Ed.), *Equal employment opportunity and the AT&T case.* Cambridge, MA: MIT Press.

MacLean, N. (2006). *Freedom is not enough: The opening of the American workplace.* New York: Russell Sage Foundation.

Northrup, R. R., & Larson, J. A. (1979). *The impact of the AT&T-EEOC consent decree.* Philadelphia, PA: Industrial Research Unit.

Oropeza, L. (2000). Making history: The Chicano movement. In R. I. Rochin & D. N. Valdes (Eds.), *Voices of a new Chicana/o history.* East Lansing: Michigan State University Press.

Peña, D. G. (1997). *The terror of the machine: Technology, work, gender, and ecology on the U.S.-Mexico border.* Austin, TX: CMAS Books.

Pesquera, B., & Segura, D. (1998). *A Chicana perspective on feminism.* Berkeley, CA: Third Women Press.

Stockford, M. A. (2004). *The Bellwomen: The story of the landmark AT&T sex discrimination case.* New Brunswick, NJ: Rutgers University Press.

Vigil, M. (2000). The ethnic organization as an instrument of political and social change: MALDEF, a case study. In M. Gonzales & C. M. Gonzalez (Eds.), *En aquel entonces: Readings in Mexican American history.* Bloomington: Indiana University Press.

Villa-Nicholas, M. (2014). Latina narratives of information technologies: Towards a critical Latina technology studies. *Media-N, 10*(3), n.p.

Wallace, P. A., & Nelson, J. E. (1976). Legal processes and strategies of intervention. In P. A. Wallace (Ed.), *Equal employment opportunity and the AT&T case.* Cambridge, MA: MIT Press.

Zuckerman, E. (2008). *Beyond dispute:* EEOC v. Sears *and the politics of gender, class, and affirmative action, 1968–1986.* PhD dissertation, Rutgers University Press, New Brunswick, NJ.

The Intersectional Interface

MIRIAM E. SWEENEY

THEORIZING THE INTERFACE

Interfaces are typically conceptualized as the point of interaction between two systems, organizations, subjects, or components. Though this interaction is usually described in social or haptic terms, the interface also serves as a cultural point of contact shaped by ideologies that are manifest in the design, use, and meaning of the technology. Selfe and Selfe (1994) echo this sentiment in their description of the computer interface as a "political and ideological boundary land" (p. 481) that may serve larger cultural systems of domination in much the same way that geopolitical borders do. Just as geopolitical borders prevent the circulation of some individuals for political purposes, computer interfaces act as "contact zones" where complicated power dynamics play out, privileging the movement of some users over others.

Pratt (1991) defines contact zones as "social spaces where cultures meet, clash, and grapple with each other, often in contexts of highly asymmetrical relations of power, such as colonialism, slavery, or their aftermaths as they are lived out in many parts of the world today" (p. 34). This is an important lens to apply to information and communication technologies (ICTs), which have historically been paradoxically positioned either as apolitical and neutral tools or as inherently democratic and liberating. Internet technologies in particular have been rhetorically

described in terms of the networked potential for democratic interactions that transcend social systems of race, gender, and class. Applying the contact zone to the computer interface offers a critical reframing of this discourse, highlighting that computers do not *de facto* serve democratic aims, and instead may be directly implicated in facilitating legacies of racism, sexism, heterosexism, colonialism, as well as capitalistic exploitation and classism. More research is needed to historicize how power asymmetries in the interface have shaped the possibilities (and limitations) of anthropomorphized interfaces in the present moment.

DEFINING AVAS

Anthropomorphized interfaces are often known as virtual agents, animated characters, embodied conversational agents, personified agents, and virtual humans ("v-humans"). This work purposefully employs the term *anthropomorphized virtual agents* (AVAs) as a way to emphasize the design aspects of these computer programs and interfaces that are designed to have human features, characteristics, and personality traits. Brenda Laurel (1997) describes an AVA as "a character, enacted by the computer, who acts on behalf of the user in a virtual (computer-based) environment" (p. 208). Anthropomorphism may be constructed *visually*, through graphic representation; *aurally*, through speech patterns and vocal styling; and *textually*, through written interactions with the user. Anthropomorphization may occur in degrees, ranging from less humanoid programs like Microsoft's old "Clippy" assistant for Office, to more humanoid examples such as IKEA's "Anna," who resembles a call center operator with a headset and cheery smile.

Laurel (1997) identifies four categories of computer-related tasks—those related to *information, work, learning,* and *entertainment*—where virtual agents may be appropriate. Information-related tasks include navigation and browsing functions, information retrieval, and the sorting, organizing, and filtering of data. Agents are also adept at performing the second category of tasks, *work* functions such as reminding, programming, scheduling, and advising. *Learning* is the third category of tasks appropriate for agents, and it includes coaching and tutoring. Finally, agents are often used in *entertainment* and are found in gaming situations performing and playing with and against human users. Apple's Siri application is a popular example of an AVA that fills work-related functions similar to a personal assistant: organizing personal data, maintaining a calendar, sending memos and text messages. Siri also fills an information role by performing search engine searches as a proxy. AVAs by companies like Artificial Solutions can be used as dialogue partners for educational goals like learning a second language, or as customer service agents like "Anna" from IKEA, who can answer questions in 21 languages. AVAs are easily recognizable in computer and video games as they interact with

the player to provide clues, fight, and advance gameplay in other ways. Increasingly they are used in personal health care interfaces such as SimCoach, a project from the USC Institute for Creative Technologies that assists military personnel and family members dealing with the effects of PTSD. As digital media platforms become sites for increasingly integrated activities, so too do AVAs move fluidly between and among these various functions, often simultaneously entertaining and educating, or performing information retrieval while also scheduling appointments.

FACING THE INTERFACE

The story of anthropomorphic computer agents could easily begin with Alan Turing's exploration of computing intelligence, commonly known as "Turing's Test." In this experiment, an interrogator tries to distinguish a man from a computer through a series of mediated question-asking and answering. If the computer can successfully fool the interrogator into thinking that it is the man, it is said to "pass" the test. In Turing's original formulation of the test, the interrogator was tasked to tell a man from a woman, rather than a computer. In this version, the man wins if he fools the interrogator by successfully "passing" as a woman. Scholars have observed that the central role of gender in the original Turing Test effectively gendered the computer as female in the second version (Brahnam, Karanikas, & Weaver, 2011; Genova, 1994; Hayles, 1999), embedding gender and sexuality firmly in the foundational theorizing of computing intelligence.

Turing's thought experiments inspired computer scientists to design programs that could act as real-life Turing Tests and pushed the idea of computer agents as interfaces. The juxtaposition of the physical and the intellectual is a theme that has run throughout artificial intelligence (AI) and, later, in agent design. This is an important theme to trace, given that the mind/body binary is also prevalent in the discursive construction of social hierarchies, such as race and gender. Feminist thought has demonstrated that men tend to be associated with intelligence, mind, and thought, while women are associated with the body, emotion, and intuition. Similarly, critical race scholars have observed that hegemonic discourse associates Whiteness with intelligence, virtue, and civility, while the racialized Other is associated with nature, the body, and the primitive. The gendered construction of knowledge and knowing in AI is one that persists in AVA design. Some famous expressions of this include the design of now famous AI programs such as ELIZA, the psychologist agent designed by Joseph Weizenbaum (1976), and Michael Mauldin's (1994) conversational agent, JULIA, entered in the first Loebner competition for artificial intelligence. Both of these programs were gendered female in their design and expressed their gender identities through conversational scripts.

For example, JULIA responded to queries about her humanness ("Are you real?") with references to having her period or "PMSing"—responses that problematically conflate gender identity with female biological markers (Foner, 1993). As with the Turing Test, gender and sexuality have remained central in the designs of current AVAs in both intended and unintended ways.

INTERACTING WITH THE INTERFACE

Alexander Galloway (2008) describes the interface as "a control allegory" that "indicates the way toward a specific methodological stance" (p. 935), highlighting the metaphoric nature of interfaces and the concomitant ideologies required to approach them. Similarly, Selfe and Selfe (1994) note that computer interfaces have semiotic messages built in that betray an alignment along the axes of class, race, and gender. As an example, they point to the metaphor of the computer desktop, which connotes a professional, middle-class workspace, as opposed to other configurations that might be referents to domestic spaces (e.g., a kitchen table), or craftsman spaces (e.g., a mechanic's workshop). Winner (1986) famously argues that artifacts have politics embedded in them, and certainly this is borne out through these examples. Selfe and Selfe argue, "if the map of the interface is oriented simultaneously along the axes of class, race, and cultural privilege, it is also aligned with the values of rationality, hierarchy, and logocentrism characteristic of Western patriarchal cultures" (p. 491). This is also true in the case of the anthropomorphized metaphor that is central to agent interface design.

Metaphor simultaneously describes two objects at once, operating through the recognition of an aspect of the primary object in the secondary object. Metaphor is a distinctive form of likening because it requires that we speak of the primary object in terms of the secondary object as if they were the same (Hills, 2012). As such, metaphors are often employed as heuristic tools, meant to facilitate understanding. Importantly, metaphors are culturally based, grounded in correlations from our own experiences (Lakoff & Johnson, 2003), and necessarily embodied. Considering the role and function of metaphor is essential when discussing interfaces and becomes even more explicit in AVAs where anthropomorphization is the foundational metaphor for design.

The point of comparison that the metaphor of anthropomorphism relies on for interface design is the sociality of human interaction. Not all virtual agents are anthropomorphized, but there are many advocates of anthropomorphization as a design strategy for enhancing usability of interfaces (e.g., Lester et al., 1997; Waern & Höök, 2001). According to Laurel (1997), "the kinds of tasks that computers perform for (and with) us require that they express two distinctly anthropomorphic qualities: *responsiveness* and the *capacity to perform actions*" (p. 210).

The foundation of this thinking is that humans are naturally skilled at relating to and communicating with other humans, thus interface design should exploit this as psychologically advantageous and human-computer interaction (HCI) should actively engage these innate skills. To paraphrase Lakoff and Johnson's (2003) work, the anthropomorphic metaphor provides us not only a specific way of thinking about a topic but also a way of acting toward it (p. 34). In other words, anthropomorphization is a tool that repurposes human skill sets for sociability in the translation of otherwise foreign interactions with computer agents into more familiar social ones. What this metaphor misses when applied to virtual agents are the ways in which social interaction is heavily mediated by culture and its associative norms, practices, and power structures. Therefore it is imperative to look more closely at the values that are designed into AVAs and interfaces, teasing out their complexities and consequences.

AVAs have been a subject of substantial scholarship within artificial intelligence and human-computer interaction research, as well as in humanities disciplines such as rhetoric. Within AI and HCI, scholars have explored race and gender as design variables that can be optimized to create believability, thus enhancing user experience of interfaces. For example, Nass, Moon, Morkes, Kim, and Fogg (1997) observe gender stereotyping in testing how users apply categories and rule in social responses to computers. J. A. Pratt, Hauser, Ugray, and Patterson (2007) have found that users prefer computer agents whose ethnicity is similar to theirs. Rhetoricians have explored how representations of AVAs often re-instantiate harmful stereotypes about race and gender. For example, Sean Zdenek (2007) finds that virtual women that represent customer service workers draw heavily from stereotypes about women's work. Brahnam et al. (2011) demonstrate that virtual women enact male fantasies of heterosexuality. The differences in disciplinary approaches to this subject illustrate the needs for interdisciplinary contributions to design of technologies.

Zdenek (2007) points out the anthropomorphization of virtual agents has become deeply naturalized, though there is no hard evidence proving they are superior in function to non-anthropomorphized agents. Instead it has become a "seemingly unassailable claim that users treat computers, regardless of whether they are designed with faces or not, as social actors" (p. 403). Clifford Nass is credited with casting computers as social actors (see Nass et al., 1997; Nass & Moon, 2000). Nass et al. (1997) tested the idea that people engage with computers as social actors. They found that the users in their study applied politeness norms and varied their responses to the computer's personalities and flattery as they might with a human actor. In another study, they found that users drew heavily on gender stereotypes in their interactions with the computers (Nass et al., 1997). This has contributed to the foundational framing of human-computer interaction as a social interaction between two human-like actors. While there have been

some challenges to this work (see Shechtman & Horowitz, 2003), the paradigm of computers as social actors remains dominant in HCI and is critically implicated in AVA design.

Previously scholars (e.g., Turkle, 1984; Winograd & Flores, 1986) attributed people's social responses to computers as proof that individuals anthropomorphize computers. However, Nass et al. (1997) found that, when explicitly asked, users acknowledge that the computer is not a human and should not be interacted with as such. Despite this awareness, they engage in social behavior toward the machines. This shows that while people may behave in social ways toward computers, they may not be explicitly anthropomorphizing the machines. In later work, Nass and Moon (2000) elaborate on this seeming contradiction by showing that people "mindlessly apply social rules and expectations to computers" (p. 81). "Mindless behavior" is a concept they borrow from Ellen J. Langer's work (1989, 1992). Mindless behavior can be characterized as an "overreliance on categories and distinctions drawn in the past and in which the individual is context-dependent and, as such, is oblivious to novel (or simply alternative) aspects of the situation" (Langer, 1992, p. 289).

Mindless behavior is presented as a kind of cognitive autopilot in these studies, though in later work Langer and Moldoveanu (2002) briefly acknowledge the social implications of mindless behavior for normalizing harmful stereotypes and prejudices. Mindless behavior describes an overreliance on categories based on personal experience as a way to deal with a novel situation or context. The paradigm for AVA design seems to cater to mindless behaviors as the path of least resistance, further entrenching the naturalization of this design strategy and ignoring how this may lead to reliance on harmful stereotypes.

Coinciding with the framework of computers as social actors is an overwhelming emphasis on the positive effects of anthropomorphized agents. Lester et al. (1997) coined the term "persona effect" to refer to the phenomenon that a life-like interface agent may have positive effects on the user's perception of a computer-based interaction task. This concept has been used widely in AI and HCI as validation for the use and design of AVAs (e.g., Moundridou & Virvou, 2002). Though many anthropomorphic agents are not humanoid in design (e.g., Microsoft's former Office Assistant "Clippy," a paperclip with eyes), many studies place a premium on increasingly realistic humanoid AVAs, asserting that humanoid interfaces engender increased cooperation (Kiesler & Sproull, 1997), or altruistically oriented interactions (Sproull et al., 1997). Interestingly, this was not actually borne out in Microsoft's Clippy, a widely maligned AVA that mostly annoyed users. Anna from IKEA, however, is an example of a hugely successful AVA (Noy, Ribeiro, & Iurgel, 2013), which may support evidence that more humanoid AVAs connect more with audiences, to the extent they do not wander into Mori's (1970/2012) "uncanny valley," in which an almost perfect humanoid resemblance creates feelings of strangeness and revulsion among users.

Most of this research is empirical, drawing evidence from user interface testing, user questionnaires, and, in some cases, biofeedback models (Prendinger, Mayer, Mori, & Ishizuka, 2003). Waern and Höök (2001) note, "the more anthropomorphic the agent is, the more naturally the user will respond to it, and the more 'human' the dialogue will become" (p. 298). This raises important questions about the underlying assumptions as to what constitutes "natural" behavior in the framework of human interactions. For example, Nass et al. (1997), finding that users apply gender stereotypes to computers, conclude that this is a natural behavior: "the tendency to gender-stereotype is so deeply ingrained in human psychology that it extends even to computers" (p. 154). This framing of sexism as a natural human behavior is dangerous and reveals the ways in which sexist ideologies are embedded in notions of nature and human behavior.

Zdenek (2007) points out that designers and researchers who build their work on the premise that human-computer interaction operates as human-human interaction "do not have to justify their own research agenda so much as claim the role of facilitator or catalyst for a phenomenon (i.e., the human propensity to treat computers as social actors) that is taken to be predetermined, universal, and above all, natural" (p. 405). This is a powerful and important observation. The scientific enterprise has a long history of using appeals to nature to explain racial, gender, and sexual difference, often for the purpose of justifying economic, political, and social projects that protect the status of the dominant power structure. Instead of approaching anthropomorphization as natural and inevitable, it must be approached as a particular philosophy of design with concomitant values that can be examined for ethical implications and moral accountability.

DESIGNING RACE AND GENDER IN THE INTERFACE

Many designers of AVAs focus on humanness and believability in agent interfaces as features that will optimize the user's information experience. These abstract concepts are often defined by component qualities such as trust, friendliness, credibility, and empathy, which are further operationalized in the design process through verbal and nonverbal cues. The key supposition in this design strategy is that the user will judge the character of an anthropomorphic computer agent based on the same criteria that they use to judge humans in daily interaction. Zdenek (2007) observes that, in focusing on user experience and believability as units of analysis for evaluating AVAs, "designers may also fail to see how their software systems are shot through with assumptions about gender, race, ethnicity, users, and so on" (p. 405). This is demonstrably true in the construction of the base category of "human," for instance. At different points in history, "humanity" and "humanness" have been denied to people based on their gender, race, religion, ethnicity,

and sexuality and have been used to justify atrocities such as slavery, genocide, and rape. Similarly, the social construction of attributes such as trust, friendliness, credibility, and empathy are mediated by systems of gender and race. Notions of masculinity and femininity are often defined by their alignment with these terms, framing women as more empathetic and friendly and men as more credible and competent. Racial stereotypes shape who is seen as authoritative and trustworthy and who is seen as pathological and criminal. AVA designers have treated humanness and believability as natural categories, forgoing deeper investigation into the political histories and social construction of these concepts. Additionally, language describing personality traits as "variables" employs a mathematical metaphor that trades on positivist scientific authority. This obscures the socially mediated and flexible realities of these categories.

Zdenek (2007) points out that race and gender themselves become viewed as variables that strengthen or weaken the design goals of believability. As a result, studies that deal with race and gender in agent interface design tend to focus only on optimization, ignoring how race and gender function within systems of social difference. Often race and gender are acknowledged only as barriers to optimization. Thus, in these configurations, the normative subject is usually constructed as White, male, and presumptively heterosexual, and therefore unproblematic and uncomplicated as a design option. Female and non-White identities are seen as potentially problematic in terms of meeting design goals that promote "authority" or "trust."

Cowell and Stanney's work (2003) provides an example of how race and gender are dealt with as design variables. Their study, undertaken with the goal of drafting design guidelines for "credible" and "trustworthy" agents, analyzes race and ethnicity (which they conflate), gender, and age in agent design and examines both visual representations and nonverbal behaviors. Cowell and Stanney begin by acknowledging the pervasiveness of gender, racial, and age stereotypes in society and providing substantive literature reviews on each area. However, even as they acknowledge this, they cite without question studies that purport to demonstrate that male and female users rank male agents more highly in terms of credibility and believability. Along the same lines, they refer to studies showing that youthful agents are more highly rated. Instead of problematizing these results against the stereotypes they enumerated, they conclude that the combination of these features (i.e., youth and masculinity) provides the best possible option for default design guidelines, effectively reinforcing the stereotypes they listed.

This had the most problematic effects on their formulations of ethnicity and race. While they acknowledge that racial stereotypes come up as major barriers in acceptance of credibility and trust, they dismiss the key political valences of Whiteness by saying that "all ethnic groups appear to harbor their own outgroup prejudices and use similar stereotypes for people in their own ethnic group" (Cowell & Stanney, 2003, p. 303). Just as the comments of Nass et al. (1997)

naturalized sexism through gender stereotyping, Cowell and Stanney (2003) seem to dismiss racism as a "natural" part of the human experience, rather than as a structural system that replicates power and privilege. By using the language of prejudice, rather than acknowledging that the racist framing of Whiteness forms the benchmark for trust and credibility, they obscure the foundational ways that power becomes operationalized in agent design.

Cowell and Stanney (2003) suggest that the solution for racial barriers to trust and credibility in agent design is to match the ethnicity of the agent to the ethnicity of the user. Customizability is often offered as a potential solution to side-step tricky questions about how to mediate, or altogether avoid, criticisms of negative stereotyping in agent design. This strategy gives users a level of control over the representation of their AVA, for which they can then design an agent that is both culturally specific and appropriate for them. While this might offer some potential remediation for problematic representations, it should be treated suspiciously as a transformative approach. Studies of avatar design in related digital environments (e.g., online gaming) demonstrate that giving users the chance to customize their avatar does not automatically result in representations that dismantle gender or racial hierarchies. On the contrary, customized avatar design tends to strongly conform to identity stereotypes (Kolko, 1999) and reflect White standards of beauty (Higgin, 2009; Lee, 2014). In addition, users are still limited to the design choices available in the system for representation (Pace, Houssian, & McArthur, 2009). In light of this evidence, customization of AVAs should be located within a discourse about the neoliberal effects of the interface as a site where individual choices are shaped by consumer power and market logics, rather than heralded as a radical shift of underlying values in design.

AVAS AS WOMEN'S WORK

While metaphors potentially facilitate new understandings of one experience through another, they may also leverage stereotypes and tropes in ways that reinforce dominant power structures. Brahnam et al. (2011) demonstrate how the foundational HCI metaphor, "computer is woman," is closely tied to the maintenance of the gendered labor force in computing. They link the history of a labor transformation in which women performed skilled computer functions until the advent of computing machinery that automated these tasks to the present trend of designing anthropomorphized agent technologies to resemble women. Zdenek (2007) likewise views the repetition and banality of tasks performed by computers as a metaphor for women's work. Recent studies of virtual assistants expand the idea of AVAs as women's work by defining emotional and affective dimensions to the functions AVAs may perform.

Emotional labor has been shown to be part and parcel of "women's work" in the domestic sphere, where women have historically managed caregiving and childrearing and performed other affective labor activities involved in maintaining domestic social relationships. As women have moved into the workplace, jobs that have been coded as "feminine" (e.g., nursing, caregiving, service) tend to require the same emotional and affective labor as an invisible component of the job. Gendered emotional labor practices are practices of sexual differentiation that both construct and reinforce gendered beliefs and stereotypes (Hochschild, 1983). Studies of affective labor in service industries demonstrate that women are expected to perform emotionally and affectively in jobs where their male counterparts are not. This includes putting up with gendered abuse and harassment as part of their affective work (Hughes & Tadic, 1998; Taylor & Tyler, 2000).

Affective agent design attempts to mediate user frustration or anxiety with the interface or information context (e.g., health care, language acquisition, etc.). There are various ways the agent may be programmed to sense and respond to the emotional state of the user. Empathetic agents may recognize emotional expression in the voice, detect facial expressions, or use sensory tools like the IBM "emotion mouse" to detect pulse rate, skin temperature, and general somatic activity (Ark, Dryer, & Lue, 1999). These data are calculated and the agent can react using strategies such as active listening and empathy.

Gendered assumptions about women's "natural" affective skills shape the discourse and design of affective virtual agents, whether or not they are explicitly represented as women. That is, even AVAs not explicitly represented as women are still discursively constructed as feminine. For example, in Brave, Nass, and Hutchinson's (2005) study, they find that both male and female users rated virtual agents exhibiting only empathic emotion as submissive, a trait negatively and stereotypically applied to women. AVAs functioning as health care workers (e.g., nurses or caregivers to the elderly) are often explicitly designed to conform to gendered stereotypes. Noy et al. (2013) state that in designing embodied agents for use in elderly digital inclusion efforts, "female and male behaviour of an EVA [AVA] should be consistent with gender stereotypes" (p. 145). Similarly, Bickmore, Pfeifer, and Jack (2009) discuss designing female nurse characters to "better match the patient demographic and improve acceptability of the VN [Virtual Nurse]" (p. 1270). Hone (2006) found that affective responses are more generally acceptable to users, and thus more effective, when coming from female embodied agents. These studies support Forlizzi, Zimmerman, Mancuso, and Kwak's (2007) findings that people prefer virtual agents that conform to gender stereotypes—and, interestingly, that men prefer embodied agents more than women do.

Brahnam et al. (2011) persuasively argue that "screen-based metaphors that cloak the interface are unspoken gendered subtexts that have the power to bind or liberate" (p. 402). This stance posits that metaphors structure access to power

and action in the world instead of being neutral or harmless rhetorical maneuvers. Brahnam et al. thus locate the design of virtual agents as a continuation of the "computer is woman" metaphor and suggest that the introduction of personified agents has simply made the longstanding feminization of the computer more visible. The metaphorical distinction becomes somewhat collapsed in virtual agents that are explicitly represented as women, and even more so when these programs are designed as affective workers that assume caregiving and emotional labor roles. Laurel (1997) dismisses the consequences that representations may have on real women in the workforce. She frames it as an issue of knowing fact from fiction, arguing that people realize the virtual agent is not a real person; therefore, their actions toward the virtual agent are separate from their behavior toward real people (p. 209). This viewpoint ignores the symbolic power that media representations have, along with their potential for upholding dominant cultural narratives that reinforce damaging stereotypes. Certainly, virtual agents designed to take on affective work are being culturally coded in gendered ways, whether they are explicitly represented as women or not.

CONCLUSIONS

AVAs continue to proliferate across platforms and are increasingly advanced in terms of computing intelligence and interactive capabilities. Now more than ever, it is crucial to interrogate the premise of anthropomorphization as a design strategy that relies on gender and race as foundational, infrastructural components. The ways in which gender and race are operationalized in the interface continue to reinforce the binaries and hierarchies that maintain power and privilege. While customization may offer some individual relief to problematic representations in the interface, particularly for marginalized users, sexism and racism persist at structural levels and, as such, demand a shifted industry approach to design on a broad level. Exploring how gender and race inform AVA design illuminates the ethical considerations that designers of technology must engage with if they are to create socially responsible technologies. Sexism and racism persist in shaping the design, use, and meaning of ICTs, and this must be prioritized as a set of key ethical concerns in those computing fields where design and implementation of these systems occurs. As this work demonstrates, there is a disjuncture between disciplinary approaches to AVAs that must be bridged for change to happen. Socially responsible interface design requires active engagement with issues of identity, representation, and power from both designers and digital media scholars. Critical cultural frameworks are potentially powerful tools for investigating culture and power in technology design and should be integrated into the training of computer engineers and designers.

REFERENCES

Ark, W. S., Dryer, D. C., & Lu, D. J. (1999). The emotion mouse. *Proceedings of the HCI International 99: 8th international conference on human-computer interaction: Ergonomics and user interfaces* (Vol. 1, pp. 818–823). Mahwah, NJ: Lawrence Erlbaum Associates, Inc.

Bickmore, T. W., Pfeifer, L. M., & Jack, B. W. (2009). Taking the time to care: Empowering low health literacy hospital patients with virtual nurse agents. In *Proceedings of the 27th international conference on human factors in computing systems* (pp. 1265–1274). New York: ACM Press.

Brahnam, S., Karanikas, M., & Weaver, M. (2011). (Un)dressing the interface: Exposing the foundational HCI metaphor "computer is woman." *Interacting With Computers, 23*(5), 401–412.

Brave, S., Nass, C., & Hutchinson, K. (2005). Computers that care: Investigating the effects of orientation of emotion exhibited by an embodied computer agent. *International Journal of Human-Computer Studies, 62*(2), 161–178.

Cowell, A., & Stanney, K. (2003). Embodiment and interaction guidelines for designing credible, trustworthy embodied conversational agents. In T. Rist, R. Aylett, D. Ballin, & J. Rickel (Eds.), *Lecture notes in computer science: Vol. 2792. Intelligent virtual agents* (pp. 301–309). Berlin: Springer-Verlag.

Foner, L. (1993). What's an agent, anyway? A sociological case study. *Agents Memo 93*. Retrieved from http://www.student.nada.kth.se/kurser/kth/2D1381/JuliaHeavy.pdf

Forlizzi, J., Zimmerman, J., Mancuso, V., & Kwak, S. (2007). How interface agents affect interaction between humans and computers. In *Proceedings of the 2007 conference on designing pleasurable products and interfaces* (pp. 209–221). ACM. Retrieved from http://dl.acm.org/citation.cfm?id=1314180

Galloway, A. R. (2008). The unworkable interface. *New Literary History, 39*(4), 931–955.

Genova, J. (1994). Turing's sexual guessing game. *Social Epistemology, 8*(4), 313–326.

Hayles, N. K. (1999). *How we became posthuman: Virtual bodies in cybernetics, literature, and informatics.* Chicago, IL: University of Chicago Press.

Higgin, T. (2009). Blackless fantasy: The disappearance of race in Massively Multiplayer Online Role-Playing games. *Games and Culture, 4*(1), 3–26.

Hills, D. (2012). Metaphor. In Edward N. Zalta (Ed.), *The Stanford encyclopedia of philosophy* (Winter 2012 ed.). Retrieved from http://plato.stanford.edu/archives/win2012/entries/metaphor/

Hochschild, A. R. (1983). *The managed heart: Commercialization of human feeling.* Berkeley: University of California Press.

Hone, K. (2006). Empathic agents to reduce user frustration: The effects of varying agent characteristics. *Interacting With Computers, 18*(2), 227–245.

Hughes, K. D., & Tadic, V. (1998). "Something to deal with": Customer sexual harassment and women's retail service work in Canada. *Gender, Work & Organization, 5*(4), 207–219.

Kiesler, S., & Sproull, L. (1997). "Social" human-computer interaction. In B. Friedman (Ed.), *Human values and the design of computer technology* (pp. 191–200). Stanford, CA: CSLI Publications.

Kolko, B. E. (1999). Representing bodies in virtual space: The rhetoric of avatar design. *The Information Society, 15*(3), 177–186.

Lakoff, G., & Johnson, M. (2003). *Metaphors we live by* (Updated ed.). Chicago, IL: University of Chicago Press.

Langer, E. J. (1989). *Mindfulness.* Reading, MA: Addison-Wesley.

Langer, E. J. (1992). Matters of the mind: Mindfulness/mindlessness in perspective. *Consciousness and Cognition, 1*, 289–305.

Langer, E. J., & Moldoveanu, M. (2002). The construct of mindfulness. *Journal of Social Issues*, *56*(1), 1–9.

Laurel, B. (1997). Interface agents: Metaphors with character. In B. Friedman (Ed.), *Human values and the design of computer technology* (pp. 207–219). Stanford, CA: CSLI Publications.

Lee, J.-E. R. (2014). Does virtual diversity matter?: Effects of avatar-based diversity representation on willingness to express offline racial identity and avatar customization. *Computers in Human Behavior*, *36*, 190–197.

Lester, J. C., Converse, S. A., Kahler, S. E., Barlow, S. T., Stone, B. A., & Bhogal, R. S. (1997). The persona effect: Affective impact of animated pedagogical agents. *Proceedings of the SIGCHI conference on human factors in computing systems* (pp. 359–366). doi:10.1145/258549.258797

Mauldin, M. L. (1994). Chatterbots, tinymuds, and the Turing test: Entering the Loebner prize competition. *Proceedings of the National Conference on Artificial Intelligence* (pp. 16–21). Retrieved from http://www.aaai.org/Papers/AAAI/1994/AAAI94-003.pdf

Mori, M. (1970/2012). The uncanny valley (K. F. MacDorman & N. Kageki, Trans.). *IEEE Robotics & Automation Magazine*, *19*(2), 98–100.

Moundridou, M., & Virvou, M. (2002). Evaluating the persona effect of an interface agent in a tutoring system. *Journal of Computer Assisted Learning*, *18*(3), 253–261.

Nass, C., & Moon, Y. (2000). Machines and mindlessness: Social responses to computers. *Journal of Social Issues*, *56*(1), 81–103.

Nass, C., Moon, Y., & Green, N. (1997). Are machines gender neutral? Gender-stereotypic responses to computers with voices. *Journal of Applied Social Psychology*, *27*(10), 864–876.

Nass, C., Moon, Y., Morkes, J., Kim, E.-Y., & Fogg, B. J. (1997). Computers are social actors: A review of current research. In B. Friedman (Ed.), *Human values and the design of computer technology* (pp. 137–162). Cambridge, UK: Cambridge University Press.

Noy, D., Ribeiro, P., & Iurgel, I. A. (2013). Embodied virtual agents as a means to foster e-inclusion of older people. In P. Biswas, C. Duarte, P. Langdon, L. Almeida, & C. Jung (Eds.), *A multimodal end-2-end approach to accessible computing* (pp. 135–154). London: Springer.

Pace, T., Houssian, A., & McArthur, V. (2009). Are socially exclusive values embedded in the avatar creation interfaces of MMORPGs? *Journal of Information, Communication and Ethics in Society*, *7*(2/3), 192–210.

Pratt, J. A., Hauser, K., Ugray, Z., & Patterson, O. (2007). Looking at human–computer interface design: Effects of ethnicity in computer agents. *Interacting With Computers*, *19*(4), 512–523.

Pratt, M. L. (1991). Arts of the contact zone. *Profession*, 33–40.

Prendinger, H., Mayer, S., Mori, J., & Ishizuka, M. (2003). Persona effect revisited. In T. Rist, R. Aylett, D. Ballin, & J. Rickel (Eds.), *Lecture Notes in Computer Science: Vol. 2792. Intelligent virtual agents* (pp. 283–291). Berlin: Springer-Verlag.

Selfe, C. L., & Selfe, R. J. (1994). The politics of the interface: Power and its exercise in electronic contact zones. *College Composition and Communication*, *45*(4), 480–504.

Shechtman, N., & Horowitz, L. M. (2003). Media inequality in conversation: How people behave differently when interacting with computers and people. In *Proceedings of the SIGCHI Conference on Human Factors in Computing Systems* (pp. 281–288). doi:10.1145/642611.642661

Sproull, L., Subramani, M., Kiesler, S., Walker, J., & Waters, K. (1997). When the interface is a face. In B. Friedman (Ed.), *Human values and the design of computer technology* (pp. 163–190). Stanford, CA: CSLI Publications.

Taylor, S., & Tyler, M. (2000). Emotional labour and sexual difference in the airline industry. *Work, Employment & Society*, *14*(1), 77–95.

Turkle, S. (1984). *The second self: Computers and the human spirit*. New York: Simon and Schuster.

Waern, A., & Höök, K. (2001). Interface agents: A new interaction metaphor and its application to universal accessibility. In C. Stephanidis (Ed.), *User interfaces for all: Concepts, methods, and tools.* (pp. 295–317). Mahwah, NJ: Lawrence Erlbaum.

Weizenbaum, J. (1976). *Computer power and human reason: From judgment to calculation*. San Francisco, CA: Freeman.

Winner, L. (1986). Do artifacts have politics? In *The whale and the reactor: A search for limits in an age of high technology* (pp. 19–39). Chicago, IL: University of Chicago Press.

Winograd, T., & Flores, C. F. (1986). *Understanding computers and cognition: A new foundation for design*. Norwood, NJ: Ablex.

Zdenek, S. (2007). "Just roll your mouse over me": Designing virtual women for customer service on the Web. *Technical Communication Quarterly, 16*(4), 397–430.

The Epidemiology OF Digital Infrastructure

ROBERT MEJIA

INTRODUCTION

The field of media and cultural studies is in desperate need of an epidemiological turn. Though it has produced a handful of exemplary forays into the study of disease, the field as a whole has yet to produce a sustained branch of epidemiological analysis. Paula Treichler's landmark text, *How to Have a Theory in an Epidemic: Cultural Chronicles of AIDS*, was published in 1999, and though one would hope that it would have served as a catalyst and model for a sustained and rigorous cultural analysis of disease, most of the work on the cultural study of disease has been produced outside the field of media and cultural studies. This is not to suggest that these works are lacking on the basis of their having been produced outside the field of media and cultural studies. Indeed, these works have advanced our understanding of the rhetorical production of medical character and trust (Keränen, 2010) and the epidemiological consequence of the outbreak narrative (Wald, 2007). And yet, these contributions likewise reflect the intellectual histories of their production and their origins in the disciplines of rhetoric and English, respectively. The absence of a sustained contribution from the field of media and cultural studies is a shame, for in spite of the contributions to a cultural analysis of epidemiology made by other fields, "unless we operate in this tension, we don't know what cultural

studies can do, can't, can never do; but also, what it has to do, what it alone has a privileged capacity to do" (Hall, 1992/1996, pp. 272–273).

The need to know what media and cultural studies alone has a privileged capacity to do regarding our understanding of disease is even more urgent today than it was at the time of Stuart Hall's admonishment in 1992. Though the rates of new HIV/AIDS and tuberculosis infections have fallen in the past two decades, these two diseases infected 2.1 million and 9 million people in 2013 and cause 3 million combined deaths annually, making them the top two "greatest killer worldwide due to a single infectious agent" (World Health Organization, 2014a, 2014b). Moreover, it is necessary that we understand that the global control of HIV/AIDS, for instance, operates unevenly, with "the lowest coverage typically in the countries with the lowest income, which tend to have the greatest needs" (World Health Organization, 2014a, p. 174). If the detection, prevention, and treatment of HIV/AIDS and tuberculosis have witnessed improvement, unevenness of implementation notwithstanding, noncommunicable diseases such as cancer, diabetes, heart disease, and obesity have grown substantially in the past two decades (Mendis, 2014; World Health Organization, 2015a, 2015b). And just like communicable diseases, "over three quarters of deaths from cardiovascular disease and diabetes [and] more than two thirds of all cancer deaths occur in low- and middle-income countries" (Mendis, 2014, p. 11). This means that of the world's 56 million deaths in 2012, "almost three quarters of all [non communicable disease deaths] (28 million), and the majority of premature deaths [caused by these diseases] (82%), occur in low- and middle-income countries" (Mendis, 2014, p. xi). If media and cultural studies has a unique contribution to make to the global detection, prevention, and treatment of disease, then it seems as though we have an ethical obligation to act today, as opposed to waiting another 20 years.

Though an epidemiological turn for the field of media and cultural studies remains, at best, on the distant horizon, Elizabeth Grossman's *High Tech Trash* (2006) and Richard Maxwell and Toby Miller's *Greening the Media* (2012) hold promise for what such a mode of inquiry might entail. This chapter seeks to build upon the best of their work and that of others who have taken seriously the task of understanding the epidemiological impact of media production, maintenance, consumption, and disposal. As Maxwell and Miller (2012) argue, most media experts and non-experts alike tend to believe that "the central event of the 20th century is the overthrow of matter" (p. 10). Yet the reality is that we do not live in a dematerialized society. Electronics infrastructure is all around us, from the cell phone towers and cell phones that power our mobile communication to the Internet cables and personal computers that power much of our leisure and productivity. The materiality and ecological effects of these technologies are often forgotten, however, for as long as their production, maintenance, and disposal remains elsewhere, "we don't mind that people die of lead poisoning or from lung disease from

air laden with coal soot" (Grischuk, 2009, p. 71). This chapter, then, is an attempt to accelerate the emergence of an epidemiological turn for the field of media and cultural studies: an attempt to illustrate how we are implicated in the emergence and spread of communicable and noncommunicable disease not just elsewhere, but here as well. To make this case, this chapter is organized according to three case studies that serve as exemplars for understanding the epidemiological impact of media production, usage, and disposal.

PRODUCTION: NITRATES, ALGAE BLOOMS, AND INFECTIOUS DISEASE

It is well documented that the manufacturing of electronic technologies is a toxic process. Superfund hazardous waste sites can be found in Endicott, New York (former home of IBM); along 200 miles of the Hudson River in New York (due to two General Electric capacitor manufacturing plants); and in Santa Clara, California (the heart of Silicon Valley) (EPA, 2014a, 2014b; Grossman, 2006). Indeed, "Santa Clara County has, thanks largely to high tech, more Superfund sites than any other US County" (Grossman, 2006, p. 54). Likewise, though not solely due to electronics manufacturing, General Electric is among the largest Superfund polluters "responsible for about 75 Superfund sites" (Nelson, 2010), and its Hudson River Superfund site is both one of the United States' largest and "most contaminated hazardous waste sites" (EPA, 2014a). Though the direct effects of this environmental contamination has been associated with "the accumulation of PCBs in the human body," which have been linked to "adverse health effects such as low birth weight, thyroid disease, and learning, memory, and immune system disorders" (EPA, 2014a), among other ailments, such as cancer (Grossman, 2006), the focus of this section will be on how the manufacturing of electronic technologies can function as a vector for communicable disease transmission.

Due to the level of chemical purification required, the manufacturing of electronic technologies is conducive to communicable disease transmission. Electronic technologies are high precision devices, and "as geometries become smaller, the sensitivity of integrated substrates to contamination and impurities increases" (Honeywell, 2003). Though the chemicals used, such as hydrofluoric acid and nitric acid, are highly toxic in and of themselves, the neutralization of their immediate toxicity is of equal concern regarding the transmission of communicable diseases. Neutralizing these acids produces water-soluble nitrates that are capable of passing through water treatment systems and entering local water sources (Grossman, 2006). This is concerning on its own terms, as nitrate contamination "can be very dangerous for infants and some adults" (EPA, 2012). Of equal concern

is the epidemiological impact of nitrate water waste, as nitrate rich ecologies are conducive to algae blooms.

Large electronic manufacturers, such as Intel, produce a substantial amount of nitrate rich water waste each day; for instance, Intel's Ronler Acres campus in Hillsboro, Oregon, consumes "3.7 million gallons of water a day and then spits most of it back into the city's water-treatment system, which ultimately feeds into the Tualatin River" (Rogoway, 2010). Since the Tualatin River processes roughly 97 million gallons per day (U.S. Geological Survey, 2013), this means that treated Intel wastewater constitutes nearly 4 percent of the Tualatin River's daily water flow. Though Intel is not the sole source of nitrate wastewater for the Tualatin River, algae blooms have long posed problems to the water quality of the river (U.S. Geological Survey, 2013). Indeed, in 2008, "a potentially toxic blue-green algae bloom, 'thicker than clam chowder' in one spot,…laced an 11-mile stretch of the Tualatin River" (Manzano, 2008).

The concern regarding the algae blooms that often emerge as a partial byprod-uct of electronics manufacturing wastewater is that algae can serve as a reservoir for infectious diseases. The El Tor strain of cholera, for instance, is "well equipped, genetically, for long-term survival inside algae" (Garrett, 1994/1995, p. 564). Indeed, epidemiologists have documented that "the key to forecasting emergence of cholera lay in tracking algae blooms" (Garrett, 1994/1995, p. 563). And beyond cholera, algae blooms have been found to harbor antibiotic resistant bacteria and vast numbers of viruses and may serve as safe havens for the emergence of new infectious diseases (Epstein & Ford, 1993; Garrett, 1994/1995). So, though it is important to acknowledge that excessive sewage and agricultural runoff are the primary sources for this ecological imbalance that is so hospitable to algae, it is imperative that media and cultural studies scholars offer an account of how the 3.7 million gallons of water used per day by Intel in Hillsboro, Oregon, and the millions more used elsewhere, contribute to an ecology hospitable to infectious disease and its natural reservoirs.

USAGE: ENVIRONMENTAL TOXINS, CONSUMER ELECTRONICS, AND RED HERRINGS

The last decade has experienced a resurgence of ecological concern regarding the epidemiological consequences of human activity. Though this resurgence in pop-ular consciousness has directed our attention to problems of increasing urgency, such as global warming and agricultural sustainability, so too has it offered an environment suitable for political and economic exploitation. Legitimate concerns about autism, for instance, have led a number of concerned parents to reject or

limit vaccination schedules due to concerns regarding the presence of thimerosal, a mercury compound, in some children's vaccines. This is in spite of the fact that since 2001, thimerosal has not been "used as a preservative in routinely recommended childhood vaccines" (Centers for Disease Control and Prevention, 2014). Even prior to the removal of all but a trace amount of thimerosal from contemporary vaccines, the presence of thimerosal in older vaccines constituted one tenth of a milligram (Minnesota Department of Health, 2012; U.S. Food and Drug Administration, 2014).

Though the concern regarding mercury is legitimate, the form of mercury found in thimerosal (ethylmercury) is broken down and processed out of the body much more quickly than is the more dangerous elemental mercury compound that is found in consumer electronics (Centers for Disease Control and Prevention, 2014; EPA, 2000). Long-term exposure to elemental mercury above concentrations of 0.0003 milligrams has been known to cause central nervous system problems ranging from irritability to tremors, and short-term exposure to high levels of elemental mercury can result in kidney failure (EPA, 2000). Considering that "mercury is used in the cell phone's battery, crystal displays, and circuit boards" and that a single phone can contain up to two grams of mercury (Anthony, 2013), it seems as though our current public preoccupation with the 0.001 milligram trace of thimerosal is little more than a red herring.

Knowing that an estimated 632,000 pounds of mercury were disposed of in U.S. landfills between 1997 and 2007, from just discarded personal computers alone, and that about 130 million cell phones are thrown away each year (Maxwell & Miller, 2008, 2012), it is urgent that we understand the epidemiological consequences of our failure to properly maintain our consumer electronics. This is especially true in the case of children's health, for in the United States alone, "one-in-six children born every year have been exposed to mercury levels so high that they are potentially at risk for learning disabilities and motor skill impairment and short-term memory loss" (PBS, 2005). And though most mercury poisoning results from the bioaccumulation of the toxin from eating contaminated fish, improper maintenance and disposal of consumer electronics contributes to this process of bioaccumulation. As elemental mercury "mixes in the atmosphere with other chemicals and is transformed through oxidation and other biological processes...it is deposited over the land into the more lethal methylmercury," where it then "moves up the food chain to concentrate at high levels in the flesh of fish" (Idaho Health & Welfare, 2014). Electronic technologies constitute a significant source of this bioaccumulation, for "22 percent of the mercury used worldwide each year goes into electrical and electronic equipment" (Grossman, 2006, p. 19). Equally important is that, though consumer electronics do not represent a mercury poisoning risk when the units are intact, "when a mercury-containing product

breaks and the mercury is spilled, the exposed mercury can evaporate and become an invisible, odorless toxic vapor" (EPA, 2014c).

Though mercury poisoning is not considered a communicable disease, Minamata disease, a neurological syndrome caused by severe mercury poisoning, has very specific vectors for disease transmission, namely, the improper handling and disposal of mercury compounds (National Institute for Minamata Disease, 2014). In the past, this vector was confined to industrial waste sites, now classified in the United States as Superfund sites. Today, however, these possible vectors are in our purses, pockets, bedrooms, living rooms, and more. These possible vectors emerge every time our cell phone, television, laptop, or other electronic device with a screen becomes cracked. Considering that "mercury is a highly toxic element" and that "there is no known safe level of exposure" (Bose-O'Reilly, McCarty, Steckling, & Lettmeier, 2010, p. 186), media and cultural studies scholars have an ethical obligation to interrogate the increasing number of consumer electronics operating as possible vectors for the transmission of acute and chronic forms of mercury poisoning.

DISPOSAL: HIGH-TECH TRASH AND LEAD POISONING

Environmental levels high enough to produce lead poisoning were once considered a natural endemic condition in the United States. Though it was understood that lead was a toxic substance and that "as many as 5,000 Americans died annually from lead-related heart disease prior to the country's lead phaseout," the automotive and oil industries convinced the government and general public that this was a natural part of our environment (Kitman, 2000; see also MacFarlane & Druyan, 2014). Though skepticism and dissent from this natural endemic thesis existed, they were not supported by studies until the 1969 work of Clair Patterson, who determined that "high background lead levels in industrial lands were [human-made]" (Kitman, 2000; see also MacFarlane & Druyan, 2014). Though the use of leaded gasoline was reduced shortly after Patterson's intervention, it would not be until 1986 that leaded gasoline was made illegal in the United States. Due to this long history of use, it is believed that "68 million young children had toxic exposures to lead from gasoline from 1927 to 1987" (Kitman, 2000). Equally concerning, the prevalence of leaded gasoline and lead paint during this period had made the toxic substance so widely dispersed that "it is doubtful whether any part of the earth's surface or any form of life remains uncontaminated by [human-made] lead" (Southwood, 1983, p. 10). Nevertheless, since leaded gasoline and lead paint were made illegal, blood-lead levels have declined by 75 percent within the United States (Kitman, 2000).

Considering the substantial success on this public health issue, it is concerning that media and cultural studies scholars have not done enough to raise awareness

of a possible resurgence of this historic epidemic. To put this into perspective, at the height of the United Kingdom's concern about lead poisoning, 274,000 metric tons of lead was being consumed annually within the country; in 2012, the United States produced 10 million metric tons of electronic waste that is often laden with toxic metals such as lead (Lewis, 2013). And from 1997 to 2007, the disposal of computers in the United States alone produced 71,667 metric tons of lead annually (Maxwell & Miller, 2012). Knowing that the world will produce an additional 65 metric tons of electronic waste (or 33 percent more than 2013 levels) (Lewis, 2013), it is necessary that we understand the epidemiological consequence of such ecological degradation.

The work that has been done evinces reason for concern. Guiyu, China, a town of 150,000 and home to the largest e-waste recycling site in the world, reports that residents of the city have experienced high rates of digestive ailments, neurological illness, respiratory problems, and bone disease (Leung, Duzgoren-Aydin, Cheung, & Wong, 2008; McAllister, 2013). Indeed, one study of 165 children at a local kindergarten found that 81 percent possessed blood-lead levels above 10 micrograms per deciliter (Leung et al., 2008). The U.S. National Institutes of Health notes that children should have blood-lead levels of less than 5 micrograms per deciliter and that even mild lead poisoning at this age can have a permanent impact on attention and intelligence (National Institutes of Health, 2015). Lead is a particularly resilient toxin, in that it can persist in the environment for up to 200 years without significant decay and, when converted to dust (via improper breakdown and disposal), can travel via clothing, wind, and waterways (Leung et al., 2008; McAllister, 2013; Robinson, 2009). This mobility and resilience mean that improper disposal in one area can lead to lead contamination in another and can be particularly harmful when the toxin migrates to agricultural centers, as the "'soil-crop-food pathway' [is] one of the most significant routes for heavy metals' exposure to humans" (McAllister, 2013). Equally concerning is that improper disposal of electronic waste can contaminate other manufacturing practices: It has been found that "lead was potentially available for human absorption" on jewelry, toys, and other consumer products manufactured in regions with high levels of environmental lead contamination (Robinson, 2009, p. 189).

Though lead contamination and lead poisoning are a transnational issue, it is imperative that knowing this does not result in a xenophobic reaction against the dangerous electronic waste and recycling practices in operation throughout the Global South. We must remember that most electronic waste is not recycled, and about 80 percent of what is collected is exported to countries in the Global South (Robinson, 2009). Indeed, it is estimated that only 20 to 66 percent of electronic waste in the United States is recycled (Davis, 2013; Vidal, 2013). This means that of the 10 million metric tons of electronic waste produced by the United States in 2012, 3.4 to 8 million metric tons ended up in national landfills, where lead

and other toxic materials seep out, contaminating the environment (Davis, 2013; Vidal, 2013). From this perspective, Guiyu, China is not the problem, but rather a global warning about the epidemiological dangers of electronic waste.

Though it is fortunate that a substantial amount of research on electronic waste has been completed by environmental scientists (Robinson, 2009), just like my introductory comments on the disciplinary affordances of rhetoric and English, so too does this research reflect the intellectual histories of its production, emphasizing chemical over cultural analysis. As valuable as the contributions from environmental scientists have been, those working in the field of media and cultural studies have a unique contribution to make regarding the intersection of technology and society. For if environmental science is able to explain the ecological irrationality of our obsession with technology, media and cultural studies is able to explain the cultural rationalities that mobilize this dependency (Maxwell & Miller, 2012; Mejia, 2015). For as Maxwell and Miller (2012) note:

> One might think that understanding the enormity of the environmental problems caused by making, using, and disposing of media technologies would arrest our enthusiasm for them. But many intellectual correctives to our 'love affair' with technology—our technophilia— have come and gone without establishing much of a foothold against the breathtaking flood of gadgets and associated propaganda promoting their awe-inspiring capabilities." (p. 4)

Hence, if the epidemiological consequences of electronic waste are to be resolved, then we need to involve ourselves in the conversation.

CONCLUSION: THE INTERSECTIONAL EPIDEMIOLOGY OF DIGITAL INFRASTRUCTURE

This chapter has offered three case studies that serve as exemplars for both understanding and illustrating the need for an epidemiological turn within the field of media and cultural studies. By operating at the intersection of media and cultural theory, scholars in this field possess the analytical insight necessary for understanding the uneven distribution of the costs and benefits of electronic technologies, as well as the cultural logic that informs their production, usage, and disposal. This theoretical and methodological sophistication is necessary, for the epidemiological consequences of technological production, usage, and disposal is most likely to harm poor women, men, and children of color. Though I have focused on the need for an epidemiological turn in terms of an infrastructural analysis of digital technologies, this is not a call for media and cultural studies to abandon its emphasis on analytical sensitivity and nuance. Indeed, as this edited collection illustrates, at its best, media and cultural studies is able to offer an analysis of *both*

the politics of technology and the technology of politics (Williams, 1974/2005). This chapter has emphasized the technology of politics, in terms of how digital infrastructure affects the emergence and transmission of diseases. This does not mean that we should forget or ignore the politics of technology, in terms of how those bodies that operate as the invisible infrastructure of technology bear the burden of technological pleasure (see Noble and Roberts, this collection). Though this intersectional spirit has operated throughout this chapter, the remainder of this chapter will emphasize why the unique intersectional insight offered by those operating in the field of media and cultural studies is so necessary if we are to critically engage issues of global health.

The field of media and cultural studies incorporates two genealogies of the concept of intersectionality that, combined, offer a powerful analytic for intervening upon issues of global health. The first, and more intrinsic to media and cultural studies, is the concept of articulation. The value of the concept, as codified by Stuart Hall, is that within the multiple layers of communication—production, circulation, distribution, consumption, reproduction, and disposal—each layer and moment "is necessary to the [communicative act] as a whole, [but] no one moment can fully guarantee the next moment with which it is articulated" (Hall, 1980/2006, p. 164). This means that though each layer of the communicative act has a determinate effect on the overall communicative outcome, each layer of the communication process nevertheless is governed by logics that may only imperfectly align with those that come before or after (Hall, 1980/2006). This chapter, for instance, has emphasized the production, circulation, and disposal elements of technological engagement, so as to emphasize the epidemiological consequences of those processes. Equally important, though beyond the scope of this chapter, would be to understand how these epidemiological consequences undergird the distribution of global pleasure, desire, anxiety, and suffering. Focusing on global hunger, for instance, my colleagues and I have argued that the contradictions between these layers can short-circuit the ostensibly good intentions of those who wish to combat global suffering (Bulut, Mejia, & McCarthy, 2014). If we are to critically intervene in issues of global health, it seems necessary that we understand the complex interplay of anxiety and desire that operates within and between every layer of the technological circuit.

The second genealogy of intersectionality "closely parallels" the concept of articulation, but the differences between them matter (Collins, 1998, p. 270). Though articulation theory often emphasizes the confluence of forces that affect the meaning of a message as it travels through the circuit of communication and does recognize that a given message can travel through multiple routes, resulting in multiple possible outcomes (Hall, 1980/2006), the concept of intersectionality is more closely attuned to the confluence of forces that affect one's relationship to systems of communication and power in the first place (Collins,

1998; Crenshaw, 1991). This latter perspective matters, for though the environmental and epidemiological consequences of communication technologies come into existence through a complex articulation of transnational desire, production, consumption, and disposal, the experience and effects of this global desire, pleasure, anxiety, and suffering operate unevenly across race, gender, class, and national lines. For instance, though most electronic waste is exported to China, India, Pakistan, Vietnam, the Philippines, Malaysia, Nigeria, Ghana, Brazil, and Mexico, most electronic waste is produced in Europe and the United States (Lewis, 2013; Robinson, 2009). This means that countries in the Global South must account not just for their own electronic waste production, estimated at nearly 14 million metric tons, but must also contend with the estimated 3 to 11 million metric tons that are exported from the Global North to the Global South annually (Davis, 2013; Lewis, 2013; Robinson, 2009; STEP, 2014; Vidal, 2013). Likewise, we must recognize that the concept of intersectionality requires that we acknowledge the fissures that exist within nations, as the distribution of pleasure and pain operates unevenly in this context as well. For instance, though "China receives some 70% of all exported E-Waste" (Robinson, 2009, p. 187), it too produces a substantial amount of electronic waste, due to its dual position as a global source of cheap manufacturing labor and an emerging world power (see Harvey, 2007). This means that, like many nations across the globe, the environmental and epidemiological consequences of, as well as pleasures afforded by, electronic technologies are unevenly distributed across the working poor and economic elite that constitute the population of China.

These two complementary genealogies to the concept of intersectionality afford the field of media and cultural studies the opportunity to offer a powerful contribution to our understanding of and engagement with issues concerning global health. Media and cultural studies alone has the unique capacity to understand and interpret both the confluence of forces that shape the effect of a message as it travels across the circuit of communication and the confluence of forces that affect one's relationship to systems of communication and power. Both perspectives are necessary if we are to understand the causes, consequences, possible solutions, and even pleasures embedded in our growing global health crisis. Indeed, both perspectives are necessary if we are to even recognize these causes, consequences, possible solutions, *and pleasures*. For the problem of our growing global health crisis cannot be resolved unless we are able to recognize the uneven distribution of global suffering *and* pleasure embedded in this system of ecological crisis. If public health scholars have placed greater emphasis on global suffering, media and cultural theorists have often been guilty of placing too much emphasis on global pleasure (Maxwell & Miller, 2012). But both perspectives matter, for a theory of pleasure helps to explain the all too human rationalities and mechanics governing our current global health crisis (Dyer-Witheford & de Peuter, 2009; Mejia, 2015).

In sum though communication technologies are definitely a part of the solution, too often they are offered without a critical assessment of their uneven operation across populations (Bulut et al., 2014). The intersectional approach I have advocated in this chapter, and the one that is advocated across this edited collection, demands that an account of digital technologies understands the complex totality of its operation, and does not just focus on the "immaterial labor" that so often is the privileged population for analysis. The field of media and cultural studies is in desperate need of an epidemiological turn; or rather, epidemiology is in desperate need of media and cultural studies. Lacking the analytical sensitivity and nuance offered by the field, it may well be that the efforts of global health practitioners will continue to struggle through the political, economic, technological, social, and cultural complexity of our contemporary global health crisis.

REFERENCES

Anthony, P. (2013). Cell phone toxins and the harmful effects on the human body when recycled improperly [Blog post]. Retrieved from http://www.e-cycle.com/cell-phone-toxins-and-the-harmful-effects-on-the-human-body-when-recycled-improperly/

Bose-O'Reilly, S., McCarty, K., Steckling, N., & Lettmeier, B. (2010). Mercury exposure and children's health. *Current Problems in Pediatric and Adolescent Health Care, 40*(8), 186–215.

Bulut, E., Mejia, R., & McCarthy, C. (2014). Governance through philitainment: Playing the benevolent subject. *Communication and Critical/Cultural Studies, 11*(4), 342–361.

Centers for Disease Control and Prevention. (2014). Vaccine safety. Retrieved from http://www.cdc.gov/vaccinesafety/Concerns/thimerosal/

Collins, P. H. (1998). *Fighting words: Black women & the search for justice.* Minneapolis: University of Minnesota Press.

Crenshaw, K. (1991). Mapping the margins: Intersectionality, identity politics, and violence against women of color. *Stanford Law Review, 43*(6), 1241–1299.

Davis, S. (2013). E-waste: What happens with your outdated or broken gadgets. *CBSNews.com.* Retrieved from http://www.cbsnews.com/8301-205_162-57580445/e-waste-what-happens-with-your-outdated-or-broken-gadgets/

Dyer-Witheford, N., & de Peuter, G. (2009). *Games of empire: Global capitalism and video games.* Minneapolis: University of Minnesota Press.

EPA. (2000). Mercury compounds. Retrieved from http://www.epa.gov/ttnatw01/hlthef/mercury.html#ref1

EPA. (2012). Frequently asked questions about nitrate and drinking water. Retrieved from http://www.epa.gov/region10/pdf/sites/yakimagw/faq_nitrate_and_drinking_water.pdf

EPA. (2014a). Hudson River cleanup. Retrieved from http://www.epa.gov/hudson/cleanup.html#quest1

EPA. (2014b). IBM Corporation—Endicott. Retrieved from http://www.epa.gov/region2/waste/fsibmend.htm

EPA. (2014c). Recommended management and disposal options for mercury-containing products. Retrieved from http://www.epa.gov/mercury/mgmt_options.html#commercial

Epstein, P. R., & Ford, T. E. (1993). Marine ecosystems. *Lancet, 342*(8881), 1216–1219.

Garrett, L. (1994/1995). *The coming plague: Newly emerging diseases in a world out of balance.* London: Penguin.

Grischuk, W. (2009). *Supply chain brutalization: The handbook for contract manufacturing.* Charleston, SC: BookSurge.

Grossman, E. (2006). *High tech trash: Digital devices, hidden toxics, and human health.* Washington, DC: Island Press.

Hall, S. (1980/2006). Encoding/Decoding. In M. G. Durham & D. M. Kellner (Eds.), *Media and cultural studies: Keyworks* (pp. 163–173). Malden, MA: Blackwell.

Hall, S. (1992/1996). Cultural studies and its theoretical legacies. In D. Morley & K.-H. Chen (Eds.), *Critical dialogues in cultural studies* (pp. 262–275). New York: Routledge.

Harvey, D. (2007). *A brief history of neoliberalism.* Oxford, UK: Oxford University Press.

Honeywell. (2003). Hydrofluoric acid. Retrieved from http://www.honeywell.com/sites/docs/doc 1c82bed-f9f3b5e484-e0df9bfada07602278603c6cb43673fb.pdf

Idaho Health & Welfare. (2014). The dangers of mercury. Retrieved from http://www.211.idaho.gov/elibrary/MercuryDanger.html

Keränen, L. (2010). *Scientific characters: Rhetoric, politics, and trust in breast cancer research.* Tuscaloosa: University of Alabama Press.

Kitman, J. L. (2000, March 2). The secret history of lead. *The Nation.* Retrieved from http://www.thenation.com/article/secret-history-lead

Leung, A. O., Duzgoren-Aydin, N. S., Cheung, K. C., & Wong, M. H. (2008). Heavy metals concentrations of surface dust from e-waste recycling and its human health implications in southeast China. *Environmental Science & Technology, 42*(7), 2674–2680.

Lewis, T. (2013). World's e-waste to grow 33% by 2017, says global report. Retrieved from http://www.livescience.com:41967-world-e-waste-to-grow-33-percent-2017.html

MacFarlane, S., & Druyan, A. (Writers). (2014). Cosmos: A spacetime odyssey [*Television series*]. United States: Fox.

Manzano, P. (2008). Tualatin River water tested for toxic algae. Retrieved from http://blog.oregonlive.com/breakingnews/2008/07/usgs_tests_for_toxic_algae_in.html

Maxwell, R., & Miller, T. (2008). Ecological ethics and media technology. *International Journal of Communication, 2,* 331–353.

Maxwell, R., & Miller, T. (2012). *Greening the Media.* New York: Oxford University Press.

McAllister, L. (2013). The human and environmental effects of e-waste. Retrieved from http://www.prb.org/Publications/Articles/2013/e-waste.aspx

Mejia, R. (2015). Ecological matters: Rethinking the "magic" of The Magic Circle. In M. Kapell (Ed.), *The play versus story divide in game studies: Critical essays.* Jefferson, NC: McFarland.

Mendis, S. (2014). *Global status report on noncommunicable diseases.* Geneva: World Health Organization.

Minnesota Department of Health. (2012). Thimerosal and childhood vaccines: What you should know. Retrieved from http://www.health.state.mn.us/divs/idepc/immunize/hcp/thimerosalfs.html#2a

National Institute for Minamata Disease. (2014). Outline of Minamata disease. Retrieved from http://www.nimd.go.jp/archives/english/tenji/a_corner/a01.html.

National Institutes of Health. (2015). Lead poisoning. Retrieved from http://www.nlm.nih.gov/medlineplus/ency/article/002473.htm

Nelson, G. (2010, May 13). EPA cleanup tactic to face GE challenge in D.C. Circuit. *New York Times.* Retrieved from http://www.nytimes.com/gwire/2010/05/13/13greenwire-epa-cleanup-tactic-to-face-ge-challenge-in-dc-69214.html

PBS. (2005). Mercury in fish. Retrieved from http://www.pbs.org/now/science/mercuryinfish.html

Robinson, B. H. (2009). E-waste: An assessment of global production and environmental impacts. *Science of the Total Environment, 408*(2), 183–191.

Rogoway, M. (2010, December 11). Oregon embraces Intel, but in New Mexico environmental doubts persist. *The Oregonian.* Retrieved from http://www.oregonlive.com/business/index.ssf/2010/12/oregon_embraces_intel_but_in_n.html

Southwood, T. R. E. (1983). Lead in the environment. *Royal Commission on Environmental Pollution.* London: Her Majesty's Stationery Office.

STEP. (2014). Step e-waste world map. Retrieved from http://www.step-initiative.org/step-e-waste-world-map.html

Treichler, P. A. (1999). *How to have theory in an epidemic: Cultural chronicles of AIDS.* Durham, NC: Duke University Press.

U.S. Food and Drug Administration. (2014). Thimerosal in vaccines. Retrieved from http://www.fda.gov/BiologicsBloodVaccines/SafetyAvailability/VaccineSafety/UCM096228

U.S. Geological Survey. (2013). Oregon Water Science Center active projects. Retrieved from http://or.water.usgs.gov/tualatin/pn356.html

Vidal, J. (2013, December 14). Toxic 'e-waste' dumped in poor nations, says United Nations. *The Guardian.* Retrieved from http://www.theguardian.com/global-development/2013/dec/14/toxic-ewaste-illegal-dumping-developing-countries

Wald, P. (2007). *Contagious: Cultures, carriers, and the outbreak narrative.* Durham, NC: Duke University Press.

Williams, R. (1974/2005). *Television: Technology and cultural form.* New York: Routledge.

World Health Organization. (2014a). HIV reporting: Global update on the health sector response to HIV, 2014: World Health Organization.

World Health Organization. (2014b). Tuberculosis. Retrieved from http://www.who.int/mediacentre/factsheets/fs104/en/

World Health Organization. (2015a). Cancer. Retrieved from http://www.who.int/mediacentre/factsheets/fs297/en/

World Health Organization. (2015b). Obesity and overweight. Retrieved from http://www.who.int/mediacentre/factsheets/fs311/en/

Education, Representation, AND Resistance: Black Girls IN Popular Instagram Memes

TIERA CHANTE' TANKSLEY

INTRODUCTION

*"Every child in America deserves a world-class education—especially in science and technology…
we also need folks who are studying the arts because our film industry…tells us our story and helps
us to find what's our common humanity." — President Obama, 2014*

In the midst of a national education crisis, where burgeoning gaps in academic
achievement, retention, and graduation rates between Black and White students
continue to surge and swell (Howard, 2008; U.S. Department of Education, 2014),
President Obama has come to understand the crucial connections among educa-
tion, identity, and the American media. His recognition of the immense power of
popular media, including social media, to sculpt our collective consciousness as
Americans is pertinent, particularly given the recent groundswell in youth media
consumption rates. When it comes to adolescents, a particularly impressionable
group, media consumption rates are soaring, marking it as a primary agent of
socialization among today's youth (Kellner & Share, 2007; Rideout, Foehr,
& Roberts, 2010).

Yet the circulation of racist and sexist media has likewise grown exponentially
with the advent of the Internet, and ideological investments in "post-racialism"
require new forms of racial common sense (Omi & Winant, 1994) and interro-
gations of how the invisibility of Whiteness (Daniels, 2013) serves to limit our

understanding of the intersectional nature of race and gender in social media engagement. Following the Civil Rights Movement, the nation discursively embraced racial equality, and everyday expressions of racism underwent a grand transformation. No longer socially or politically acceptable, overt expressions of racism metamorphosed into subtler, more clandestine forms (Delgado & Stefancic, 2012; Tate, 1997). This neo-racism, perpetuated as "color-blindness," enabled systems of oppression and disenfranchisement to remain intact while making public acknowledgment of race and prejudice a social taboo (Bell, 1992). Now more than ever, recognizing and challenging racial inequality are hotly contested tasks, as many Americans believe wholeheartedly that the legacy of racism has been abolished (Bell, 1992).

The nation's belief in post-raciality extends far beyond physical society, manifesting regularly within digital, cyber, and televisual spaces as well (Daniels, 2009; Noble, 2014). Online media often circulates in the context of a post-racial utopia wherein viewers willingly consume fictional, value-free images as a form of escapism (hooks, 1992, 1996; Noble, 2013; Senft & Noble, 2013). This color-blind construction of online media, coupled with the prevailing belief in a post-racial America, poses a unique challenge for scholars attempting to document the deleterious effect of stereotypical images on marginalized race-gender groups (Daniels, 2009; hooks, 1996; Howard & Flennaugh, 2011; Noble, 2013). The struggle against perennial (mis)representations of Black womanhood has been hotly contested, as critical scholars continuously strive to achieve socially just media representation. Ultimately, the reluctance of Americans to acknowledge the pervasive realities of race and gender oppression, especially within the confines of beloved, "apolitical" entertainment spaces, necessitates the use of identity-centered, historically situated bodies of scholarship (Bell, 1992; Howard & Flennaugh, 2011; Solórzano, 1997) to make sense of resistance to systemic oppression.

In this chapter, I draw upon Black feminist thought (BFT) and critical race theory in education (CRT) to unearth how Black women and girls resist everyday iterations of oppression in seemingly neutral cyberspaces (Ladson-Billings, 1998) through the particular lens of Instagram memes. In recognizing the pervasive presence of popular media, particularly social media, in the lives of today's youth, I also examine the ways that Black girls resist misrepresentation and represent themselves more powerfully by talking back to popular culture through social media. I then analyze the discourses of Black girls on Instagram and discuss and propose a nuanced critical media pedagogy, or a *Black feminist media literacy*, which can emerge as a way of thinking about resistance to misrepresentation as Black girls combat multitudinous microaggressions in the media, in schools, in their communities and online. This framework merges Black feminist thought (Collins, 2002), critical race theory (Bell, 1992), and intersectionality (Crenshaw, 1991) to theorize a media literacy framework that can illuminate the pervasive reality of

racism and sexism in social media, while simultaneously exhuming their injurious effects on African American girls, both inside and outside of school (Noble, 2012, 2013). Ultimately, the goal of this research is to engender transformational resistance among Black female students and theorize pedagogical interventions.

BLACK GIRLS AND MEDIA CONSUMPTION

According to the Kaiser Family Foundation, adolescents between 8 and 18 years old consume about 7.5 hours of non-academic media per day, 7 days a week (Rideout et al., 2010). When the reality of multitasking and simultaneous media use is taken into account, these intake rates skyrocket to about 10 hours of media ingestion each day. This means youth are spending more time consuming media than they are attending school. Disaggregating the data by age and race, it becomes clear that there are two groups that consistently maintain the highest levels of media consumption over time: "tweens" (11–14 years old) and African Americans (Rideout et al., 2010). While "tweens" consume about 12 hours of media per day, Black youth consume upwards of 13 hours of mass media per day— four and a half more hours than their white counterpart (Rideout, Lauricella, & Wartella, 2011). Lenhart's recent study on teens and social media consumption (2015) reports that 92 percent of teens are online every day, their access primarily facilitated by smartphones. Pew reports that African American teens (85 percent) are the most likely to have smartphones and access the Internet through mobile devices, compared to White and Hispanic teens (71 percent). African Americans are the group to most frequently be on the Internet throughout the day compared to their White and Hispanic counterparts (Lenhart, 2015). Overall, teens are most likely to be on Facebook (71 percent), followed by Instagram (54 percent) and Snapchat (41 percent). Among these findings, girls (61 percent) are more likely to be on Instagram than boys (44 percent) (Lenhart, 2015). Lenhart's study indicates that Black youth are the most connected and largest consumers of media among all teens in the United States.

Despite the proliferation of innovative media forms, television still reigns supreme as the most popular form of media used by adolescents. In fact, TV comprises nearly half of their total media intake each day (Rideout et al., 2010, p. 11). Black adolescents stand out as the greatest media consumers, averaging just over 6 hours of daily TV ingestion—2 hours over the national average and 3 hours more than White adolescents. Further, a recent consumer report found that Black girls and women consistently consume more television (Pearson-McNeil & Ebanks, 2014, p. 15) than their Black male counterparts. While television continues to be one of the most popular forms of media consumed, the ways shows are formatted, disseminated, and accessed has changed rather significantly over the past few decades.

Smart devices, coupled with the growing popularity of video streaming, has also tethered together televisual and cyber spaces, effectively blurring the lines between what is watched on TV and what is created, shared, and accessed online. Vine videos, Snapchats, Twitter hashtags, and Instagram memes serve as timely exemplars of the growing ambiguity between digital, cyber, and televisual artifacts. Now, more than ever, youth TV viewership is moving online, exponentially expanding consumption options from local to international, primetime to real-time, and full-length to Internet shorts.

As the lines blur between media devices and multiple screens, young Black women are responding to, and resisting, mass media images of Black woman/ girlhood by using social media, particularly Instagram memes, as a mechanism to critique and speak back to their (mis)representations in the media. Examined within the context of racially degrading and sexist media messages, which cultural critics argue make up a significant portion of televisual messages both on and offline, the statistics on Black girls' media intake become an irrefutable cause for concern (Harris-Perry, 2011; hooks, 1992, 1994; Noble, 2012). Though no single group can escape the media's harsh and inaccurate portrayal, Black women and girls are disproportionately misrepresented and degraded in popular media compared to other race-gender groups (hooks, 1992). Historically oppressive stereotypes about Black female promiscuity, hostility, and ineducability are still regularly disseminated in popular Web series, hashtags, and Instagram memes with large Black female viewership.

If President Obama is correct in assuming that the media is responsible for conveying our "common story" and establishing our "common humanity" as Americans, then what impact does that story have on the Black girl "tweens" who regularly consume racially and sexually degrading media? To address this question, this chapter examines images of Black girls and women on Instagram through the lens of an intersectional analysis that uses Black feminist thought (Collins, 2002, 2004; Crenshaw, 1991) and critical race theory in education (Bell, 1992; Delgado & Stefancic, 2012; Solórzano, 1998; Ladson-Billings, 1998), two foundational bodies of scholarship that explore intersectionality and the compounded consequences of race, class, and gender oppression on girls of color.

THE LANDSCAPE OF (MIS)REPRESENTATION AND BLACK GIRL RESISTANCE

From Vine videos to podcasts to blogs, the social media landscape is virtually saturated with demeaning images of Black womanhood (hooks, 1996; Richardson, 2007; Stephens & Few, 2007; Stokes, 2007). For hours on end, Black women

are continuously portrayed as hypersexual, hyperaggressive, and wholly incompetent in a seemingly unbroken stream of video clips and sound bites (hooks, 1992; Richardson, 2007; Stokes, 2007). Images of African American women as hoes, divas, baby mamas, gold diggers, high school dropouts, and welfare queens are multitudinous, manifesting visually, verbally, and textually in a range of digital media products (Richardson, 2007; Stokes, 2007).

Cybershow titles such as *P.O.P. That Pussy* and *The Slutty Years* rhetorically position the Black female body as a site of hyperaccessible, commodifiable sexuality, while the content of "fight compilation" Vine videos characterizes Black girls as volatile and uncivilized (Henry, West, & Jackson, 2010; Stephens & Few, 2007; Stokes, 2007). These stereotypical images are often bolstered by an underlying assumption of Black female ineducability and incompetence (hooks, 1992, 1996). World Star Hip Hop's newest Web series, *Questions*, is an exemplar of how mass media constructs raced and gendered notions of intelligence. The series, dedicated to "exposing" incompetence as a form of entertainment, feeds trivia questions to unsuspecting bystanders in real-time street interviews. More often than not, the female interviewees are beautiful, provocatively dressed, and comically uneducated. Interestingly, Black women make up a significant portion of the interview pool, their bodies always working to affirm jocular images of the handkerchiefed Mammy, the finger-wagging Sapphire, and the oversexed Jezebel. Such exaggerated media representations inevitably tether hypersexuality, hyperaggression, and ineducability to African American womanhood, engendering a range of consequences for Black girls looking to the Web to find authentic representations of themselves (Boylorn, 2008; Noble, 2012; Stephens & Few, 2007).

Figure 14.1 World Star Hip Hop's Web Series *Questions, Episode 4.*

In resistance to many of the mass and online media depictions of Black girl/womanhood, Black girls have created and circulated memes as a means of resistance. These memes, which consist of text written over images as a form of social critique, address sexism, racism, colorism, and multiple forms of aggression against Black girls. Since they work to challenge dominant narratives of Black female depravity, satirical Instagram memes can serve as cyber counter-stories that affirm and validate Black girls' lived experiences with intersectional oppression. Since critical counter-stories represent the collective experience, they often include socioculturally informed ways of doing, speaking, and resisting that denote a particular standpoint and collective experience. Thus, to interpret the meme-as-counter-story, users must have an understanding of or familiarity with said language, culture, or experience.

Instagram's malleable, minimalist structure likely contributes to its popularity as a site of quick-witted image critique. Relying heavily on the creation and dissemination of visual media, Instagram's communicative conventions lend themselves readily to televisual remix and revision. By offering a platform that resembles a more user-driven TV screen, Instagram can readily be operationalized as a tool to directly critique, remix, and respond to what were once inaccessible, unalterable TV images.

CHALLENGING NOTIONS OF BLACK GIRL INCOMPETENCY

Figure 14.2 Popular Instagram Memes Found on hashtag #blackgirlproblems, #blackgirlskillinit, and #blackgirlsrock.

Perhaps one of the most prevalent, regularly employed stereotypes about Black identity is the belief in Black intellectual inferiority. With roots in slavery and the construction of Black as docile and subhuman, African American language, culture, and temperament is often tethered to notions of incompetence. The memes in Figure 14.2 challenge problematic constructions of race and intelligence through the use of socioculturally informed gestures and linguistic practices. In her discussion of the role race, gender, and class play in development of resistance practices, Richardson (2007) asserts that Black women and girls have their own ways of reading, understanding, and responding to dominant narratives. Mockery, sarcasm, and gestures are key features of what Richardson (2007) terms "African American female literacies." Whether they are targeting prevailing social stereotypes or womanizing media images, African American female literacies are often employed by Black girls to "bring wreck," or revision, to problematic notions of Black womanhood. In the memes in Figure 14.2, Black girls use culturally understood facial expressions, gestures, and body language to voice their discontent with societal (mis)representations.

The first image, captioned "'You talk white,'" draws heavily upon the conventions of Black female body language as the primary mode of critique. Through the use of signature hand gestures and eye rolls, the young women in these pictures relay messages of frustration and discontent with the idea of "talking white." Placing the racialized insult in quotes detaches it from an individual perpetrator and instead hints at some sort of societal omnipresence. It would seem as though this insult, and the racialized ideologies of Black incompetence and White intelligence that underpin it, are so ubiquitous in the lives of Black youth that the words doesn't require a context or a specific perpetrator.

The second image is reminiscent of the first meme, with a floating quote that suggests frequent, widespread usage. However, in this particular image, the

microinsult "You don't sound Black" is countered with mockery, Southern drawl, Black vernacular, and a subtle reference to slavery. Employing all of these dialogic devices simultaneously gives the meme an exaggerated, humorous quality that isn't necessarily embedded in the first meme. Again, in her discussion of African American female literacies, Richards (2007) notes that Black girls often employ Southern drawl in their critiques of popular media because of its historic connection to Blackness and "dimwittedness" (p. 802). By using such speech in a mocking, overdramatized fashion, these meme creators acknowledge both the prevalence and fallacy of stereotypical beliefs in Black intellectual inferiority. The third and final meme isn't so much a critique as it is an expression of empowerment. The woman in the picture embodies visual characteristics of the "Earth Mother," a construction of Black womanhood typified by its affirmation of sisterhood, empowerment, and African pride (West, 2009). With a confident gaze, Afro hairstyle, and Afrocentric jewelry, the woman in the photo is positioned as educated and deserving of love.

CHALLENGING NORMATIVE CONSTRUCTIONS OF BEAUTY

Figure 14.3 Popular Instagram Memes Found on hashtag #blackgirlproblems, #blackisbeautiful, and #blackgirlskillinit.

Apple's recent release of "ethnic emojis" has altered the textual landscape of cyberspace, enabling users to employ racially encoded images in their everyday speech. The image in Figure 14.3 is a meme-within-a-meme, or a user's attempt to remix and revise what they viewed as a problematic cyber-image. The original meme shows three girls of color positioned left to right with complexions of successively darker skin tones, labeled with different seasons of the year. The underlying text

states "the disadvantages of being brownskin." To understand the message of this text, one must understand the role of colorism in the lives of Black women and girls. Colorism, defined as a system of discrimination and exclusion based on hierarchies of skin tone (Glenn, 2009), plays a prevalent role in the perception and treatment of girls of color. By placing Eurocentric beauty standards at the top of the hierarchy of worth and desire, colorism inherently positions Blackness as ugly and undesirable. Thus, darker skin tones are frequently perceived as a disadvantage since their "undesirability" engenders a nuanced form of oppression and invalidation for Black girls, the consequences of which manifest everywhere from love and dating to career and employment to health and life expectancy.

While the original meme validates the ideology of colorism, positioning Blackness as a deficiency, the "remixed" version affirms Afrocentric notions of beauty and worth. In the second image, the word "disadvantages" is crossed out in a vibrant red and the derogatory term is replaced with its diametric opposite: advantages. In doing so, this user creates a cyber-visual counterstory that challenges prevailing White supremacist notions of beauty and worth. Given the prevalent role of colorism in the lives of Black girls, it's not surprising that many memes tagged with pro-Black and pro-feminist hashtags speak out against this oppressive hierarchy of complexion, skin tone, and phenotype.

DISCUSSION

Racialized misogyny creates and sustains contemporary constructions of Black womanhood by embedding them into a history of exploitation and bondage (Harris-Perry, 2011), and Black women and girls have struggled for centuries to resist these narratives. Forged during slavery, controlling images of the hypersexual Jezebel, the overaggressive Sapphire, and the self-sacrificing Mammy were used to rationalize the continued exploitation, brutalization, and commodification of Black female bodies without consequence (hooks, 1992, 1996; West, 2009). By constructing Black women as angry, sexually insatiable, and sacrificial, plantation owners were able to render the Black female body as a welcoming site of violence and monetary gain. By aligning contemporary images of the angry, incompetent, and oversexed Black woman with its historic origins, BFT and CRT position the televisual landscape as a cyber plantation wherein Black female bodies are continuously stereotyped, stripped, and sold for entertainment and profit. In fact, the more exaggerated the race-gender stereotypes are in a show, the higher the ratings and revenue are for the series (Hopson, 2008; Tyree, 2011).

Black feminist and critical race theory scholarship affirms this connection by revealing that the visual and verbal rape and sale of Black female bodies in music (Henry et al., 2010), television (Boylorn, 2008; Tyree, 2011) pornography (Hunter

& Soto, 2009; Miller-Young, 2008), and commercial Internet search (Noble, 2012, 2013) garners record-breaking profit for corporations. These studies illuminate how the commodification and brutalization of Black womanhood is historically anchored, and its unchallenged existence continues to have deleterious repercussions for African American women and girls. By centering the voices of Black girls (who are likely students) through the memes in this chapter, we can recognize the range of inter- and intrapersonal consequences that emerge from the proliferation of racially degrading media images and how Black girls are speaking back.

These forms of resistance are crucial to the well-being of Black girls, as studies show that extensive exposure to raced and gendered stereotypes, or microaggressions, can result in lowered self-esteem (Yosso, Smith, Ceja, & Solórzano, 2009), feelings of isolation, anxiety, and depression (Solórzano, Ceja, & Yosso, 2000), racial battle fatigue (Smith, Allen, & Danley, 2007), and stereotype threat (Perry, Steele, & Hilliard, 2004). These sentiments have been found to lead to decreased levels of academic achievement and engagement. In some instances, Black girls willingly perform these racialized scripts of sexuality, aggression, and incompetency (Stokes, 2007). Yet the enactment of controlling images can be self-defeating in many cases, as these girls are more likely to engage in riskier sexual behaviors that can lead to pregnancy and delayed graduation; verbal and physical altercations that lead to suspension and expulsion; and poor study habits that lead to academic failure (Crenshaw et al., 2015; Stokes, 2007).

As if the consequences of internalizing dominant racist and sexist narratives about Black girl/womanhood weren't damaging enough, mass media simultaneously affects the interpersonal experiences of Black girls in urban schools. Attending academies that maintain rather homogenous faculty groups in terms of gender, race, and class, Black female students often interact with educators and administrators who have had minimal personal experience with African Americans before starting their careers (Ladson-Billings, 1994). Unfortunately, there exists an undeniable link between consumption of media stereotypes and the negative perception and treatment of African Americans when the viewer has had limited personal experiences against which to evaluate and counter the images (Fujioka, 1999; Hopson, 2008). Engaging in a form of people watching, many viewers extract fallacious information about the culture, personality, and educability of Black children from mass media (Ward, 2005). In many cases, these mass-produced, racially degrading notions of socio-academic failure inform teachers' beliefs about Black youth and are used to justify (1) having low expectations for educational outcomes; (2) placing Black students into segregated classrooms and tracks; and (3) remediating the curriculum and pedagogy (Solórzano, 1997, p. 10). Similarly, students of color are aware that societal stereotypes affect the quality and quantity of academic resources their schools receive, which inevitably affects the caliber of teaching and instruction they receive (Yosso, 2005).

Toward a Black Feminist Media Literacy

In the case of social media, the macro component of racism is the endemic and institutionalized disease of White supremacy (Daniels, 2009, 2013; Noble, 2014) that allows for the creation and proliferation of derogatory images of Black womanhood within digital spaces. Likewise, the micro component is the cumulative racial assaults, or microaggressions, present within the media that target Black female identity (Solórzano, 1997). CRT also asserts that racial identity is indivisibly tethered to other identity constructs, including gender, class, and sexuality. What we need is an intersectional theory of media literacy for Black women and girls that merges the tenets of critical race theory and Black feminist thought to better articulate the media experiences and forms of resistance that Black girls are using to critique racism and sexism. We need Black feminist media literacy.

As a social justice framework, critical race theory in education was designed in response to the emergence of color-blind racism, particularly in its manifestations in schools. Its purpose, as explicated by CRT scholars, is to deconstruct color-blind ideology at "its racist premise" to transform those structural aspects of society, including educational institutions and mainstream media, that maintain the subordination of students of color (Malagón, Pérez Huber, & Velez, in press, p. 3; Solórzano, 1997). The five tenets of CRT in education, which I expand upon to begin articulating a Black feminist media literacy, can be used to address the reality and complexity of racism and sexism embedded within both contemporary media and American schooling.

1. The Centrality of Race and Racism: CRT in education acknowledges that racism is permanent and deeply ingrained within the fabric of American society (Bell, 1992; Solórzano, 1997) and should therefore be centralized in discussions of Black students' educational experiences (Huber, Benavides, Malagón, & Solórzano, 2008). Critical race theory simultaneously asserts that racism can be either conscious or unconscious and is often perpetuated as jocular, innocuous entertainment. Black feminist media literacy can contextualize racism *and* sexism as endemic to educational socialization and public policy, so that Black girls can understand educational system practices and identify when these practices are not working in their interests, such that they can find advocates and support for intervention and protection.

2. The Challenge to Dominant Ideology: CRT in education challenges traditional social science and media discourses that place the blame of academic failure on African Americans (Yosso, 2005; Yosso et al., 2009). Instead, CRT acknowledges cultural deficit frameworks endorsed in school and popular media, which overlook the systemic inequalities that contribute to Black students' academic struggles (Solórzano et al., 2000). Black feminist media literacy can teach all students how to recognize harmful images of Black girl/womanhood and speak back to or intervene upon these discourses.

3. Commitment to Social Justice: In its struggle toward social justice, CRT in education aims to completely abolish racism, as well as to eliminate all other forms of marginalization such as class, gender, and linguistic oppression (Solórzano, 1997). This objective transcends education, as CRT is subsequently dedicated to eradicating classed and gendered stereotypes within popular media that are regurgitated within the walls of academia and help to sustain educational inequality. Black feminist media literacy can build upon and incorporate the intersectional strengths and contributions of Black girl/womanhood, rather than just neutralizing and erasing it through one-dimensional ways of engaging identity.

4. The Centrality of Experiential Knowledge: CRT in education recognizes that lived experiences of Black students are legitimate and critical to understanding the current condition of social and academic inequality for Black Americans (Huber, 2009; Solórzano & Yosso, 2002). Thus, CRT encourages girls of color to construct cyber-counterstories and counternarratives as a means of challenging, resisting, and speaking back to degrading media images (Huber, 2009; Solórzano & Yosso, 2002). Black feminist media literacy creates and foregrounds the lived experiences and stories of Black girl/womanhood.

5. The Interdisciplinary Perspective: Critical race scholars actively integrate race and racism within a historical context by drawing upon scholarship from ethnic studies, feminist theories, history, film, social science, and other fields (Yosso, 2005). Black feminist media literacy uses these interdisciplinary fields of study to foreground and interrogate the intersectional nature of oppression so that specific interventions can emerge on behalf of improving the quality of life of Black girls and women.

Though rife with benefits, CRT's central focus on race limits its ability to fully examine what it means to be poor, Black, and female within a society that is markedly racist, misogynistic, and capitalistic (Davis, 2011; Lorde, 1992). Recognizing the ways these macro structures intersect to create an exacerbated form of subjugation, Afro-feminist scholars offer Black feminist thought as a theoretical body containing the cultural knowledge, sociopolitical experiences, and historical insight required to fully understand Black women's triply marginalized state (Collins, 2002, 2004). Using the lived experiences of everyday Black women as a guide, BFT lends a helping hand to scholars whose research seeks to complicate prevailing notions of Black girls as resistant, incompetent, hypersexual, and the source of their own socio-academic struggles (Bryson, 2003; Collins, 2002). Through its use of dialogue, affective knowledge, historical analysis, and experiential insight, a commitment to Black feminist media literacy acknowledges the enduring images of Black female depravity that have fostered the continued marginalization, exploitation, and disenfranchisement of Black females in both school and society (Harris-Perry, 2011), and actively seeks to intervene upon and dismantle these notions about Black girls and women.

There exists a growing body of critical scholarship dedicated to teaching, bolstering, and cultivating strategies of resistance, survival, and empowerment in urban schools within the context of media. These bodies of work support the development of students' critical media literacies—or the ways of understanding, creating, and reading media—to help them challenge and interrogate problematic stereotypes about their social identity (Kellner & Share, 2007). Perhaps the most well-known of these disciplines, critical media literacy (CML), is broad and inclusive, encouraging students to critique representations of race, gender, class, language, sexuality, and beyond to achieve social justice (Kellner, 2005). CML is particularly powerful because it moves beyond mere critique and encourages students to take a stance against social injustice through the creation and dissemination of counter-hegemonic media (Morrell, 2008). Critical media scholars position CML as a form of social justice pedagogy, pushing educators to equip students with the skills to critique and transform both school and society (Morrell & Duncan-Andrade, 2008).

By drawing upon CRT and BFT, this chapter seeks to offer a nuanced lens on critical media literacy as it currently stands—one that centers race, gender, and class not only in its interrogation and construction of media but also in its conceptualization of literacy and language. Recognizing the way social identities are indivisibly tethered to one's way of reading and engaging with the world (Freire, 1985), this chapter offers *Black feminist media literacy* (BFML) as a reconfiguration of CML that validates Black girls' sociocultural literacy practices. Drawing upon the tenets of CRT and BFT, Black feminist media literacy challenges prevailing notions of Black girls as inarticulate, illiterate, and uncritical consumers of problematic media. Instead, this conceptualization recognizes that Black females have always taken pleasure in critiquing and deconstructing societal images—a practice bell hooks calls the "oppositional gaze" (hooks, 1992). Validating this Black female gaze in the classroom is a critical component of BFML as it challenges the notion that teachers are the sole purveyors of critical consciousness, responsible for passing resistance literacies down to their students. Conversely, BFML asserts that Black women regularly use historically anchored literacy practices designed to critique, liberate, and empower (hooks, 2013). In fact, these *African American female literacies* (Richardson, 2007) are operationalized by Black girls to "bring wreck" (i.e., remix or reconstruct) to prevailing stereotypes in creative and subversive ways. Through "smart talk," sarcasm, mockery, dramatic pauses, call and response, double meanings, and tonal emphasis, young Black girls regularly revise and redefine traditional readings of Black female sexuality, aggression, and incompetency as presented in both media and educational discourse (Richardson, 2007). Thus, a critically conscious, student-centered framework of "critical media literacy" would necessarily incorporate the diversity of sociocultural literacy practices Black girls may use into its anatomical structure.

Blending together BFT, CRT, and critical media scholarship, Black feminist media literacy operationalizes a range of academic, technovisual, digital, and sociocultural literacies to cultivate students' skills with analyzing media codes, criticizing dominant ideologies, and constructing alternative media products that aim to produce transformative change (Yosso, 2005). BFML can bolster students' feelings of empowerment and academic resilience by enabling them to speak openly and honestly about their personal experiences with race, gender, and class oppression. In the end, BFML can bolster Black girls' transformative resistance by invalidating notions of Black female deficiency, reengaging them in school and cultivating their ability to positively define Black womanhood for themselves. Ultimately, it is the author's hope that Black feminist media literacy can help students and teachers make strides toward eliminating marginalization in schools, media, and society.

REFERENCES

Bell, D. (1992). *Faces at the bottom of the well: The permanence of racism.* New York: Basic Books.

Bell, D. A. (1995). Who's afraid of critical race theory? *University of Illinois Law Review,* 893–910.

Boylorn, R. (2008). As seen on TV: An autoethnographic reflection on race and reality television. *Critical Studies in Media Communication, 25*(4), 413–433.

Bryson, V. (2003). *Feminist political theory: An introduction.* New York: Palgrave Macmillan.

Collins, P. H. (2002). *Black feminist thought: Knowledge, consciousness, and the politics of empowerment.* New York: Routledge.

Collins, P. H. (2004). *Black sexual politics: African Americans, gender, and the new racism.* New York: Routledge.

Collins, P. H. (2005). *Black sexual politics: African Americans, gender, and the new racism.* New York: Routledge.

Cooper, R., & Huh, C. R. (2008). Improving academic possibilities of students of color during the middle school to high school transition: Conceptual and strategic considerations in a US context. In J. K. Asamen, M. L. Ellis, & G. L. Berry (Eds.), *The SAGE handbook of child development, multiculturalism, and media.* Thousand Oaks, CA: Sage.

Crenshaw, K. (1991). Mapping the margins: Intersectionality, identity politics, and violence against women of color. *Stanford Law Review,* 1241–1299.

Crenshaw, K. (2014). Did you know: The plight of Black girls and women in America. *African American Policy Forum.* Retrieved from http://www.aapf.org/publications/

Crenshaw, K. W., Ocen, P., & Nanda, J. (2015). Black girls matter: Pushed out, overpoliced and underprotected. In African American Policy Forum. Columbia Law School Center for Intersectionality and Social Policy Studies. N. p.

Daniels, J. (2009). *Cyber racism: White supremacy online and the new attack on civil rights.* Lanham, MD: Rowman & Littlefield.

Daniels, J. (2013). Race and racism in Internet studies: A review and critique. *New Media & Society, 15*(5), 695–719.

Davis, A. Y. (2011). *Women, race, & class.* New York: Vintage.

Davis, P. Law as microaggression. *The Yale Law Journal, 98*, 1559–1577.

Delgado, R. (1989). Storytelling for oppositionists and others: A plea for narrative. *Michigan Law Review, 87*, 2411–2441.

Delgado, R., & Stefancic, J. (2012). *Critical race theory: An introduction.* New York: New York University Press.

Duncan-Andrade, J. M. R., & Morrell, E. (2008). *The art of critical pedagogy: Possibilities for moving from theory to practice in urban schools.* New York: Peter Lang.

Freire, P. (1985). Reading the world and reading the word: An interview with Paulo Freire. *Language Arts*, 15–21.

Fujioka, Y. (1999). Television portrayals and African-American stereotypes: Examination of television effects when direct contact is lacking. *Journalism & Mass Communication Quarterly, 76*(1), 52–75.

Glenn, E. N. (Ed.). (2009). *Shades of difference: Why skin color matters.* Stanford, CA: Stanford University Press.

Harris-Perry, M. V. (2011). *Sister citizen: Shame, stereotypes, and Black women in America.* New Haven, CT: Yale University Press.

Henry, W., West, N., & Jackson, A. (2010). Hip-hop's influence on the identity development of Black female college students: A literature review. *Journal of College Student Development, 51*(3), 237–251.

hooks, b. (1992). *Black looks: Race and representation.* Boston, MA: South End Press.

hooks, b. (1996). *Reel to real: Race, sex, and class at the movies.* New York: Psychology Press.

Hopson, M. (2008). "Now watch me dance": Responding to critical observations, constructions, and performances of race on reality TV. *Critical Studies in Media Communication, 25*(4), 441–446.

Howard, T. (2008). Who really cares? The disenfranchisement of African American males in preK–12 schools: A critical race theory perspective. *The Teachers College Record, 110*(5), 954–985.

Howard, T. C., & Flennaugh, T. (2011). Research concerns, cautions and considerations on Black males in a "post-racial" society. *Race Ethnicity and Education, 14*(1), 105–120.

Huber, L. P. (2009). Disrupting apartheid of knowledge: Testimonio as methodology in Latina/o critical race research in education. *International Journal of Qualitative Studies in Education, 22*(6), 639–654.

Huber, L. P., Lopez, C. B., Malagon, M. C., Velez, V., & Solórzano, D. G. (2008). Getting beyond the 'symptom,' acknowledging the 'disease': Theorizing racist nativism. *Contemporary Justice Review, 11*(1), 39–51.

Hunter, M. L. (2013). *Race, gender, and the politics of skin tone.* New York: Routledge.

Hunter, M., & Soto, K. (2009). Women of color in hip hop: The pornographic gaze. *Race, Gender & Class*, 170–191.

Kellner, D. (2005). *Media spectacle and the crisis of democracy: Terrorism, war, and election battles.* Boulder, CO: Paradigm.

Kellner, D., & Share, J. (2007). Critical media literacy, democracy and the reconstruction of education. *UCLA center Xchange*, 1–23.

Ladson-Billings, G. (1994). *The dreamkeepers.* San Francisco, CA: Jossey-Bass.

Ladson-Billings, G. (1998). Just what is critical race theory and what's it doing in a nice field like education? *International Journal of Qualitative Studies in Education, 11*(1), 7–24.

Ladson-Billings, G., & Tate, W. (1995). Toward a critical race theory of education. *The Teachers College Record, 97*(1), 47–68.

Lenhart, A. (2015). Teen, social media and technology overview. Pew Research Center. Retrieved from http://www.pewinternet.org/2015/04/09/teens-social-media-technology-2015/

Lorde, A. (1992). Age, race, class and sex: Women redefining difference. In M. Anderson & P. H. Collins (Eds.), *Race, class, and gender: An anthology* (pp. 495–502). Belmont, CA: Wadsworth.

Malagón, M., Pérez Huber, L., & Velez, V. (in press). Our experiences, our methods: Using grounded theory to inform a critical race theory methodology. *Seattle Journal for Social Justice, 8.*

Miller-Young, M. (2008). Hip-hop honeys and da hustlaz: Black sexualities in the new hip-hop pornography. *Meridians: Feminism, Race, Transnationalism, 8*(1), 261–292.

Morrell, E. (2008). *Critical literacy and urban youth: Pedagogies of access, dissent, and liberation.* New York: Routledge.

Morrell, E., & Duncan-Andrade, J. M. (2002). Promoting academic literacy with urban youth through engaging hip-hop culture. *English Journal,* 88–92.

Noble, S. (2012). Missed connections: What search engines say about women. *Bitch Magazine, 12*(4), 37–41.

Noble, S. U. (2013). Google search: Hyper-visibility as a means of rendering Black women and girls invisible. *InVisible Culture:* Issue 19, n.p.

Noble, S. U. (2014). Trayvon, race, media and the politics of spectacle. *The Black Scholar, 44*(1), 12–29.

Omi, M., & Winant, H. (1994). *Racial formation in the United States: From the 1960s to the 1990s.* New York: Routledge.

Pearson-McNeil, C., & Ebanks, M. (2014). The African American consumer 2014 report. Retrieved from http://www.nielsen.com/content/dam/corporate/us/en/reports-downloads/2014 Reports/ nieslen-essence-2014-african-american-consumer-report-Sept-2014.pdf

Perry, T., Steele, C., & Hilliard, A. G. (2004). *Young, gifted, and Black: Promoting high achievement among African-American students.* Boston, MA: Beacon Press.

Richardson, E. (2007). "She was workin' it like for real": Critical literacy and discourse practices of African American females in the age of hip hop. *Discourse and Society, 18*(6), 789–809.

Rideout, V., Foehr, U., & Roberts, D. (2010). Generation m2: Media in the lives of 8- to 18-year-olds. Menlo Park, CA: Henry J. Kaiser Family Foundation.

Rideout, V., Lauricella, A., & Wartella, E. (2011). *Children, media, and race: Media use among White, Black, Hispanic, and Asian American children.* Report for the Center on Media and Human Development School of Communication Northwestern University.

Senft, T., & Noble, S. (2013). Race and social media. In T. M. Senft & J. Hunsinger (Eds.), *The Routledge handbook of social media.* New York: Routledge.

Smith, W. A., Allen, W. R., & Danley, L. L. (2007). "Assume the position...you fit the description": Psychosocial experiences and racial battle fatigue among African American male college students. *American Behavioral Scientist, 51*(4), 551–578.

Solórzano, D., Ceja, M., & Yosso, T. (2000). Critical race theory, racial microaggressions, and campus racial climate: The experiences of African American college students. *The Journal of Negro Education, 69*(1), 60–73.

Solórzano, D. G. (1997). Images and words that wound: Critical Race Theory, racial stereotyping, and teacher education. *Teacher Education Quarterly, 24*(3), 5–19.

Solórzano, D. G. (1998). Critical race theory, race and gender microaggressions, and the experience of Chicana and Chicano scholars. *International Journal of Qualitative Studies in Education, 11*(1), 121–136.

Solórzano, D. G., & Yosso, T. J. (2002). Critical race methodology: Counter-storytelling as an analytical framework for education research. *Qualitative Inquiry, 8*(1), 23–44.

Stephens, D. P., & Few, A. L. (2007). The effects of images of African American women in hip hop on early adolescents' attitudes toward physical attractiveness and interpersonal relationships. *Sex Roles, 56*(3–4), 251–264.

Stokes, C. (2007). Representin' in cyberspace: Sexual scripts, self-definition, and hip hop culture in Black American adolescent girls' home pages. *Culture, Health & Sexuality, 9*(2), 169–184.

Tate, W. (1997). Critical race theory and education: History, theory, and implications. *Review of Research in Education, 22*, 195–247.

The Black Women's Blueprint. (2015). Sexual violence against Black women in the United States. Retrieved from http://www.blackwomensblueprint.org/wp-content/uploads/Sexual-Violence-Against-Black-Women-2015-BWB-2015-final.pdf

Tyree, T. (2011). African American stereotypes in reality television. *The Howard Journal of Communications, 22*, 394–413.

U.S. Department of Education, National Center for Education Statistics. (2014). The condition of education 2014 (NCES 2014-083), Status Dropout Rates. Retrieved from http://nces.ed.gov/pubs2014/2014083.pdf

Ward, M. (2005). Children, adolescents, and the media: The molding of minds, bodies, and deeds. *New Directions for Child and Adolescent Development, 109*, 63–70.

West, C. M. (2009). Still on the auction block: The (s) exploitation of black adolescent girls in rap (e) music and hip-hop culture. S. In Olfman, *The sexualization of childhood* (pp. 89–102). Westport, CT: Praeger.

Yosso, T. (2002). Critical race media literacy: Challenging deficit discourse about Chicanas/os. *Journal of Popular Film & Television, 30*(1), 52–62.

Yosso, T. (2005). Whose culture has capital? A critical race theory discussion of community cultural wealth. *Race Ethnicity and Education, 8*(1), 69–91.

Yosso, T. J. (2006). *Critical race counterstories along the Chicana/Chicano educational pipeline.* New York: Routledge.

Yosso, T. J., Smith, W. A., Ceja, M., & Solórzano, D. G. (2009). Critical race theory, racial microaggressions, and campus racial climate for Latina/o undergraduates. *Harvard Educational Review, 79*(4), 659–691.

Contributors

Ergin Bulut, PhD
Department of Media and Visual Arts
Koç University

Dr. Ergin Bulut is an assistant professor at the Department of Media and Visual Arts at Koç University, Istanbul, Turkey. He is currently working on his book manuscript on the precarious work experience of video game developers where he explores processes of financialization, corporatization, and spatialization. His research interests cover political economy of media and media labor, critical/cultural studies, game studies, and philosophy of technology. His writings have appeared in *TV and New Media*; *Communication and Critical/Cultural Studies, Globalization, Societies and Education*; and *Review of Education, Pedagogy,* and *Cultural Studies.* He is the co-editor of *Cognitive Capitalism, Education, and Digital Labor* (Peter Lang, 2011).

Aymar Jean Christian, PhD
Department of Communication Studies
School of Communication
Northwestern University

Dr. Aymar Jean Christian is an assistant professor of Communication at Northwestern University. Dr. Christian researches television and digital media

industries, publishing studies on indie TV in a forthcoming book manuscript and the academic journals *Continuum*, *Cinema Journal*, *Journal of Communication Inquiry*, *First Monday*, and *Communication, Culture and Critique*. He has worked as a journalist, curator, and producer of web series for Indiewire, the Peabody Awards, Tribeca Film Festival and LA Web Fest, among other institutions. He is currently developing his next research project, Open TV (beta), a platform for distributing TV by queer, trans, and cis-women and artists of color, primarily in Chicago.

Jessie Daniels
Professor, Sociology
Hunter College and The Graduate Center - City University of New York (CUNY)

Jessie Daniels is professor in the Department of Sociology at Hunter College and The Graduate Center, CUNY. She is an internationally recognized expert on Internet manifestations of racism, She is the author of two books about race and various forms of media, *White Lies* (Routledge, 1997) and *Cyber Racism* (Rowman & Littlefield, 2009), as well as dozens of peer-reviewed journal articles. She is co-founder and editor of *Racism Review*, (www.racismreview.com). Daniels is the co-author of two books about academia and technology: *Going Public* (University of Chicago Press, with Arlene Stein) and *Being a Scholar in the Digital Era* (Policy Press, with Polly Thistlethwaite). She is co-editor, with Karen Gregory and Tressie McMillan Cottom, of *Digital Sociologies: A Handbook* (Policy Press). She is currently at work on a memoir about her relationship with her father, who identified both as Native American and with white racist segregationists, called *No Daughter of Mine*.

Jenny Ungbha Korn
Department of Communication
University of Illinois at Chicago

Jenny Ungbha Korn is a Thai American feminist of color from Alabama. She is a scholar-activist of race, gender, and online identity with academic training in communication, sociology, theater, public policy, and gender studies from Princeton, Harvard, Northwestern, and the University of Illinois at Chicago. As a public scholar, she has given nearly 100 presentations, including invited keynotes, refereed conferences, guest lectures, and community talks.

Korn has been quoted in interviews with CNN, National Public Radio, Colorlines, Fox News, Policy Mic, South by Southwest, RedEye Chicago, UIC News, and more. Her work has been published in *Contexts*; *Our Voices*; *Multicultural America*; *Hashtag Publics*; *The Intersectional Internet*; *Television, Social Media*, and *Fan Culture*; *Women, Work, and the Web*; *The Journal of Economics and Statistics*; *The Encyclopedia of Asian American Culture*; and Harvard University's *Transition*. Leveraging her scholarship and polymathy, she explores how the Internet environment resonates user assemblages of race and gender and how online producer-consumers have constructed inventive digital representations and computer-mediated communications of identity. Please connect with Jenny Korn at http://JennyKorn.com, @JennyKorn on Twitter, http://facebook.com/JenKorn, and http://linkedin.com/in/JennyKorn.

David J. Leonard, PhD
Department of Critical Culture, Gender, and Race Studies
Washington State University

Dr. David J. Leonard is associate professor and chair in the Department of Critical Culture, Gender and Race Studies at Washington State University, Pullman. He regularly writes about issues of race, gender, inequality, and popular culture. His work has appeared in a number of academic journals and anthologies. His works can be found at http://www.drdavidjleonard.com. Follow him on Twitter @drdavidjleonard.

Robert Mejia, PhD
Department of Communication
The College at Brockport (SUNY Brockport)

Dr. Robert Mejia is an assistant professor of Media Studies at the State University of New York, Brockport. He received his doctorate from the Institute of Communications Research at the University of Illinois at Urbana-Champaign. He has published on the politics of the digital divide, mobile technologies, gaming, artificial intelligence, and philanthropy. His work has appeared in *Communication and Critical/Cultural Studies*, *Explorations in Media Ecology*, *Playing With the Past: Digital Games and the Simulation of History*, and *Race/Gender/Class/Media 3.0*.

Molly Niesen, PhD
Communication Studies
Eastern Illinois University

Dr. Molly C. Niesen is an assistant professor of Communication Studies at Eastern Illinois University. She completed her PhD in the Institute of Communications Research at the University of Illinois at Urbana-Champaign. Her doctoral thesis, "Crisis of Consumerism: Advertising, Activism, and the Battle Over the U.S. Federal Trade Commission, 1969–1980," won the National Communication Association's Most Outstanding Dissertation Award for 2014, Critical Cultural Studies Division. Another paper on regulatory debates over children's advertising was awarded the Brian Murphy Best Paper Award at the 2013 Union for Democratic Communications conference in San Francisco, CA. In addition to her research on the online dating industry, Dr. Niesen also pursues research in the political economy of media, media and advertising history, public policy, and public relations.

Safiya Umoja Noble, PhD
Department of Information Studies
University of California, Los Angeles (UCLA)

Dr. Safiya Umoja Noble is an assistant professor in the Department of Information Studies in the Graduate School of Education and Information Studies at UCLA and holds faculty appointments in the departments of African American Studies, Gender Studies, and Education. She conducts research in socio-cultural informatics, including feminist and political-economic perspectives on computing platforms and software in the public interest. Her research on the design and use of applications on the Internet is at the intersection of culture and technology. She is currently working on a monograph that uses Black feminist and critical race theory as a framework for making sense of racist and sexist algorithmic bias (forthcoming, New York University Press) in search engines like Google. She currently serves as a member of the editorial board of the *Journal of Critical Library and Information Studies*. She is co-editor of *Emotions, Technology & Design* (Elsevier, 2015). Her work is documented at safiyaunoble.com and can she be reached on Twitter @ safiyanoble.

Sarah T. Roberts, PhD
Faculty of Information & Media Studies
University of Western Ontario

Dr. Sarah T. Roberts is an assistant professor in the Faculty of Information and Media Studies (FIMS) at Western University in Ontario, Canada. Her work focuses on a variety of issues related to the political economy of many aspects of "the Information Society" and its sociocultural, economic, and ethical implications, with special emphasis on digital labor. She is at work on a monograph on commercial content moderation, and her CCM research has been featured in *Wired* and Al Jazeera America, among other outlets. Prior to returning to academe, she worked for over a decade in IT, leading her to reject the mythos of the digital sublime. Sarah blogs periodically at http://illusionofvolition.com/ and can be tweeted @ubiquity75.

Joshua Schuschke
Rossier School of Education
University of Southern California (USC)

Josh Schuschke is a doctoral student and research assistant in the Rossier School of Education's Urban Education Policy program. His work is concentrated in educational psychology. Specifically, his research looks at identity development for African American students on social media. Josh's educational background includes an MA and a BS from the University of Louisville in Pan-African Studies. His master's thesis constructed a theoretical model of identity development for African American students utilizing social media platform affordances.

Catherine Knight Steele
Department of Journalism and Media Communication
Colorado State University

Dr. Catherine Knight Steele is an assistant professor in the Department of Journalism and Media Communication at Colorado State University. Her research focuses on issues of representation in mainstream media and resistance discourse from marginalized communities in online spaces. Some of her recent work engages with blogs as sites, which replicate features of Black oral culture in order to engage in political discourse in seemingly apolitical spaces. Dr. Steele's research explores the connections between traditional news, online writing and entertainment media to better elucidate how ideologies are formed, maintained, and changed in a given culture over time. Teaching courses in multicultural media and advanced cultural theory, she

focuses on making clear the connections between liberal arts education and practical communication practice. Dr. Steele received her PhD from the University of Illinois at Chicago in Communication.

Miriam E. Sweeney, PhD
School of Library and Information Studies
University of Alabama

Dr. Miriam Sweeney is an assistant professor in the School of Library and Information Studies. Sweeney holds a bachelor's degree from Indiana University in Anthropology, a joint master's degree in Library and Information Science and certificate in Book Studies from the University of Iowa, and a doctorate from the University of Illinois, Urbana-Champaign in Library and Information Science. Her research employs critical cultural frameworks to interrogate the intersections of gender, race, and technology, with a focus on digital media and Internet technologies. Her current projects include exploring the design, use, and meaning of emojis in society, particularly as they intersect with rhetorics of race and diversity. This work expands her research on anthropomorphic interface design and technoculture. She has related research interests in information technology and ethics, digital labor, and social justice.

Tiera Chante' Tanksley
Graduate School of Education & Information Studies
University of California, Los Angeles (UCLA)

Tiera Chante' Tanksley is a doctoral student in the Graduate School of Education and Information Studies within the Urban Schooling program. Broadly, her research examines the intersectional impacts of race, class, and gender on the educational experiences of African American girls. More narrowly, she explores the ways Black girls read, resist, and revise degrading images of Black girlhood as presented in digital, cyber, and televisual spaces. Tiera's educational background includes an MA in Cultural Studies in Education from UCLA and a BS in Inclusive Elementary and Special Education from Syracuse University.

Brendesha Tynes, PhD
University of Southern California (USC)

Dr. Brendesha Tynes is an associate professor of Education and Psychology at the USC Rossier School of Education. Her research focuses on youth experiences with digital media and how they are associated with academic

and socio-emotional outcomes. She is also interested in equity in digital literacy, which includes empowering uses of digital tools for underrepresented youth. Tynes has published widely, including in the *Journal of Applied Developmental Psychology*, *Cyberpsychology & Behavior*, and the *Journal of Adolescent Health and Developmental Psychology*. She has also been cited in numerous media outlets, including the *New York Times*, the *Los Angeles Times*, *Newsweek* and *Woman's Day*. She is the co-editor of the *Handbook of African American Psychology* and associate editor of the *American Educational Research Journal*. Tynes is also the 2015 recipient of the American Educational Research Association Early Career Award as well as the Spencer Mid-career Award.

Melissa Villa-Nicholas
Graduate School of Library and Information Science
University of Illinois Urbana-Champaign
Melissa Villa-Nicholas is a doctoral candidate in the Graduate School of Library and Information Science at the University of Illinois Urbana-Champaign. Her research interests include Latina socio-techno practices, and intersectional implications of new media technologies. Her current research focuses on Latina information workers during and after the EEOC v. AT&T consent decree. Recent publications include: "Latina Narratives of Information Technologies: Towards a Latina Science and Technology Studies" in *Media-N* and "Latina/o Librarian Technological Engagements: REFORMA in the Digital Age" in *Latino Studies*.

Myra Washington, PhD
Department of Communication & Journalism
New Mexico State University
Dr. Myra Washington is an assistant professor at the University of New Mexico specializing in critical cultural and media studies. Her research focuses primarily on race, non-White racially mixed people, popular culture, and media. More specifically her work attempts to connect mediated representations to cultural formations, and she looks for tensions, contradictions, and possibilities in those relationships. She also analyzes how digital rhetorics of race inform and construct identities and ideologies. Myra enjoys ocean expanses, the color yellow, and Nutella.

Index

Digital Formations

General Editor: **Steve Jones**

Digital Formations is the best source for critical, well-written books about digital technologies and modern life. Books in the series break new ground by emphasizing multiple methodological and theoretical approaches to deeply probe the formation and reformation of lived experience as it is refracted through digital interaction. Each volume in **Digital Formations** pushes forward our understanding of the intersections, and corresponding implications, between digital technologies and everyday life. The series examines broad issues in realms such as digital culture, electronic commerce, law, politics and governance, gender, the Internet, race, art, health and medicine, and education. The series emphasizes critical studies in the context of emergent and existing digital technologies.

Other recent titles include:

Felicia Wu Song
 Virtual Communities: Bowling Alone, Online Together

Edited by Sharon Kleinman
 The Culture of Efficiency: Technology in Everyday Life

Edward Lee Lamoureux, Steven L. Baron, & Claire Stewart
 Intellectual Property Law and Interactive Media: Free for a Fee

Edited by Adrienne Russell & Nabil Echchaibi
 International Blogging: Identity, Politics and Networked Publics

Edited by Don Heider
 Living Virtually: Researching New Worlds

Edited by Judith Burnett, Peter Senker & Kathy Walker
 The Myths of Technology: Innovation and Inequality

Edited by Knut Lundby
 Digital Storytelling, Mediatized Stories: Self-representations in New Media

Theresa M. Senft
 Camgirls: Celebrity and Community in the Age of Social Networks

Edited by Chris Paterson & David Domingo
 Making Online News: The Ethnography of New Media Production

To order other books in this series please contact our Customer Service Department:
 (800) 770-LANG (within the US)
 (212) 647-7706 (outside the US)
 (212) 647-7707 FAX

To find out more about the series or browse a full list of titles, please visit our website:
 WWW.PETERLANG.COM